Moving Beyond Boundaries

Black Women's Diasporas

Companion volume
MOVING BEYOND BOUNDARIES
Volume 1
International Dimensions of Black Women's Writing

Moving Beyond Boundaries

Volume 2: Black Women's Diasporas

Edited and Introduced by
Carole Boyce Davies

NEW YORK UNIVERSITY PRESS
Washington Square, New York

Introduction © Carole Boyce Davies 1995

Editorial selection and arrangement © Carole Boyce Davies 1995

First published in the U.S.A. in 1995 by
NEW YORK UNIVERSITY PRESS
Washington Square
New York, N.Y. 10003

Library of Congress Cataloging-in-Publication Data

Moving beyond boundaries.
 Vol. 2 edited by Carole Boyce Davies.
 Includes bibliographical references and
index.
 Contents: v. 1 International dimensions of
Black women's writing — v. 2. Black women's
diaspora.
 1. Literature—Black authors. 2. Literature—
Women authors. 3. Literature, Modern—Translations
into English. I. Davies, Carole Boyce.
II. Ogundipẹ-Leslie, 'Mọlara.
PN6068.M68 1994 808.8'99287'08996 94–31075
ISBN 0–8147–1237–1 (v. 1)
ISBN 0–8147–1238–X (v. 1: pbk.)
ISBN 0–8147–1239–8 (v. 2)
ISBN 0–8147–1240–1 (v. 2: pbk.)

Printed in the EC.

To my daughters Jonelle Ashaki Davies and Dalia Abayomi Davies.
May they grow in strength and beauty as black women.

Contents

Acknowledgements

A project of this size and breadth could not be completed without the support of a number of people. I would therefore like to identify the following: Lisa Fegley of the Dean's Office, Arts and Sciences, SUNY-Binghamton, gave critical word-processing advice and assistance. Arlene Norwalk of the English Department, SUNY-Binghamton, helped with inputting some documents.

Phillis Reisman Butler in particular and the NEH (National Endowment for the Humanities) fellowship to Brazil in 1992 helped in providing initial contact with, and knowledge of, Afro-Brazilian culture.

A SUNY-Binghamton Faculty Development Grant allowed me to return to Brazil in summer 1993 where I met, interviewed or talked with Miriam Alves, Lia Vieira, Esmeralda Ribeiro, Sônia Fátima da Conceição, Conceição Evaristo and a number of writers of *Quilhomboje* in São Paulo.

Carol Beane provided some of her work on Chiriboga.

All the writers in this collection are thanked for their enthusiasm, interest in and patience with this project.

The staff at Pluto Press, particularly Anne Beech, are acknowledged for their initial interest in converting the *Matatu* special issue on 'Black Women's Writing. Crossing the Boundaries' into book form and their ongoing commitment to this ever-expanding project.

Artist Vanda Vaz Ferreira of Salvador-Bahia, Brazil is acknowledged for artistic interpretations of the meaning of these volumes represented in the cover design.

CBD

Introduction:
Black Women Writing Worlds:
Textual Production, Dominance, and the
Critical Voice

Carole Boyce Davies

Black women's writing in this particular conceptualization is a series of boundary-crossing literatures, not a fixed geographically, ethnically, or nationally bound category of writing. Black women's writing, therefore, exists in cross-cultural, trans-national, diasporic contexts. These contexts rework the grounds of this literature as they demand a more expansive set of interactions at the level of the critical voice. Since black women's writing exists everywhere that black women exist, then the limitation of some understandings of black women's writing to specific nationalities, or specific forms, traditional genres and the scriptocentric may only have meaning in a particular ideological context in which one is activating a narrow particularity. Limitations of that sort have more to do with the ways in which literature is perceived by dominant cultures as annexes to specific nationalist agendas.

A number of historical events have created an automatic equation of black women's writing with US African-American women's writing: the prominence of US hegemony and marketing practices; the self-assertion and self-identification of African-American people in the USA; the internationalizing of US black struggles; the fact that people of African descent around the world tended (particularly during and after the period of Civil Rights/Black Power movements) to see black US experiences as part of the vanguard of movement for black liberation. Perhaps most importantly, black women writers in the USA have pursued the task of writing themselves into literary history in a very vigorous way. Still, their location in the USA allows more developed access (limited as it may be) to publishing enterprises in ways difficult or impossible for other women in other parts of the world have all contributed to this.

Black women's writing, first of all, is literary creativity as expressed by women who define themselves as black and who have historical/political reasons for assuming this self-definition. As such, this particular identification is not a forced construction of a monolithic category imposed externally. Rather, it is the opposite. This critical and creative collection's principle objective, therefore, has been to identify and include women who define themselves as black, as women, and as writers whether they live in Brazil or in Britain. By 'black' we mean here (1) of African origin or familial or cultural history or identification; (2) of non-

western/Caucasian orientation and articulating 'blackness' as a self-defined cultural descriptor; (3) existing in opposition to or outside of dominant racial definitions of whiteness and its politics of oppression.[1] Nevertheless, the phase 'black women's writing' is used provisionally here as a category on the understanding that each of these terms ('black,' 'woman,' 'writing') is subject to re-interpretation and deconstruction as they themselves become totalizing and oppressive discourses. It is a phrase which, I have argued elsewhere, has migratory capability as it traverses a variety of locational, thematic, and generic identities.[2] It is in this context that I see the necessity of examining black women's writing in relation to literary canonicity and textual production in order to disentangle the ways in which dominance becomes instituted.

I want to state first of all that within the general category of black women's writing, processes of canonizing are already taking place. The nature of academic/textual production, rather than the literature or the writers themselves, dictates these processes. In an earlier work, 'Writing off Marginality, Minoring and Effacement,'[3] I identified the ways in which processes of canonizing worked to deny the presence of African women's writing. Of course, similar arguments have been raised with regard to women's writing in general and to the writings of a variety of other excluded groups. I identify again the 'discourse of the prize' as not only the material prize or the specific cash award, but also as the way that one *gains* a certain prominence and acquires a certain cumulative recognition within the terms of literary canonicity.

In this introduction, then, I propose to take this discussion further by looking at the ways in which, within the field of black women's writing, already marginalized from mainstream literary discourses, only certain writers have attained prominence. By attempting to understand the institutional implications of these internal processes of hierarchization, more expansive, future work on black women's writing can challenge some of the 'masters' tools.'

The black women writers who are generally accorded major identification tend to be from the USA. This is coming to mean, through no fault of the individual writers themselves, that the work of other black women writers is measured against their writing. Also, black women in the USA who are writing in different ways, outside the accepted patterns, remain unaccounted for. Various communities and individual instances of black women's writing in other parts of the world remain unknown. We can therefore conclude that, marginalized and subordinated, historically, in the USA because of literary and social hierarchies, certain black women writers nonetheless become allied with hegemonic political and economic practices on an international scale, even as their writing resists these on a domestic (US) level. If we critique hegemonic practices, then, within the field of black women's writing, it is also necessary to identify these processes of hierarchization as they become entrenched.

The canonical black women writers are those who now appear most prominently in a variety of syllabi, journal articles, and popular media, literary conferences, and scholarly texts; those who are the beneficiaries of the 'discourse of the prize'. Availability in major bookstores world-wide, and translation into other languages are also marks of canonization, as is inclusion in mainstream anthologies. For these reasons, with particular reference to availability, we can at this point identify possible canonical writers to be Toni Morrison, Alice Walker, Zora Neale Hurston, Gwendolyn Brooks, and Maya Angelou. This inclusion has not come easily. Rather a great deal of struggling outside the gates of what constitutes mainstream literature has finally allowed a certain degree of entry. The question which still remains is, what does this entry into a certain form of recognition entail and mean?

It is important to note that other writers have begun to receive specific recognition in their own regional and national locations outside the USA. Certain African, Caribbean and European-based black women writers attain some readership in their own home contexts. The ways in which their work is translated, discussed in literary fora, and made accessible sometimes reveal as well a series of processes based on astute marketing practices and the thematics of the writing itself and the nature of literary production.

But if we look openly within the field of black women's writing in the USA, it is also necessary to identify a writer like Terry McMillan who has reached a mass popular audience but who still remains outside the realms of critical inquiry which is one of the routes to canonical identification. It may well be that the field is broadening, as it should, to include a range of readerships: the popular, the academic, and so on.[4] I hasten to reiterate that I am speaking of what is taking place within the category 'black women's writing' in order to dismantle the monolithic reductive understandings of this literature.[5] For within mainstream literature, primarily understood as being European, male, and white, these writers still exist in a marginal way. If we want to move away from the dominating ideologies of mainstream textual production, it is necessary to look at the various selection processes in detail and to understand the motivations and visions behind them. Similarly, it is important to rethink ways of making material available without resorting to the same hierarchization processes.

Dominance and Literary Curricula

The central position of literary dominance, as represented in a series of articles and statements by scholars who are predominantly white, male, outdated, and paranoid about equality, is that the master texts have survived the test of time and have much more literary merit than the 'hodge podge of popular culture which represents workers, women, homosexuals and nearly every ethnic group that wants to be included.'[6] The terms of their discussion suggest that the literary

production and artistic creativity of people who are not European/American and male are reducible to 'popular culture.' Clearly, then, the basic assumption of this type of reduction is biased, and reveals a fundamental aspect of Eurocentric epistemic violence. To dismantle such arguments we have to begin by challenging the history and nature of that violence at the physical, emotional, and epistemic levels; and then we must demonstrate how that violence seeks to maintain a specific power imbalance in all fields, disciplines, institutions, and so on. In this process it also becomes clear that the aesthetic judgments used to decide which literature is good and which is bad similarly come out of historic Western European and male understandings. We must also remember that Western European aesthetic and artistic hegemony has its roots in the capturing of Greek, Egyptian, and Asian knowledges in order to construct 'Western Civilization.' It is perhaps an unnecessary activity to take apart all the terms and concepts on which such limiting readings of the world are based; but such assertions help us to understand how a logic of dominance sustains itself by attempting to hide dissent. In the context of literary dominance, the construction of hierarchies, and patterns of inclusion and exclusion which are taken as normative, are centralized.

Central to this discussion is the entrenched notion of the existence of 'major' literature and 'minor' literatures, and the fact that 'minor literature' is equated with 'minorities.' What defines and constitutes a major literature? What makes a literature or writer minor or major? These are some of the questions that have been raised and answered in the context of 'minority discourses.'[7] Still, it is important to state that most departments of literature are organized on the basis of studying 'major literature' and that this is at the heart of discussions which set curricula requirements for English literature courses as predominantly European/American and male. An understanding of the major/minor writer distinction is central to any transformation of curricula as it identifies issues of marginalization and the subordination of a variety of underrepresented literatures and voices.

The idea of having a 'center,' which the Claussen article quoted above expresses, is also located within discourses of 'core' and 'periphery' which replicate arrangements at the global level whereby, somehow, Europe and America occupy the center while the rest of the world is on the periphery. The replication of this paradigm at the literary level is necessarily addressed in any discussions which speak of textual production and dominance. Clearly we are in the midst of an obligatory re-imagining of institutional structures which does not visualize automatically one center but perhaps a series of concentric circles of various literatures, and there are other patterns which can emerge with some imaginative reconfiguring. Russell Ferguson would speak of the 'invisible center'[8] and Ngugi wa Thiong'o of *Moving the Center*,[9] identifying some of the problematic notions surrounding centering European cultures, ideologies, and practices. Related questions of genre, of literary tradition, natural choices and

preferences, and the vexed question of standards, are all implicated. Thus, entrenched (often a synonym for exclusion) notions about what goes into a literary curriculum, and who defines it, even the notion of having an 'English' department at all, would have to be readdressed.[10] Which version of English and English literature is being centered? Which literature? Which writers? These are the hidden questions contained in some of those casual formulations which conceal ideologies of literary dominance – just one aspect of the Eurocentric hegemony to be found at the academic, popular, and sociopolitical levels.

Thus, on the question of textual production and on assumptions about literary merit and authority, we can as well ask: Whose authority? Textual production is not just the process of publishing but the way in which the text is produced and reproduced. If we identify all the processes, both implicit and explicit, of production and maintenance,[11] then teachers and critics are strategically located in the production of a literary text as well as in their teaching of it. Various aesthetic judgments are applied to texts and preferences are identified and passed on. Aesthetics, like taste, are shaped historically, culturally and socially. Therefore they can be changed. As teachers and scholar–critics, we need to be clear that we bring our own culturally-based assumptions about what is literary into the classroom and to the evaluation of the text. For students, our standards and directives can, in turn, become a generally accepted mode of inquiry and aesthetic preference. These standards are not only culturally based but are cultivated by very specific and political processes which represent state interests. These aesthetic formulations which assign value in certain ways and to certain texts begin very easily and are developed further through all the educational levels.

Publishing and other critical practices, such as lecturing to students, are similarly central in the maintenance and reproduction of a text. These are political exercises which align themselves with power and dominance in a variety of ways or in resistance to them. If publishing, then, is similarly shaped by aesthetic practices, choices, institutional and marketing mandates (also related to aesthetics), then it is not difficult to understand how libraries' holdings, reviewing, publishers' lists, anthologies and the inclusion/exclusion of some works relate to the maintenance of certain ideologies of dominance. So, in terms of examining these ideological formations which produce values, it is necessary to identify how a set of given ideas can attain a certain hegemonic existence in a culture and is thereby maintained, reshaped, and reproduced by a variety of practitioners who write and read that culture. These ideas become a 'tradition,' and then, over time, 'classics,' from which point they become standard and go on to affect taste, sensibility, aesthetic choices, in a seemingly uninterrupted cycle.

Today, literary ideological formulations, historically produced by Western European culture, are being addressed at a number of institutions. In the academy, this critical examination is resisted by those who want to maintain things as they are, although the world is changing. In particular, a number of teachers and professors

are extremely resistant to any kind of new theoretical formations and any new literatures, and even go as far as seeing people who are posing new knowledges as their enemies. This is an interesting development since the academy generally operates on the basis of the production of new knowledges and redefinitions of existing models. So, resistance to new information is a deliberate ideological position which seeks to pass itself off as apolitical. It is also clear that a particular aspect of this resistance exists because a variety of new theoretical constructions and knowledges challenges the kind of narrative or meta-narrative of dominance that locks in any monolithic view. Instead, newer paradigms seek to destabilize a variety of accepted and institutionalized 'verities.' So, for the entrenched members of the professoriat, narrow readings which hide the privileging of Euro-American thought and textualities operate out of a situated logic of dominance which enforces domination in the same way that the larger 'discriminatory paradigms' exist and normalize themselves at the state level.

In a similar way, the application of specific juridical standards or aesthetics or generic categories to a text, with the demand that it fits into them, is a flawed critical practice. Instead, newer approaches should encourage students to understand how meaning is constructed. This in turn allows the reader/spectator to move to a different level of aesthetic response, one that is informed by a sense of possibility and opening rather than closure.

Anthologizing Processes

Examinations of anthologies of mainstream European and American literature, such as the *Norton* anthologies,[12] reveal that there has been a consistent exclusion of a variety of black women writers with one or two exceptions, generally Phillis Wheatley and Gwendolyn Brooks. Since these same writers tend to appear from anthology to anthology, readers begin to have some familiarity with their names if not with their corpus. Even so, the works included tend to be very particular poems which are not representative of those writers. For example, there had to be some specific ideological import representing the interests of the dominant culture in the presentation of 'On Being Brought from Africa to America,' which begins with 'Twas mercy brought me from my pagan land...,' as the canonical Phillis Wheatley poem, the one for which she is best known. It becomes clear that these selections may be arbitrary, or may be representative of the point of view of the anthologizer, or may sometimes be based on the availability of the authors' work as well as specific criteria of selection; generally, however, they represent the anthologizer's vision of that field.[13] In sum, the reason for their inclusion was not always literary merit and did not necessarily represent the writer's strength. Wheatley was popularly represented as an intellectual curiosity; continuing to represent her in that way in the anthologies perpetuates this process.

It is also necessary to assess the way in which Gwendolyn Brooks, gifted enough to be named the Poet Laureate of Chicago and to win a major prize for her work, is often erased in relation to mainstream American literatures. For Brooks, in particular, the works often canonized do not generally capture the range or rage of the poet and the general intellectual output represented in her entire oeuvre. Still, it is important to bear in mind that, within the field of literature, there is a particular location for poets, and in particular for black women poets, which often does not turn up the same prize potential as does fiction. By prize potential, I refer again not to material rewards but to the way in which a writer's work attains a certain meaning conceptually within a larger set of institutional frameworks.

The erasure or dis-identification of black women in literary anthologies of African-American literature, in the 1920s and beyond, has been the subject of much previous discussion by a variety of African American literary scholars. It has driven the production of a literary criticism on black women's writings and has also made space for the production of this literature.[14] For example, Alain Locke's *The New Negro*[15] included some black women writers but in no way adequately represented the range of work being produced by black women during the Harlem Renaissance.[16] Thus, there was a very definite canonizing process taking place, as scholars studying that period have observed. And this process generally worked to exclude the particular vision of black women.

As one who offers a critique of anthologizing processes which automatically entail the politics of inclusion/exclusion, it is necessary to be similarly self-critical. While they do have a limited utility, my approach is to see anthologies as they relate to black women writers as one mode of getting a variety of voices heard which otherwise would have reduced audibility. So, it is not a process of saying: *These are the writers.* Rather it is that this represents only a small fraction of the range of possibilities. In fact, my experience has been one of struggling, as my publishers would attest, to include everything rather than operating on the basis of narrow selection.

The Politics of Critical Reading

The classic case of exclusion and recanonization is that of Zora Neale Hurston, who was a significant member of the Harlem Renaissance, a literary movement which came to be identified predominantly by and for the male members. Defined as existing outside the given paradigms of what constituted acceptable credentials for recognition, of which masculinity was prominent, Hurston's work remained for decades inaccessible to a range of scholars, students, and writers. In her case, class, personal style, regional origin, gender, language, politics, combined to present a dynamic of presence that was different from what was considered necessary. In subsequent years, Hurston's work, particularly *Their Eyes*

Were Watching God (1938), was further defined by Richard Wright as existing outside the boundaries of his 'Blueprint for Negro Writing.' It is significant that Richard Wright was also in the process of making himself the canonical writer of his generation. Thus, Hurston's work, defined by him as having no theme, message, or meaning, remained unacknowledged within the black/American literary tradition until it was literally rediscovered by black women writers and feminist critics of another generation and made central to black feminist literary tradition.[17] The subsequent readings of this work, its reissue, and the ways it has been/is being readdressed within women's literary history and critical circles, and secondarily within African-American and general American literature, are paradigmatic.

The Zora model offers an interesting presentation of the issues of the politics of critical reading and how this can effect marginalization. It makes the point that consistent exclusion of some writers from the pale of serious consideration contributes to canonizing some writers and erasing others. In addition, the setting of narrow paradigms and definitions of what constitutes a certain writing, as in Richard Wright's 'blueprint' or specific mandates for the Black Arts Movement, should be considered significant. In Wright's case, as in others, the influence that one's work may have on succeeding generations and the ways in which it interacts with meaning have to be considered central. Thus, the thematics of black literature are often set in what are considered sometimes very personal and political acts of writing which exist both inside and outside the writer/critic. Today, Hurston's work is indispensable to those wanting to understand black/women's/African/American literatures, particularly the general category of black women's writing. At the same time, it is possible to examine what kind of duty Hurston serves in the politics of black women's writing in the USA; that is, how she had to be reinvented and reimagined, reinterpreted. The recent *Zora* conferences in her hometown of Eatonville, Florida, must be identified as central to this process. This is particularly significant when Hurston's trajectory was one which saw the African diaspora as her field of operation. What does it mean, therefore, to the larger understanding of black women's writing transnationally when Hurston's work is interpreted, particularly within a narrow North American focus?

The questions of politics, social movements, and literature are clearly identified if we examine some of these operations. The issue of recuperation is also significant in understanding the politics of canonicity. The politics of reading is also involved here as expressed in the earlier Richard Wright under-reading or misreading. This had to give way to much richer textual analysis developed subsequently and in different contexts. The tools for reading Hurston fully had to be constructed in process. The Zora text had to wait for a different historical period and a different set of critical inquiries. This is an important point in our understanding of literary textualities, critical responses, and history. Because of

this, it is absolutely necessary for critics to move out of the juridical mode and more into a mode that is grounded in multiplicity and is expansive, but which at the same time remains tentative and provisional.

Writing Oneself Into the Canon

The process of writing oneself into the canon is perhaps most clearly expressed in the trajectory of Toni Morrison as a writer. Her series of literary movements, from *The Bluest Eye* (1970) to *Song of Solomon* (1977), and *Beloved* (1988) to *Jazz* (1992), express deliberate narrative power, innovativeness, and presence. In particular, Morrison has expressed a narrative mastery as a mode of expressing the black female/African-American subjectivity as she sees it. Morrison's narrative mastery is one which aligns well with major writers in the western tradition and particularly with those who have mastered the novel form.

Still, along with the question of narrative mastery is that of access, marketing and textual production in their myriad forms. It is significant that Morrison herself has worked as an editor at Random House in which she ushered into existence a number of books by US black writers. Morrison knows intimately the ingredients in producing a successful novel. One has to factor the knowledge and agency of the writer into the myriad processes of *producing* a great novel as well as *writing* it.

The awarding of the Nobel Prize for literature for 1993 becomes, therefore, the final, high canonical moment. In fact, the ceremonial activities around the prize directly identify the politics of the state with literary hegemony. As I argued in 'Writing off Marginality, Minoring and Effacement,' this has more to do with the high canonizing of an individual writer, whom we all love and celebrate on a personal level, than with the enhancement of the entire field of writing. Even so, it must be understood how, within the local US context, the politics of race and gender interfere with the kind of full recognition which a Nobel prize has accorded male writers.

One can come to similar conclusions from an examination of the literary career of Maya Angelou. The conjunction of perspicacious output to write herself out of silence, as expressed in *I Know Why the Caged Bird Sings* (1969) and a series of autobiographical books, popular poetry, with a dynamic public presence culminated in Angelou being named the inaugural poet for President Clinton in 1993. This national visibility was aided by coming from the same state as the president, and by being the mentor and literary guru of Oprah Winfrey, one of the most popular talk show hosts in the USA. The politics of the 'talk show' and its mode of both giving voice to a variety of marginal voices and exposure to a variety of erased people, as it reproduces some of the state dynamics and ideological processes, can be relatedly identified. The national and international recognition and visibility thereby garnered from being asked to create a text for

the presidential inauguration and to share the platform and television audience with the president at such a crucial historical moment perhaps rivals the awarding of the Nobel Prize in its possibilities for high canonization and textual production.

It is important to identify, therefore, the historical link between the artist and political patronage as well as the oppositional role that the artist can and sometimes does play in political patronage. It seems to me that processes of high canonization as identified here replay the historical role of the court poet in a contemporary setting. Thus, when Morrison was awarded the Nobel Prize she was escorted by the King of Sweden; and Angelou has shared a platform with the president. The result, in both cases, has been widespread recognition of these writers' works, appearances in bookstores, and the media, a readership which includes children in schools, critics, the public at large, and academic critics, as well as increased material gain. In fact, within the 'discourse of the prize,' high canonization has a direct link with royal/state patronage as it existed for other artists before the recognition of black women writers.

The dilemma is, of course, does one not accept all the accolades after having done the work? The answer for me could be affirmative only if it is accompanied by some clear critical understanding of the logics and dynamics of dominance in operation. For it is at the moment when the 'discourse of the prize' activates itself that the writer comes face to face with hegemony. This is the same encounter that the teachers/critics/readers/students engage in at various points in their processes of teaching/reading/doing critical work, and which similarly demands a series of choices or 'moments of choice.'

My point in locating these writers as a way of introducing the critical responses to a variety of black women writers from around the world is not to demean the accomplishments of those US writers who have functioned as effective guides, inspirations, and so on, but to find a way to talk about what the trajectory of high canonization has been, and what happens institutionally in the process, and the implications for those who do not or cannot participate in these processes. Further, it is to reveal how we are all interpellated in various ways in these institutional processes. In my view, one need not see participation in these state processes as being without contradiction, and agency. I hope that an effective model would be to see 'prizes' not as the culmination of one's personal struggles, but instead as an opportunity to provide space for the multiplicity of voices speaking from different geographical, generational, ideological, and artistic positions.

Popular Recognition and Its Demands

A different movement into popular recognition and canonization can be observed in some writers' articulation of a specific, timely politics. Although Alice Walker had achieved a certain recognition within black feminist circles as a writer, it was the timeliness of her novel *The Color Purple*, which won the American Book

Award and the Pulitzer Prize for Fiction in 1983, which has garnered her the audience, respect, and simultaneous disdain and criticism in some quarters. The successful though controversial movie of *The Color Purple* by Stephen Spielberg, and the Hollywood mainstreaming of it, has produced Alice Walker as a canonical writer with international recognition. Her most recent novel on genital mutilation, *Possessing the Secret of Joy* (1992), and the film version, *Warrior Marks* (1993), is beginning to generate intense criticism of her by many African women for her participation in western imperialist discourses and her representation of African women's bodies.[18] In Walker's case, (particularly in the movement to the medium of film) it seems that the text itself and its critique combine to produce the Walker corpus.

The identification of the writers – Walker, Morrison, Angelou, Hurston – for particular discussion within the context of canonicity has less to do with the persons of these writers than with the extent to which their works are available. Wherever I go, when I ask to see the section on black women writers, these are the writers to whom I am directed. After traveling in Europe and South America, and meeting the same response, I began to question the identification of black women's writing with the US writers, even when there are women in these places who identify themselves as black women writers. This is an anomaly which, I believe, the US black women writers mentioned above would themselves question. Still, many black women writers from different locations participate in or await their own, local and international versions of the 'discourse of the prize.'

This analysis of these writers within these processes of canonization allows me to reassert my formulation that the 'discourse of the prize' offers central and isolating moves associated with literary hegemonic practices which do not necessarily advance the field as they advance the various careers of individual writers. Most black women writers whom I have met in different countries write out of the sheer desire for self-articulation and self-presentation, or for personal healing and renewal, and sometimes for the specific purpose of historicizing a series of events which they or others experienced. In relation to major canons, most black women writers exist/ed in a multiplied marginality. Or, these various marginalities may combine to recognize *the writers* without full hearing or proper reading of the content of *their works*, which in turn dilutes the radical propensities of their contributions. The politics of selective hearing which I identified in the introduction to Volume I comes into play. For writers like Morrison, Walker, Angelou, as black women, are writing still from a position that is fundamentally oppositional to the meaning of state power. Even so, state power and hegemonic practices have a way of recouping these very oppositional identifications by centralizing them and/or commodifying them.

For me, then, it is necessary to complicate and expand the conception of black women's writing by locating its existence in terms of a variety of locations, positions,

and identities. For example, in European contexts one can identify some specific recognitions. Audre Lorde is a well respected and iconic figure among a number of black women's communities, particularly because of her politics in addressing the existences of the various 'sister outsiders' who often remain unaccounted for. Based on my own observations of the scale of Audre Lorde's organizing of black women on an international level, I believe there is room for a major study of her activism across black women's communities; her influence as a writer is implicated in all of these. It was an activism which parallels, for black women, the kind of organizing that Marcus Garvey was able to do at the turn of this century. Still Lorde, for a variety of reasons, including heterosexism, never received in life the kind of 'prize' recognition from the larger African/literary communities that she deserved.

Black women are creating with such fervor that the critical response is, as usual, way behind in even identifying the full nature of this output.

Critical Conversations

This volume of *Moving Beyond Boundaries* focuses on critical conversations. By 'critical conversations' I want to pose the critical voice as not residing solely in the purview of the academic scholar–critics. At the same time, I want to assert that the creative voice does not reside solely with the designated creative writers. This is clearly a forced opposition which has to do with the sense of disciplinary boundaries, job specializations and so on. In fact, in many cases both critics and writers exchange positions if not momentarily, then periodically and sometimes consistently. Further, there is not necessarily always a clear demarcation between them. Rather, by 'critical conversations' I am suggesting a paradigm other than some sort of hierarchical relationship existing between the work and the critical response, between the critic and the writer, between the critic and the creative work, and so on. If we can move out of the patterns set up by the older white and male systems of creative and critical production, we can have some other mode of interacting and speaking together as opposed to 'to' and 'for.' For black women's writing, then, the critical voice can of necessity move out of the juridical mode or 'standards' mode into a different set of relationships which see work as existing with different audiences, different contexts, and situations.

This volume, therefore, begins with 'Conversations' in order to provide a context for looking at critics and writers speaking to each other about work, rather than occupying the mode of the traditional/male interview format. It provides conversations with writers, cultural workers, and activists from a variety of locations and contexts. Included are conversations between Paule Marshall and 'Molara Ogundipẹ-Leslie in the context of FESTAC in Nigeria in 1977;

Tsitsi Dangarembga of Zimbabwe and Flora Veit-Wild; Merle Collins, a Grenadian writer resident in England and Brenda Berrian of the USA; Ifi Amadiume of Nigeria and Nzinga of the Caribbean; Latina Lesbians in conversation in New York City; Carol Beane speaking with Afro-Ecuadoran writer, Chiriboga; and Rosemari Mealy talking with Assata Shakur in Cuba. In each case, a series of cross-conversations are engaged in which have to do with revealing the emotions and intent which go into writing a particular set of experiences.

Part II is devoted to 'Critical Responses' and includes essays which pay particular attention to a variety of writers and their works from different contexts. Represented here are critical essays on Afro-Brazilian, African-American, Francophone African and Caribbean, South African, West African, East African, Afro-Ecuadoran, Dominican and Cuban writers. Some of these critics have translated the works of these writers, as for example, Daisy Cocco de Filippis who has translated poems of Aída Cartagena Portalatín, Celeste D. Mann who has translated poetry of some Afro-Brazilian writers, and Carol Beane who has translated Chiriboga's work which appears in Volume I. What is represented here, therefore, is work of critics who have been working diligently on individual black women writers from different places. Some of the critical responses in this volume deal with writings outside their direct experiences but which they have studied carefully. Others write directly out of a subject which they know intimately and directly in terms of 'cultural insiderness.' For example, it is interesting to read Astrid Roemer's thoughts on Surinamese literature. Although the ideal is coverage from every part of the world, that would take numerous volumes – indeed, a worthy project for the future. What is included here is based on availability of materials and the other automatic constraints which go into works of this sort.

In the last few years a variety of conferences have exposed the breadth of black women's writings. Works such as Margaret Busby's *Daughters of Africa*[19] reveal that in any examination of black women's writing we are in fact dealing with the world and with a long history. Clearly, there will be a time when we rethink the very meaning of the category, 'black women's writing,' much more than is done here. As Marlene Nourbese Philip suggests in 'Damned if We Do, Damned if We Don't' which appears in Volume I, the very identification of black women's writing hinges on dominant identifications of women's writing as white women's writing, itself a category which does not so name itself but instead naturalizes the exclusions which often make identifications such as 'black women's writing' necessary. For now, I think that a process of critical interrogation and creative reflection based on direct experience, serious study, respect for, and support of the work, is the ideal. *Moving Beyond Boundaries: Black Women's Diasporas* offers such a process. It sees black women's experiences as existing in a variety of dispersed locations, all engaged in the process of re-creating our worlds as they write new and positively transformed worlds into existence.

Notes

Selected portions of this introductory chapter were presented at a variety of conferences including the XIX International Congress of the FILLM (International Federation for Modern Languages and Literatures) in Brasilia, August 1993; 'Voices and Visions: Literature and the Cross-Cultural Perspective' Conference on College Compositions and Communication, Clearwater, Florida, January 1990; and at the SUNY-Wide Women's Studies Council, Curriculum Diversification Project, Summer Program, 1990. Thanks are due to my colleague Maria Lugones, for her thoughtful reading of this version.

1. See, for example, 'The Black Americas 1492-1992,' *Report on the Americas* 25, 4 (February 1992). See also Michele Wallace and Gina Dent (eds), *Black Popular Culture* (Seattle: Bay Press, 1992), particularly essays like Stuart Hall's 'What is this "Black" in Black Popular Culture?', pp. 21–33.
2. Carole Boyce Davies, *Migrations of the Subject. Black Women, Writing and Identity* (London: Routledge, 1994).
3. Carole Boyce Davies, 'Writing off Marginality, Minoring and Effacement,' *Women's Studies International Forum* 14, 4 (1991), pp. 249–63.
4. An anthology such as Barbara Smith (ed.), *Homegirls. A Black Feminist Anthology* (New York: Kitchen Table, Women of Color Press, 1983) has a completely different set of interests and selection of writers than one sees in the majority of collections. An attempt was made to include a large selection of black lesbian writers, for example, who would not have been included in other collections. Similarly Gloria Anzaldua, *Making Face, Making Soul/Haciendo Caras. Creative and Critical Perspectives by Women of Color* (San Francisco: Aunt Lute Foundation, 1990) offers a selection which proposed to open the categories of inclusion a bit more.
5. Roseann P. Bell, Bettye J. Parker and Beverly Guy-Sheftall (eds), *Sturdy Black Bridges. Visions of Black Women In Literature* (New York: Anchor/Doubleday, 1979) began their presentation of black women's writing by opening the category to include much more than the US writers.
6. See, for example, Christopher Claussen's 'It is Not Elitist to Place Major Literature at the Center of the English Curriculum,' in *Chronicle of Higher Education*, 13 January 1988. See also statements of the National Association of Scholars, particularly 'Is the Curriculum Biased?'
7. See papers of conference published in *Cultural Critique* 6 and 7 (spring and fall 1987).
8. Russell Ferguson, 'Introduction: Invisible Center' in *Out There. Marginalization and Contemporary Cultures*, ed. Russell Ferguson, Martha Gever, Trinh T. Minh-ha and Cornel West (New York: New Museum of Contemporary Art 1990), pp. 9–14.

9. Ngugi wa Thiong'o, *Moving the Center: The Struggle for Cultural Freedoms*, (London and New Hampshire: Heinemann, 1993).

10. Ngugi wa Thiong'o et al. had already addressed this issue at the level of the neo-colonial Kenyan university. It was published as a position statement, 'On the Abolition of the English Department,' in *Homecoming* (London: Heinemann, 1972), pp. 145–50. The University of Brasilia has a department of literature and literary theory.

11. In early considerations of issues of canonicity I found Barbara Herrnstein Smith's 'Contingencies of Value,' *Critical Inquiry* 10 (September 1983), pp. 1-35 helpful in the way it lays out all the various processes which go into producing a literary text.

12. See for example the *Norton Anthology of American Literature*, (New York: W.W. Norton, 1979). Norton subsequently published anthologies of women's literatures and Afro-American literatures in order to balance the earlier biases.

13. In my own case, a very particular and identified agenda is the presentation of a more expansive reading of what constitutes the general category of 'black women's writing.'

14. See the various anthologies of Mary Helen Washington: *Black Eyed Susans* (1975), *Midnight Birds* (1980), *Invented Lives* (1987), *Memory of Kin* (1991); all published by Anchor/Doubleday, New York.

15. Alain Locke, *The New Negro* (New York: Atheneum, 1986; first published 1925).

16. See, for example, Ann Allen Shockley (ed.), *Afro-American Women Writers 1746–1933. An Anthology and Critical Guide,* (Boston: G.K. Hall, 1988) for a wider selection.

17. See pieces in Alice Walker (ed.), *I Love Myself When I Am Laughing ... And Then Again When I Am Looking Mean and Impressive*, (New York: Feminist Press, 1979).

18. But see also Gina Dent's discussion in 'Black Pleasure, Black Joy: An Introduction,' *Black Popular Culture*, (Seattle: Bay Press, 1992), pp. 1–19.

19. Margaret Busby (ed.), *Daughters of Africa: An International Anthology of Words and Writings by Women of African Descent from the Ancient Egyptian to the Present* (New York: Pantheon, 1992; London: Jonathan Cape, 1991).

Part I

Conversations

'Re-creating Ourselves All Over the World.' A Conversation with Paule Marshall

'Mọlara Ogundipẹ-Leslie

The following conversation with Paule Marshall was conducted on 28 January 1977 by 'Mọlara Ogundipẹ-Leslie in Ibadan, Nigeria. Paule Marshall was in Nigeria attending FESTAC (Festival of African Arts and Culture) and visited the University of Ibadan during her stay. The context of an African-American writer returning to Africa is important, as are the boundary-breaking implications of a black woman writer being interviewed by an African woman critic and writer, on home soil.

'Mọlara Ogundipẹ-Leslie (M O-L): It has been said you've been influenced by Thomas Mann. Could you say how and why you find him artistically attractive to you?

Paule Marshall (P M): I consider Mann one of the influences. I don't consider him so much an influence now because I really think of him as a writer of my adolescence, in the sense that I read him when I was just beginning to contemplate the idea of becoming a writer. But he is of value to me on two counts, firstly because he handles so well the full-blown, the large-scale novel. *Buddenbrooks* and *The Magic Mountain* were instructive to me because I knew early on that that was the kind of novel – in a sense the traditional novel – that most interested one because of its form. And Mann was such an expert at handling this great mass of material that I learnt tremendously from him. The other aspect of Thomas Mann that I found exceedingly rewarding was his handling of characters, which more or less coincided with the way I wanted to deal with people in literature. Because literature, or good fiction, is the ability to make your people come alive on the page and Mann was an expert at that for me. When you think of Hans Castorp, the protagonist of *The Magic Mountain*, you find in him a fully realized, a fully delineated human being on the page. He is there with all his foibles, shortcomings, his positive attributes as a human being but at the same time, and this is why Mann is also important to me as a literary artist. Hans Castorp in *The Magic Mountain* and the artist Gustav Aschenbach in the novelette *Death in Venice* are not only characters, not only people, but Mann invests them with symbolic meaning and this was important for me. I wanted my characters to exist on these two levels. To be people in their own right, to have them come across on the page, to help the reader identify with them; yet on the other hand for them to serve as symbols of principles. So Mann was extremely helpful in that regard.

M O-L: Did you use this approach to characterization in *The Chosen Place?* Could you say you were somehow dramatizing some ideas?

P M: Yes, I would say so. I was largely dramatizing political ideas. I like to think of *The Chosen Place, The Timeless People* as a strongly political novel. I was trying to sort out what was happening to black and colored peoples throughout the world. I was trying to deal with what I see as the new colonialism. The white woman character in the novel, Harriet, is not only a woman who I hope comes across as a character, but she was also symbolic of the western principle in her need to control, to dominate, in her basic feelings of superiority. She embodies some of the unhappy aspects of the western personality. The main black woman in the novel, Merle Kinbona, meaning 'good kin,' for me is not only a black woman who is struggling for her identity, struggling to assert herself, to give meaning to her life, she is also reflective of the horrendous colonial experience we have all undergone, and her struggle to bring together all of these influences that have gone into making her so that she could fashion out of it a whole person. So she in a sense reflects the struggle of black people to come into her own.

M O-L: Would you say, like Mann, you're concerned with the underworld of the bourgeois experience, that you're concerned with purpose and the disorderly aspects of western culture, such as his concern with the incest theme, for instance? Such themes indicate a concern with the decadence of western culture.

P M: Yes, I'm very concerned with that. I see decadence as one of the insidious exports of the western world to the Third World: a whole emphasis on a kind of cushioned and comfortable but essentially meaningless bourgeois life. And to make that so attractive that people become centered on self, which makes it almost impossible to think in terms of nation, to think in terms of the good of society. The emphasis resides mainly on how-am-I-going-to-make-it-for-myself? In *The Chosen Place, The Timeless People*, the character who epitomizes this dilemma is the lawyer, Lyle Hutson, who, as a young man in England going to the London School of Economics, is a devoted socialist. He sees the only solution to the problems in the West Indies is for the societies there to move towards socialism. Yet when he returns home he fits into and conforms to the bourgeois mold and he abandons all his idealism, the radical position of his youth. I see that happening time and again, not only in West Indian societies, but in African societies and in black American society. So that the book really should not be seen so much as a West Indian novel, it is simply that I was using the West Indies as a kind of place, I was selecting it as a sort of focal point because it is a small society and I was hoping to use it as a kind of microcosm which would have larger application and meaning.

M O-L: I would want to call the novel a 'Third World novel' – would you agree to that description?

P M: Very definitely. I would like to see it described as a Third World novel, because it is set in a mythical island in the West Indies. Readers spend an awful

lot of time trying to identify the place rather than seeing its larger meaning; the fact that it makes a statement about what is happening in the Third World in general.

M O-L: Politically and psychologically?

P M: Yes.

M O-L: What other writers would you say have influenced you?

P M: Well, any number, because I was a voracious reader from very early, as a little girl. I would say Ralph Ellison, the author of *Invisible Man*. Not so much that novel, but his collection of essays on literature and society called *Shadow and Act*. I find them seminal to my approach to writing. Because what he insists upon is that there is a whole culture, a whole field of manners about black American life that has to be first of all acknowledged and celebrated. That we are not, as so many of our detractors would like to insist, a people without a culture. That out of the painful experience of slavery and the aftermath we have been able to mold a culture which is unique to us. That culture has to be made available to black readers and it has to be celebrated. This makes for our strength and our validity as a people. And I think that that aspect of Ellison has been very helpful to me. I see it as one of the major influences on me as a writer. One of the things that really prompted me to write was the fact that I came out of a family of poets. My mother and her friends spent endless afternoons talking when they came home from work. They worked as domestics. And their whole ability to convey the character of the women they worked for taught me about characterization. Their ability to tell stories in a colorful, exciting way taught me about the narrative art. It was then in those early years just sitting and listening – and in those days children were seen and not heard – just sitting and listening and absorbing in the blood their African ability as story-tellers, folk-oral you see. Recreating, they were highly political people. They would sit around and talk about Marcus Garvey, the New Deal, the Depression; talking about Roosevelt so that they gave me a sense that women could be involved politically. This is why *The Chosen Place* is essentially a political novel. They were the main influences in terms of technique, because those women had taken a language imposed upon them, English, and had brought a new dimension to it. They made it into a language which reflected them, with their use of imagery and metaphor, making their points through story. They taught me how one uses language in a creative and vital way.

M O-L: That's very interesting. In that way the women are poets, poets of the human experience. Which writers do you admire?

P M: Well I mentioned Ellison. I also admired Joseph Conrad during my adolescence. Again for this marvellous use of language. I found *Heart of Darkness* valuable because the theme is that man is complex, and until you begin to deal with all the dimensions of his personality, the sort of dark underbelly of the human personality, you are not dealing with him in his full dimension. I find that there is a reluctance, an inability on the part of white writers sometimes to acknowl-

edge the multifaceted nature of the human personality. And one of the things that I am always trying to do as a writer is to suggest how complex and sometimes contradictory human nature is. So Conrad was also helpful. From the contemporary writers, I find Sartre exciting, John Updike because, again, of his use of language. I read a lot of Paul Laurence Dunbar because in his dialect poetry he shows what blacks have done with the language imposed on them. It is the kind of thing I am attempting to do in my work.

M O-L: … trying to bring the language across, create a new language and literature to express the black consciousness. So what is your view of the current black aesthetic movement which is going on both in the States and Africa?

P M: I think it's all to the good. Because we are attempting to reconstruct our personality in our own terms. I see writers as image-makers, and one of the ways that we can begin offering images of ourself which truly reflect us, which begin to throw off the negative images the West has imposed on us, is to begin having our literature offer to the black reader the image of himself that is positive and creative. I don't think a people really progress until they think positively of themselves. Cultural revolution is about how you see yourself. What you think of yourself is part and parcel of other aspects of the revolution, the political revolution. You can't have the one without the other. And the black aesthetic, with its emphasis on the celebration of blackness, of seeing beauty in blackness, an emphasis on using some of the traditional forms, rhythms, and imagery in the work and dealing with themes that have to do with black life, is one of the ways of creating this positive image. We are in the process of re-creating ourselves all over the world and it's a fascinating task.

M O-L: How would you say this is expressed in your work? How does black aesthetic appear in your writing?

P M: Interestingly enough, with *The Chosen Place* someone said to me, 'Why is it that the way you describe things is not done in terms of western metaphor and imagery but largely African imagery and metaphor?' For example, there was a description of the man who owns the rum shop in the novel. When I describe him, I say he is almost like an African chief, presiding at the counter in the rum shop, with the rum bottle almost as if he is pouring libations, like a god who has had an injury. I was trying to show the way in which you can draw on the traditional material to make it a vital part of your fiction.

M O-L: You tend to compare people to masks. I thought that was very effective, using African masks to describe the facial figuration of people.

P M: Yes, these are the ways I am attempting not only to make the connection between the black experience in the western hemisphere and in Africa, but also to infuse the work with a new kind of imagery, a new reference.

M O-L: … and vision. Are there African renderings of form in your style?

P M: I think it's basically African. Also in a sense basically universal. Storytelling is an ancient art, it is not the exclusive domain of any people or civilization.

The basic forms of story-telling are true in China, in Africa, wherever you find people telling stories. So I don't think of my work as reflecting the western tradition so much but rather as a part of a universal body of fiction. There are things that make a story work – characterization, the way you use language, how you orchestrate your plot so that you engage and hold the reader – and these are principles which operate in no matter what the society.

M O-L: Don't you think there are certain combinations of these basic elements of fiction that are typical of people, that are determined by their culture? For instance, the attitude towards the work itself or the handling of time and plot structures? Don't you think that certain handlings would appeal to a people?

P M: That is probably true, for example with Amos Tutuola you get a different way of handling plot, you get a kind of stream and flow, the character moving constantly through a world that is both real and unreal. With myself there is a use of reality to suggest what is not real. In *The Chosen Place* the situation seems very real on the surface. There you have a small, somewhat underdeveloped village which has been pretty much isolated and forgotten. It seems real enough, the people working in the cane fields, going about their daily task, yet there is a dimension of unreality to those people. I tried to suggest it by the way they greet people by rasing a hand as if they were witnesses on a stand. They are witness to their history and their suffering: the whole history of slavery and its aftermath. I begin at the level of reality but suggest there is another dimension, that I am after another statement which I am making through the use of reality.

M O-L: And Carrington the maid is one such figure?

P M: Yes, when I describe her with her full breasts – the mother figure who suckles the world – I was trying by that to suggest that we as a people have been used to feed the world. Not only with our raw materials and resources, but our historical role has been the force that suckles the world. So this is why even though she is a very peripheral figure, I wanted to strike that note of how the black person has been used by western society.

M O-L: How do you feel your work fits in with black American literature and Caribbean writing?

P M: I think that I am in a unique position. I know that people have trouble defining me as a black American or Caribbean writer. I fall between two stools, I'm neither West Indian nor black American. My parents were from the West Indies and they gave me a very strong sense of the culture out of which they came. That was one of the things that molded me as a person and a writer. Yet on the other hand I was born in Brooklyn, went to public schools and I'm very much a black American. I have got my feet in both camps, so that I am able to understand and respond to black American culture as well as West Indian writers who feel their situation is unique and apart from the black American experience. Similarly, I have no patience with black American writers who feel that the

Caribbean is exotic and curious and different. To me it's all part of the same thing. There may be differences of expression, but at the base it's the same cultural expression.

M O-L: Yes, the same historical experience of oppression and slavery.

P M: This is what my work is about: to bring about a synthesis of the two cultures and, in addition, to connect them up with the African experience.

M O-L: I know writers don't like to talk about each other, but would you make a comment on Caribbean writers briefly – an appraisal or evaluation of them? Which ones do you like?

P M: The Caribbean writers I read – people like Eddie Brathwaite – are very interesting because they attempt to reach out to the African component in our experience and celebrate that. Given the fact that ours is basically an existential situation, we can create our history and personality. Writers like Brathwaite and Sam Selvon are saying, 'This is the kind of personality I am going to create for myself as a black man, a fully faceted figure, by bringing into play the importance of the African aspect.' So I like Eddie's poetry, also some of the things George Lamming does in his early novels where he exposes West Indian society, its hypocrisy and dependency on England and the need to break away from that and form a West Indian personality. In terms of writing, I find that the ability to describe the West Indian landscape by writers like John Hearne and Naipaul is just fantastic, they make that landscape live for you. These are some of the writers from the West Indies that I admire.

M O-L: What do you mean by saying yours is an existential situation as black people ...?

P M: Here we are presented with this absolutely absurd history, certainly with blacks in the western hemisphere, and in Africa: the horrendous severing that took place, the separation from the motherland, the source. Then the traumatic business of slavery and colonialism, the insult of our color making us a lesser people, the notions of inferiority on us as a people – these are all things that have no sense. How can we, given these facts, create out of this horror a personality which would be positive and assist us to erect a new society, a new nation?

M O-L: And, of course, there are the psychic effects of these experiences which you find even in Africa, even though the immediate, material severance is not that obvious.

P M: This is why the writer is so important. The writer feels the battle is the psyche; is that whole area of what people think of themselves, how they see themselves, what happens to them. It is the writer's great contribution to create new images that will overcome the negative psychological images we have because of our history. I don't think the political thrust can be really effective until there is a new thinking on the part of the black man. The cultural and the political revolution of China is so important. China closed its doors to the insidious influence of the West. They said: 'Keep out your televisions, keep out

your materialistic values, we are involved in the serious business of not only transforming our society materially but also making for a new man in China.' What distresses me so about the developing nations as I see them is that all the emphasis is placed on the economic and the political advancement to the detriment and neglect of the real battle which, to my mind, is the way we see ourselves. If we take on western images, western values and attitudes, then all the work that is being done in the economic sphere is of no use.

M O-L: And that would affect the way we proceed to galvanize the society; our mentalities are so important. So what are the trends in black fiction today in America? I am sure this kind of image-building and re-creation of self must be going on?

P M: Yes. In the serious fiction being written by black Americans today, I see two themes dominating. First of all, an examination of how black men and woman relate to each other, why we have had such a troubled history relating to each other. I think the fiction is concerned with this problem because there is recognition that we need all the forces within our community working together in order to make progress. If we spend our energies opposing each other in conflict, this takes away from the struggle. So there is an examination of this by some of the young writers. The other aspect which characterizes black fiction at this point is going back and dealing with some of the aspects of our culture which make for strength. Our legends and myths. We are saying essentially that man is not only defined by what he is materially. There is a whole aspect of the human personality which has to do with his spiritual quality, which we are examining. In the book that I am working on presently, I have gone back to some of the legends that are an important feature of early black American life and try to hook them up with the legends in the West Indies. One of the things that is striking about them is that those legends reflect a tremendous nostalgia for Africa. In black American folklore there's a notion about people flying. There are stories of how a man working out in the field, a slave, would suddenly throw down his hoe, abandon his plough, just spread his arms and take off to fly back to Africa. All these have to be made available for our young people to show that we had a culture, a tradition, and a history. And that this has to be used to form the new personality.

M O-L: Is fiction exclusively your medium? Have you tried your hand at poetry or drama?

P M: I started off with poetry. I wrote poetry when I was twelve years old, very bad poetry. I haven't written any since then. But I like to think of myself as using poetry and prose so I use a lot of imagery in my writing, but I don't write poetry as such. I tried my hand only once at the dramatic form. I was asked to do a dramatic adaption of *Brown Girl, Brown Stones* and I did that. It was a television play and came off very well, it won the award for that year. But I recognize that I only have a certain amount of energy and I have decided to

devote that to perfecting myself as a novelist. I feel most comfortable with that form.

M O-L: Do you feel that there are urgent themes that should be given priority over others in literature in general?

P M: Maybe! I can't speak for literature in general, but one of the things I'm preoccupied with is the need to celebrate black experience. History has been hidden from us, especially in the western hemisphere. I feel we have to go back and re-create that past so that we can use the lessons from that to aid us in the present struggle. I'm using the past as a way of 'existing' us in the present and in the future. So there is a reappraisal of our past and a celebration of the positive aspects of our experience. Those are the two things which I feel have greatest priority in my work.

M O-L: What do you think about the teaching and uses of literature in schools?

P M: I went to schools where I was never made aware that there was a body of black literature. I read people like Thomas Mann and Joseph Conrad, James Joyce and they are fine writers but I was never aware that there was a Richard Wright. I discovered black writers on my own. Even though I know there are any number of detractors now of the Black Studies programs and feel that blacks should be addressing themselves to technological knowledge, I still think it is important that this dimension of our experience be made available to our students. For a period of three years, I taught Black American Literature at Yale and what was so encouraging about it, was that I had black biology majors coming and taking a course on black autobiography. They did not know about people like Frederick Douglass or DuBois, the great leaders. It was a chance for them to fill in this tremendous gap in our education. So I think that the schools have an important task to fulfill in making available to young black students our history and our literature.

M O-L: Thank you very much.

'Women Write About the Things that Move Them.' A Conversation with Tsitsi Dangarembga

Flora Veit-Wild

This interview was conducted in Harare, in September 1988, a few days before students of the University of Zimbabwe and Harare Polytechnic demonstrated against corruption.

Flora Veit-Wild (F V-W): Probably you are often asked whether what you have depicted in your novel *Nervous Conditions* is, directly or indirectly, auto-biographical. Which, I think, it must be in a certain way because you have depicted it so convincingly. And in your novel you describe a lot of worries, very severe worries, desperate situations ...

 Tsitsi Dangarembga: (T D): ... about money and that kind of thing ...

 F V-W: No, I am thinking of the psychological traumas your two main girl characters go through in the process of education, in different ways: the one coming from a very modest home trying to get educated, and the other one, who was in England for some time and comes back and feels very, very alienated and tries to sort that out.

 T D: I think this is, of course, a question that people who write or do any kind of art are asked. And I find it a very difficult question to answer because I know if I were to sit down to write my autobiography, I would find it extremely boring and I wouldn't get beyond the first page. That is, writing about me as an individual, what I have experienced: problems, joys and so forth. But when one comes to write a novel, and especially the kind of literature that I like to write, it uses the medium of very real individual people to make points that are beyond the individual. And that I think of as the mark of good literature, that anybody who picks it up is going to find something to identify with. So for me, when I am trying to produce that kind of literature, this is a very conscious process: If I want to make this point, what kind of character can I use? And what might be happening to this character? And then, in order to make that real, of course I have to look into myself to see where I can get that emotion from, that representation.

 F V-W: Trying to pin you down a bit more, thinking of the two girls in your novel, would you identify with one of them rather than the other?

 T D: I would identify with both of them, really. From a psychological point of view, a person is very complex, guided by various motives. In writing,

however, you try to evolve the dominant feature of a character, the main thrust of a character: if one tries to incorporate all the diversity in a single character you end up in a mess. Writing is a distillation process.

F V-W: Did you not spend – like Nyasha in your novel – some time abroad when you were a small child?

T D: Yes, I did. From the age of about two to the age of about six. But, I don't know, it's very difficult. Let me give you an example (this is not a very good example): I would be having problems with somebody I was having a relationship with, and then it sort of blew up, and I started behaving in a way that to me was very appropriate in that situation. But then I said to myself: My God, I am behaving just like Lucia, one of the other female characters in the book. So this is what I mean: all of it has to have some internal representation somewhere, so I really find it difficult to say, I would identify with this one more than the other in a context that is relevant for me.

F V-W: You started writing when you were at secondary school. That was in the mid–1970s, a very tense political situation in Rhodesia. Did that situation affect you as a student, did it affect your thinking and writing?

T D: I would actually say that it did not. Because I had a very sheltered upbringing, my parents were relatively well off by black Rhodesian standards at that time. And so really nothing was affecting me, you know. I was one of the elite of our circles, and I didn't have to think about anything.

F V-W: But the Mutare area, where you went to school, is not far from the Mozambican border, and many schools in that area were affected by the war.

T D: It's embarrassing when looking back: how was it possible to be living in the middle of that and to feel that one is really in calm water? It's not that things didn't happen. I remember, I taught at another mission in 1977, and it was so disappointing to wake up one day and to go to class and your best students were not there. And when you asked, people didn't say outright where they had gone but it was obvious that they had left for military training. And that did make an impression on me. But I think my idea was: of what use would I be, with my kind of background? I can't run half a meter … So, whatever contribution I will ultimately make, it will be through being educated, getting into a useful profession, hence medicine, and that will be how I can make a contribution.

F V-W: So you went to Cambridge to study medicine. How did you find the situation there?

T D: It was awful. I couldn't stand it. This upper middle class English environment. And I was shocked at how narrow-minded people were. I had seen people who had become so Anglicized and don't realize that there is anything outside this little narrow world that they are living in. And I can remember one thing that used to irritate me is that some people just did not want to watch the news to see what was going on at home, and they would be watching some

really silly programs. It seems like a very small thing but at that time it influenced my outlook. Like people would say: Oh, Rhodesia, where is that? Is that in Africa? And I thought: What am I doing here? There is the war going on: my family, my relatives are being killed, and I am enjoying a lifestyle in which people will say, where is Rhodesia? And so I thought, OK, let me get out of it and look around a little bit and then see where I want to go.

F V-W: And then, when you finally came back in February 1980, how did you find the situation in independent Zimbabwe?

T D: It's difficult to say. I would look at it at a more personal level because with my family background we were always on the right political side. So that was never a problem for me. It was very difficult because I knew I wanted to do something creative but with the kind of cultural colonization that we had had, there was actually nothing that one could come back to in order to do something creative. It was only when I came to the university that I really began to enjoy being back home. Because the university then was more radical than it certainly is now, things were still very much on the boil, people were still thinking. I carried on my being conscientized in this period of 1982 to 1985.

F V-W: In which way?

T D: Just exposure to ideas: being able to talk to people about the things that are important; arguments, again with all this rhetoric going on about socialism. I didn't know much but at least I could listen to the rhetoric and read all the correct texts to make my own decision as to what I thought about these people who were giving out these phrases and this jargon. And it was also good in terms of my creative development because I was able to get into things like *Focus*, the student magazine. And the drama that I did with Robert McLaren, very important sociohistorical, political issues – and so this was maybe the most significant period of my creative development, both at a purely creative and a level of being conscientized.

F V-W: You are the first black woman in Zimbabwe who has written a novel in English, a novel that looks into the specific difficulties and pains that black girls in this country had to go through in the process of their education. What does female writing, or feminine writing – in short: woman writing – mean for you?

T D: It means: women writing about the things that move them – they should not develop formulae that they have taken from male writing. Female writing comes from the consciousness of being a woman and the problems that arise as a result of that; but then again, good female writing can put that in a wider context, realizing that what is particular to me or to us as a group stems from general problems in our society. You have the parallel with racism: the problems of a race have their foundations in the problems of a society. So one has to move from the individual woman to the group and from there to the fundamental causes. This kind of women writing I have found with the black American female writers

and also with Mariama Bâ, whereas the Egyptian author Nawal el-Sadaawi lacks heart, she is sterile in terms of the real human aspect of her writing. Creative writing is more complex, messages must not be so overt, they must evolve through the light of the characters. White western feminism does not meet my experiences at a certain point, the issues of me as a black woman. The black American female writers touch more of me than the white ones.

F V-W: What about women writers in Zimbabwe?

T D: I have not read much. Kristina Rungano is good, she has heart and a great ability with the language to bring out whatever she feels. Usually, I find the things boring because a lot of the women do not go as far in their thinking as I do. I don't understand it, though, because the experiences are definitely there. Why are they not expressed? That goes beyond me. So many people experienced many things – why don't they express it? That is how good literature develops.

F V-W: Do you feel isolated?

T D: No. What is so frustrating is that though there are so many people that I can share ideas with – why don't they write it down? I suppose, because it always is a risk. You could be misunderstood, or your writing might be not very good and hence not appreciated. The funny thing with art is, when one really takes it seriously, real art is honest, and that means one is prepared to take the risk.

F V-W: What other literature except the already mentioned black American women writers has been influential for you?

T D: Well – everything. If you want me to single out some: James Baldwin, Tennessee Williams, D. H. Lawrence. I could see what he was aiming at – all the anxieties he would put in his writing. I admire this ability to externalize things. The same thing with the Russians. I read Tolstoy at the moment and admire him a lot. For other Russian authors like Dostoyevsky, I almost feel a sort of respectful horror.

F V-W: And among Zimbabwean writers?

T D: Mungoshi is a good writer but he does not touch me particularly. The *Non-Believer's Journey* by Stanley Nyamfukudza is a rather brilliant book.

F V-W: Why did that touch you?

T D: Because of its simplicity and honesty. We did not have to admire this person in the novel, there he was.

F V-W: What about the political 'message' of this book?

T D: There was no message. How many people really fought in our war? Most of us did not because we were scared. This is the story of any character out of 6 million who were scared. That is the honesty about it.

F V-W: What about Dambudzo Marechera?

T D: I could identify with him very much because of the conditions which brought him to what he was. At the time I met him (in 1982) he had already

found that niche as a writer and that was all there was; it was difficult to relate to him as a person. There are so few people who are writers and nothing else – somebody like Marechera sticks out very much: that made him so isolated and so self-conscious. If the conditions had been more relaxed, it could have been better for him.

F V-W: Thank you very much for the interview, Tsitsi.

'We Speak Because We Dream.'
Conversations with Merle Collins

Brenda Berrian

London, 17 June 1991 and 28 May 1992.

Brenda Berrian (B B): Would you share the story behind the writing of 'The Butterfly Born,' 'The Lesson,' and 'Callaloo'?

Merle Collins (M C): My mother actually told me the story that became the basis for 'The Butterfly Born.' Listening to that, I thought of the tremendous gaps between my grandmother's experiences, my mother's and mine. That is what I tried to capture in 'The Butterfly Born.' That transition between generations, different ways of thinking and perceptions of the world. I thought about how difficult the transition from my grandmother's generation to my mother's and mine must have been. In order to convey that, I used the voices of my grandmother and of the National Women's Organization of the late 1970s to the mid-80s. So, the poem moves from my grandmother's *'Allez assise au bas table-là* ('Go and sit down under the table') to the National Women's Organization's statement, 'Woman, step forward.' And I like to link the three poems – 'The Butterfly Born,' 'The Lesson,' and 'Callaloo' – together, because they all were written around the same time in Grenada. All of them came out of that period of revolutionary excitement and change in the early 1980s.

B B: Would you say that these three poems are interconnected and have the same theme?

M C: Yes, they interconnect because they talk about various historical experiences. 'The Lesson' focuses on education; 'The Butterfly Born' focuses on the experiences of women; and 'Callaloo,' in a sense, puts both of them into the context of what was going on within the experience of the revolution. So, I definitely think of all three as poems of the revolutionary period.

'The Lesson' looks at the fact that my grandmother's education was very much centered round the stories of the English kings and queens. My grandmother knew details about William the Conqueror which would perhaps not be taught in English schools. Certainly, they would not be taught today in English schools and perhaps not even in my grandmother's day. She knew about William the Conqueror's wife and exactly what were the names of his children. My grandmother used to walk, talk, and forget things. She would walk with her hands folded behind her back. As she walked, she would mutter little bits and pieces of history that she had learned as a child. At her age, my grandmother could clearly recite that the Duke of Normandy had been married to Matilda whose children were Robert, Richard, Henry, William and Adella. She did not study about the Caribbean and Africa in the formal sector. Her concentration was William the Conqueror and by the time I came around my concentration was upon the Tudors and the Stuarts.

During the revolutionary period, there was talk about the need to have a different approach to education, the need to look at ourselves, to know Grenadian history and to move away from an extremely Eurocentric education. In this context, my grandmother readily came to mind and I wrote 'The Lesson.' Whenever I am reading or performing it, it brings back memories of her walking and reciting. That image is with me when I read the poem.

'The Butterfly Born' analyses the women's experiences of my mother's generation; 'Callaloo' talks about the revolutionary fervor which was trying to change the approaches to education and to the treatment of women. All of this outlines an interconnection between the three poems.

B B: What are your reasons for writing the poem 'The Search'?

M C: In 'The Search' the focus was actually on the experience of filling in forms at the University of the West Indies in Jamaica. If I recall correctly, I was in the process of filling in forms along with a Trinidadian friend. At that time, Trinidad was already independent, but Grenada was not. So we were going through all of these growing pains about nationalism and having to call ourselves 'British.'

Then there is the memory of actually having to write in 'British' on the form. In my own mind, I represented something that had to be *penciled in*, whereas my friend could *pen in* Trinidadian.

Therefore, the search was rooted in the grounds of nationality. To search for a sense of self. The search to move away from the same theme of self-negation that I mentioned in 'The Lesson.' And, of course, the search goes on because living in Britain you must fill out forms where you have to think of all those questions of identity, definition and labeling. There are the census forms that have heaps of categories, white is one category and then you have categories such as Afro-Caribbean, Asian and under Asian you have Bangladeshi, Indian, etc.

Incidentally, the category Indian-Caribbean does not exist. There are Indian-Caribbean people who have said to me that they think of themselves as the ultimate

'Other.' There is that other category which is actually 'Other' where one who is neither white nor African-Caribbean is supposed to fit in. The important thing is that white does not need any sub-categories. White is sufficient by itself. In short, the poem 'The Search' is about a specific experience of filling in forms, but it also touches on what is an everyday experience.

B B: Isn't 'The Search' one of the poems found in *Because the Dawn Breaks?*

M C: Yes, 'The Search' is one of the poems in my first published collection, *Because the Dawn Breaks.* The title poem of the collection simply says that 'We speak because we dream.' The collection is really an exploration of the Grenadian experience beginning from the period of the revolution right through to the United States' invasion.

The very first poem in the collection 'Nabel-String,' which translated means umbilical cord, was the first poem that I had the confidence to leave on paper and not destroy. When I reflect on it, I guess I began to find my poetic voice during my stay in the United States around 1978. This is why I chose 'Nabel-String' as the first poem for the collection, because it was the beginning of that whole feeling. It is followed by 'Callaloo,' 'The Butterfly Born,' and 'The Lesson' – the kind of poems that are about the revolutionary period and change in Grenada from 1982 to 1983.

Then later on, there is a change of feeling. A sort of hesitation. A different kind of mood in the country. A sort of questioning. This is reflected in the poem 'Just Suddenly So.'

> All of a sudden
> It not nice again
> Jus' suddenly so
> Wid a funny kind o'
> Reasonless reason
> De experience turn sour
> Is not a adventure again

I was reflecting on what I could feel around me. Something less than the enthusiasm of the 1981–82 'Callaloo.' That is why this poem was written in a much slower, reflective pace. The rhythm is much slower than that of 'Callaloo' which has a quicker 'mix up' tempo. The intensity is deeper with 'Callaloo' too. 'Just Suddenly So' is more downbeat. The collection, as a whole, covers the whole panorama of the Grenada experience before, during and after the invasion.

When I finished the collection, one of the bigger publishers offered to publish a couple of the poems. I preferred to accept the offer from a smaller press, Karia Press, who decided they wanted to put the entire collection together. They saw it as a whole and could read it as a story. Karia Press therefore had a political commitment to the ideas of the collection.

In one poem, 'Rock Stone Dance,' you have the implosion of the revolution. Leaders are questioning each other and people are turning on each other. Then I question the whole rationale for the invasion and the fact that people have left the United States where they haven't sorted out their own problems to invade and to 'save' this tiny Caribbean island. The collection questions that duality, and it eventually moves to looking at the responses of the Grenadian people toward the invasion. Then I proceed to question the Grenadians' responses as well as the attitudes of those who welcomed the invasion.

> We have learned so well the
> lesson of self-negation at
> our arrogant teachers' hands
> (from 'A Song of Pain')

Using the invaders' words we call their rape 'deliverance', so that instead of saying invasion we say 'rescue mission.' Of course, we Grenadians contributed to some of this confusion but it was up to us to solve our problems. We did not and do not have to look for outside saviors who are not saviors at all. That is how I envisioned *Because the Dawn Breaks* as a whole.

B B: Did you deliberately decide to end the poem 'Because the Dawn Breaks' on a note of hope?

M C: Yes, because in a full analysis, after I have gone through all of the pain, the book has hope. There is the destruction of hope, the destruction of dreams and depression. Despite this, I wanted to end the book on a note of hope.

In fact, you can feel the depression. Perhaps more after the implosion rather than the invasion I felt a tremendous amount of depression about the Grenadian situation, but it always comes back to a situation where you say: 'Life goes on, and I am going to ensure that I make something out of it rather than dwell on what has passed.' Even though I say 'I' here, I mean 'we.' This is why in *Because the Dawn Breaks* I insist that we continue speaking. We speak because we dream, and the somewhat hackneyed dream image is important too. Even when our dreams threaten to become nightmares, we have to control them again.

We do not speak to agitate anybody in spite of the fact that we do. The poems may sometimes seem didactic, but I do not say: 'Look, you people out there. You ought to listen.' Not that kind of didacticism. Just coming out of what I deeply feel. What I could feel around me. What I felt a lot of people were feeling. Of course, I always hesitate to speak on behalf of any group called 'The People,' because their ideas are different and people have different approaches. Nonetheless, I was writing and reflecting upon the actual world-views of those people who were really interested in a revolutionary future for Grenada. I am not even talking about systems and how the revolutions are to be achieved, or whatever. But I feel that any colonial people have to have a revolutionary future in order

to really move forward for themselves. In order to be ourselves, we have to throw out a lot of what has been given.

B B: Is your new collection *Rotten Pomerack* taking on a totally different view? Is it simply dwelling on your experiences in England or are you combining the trips that you have made to Grenada after your migration to England?

M C: Yes, *Rotten Pomerack* is everything. It is concentrating on England much more than the previous collection, *Because the Dawn Breaks*, which is totally located in Grenada. *Rotten Pomerack* begins in Grenada but continues onward to England then to Ghana and back to Grenada. The trip to Ghana made quite an impact on me. In this book there is a constant movement, and the voices reach out at each step of the way. It is certainly more of a concentration on England, but there is always that look back to where I come from in terms of nurturance. It is also a continuous process, and the past is always there. For example, there is a poem called 'The Sheep and the Goat.' Here I come back to remembering the voice of my mother. In 'The Sheep and the Goat' I am standing at Heathrow Airport, coming into London. When talking about different kinds of people, my mother likes to say, 'You can't separate the sheep from the goats.' Standing there at the airport I recalled this statement, because looking around me I could see the effect of separating the people, like the sheep from the goats. I watched people coming through customs, and I think the sheep are on one side; the goats are on the other. For example, I look at someone holding the hand of a child and the child is twitching and moving away. So, it is like the goats are restless over there and the sheep are serene, knowing that they are going to be accepted. So even there, when I am moving into a new situation, my frame of reference and the figurative language to describe my experiences all come from Grenada, not necessarily originating there, but certainly introduced to me there.

The collection is written in a circular way. The first poem of the collection is the remembering of the voice of the uncle who now lives in London. He remembers his stories when he used to be in Grenada. Now, he is living in a flat in London with no steps of its own. There is no space for beginnings; for he has lost his stories. But he left his story behind in Grenada in order to find a real story in the London bookstores. So, it begins there. He used to shout, 'Sa sa mi oh!' to begin his stories. The people would answer: 'Sa i yo?', a call and response pattern which begins the story. But in the imagined situation of the poem, when he is urged to tell the story in London, he has no answer. He has lost that story.

The collection moves through various experiences of racism in London, and it looks at the way Caribbean people claim or do not claim space in London. It also looks at the fact that people are constantly saying that they came to England for a year or two but have stayed longer. Then I move to Ghana and to my reaction on visiting one of the forts on the Atlantic coast. After that, I end the collection going back again to the beginning of the story that we knew but hadn't

known that we knew. *Rotten Pomerack* is a journey and at the center of this journey you can expect anything to happen. The rotten pomerack slips and slides so that you are not too sure which turn the journey will take.

B B: Step upon the fruit?

M C: Figuratively. The pomerack is actually a fruit, the French cashew in French Creole. The title of the collection is taken from the saying, 'Crick crack monkey break he back on a rotten pomerack.' That is also where the title of Merle Hodge's novel comes from. The idea I wanted to use is that there is a rotten fruit some place that you step on; you will probably slip on it, and anything can happen. You can expect all sorts of twists and turns.

B B: Coming from such a warm climate and leaving behind family and friends in Grenada for England must have been very difficult for you?

M C: Well, it is always difficult to leave warmth, literally and figuratively, for the cold. I think that the reason for coming to England was the fall of the New Jewel Movement and the tremendous amount of confusion. When I got here in April '84, I went to Bradford, a town in the northern part of England in West Yorkshire where I have relatives. What a surprise! I did not expect it to be snowing in April. And I came to deal with the particular brand of racism which exists in England. In the Caribbean, or I should say in the part of the Caribbean where I was nurtured, there are different shades and it is easier to believe that racism does not exist. In England it is very obvious and overt that if you are black you are treated like an inferior person. In any case, it was during those first few months after coming here that I started to write about the impact of racism, and this appears in such poems as 'Shipmates,' 'When Britain Had Its Great,' and 'No Dialects Please.'

One day I was sitting in the train and this black man came in. I was the only black person in that compartment. He came in, and his face was all tensed up. He stopped and looked around very suspiciously until his eyes met mine and you could see that he relaxed a bit. While I was wondering whether or not to say 'Hello,' his eyes wandered off. It was this small incident that was the basis for 'Shipmates.' The poem 'When Britain Had Its Great' was inspired by a party political radio broadcast during the 1987 elections in Britain. A Conservative Party broadcast promised to put 'the Great back into Britain.' I found the whole idea frightening, and months later I wrote 'When Britain Had Its Great.'

B B: In your novel *Angel* you discuss many themes. Two of them are the mother–daughter relationship and the landscape of Grenada.

M C: It is interesting that you mention those two themes, mother–daughter relationships and landscape together. The mother–daughter theme is very strong in *Angel* across three generations. The scenes in which the women are involved happen against the backdrop of the Grenadian landscape. For me, it is no passive kind of landscape or backdrop. There are the nutmeg fields and the cocoa plantations. All of that is alive, along with the story of all those long physically dead

mothers and daughters whose stories are informing the interaction in the novel between the mother, Doodsie, and the daughter, Angel. Indeed, these are two themes which I was very interested in exploring. There is the journey and the colonial education which separates Angel from her mother, Doodsie.

B B: When you sit down to write, do you consciously think about a specific theme?

M C: I do, but the details are worked out as I write. It is complicated to explain all of the different things I was thinking about while in the process of writing *Angel*. At the beginning of the writing process, I saw things so clearly. You see all the things you set out to do, but this is different – writing and speaking retrospectively about the process of writing. Now, I find myself going into a critical mode which is very different from the other creative world. I find it fascinating to listen to how you and other critics interpret my writing. It is fascinating to look at my work from another perspective and to see and hear others do it. I cannot distance myself sufficiently from my own work to do a fair job of criticism.

I think that I create the scene against the backdrop of the landscape. I do have a general idea of a theme, but it is not a static thing. The framework is mine. What happens with the theme and my general idea depends very much upon the characters, their tensions, their agreements, their joys, their dreams and the friction between them as they work out their various world-views.

B B: Would you elaborate upon the mother–daughter tensions?

M C: There is much friction between the mother and daughter. Perhaps there is friction in most mother and daughter relationships. Here we have two individuals who are alike and yet are not alike and very often do not want to be alike. Two different generations searching for solutions, often with similar ideas but with very different resources provided to bring these prevailing ideas to fruition at the time. Angel and Doodsie take different and yet very similar political stands. What Doodsie considers to be Angel's radicalism is the logical outcome of her own radical ideas. In a very fundamental way, Doodsie is more radical than Angel because such theory as she formulates is a result of her practical experiences of poverty, and her caution, in action, is simply her defense mechanism; not at all an indication of her conservatism.

Hence, the friction is evidently there because the characters and their personalities are not so dissimilar. For example, Angel's views of life have been shaped a lot by her mother. Even what Doodsie appears to dislike in Angel is actually her own influence. What Angel sometimes dislikes is her own subconscious awareness that she is her mother. The streak of stubbornness and rebelliousness in Angel is Doodsie's. It is funny how mothers seem to know that was how they were, but then they, in turn, are going to try and wipe out this same streak from their own daughters.

B B: Why did Angel have to lose an eye?

M C: The physical dismemberment is part of that psychological trauma, and also while she loses her eye it is like she is gaining a lot else. There is this whole idea that, when you can't see, the other senses will come alive and sharpen. It is clearly a symbol for what the country has lost. The loss of the revolution. The actual loss and the psychological torment that went with it. In that sense, Angel's loss of an eye is symbolic of a much wider loss for the country. It can also be linked up with the fact that during the invasion there were people who actually lost a leg, an arm, or an eye. That dismemberment did happen. These symbols in books reflect the same tragic symbolism which occurs in the reality.

Also, it is part of the conflict within Angel. Although she has lost an eye, there is a deeper sensitivity, a deeper understanding, and a deeper insight into herself and the Grenadian society. Angel has lost; but perhaps in the long term she has gained. Hopefully, since the loss has taken place, the same can be said for the wider society.

B B: I have noticed that Caribbean women writers are preoccupied with the return to the source, origins, and the movement of the woman to a more independent state. Are you writing about these topics in *Angel?*

M C: Yes, I definitely write about a return to the source in order to understand and to make sense of today's flow, of today's turbulence. I am more concerned with the move forward, but some time is needed for looking back in order to make moving forward easier and more productive. If we look at *Angel* in a generational sense, from the beginning Ma Ettie had that very independent state of being even though it might not have generally been recognized as such. Doodsie is independent in a way that we might find Angel theorizing more about and putting it into a framework.

B B: Would it be correct to say that your being conscious of the need for women to step forward resulted in your writing of *Angel?*

M C: No, that is part of it, but *Angel* is more consciously concerned about the historical – about the colonial and neo-colonial existence. The experiences of women are subsumed in that, but it would not be correct to say that in my mind that was the starting point. For example, Angel decides to study in Jamaica and that helps her to analyse better what was happening around her in Grenada. There is a scene in the novel where Angel's friends are engaged in a heated political debate. During this lengthy conversation Angel finally has the courage to contribute, and what she says is in her mother's words. There is the history and everything is a part of that. It is part of that recognition of the independent state of being that has always been there. It is part of her developing story as a woman; part of the changing story of her region.

Women writers of the 1980s and '90s are writing of a return to the source. In her essay on 'The Kitchen Poets' Paule Marshall talks about listening to the voices of older women (her mother and her mother's friends), and the fact that she did not know what an impact they would make on her consciousness. When

she began to write, she found herself returning to the source: to her mother and her mother's friends' stories of the past. All women, who are writing today, are recognizing not so much something new, but the historical existence of an independent state of being.

With a mention of the importance of what was considered unimportant, I can picture my mother turning to look at me while I was enjoying the stories and asking me: 'You're laughing? Stop listening to stupidness. You better study your book.' All of that story-telling was considered stupidness. Here you have no recognition of the fundamental importance of all of those stories and that very independent philosophy of life that was so well presented in the orature. What women writers are doing today is reclaiming all of that which is our story, and in that reclaiming of them is some kind of assessment of our situation as women.

As for the idea of the novel *Angel*, it came after the 1983 events in Grenada. Maurice Bishop was killed as well as lots of other people. The United States army invaded. I needed to explore 'our' story behind the headlines which were quite sensational and inaccurate sometimes. *Angel* was the result of that psychological trauma. The title 'angel' refers to the angelical image that Angel could not formulate for herself in her childhood while in school. On one occasion in the novel, one of the parents' friends said that Angel was too black to be an angel. That idea gave me the title for the novel.

B B: In *Angel* you address political and socioeconomic conditions along with the themes of women's consciousness and the mother–daughter relationship.

M C: Politics is life, so that when I look at the themes of women's consciousness, the relationship between women and men and the mother–daughter relationship I am always looking at politics. All of the interaction is informed by the socioeconomic or political situation. Politics is in the everyday experiences of the people of Grenada and of people generally. What happens in particularly small communities is that there is a constant on-going debate on what is happening in the formal political sector. That is what is very present in *Angel*.

B B: Rather than divide your novel into chapters you quote directly from French and English-based Creole to move from one topic to another.

M C: What I am doing in *Angel* is simply duplicating people's speech patterns. Very often, we speak in headlines. When I say we speak in headlines, I am referring to the way of encapsulating a whole philosophy of life into a short proverb. For example, Doodsie might say to Angel, 'Look child, don't live on nobody's eyelash so that when they wink you fall.' Immediately, Angel understands that this is relevant to a conversation that they may have had some ten minutes ago or is the substance of a conversation which will follow. This is what I mean when I say we speak in headlines. The proverbs. The philosophy of life.

This is why I decided to use that kind of formulation in the novel. Also, my writing is very much influenced by my concern with the Creole languages in

Grenada – French- and English-based. I grew up with this variety of language. However, I only speak English-based Creole and standard English. While I don't speak French Creole (or Kweyol), it was always spoken around me, so that I know many of the sayings: proverbs, commands, experiences of anger, annoyance, etcetera. Generally, I understand it when it is spoken and, of course, the English-based Creole is my language.

B B: What have been the reactions of Grenadians to your writings?

M C: Positive generally, I think. More than anything, people have been pre-occupied with seeing themselves on the page, reading about familiar events, seeing people they recognize and hearing familiar voices. A lot of the reaction that I have heard has been from that kind of perspective; the kind of recognition of self. I find that very positive because the feeling is, generally, that that image is neither there on the page to be analysed nor to be joyfully recognized.

B B: You have attended and participated in the two Caribbean Women Writers' Conferences. What was it like to participate in the second one held in Trinidad?

M C: The second Caribbean Women Writers' Conference, held in Trinidad in April 1990, was the first in the Caribbean. It was interesting comparing it to the first, which was held in the United States. The Trinidad conference was the Caribbean at home and the atmosphere was different. As it would be, I guess. Caribbean people in the region have a different sense of self. Of course, this did not mean an absence of controversial issues. I'm talking here about the feel, the ethos. Depending on location, different dynamics and the agitation for focus on particular issues of current local concerns will surface.

B B: How does the atmosphere affect you, as a writer, when you are outside of Grenada or the entire Caribbean region?

M C: In a variety of ways. The agenda outside the region is often very different to that existing within it. Attitudes are different. Concerns are different. The focus is not the same. There are things that are happening to black people in England, Canada and the United States that are not occurring in the same way in the Caribbean; therefore, they do not have the same impact on Caribbean-based writers, and vice-versa. So, in a sense, we are all Caribbean people, but we are engaged in talking about things from different perspectives because we live in different places and are influenced by different situations.

B B: I know that there is this argument that a Caribbean writer can no longer be a 'Caribbean writer' if she lives outside the region.

M C: That is ridiculous because migration is part of the Caribbean experience. There was the major migration from the late 1940s and early 1950s to England, Canada, and the United States in search of an education, better job opportunities and exposure to an international audience. In fact, most Caribbean writers do not live on their islands of birth.

B B: Have you found that cliques exist among the Caribbean writers who live abroad and at home?

M C: Well, I try to avoid getting into the cliques issue. But I suppose it happens simply because you are closer to the people that you see all of the time. I suppose also that people's perceptions of themselves change, and those with similar ideas may tend to organize together or to be in similar groups.

B B: Are you finding it cumbersome to juggle a teaching career along with that of a writer and poet?

M C: Well, I'd quite like to be able to dedicate more time to writing; it is the form of expression that is most important to me. But, in a way, I guess I'd like the best of all worlds: to be able to do research, to teach and to write. They feed off each other. But certainly I would always be terribly frustrated in a job that leaves no space for writing because that for me is always a substantial part of the job.

B B: Do you intend to go back home one day?

M C: I am always back home. Permanently, as a base? The short answer is 'yes'. The fact that we are getting together as 'Caribbean writers' means that is where we define ourselves, no matter where we live. While I believe I will always be most at home in the Caribbean where I had my early nurturing, I guess I will also always be wanting to leave to find out what else there is to learn.

B B: In an earlier conversation you had mentioned that your first visit to Grenada after your departure in 1984 was quite painful. Did this hold true for your other visits?

M C: The second visit was not as painful as the first one. Grenada is undergoing many changes and a lot of reassessment. When I went back in 1990, it was just after the elections. There was a new mood of optimism. When I went in May 1988, I was there for May Day and it was quite a thrill being there to hear people talking again about the People's Revolutionary Government [PRG]. When I had been there before in 1987, all of that talk had been undercover and very hush-hush.

For Grenadians living at home, attitudes to past events and to the political reality of the country are in constant metamorphosis; opinions may not have changed that much, but people adjust to deal with particular circumstances. Grenadians who live abroad are perhaps more inflexible in their positions, caught or sort of preserved at particular points of responses to traumatic experiences. In some ways, it is the difference between theory and practice. Who feels it, knows it.

B B: When I first met you, you said that you saw yourself as a performer rather than a writer. Do you still see yourself as a performer five years later?

M C: Did I say that? Perceptions change because of different experiences. In Britain there often appears to be a distinction between the 'performance poet' and the 'poet,' the latter apparently being considered more artistically pure than the hybrid performer. Because I feel that the 'performance poet' category often

implies both a value and discriminatory judgement, I opt for poet and writer. But certainly a poet who loves to perform, with all the theatrical implications of the terminology.

From Grenada to here, my first love is the performance. I both read from my work and perform it. [Laughter.] Why are you reminding me of that statement? OK, I guess it is good to look back and to see what I had said years ago.

Culture and Liberation in Zimbabwe: African Women in Conversation

Ifi Amadiume and Nzinga

I first met Nzinga, an African–Caribbean scientist, in 1977 as a member of the British contingent of artists, scientists, intellectuals, academics, and political activists who attended the First World Black and African Festival of Arts and Culture (FESTAC) in Nigeria. Ever since then we have been friends, and constantly agonize over the traumatic events on our continent, Africa. On learning that Nzinga had just returned from a visit to Zimbabwe with her husband Alex, I persuaded her to give this interview in the winter of 1991.

Often, our 'serious' journals, newspapers, and magazines, when accused of lack of contributions by African women, have given the lame excuse that women don't send in articles for publication. From personal experience, I know that this is not so, and that editors have often considered articles sent in by women too critical of the male establishment, and therefore too controversial. In order to face squarely some very important current social and political issues about the much-mouthed question of democracy in Africa, that we feel need to be aired and subjected to rigorous debate, we have chosen the conversational mode as a traditional and much easier medium of expression and commentary for African women.

Here, we touch on important issues, such as the relevant role and concerns of diaspora Africans for African progress; the meaning of independence and African liberation; the land question; rural infrastructure and the provision of basic social amenities; the economic and political status of Africans in relationship to white settlers; the economic system and AIDS; the role of the black elite; the relevance of African culture for identity, self-government and progress; history, tradition, and the woman question.

Ifi Amadiume (I A): Why were you as African Caribbeans interested in going to Zimbabwe?

Nzinga (N Z): The thing about being an African Caribbean person who is conscious of our responsibility for our own group is that one is looking for a focus of place where one could situate oneself in order to make a contribution towards the growth of African people and that was one of my main reasons for going to Zimbabwe. We were here in England in the '60s and '70s and we were involved in the black movement in general. In particular relation to Zimbabwe, we got involved in all the struggle against Ian Smith's UDI, marching to Rhodesia House as it was at the time. We were involved in the struggle for liberation. As Alex told a lot of Zimbabweans the only thing we didn't do was to go and pick up the gun with them. Otherwise we were doing everything for the struggle for the liberation of Zimbabwe. Our interest in going to Zimbabwe was to see if it was a possible point at which one could contribute to the growth of African people.

I A: You mean in a more concrete sense I suppose, having struggled collectively for the liberation of Zimbabwe.

Alex (A): I would like to stress the fact that we were in Zimbabwe for only a month. We went there because during the liberation struggle, we were very close to that struggle, living in England and making our contribution demonstrating, fund-raising, listening to the news and generally giving support to the liberation struggle. So we went there really to learn, as we see the struggle as a continuous one. We did not know how far that struggle had reached before we left England and went there. Getting there, we talked to people, we listened and gave our own opinion about the situation that we saw.

I A: What struck you most as you got there?

N Z: One of the interesting things about going there is that we found the experience to be a very sharp one, in that every day you spent in the place made you realize that black people haven't got the power that they lost their lives fighting to gain. It was very painful to be driven through miles and miles of countryside in Zimbabwe and being told that this is a white farm and you don't even reach the end of it after driving more than 300 kilometers. Yet, African people in that society fought such a bitter struggle, but are apparently just on the periphery of the society. People walk miles for transportation in order to fulfill the basic necessities of life.

I A: Alex, having been involved in the different liberation struggles in Southern Africa, on getting to Zimbabwe, what exactly did you expect to see? (Nzinga talked of not expecting to see mass and mass of land still being occupied by whites.) Knowing that a war had taken place which we were told in 1979 had finished; then in 1980 there was an election which brought ZANU and Robert Mugabe to power; so, effectively, we knew that there was independence in Zimbabwe. Now, in your own case, as an African from the Caribbean who has

been involved in that struggle right from the beginning to the end, in your mind, going there, what did you expect would meet your eyes as evidence of an independent African nation?

A: Coming from the airport and driving through, I did see a lot of black people around as I had expected to. It was only when we got to the place where we would be staying that I realized that there was something wrong: I got up in the morning and saw so many black people with their overalls on in that neighborhood, and it wasn't something to do with going to work in a factory. They were just servants! Then when you listen to the news, you hear of shortage of water and people were going to pay a penalty. We began to think of when there was a drought in England, people were not paying any penalty or going to be put in prison if they abused the water system. The government just said that you could not use water for washing your car or watering your garden. You could not use water for that sort of thing. We know that there is drought in Africa. People in Bulawayo are starving because they cannot grow food and distribution is not well organized in Zimbabwe to meet the needs of the African people there. Yet white people were using sprinklers on the grass and pavement. That was one of the most shocking sights. When you go into the country, you see how the kids and their mothers have to go very far to fetch water. The whites either live very near the river or they have the pleasure of abundance of water because they have the privilege that the African people don't have.

N Z: One of the things that Alex remarked about which baffled us throughout the whole trip was that as you are driving through the countryside, you begin to ask yourself where are the African people? Where are these people? These people liberated this country, where are they? We drove from Harare, we were going to Greater Zimbabwe and we had to go through Masvingo. Between Harare and Masvingo, we drove for about two hundred kilometers and saw one or two African men alongside the road doing fencing, obviously for a big, white farm. But for those two or three hundred kilometres we hardly saw any people.

I A: Nzinga, you and I traveled to Nigeria in 1977 for FESTAC, and as an African Caribbean that was your first visit to Africa. How do you contrast what you've just said about Zimbabwe with your experience of arrival in Nigeria?

N Z: I think that what was different about it was that in West Africa, particularly in Nigeria, you could feel the presence of African people in that place. You'll drive through the place and you'll feel life and that African people ran and controlled that place. Whereas in Zimbabwe, you feel that African people are on the periphery of the society. It is a very difficult feeling to describe because it is subjective. You go to the airport and you see people, taxi drivers and people like that, but in the suburbs where we were living you wouldn't see anybody on the street, and the handful of Africans that you do see you come to realize that they are servants working in this suburb. But in terms of the bustling life of African people, like seeing groups of people, you have to go out to like Mbare

to the market to feel that this is an African country, throbbing with life. That was one of the most unnerving experiences about being in Zimbabwe, that you felt that the people were pushed to the edge of society. In fact, when we were in Mosi oa Tunya, known in the West as Victoria Falls, I kept feeling that I was in South Africa. We were the only African tourists as far as I could tell, and the majority of African people who were in that area were working in the tourist industry. When you ask to be taken to where African peoples live in the town, they would be driving through little tracks. You immediately leave the paved road, and as soon as you get to where Africans live, you would be on an untarred road. The presence of the whites is felt. They have the money and they have the big Land Rovers. They occupy the hotels, and you hear the South African accent, and people talk about rands as though it was the currency of Zimbabwe! African people live as if they are there to serve those people and not as though they are citizens of an independent African nation.

I A: In effect, it is as if there was no liberation struggle, and as if there was no independence. In that kind of situation how can we begin to understand the meaning of African independence? What was our expectation about independence? What should independence really mean?

N Z: I always like to come down to the specific experience of people. When we expressed this impatience to one or two Zimbabweans, one woman in particular reminded me of the fact that in the past in Zimbabwe they couldn't walk on the pavements next to whites. She said that Zimbabwe has changed a lot. African people were not allowed to shop in the same shops. For them that past is not long ago, being within her own living memory, and she is only a young woman in her mid-thirties! You had to have a note from your madam saying she sent you to get such and such an item.

A: Otherwise you'd be arrested. People were being arrested for being on the streets.

I A: So really, in substance that system has not changed because the whole idea of apartheid was based on the separation of space between whites and blacks. It was also an economic division. Now to say that Zimbabwe had gained independence through a war of liberation, it makes one ask again, what was the purpose of the war? Was it to regain land from the whites? Was it for a specific class of blacks to be integrated with the ruling class of whites? What I am trying to ask is this: What really did we fight for? What were we saying at the time that we were fighting?

N Z: We kept asking people that question during the liberation war. What was the plan? What was the discussion about how the economy would be run, and about how things would be done? For the simple reason that the average Zimbabwean doesn't have a say in the running of the country.

A: When we were in Ndebeleland in Bulawayo, we were asking a young brother who was trying to help us to get the right direction. He was saying that a lot of people could not give an answer as to why this thing did not change.

N Z: He expressed it so beautifully. He said: 'You know we fought and we now have independence, but all the money is in the hands of the whites. I have no explanation for it, and I don't know any Zimbabwean like myself who has an explanation for it.' And we were absolutely silenced, because he was so precise about it.

I A: It seems to me that's a crucial issue given the fact that Namibia is now supposed to have an independent state, also there are present negotiations in South Africa which makes one ask what it is all about. Is it for the integration of some black people to rule the country, or the dismantling of apartheid? Therefore, the processes which came into effect in Zimbabwe seem to me a kind of prediction of what could happen in Namibia or South Africa. In a way, we are pinpointing some very precise mistakes, or shall I say injustices, or the deceiving of people about what politicians claimed they were going to do and did not do. Should we reach the conclusion that exactly the same process will take place in Namibia and South Africa? What is African liberation?

N Z: I think that we can tackle these things on many levels. If you take Zimbabwe in particular, many people who know the particular politics of that situation cite the Lancaster House Agreement where the negotiations on the part of the Africans were such that they had to agree to compensate Europeans for land which the Europeans had taken by force, and Europeans had to agree to sell that land, and Africans were bound to that process for ten years, then the present government would then be allowed to change the law. When you talk to many Zimbabweans, you get two types of response to the land question. The first important thing to say, which is shocking, is that the issue for which African people fought and died has not been resolved; the revolution is not complete because people did not get back the land. This is to the extent that somebody has estimated that 4,000 whites control 60 per cent of the acreage of Zimbabwe. There is such a critical land crisis that an average family in Harare, for instance, cannot afford to buy a house because the houses that were built were built by whites, and those houses have escalated in price, and there is no land available for them to buy to build. So there is a land crisis in Zimbabwe. People respond to it in two ways. They either say that lots of this land in Zimbabwe is commercial farming. The whites are running the commercial farming. Many co-operatives which were set up by the government for African people have failed for one reason or another. Therefore we need the management skills of the whites in order to produce and earn money for Zimbabwe. But when you probe the question a little deeper you see that many whites have ceased to produce food. They now produce flowers. They now turn their lands into animal sanctuaries, and so on. The land therefore ceases to be a productive instrument from that point of view.

I A: When you say that the land ceases to be a productive factor, you mean that it ceases to produce for self, that is, for the population that is there?

N Z: Yes, it ceases to produce for the needs of the people that are there.

A: Again, what people are saying is that these white farms used to produce wheat and maize.

I A: It sounds like the classical situation of cash crop at the expense of basic food production.

A: Yes. Lots of the white landowners left the country, and many of them are still out of the country. They abandoned those lands, but the title is still in their hands. They've just left a relative in the farmhouse, and the land is not being productive in any way.

N Z: It begs the question of whites being successful commercial farmers. It is like a cover-up, because how much of that land that they really own is in creative production, meeting the needs of Zimbabwean people? The other question that it begs is, before whites forced Africans off the land in Zimbabwe, what did African peoples do? Africans were autonomous, living and producing food. To put forward this argument that you need these people in order for your country to produce food is really a spurious argument. It is like an excuse, an exit from confronting the issue that this land has been taken from them.

I A: That's interesting, because if we look back to the First Chimurenga, the first liberation armed struggle against the white settlers, it was very clear to those Zimbabweans then that the issue was land. The prophesies and instructions of Mbuya Nehanda, the national goddess and founding ancestress of the Shona, was that they must reclaim the land. It seems that that clarity has changed since that time and since the second armed struggle.

N Z: I think the clarity gets muddied by leadership, or lack of leadership, Ifi. I don't think people have changed their clarity. Many people in Zimbabwe, including the peasantry, are quite clear that they haven't gained the land they struggled for. One young lawyer was saying to us that, in Mazowe, there are estates that produce a lot of oranges for Zimbabwe, controlled by whites. The farmers who are now on other lands were pushed off those lands in 1948. They remember being pushed off those lands. They want that land back. So the issue for a lot of people, and particularly the peasantry, is clear: they want the land back. What has happened in Zimbabwe, like many other African countries, is that the whites have put the elite to control the rest of the African population. Some of those elites have been granted the very land that the peasantry are fighting for.

I A: You said that there are two strands to the exploitation of Africans in Zimbabwe. Could you elaborate on them?

N Z: I would say the two main strands are the problems that were left by white rule, and a more fundamental one being the failure of the completion of the revolution for which the present leadership was responsible. In the first category,

I would put problems such as the lack of a transportation system in such a large country in which people have to move about and go to work. Whites are better placed in that situation because they have cars. In Harare, we counted the number of people driving motor cars and nine out of ten were white. black people face a major crisis when they have to get to work in the mornings or get home in the evenings. The second problem we saw was the complete failure to reach the goal of the revolution which was to acquire the land of Zimbabwe. The fundamental struggle for which a war was fought and for which many people died was for the return of the land to the people. Without the return of the land, so many other things hang on it that affect the lives of African people. Without the land people become displaced. They have to go long distances to work. They then have to leave their families. It probably explains why AIDS is so rampant in the country because of the break-up of family life or absence of family life caused by this pattern of internal migrant labor in the country.

I A: Yes, I can see very clearly the importance of Africans retaking their land. If you look at the history of industrialization in South Africa, of commerce and trade in Kenya and the former Rhodesia, you can see a systematic strategy of displacing Africans from land-ownership and agricultural production, and turning Africans into migrant wage-laborers. You were saying something about that in relation to domestic labor and how the reacquisition of land could give Africans back some economic autonomy.

N Z: Yes, the basis of all independence is land. Malcolm X used to make that point even in the United States of America, which is a highly urbanized society, in relation to African people there. And this is even more so in Africa where there is a massive unemployment problem in a country like Zimbabwe. In the context that the government is talking about Structural Adjustment, they themselves admit that they haven't got a solution to the unemployment problem. You have two real prongs to this question: one is that you continue to facilitate the whites to own the land for which black people fought, then you keep talking about Structural Adjustment so that you imply that you need people to come in and invest in the economy of Zimbabwe. But you don't give the population the opportunity to be productive. You continue to allow the population to be a dependent population going from place to place in search of work, when, if they were in control of the land, that would be the activity from which they would build a new society. We thought that that was what the revolution was supposed to be about, that is, providing people with the basis from which to build a new society.

I A: Instead of that, 40 per cent of the population is dependent on domestic labor!

N Z: Yes. In the Zimbabwean economy, domestic labor makes up 40 per cent of the working population. In other words, four out of ten are working as servants,

and that goes for both men and women. The productive population are not working at producing food, but working at producing people in domestic work.

A: You could draw examples from the area in which we were living.

N Z: When you look at the big suburbs of Harare and large houses situated on an acre of land, and you see black people in those areas, a fair proportion of them are engaged in domestic work as gardeners, laborers, housekeepers and so on. They are occupying those places not as true Zimbabweans asserting their role in the society as productive people, but as people on the periphery of society. When the white man blows his horn, then the black gardener has to run and open the gate. That is not a productive workforce for Zimbabwe.

I A: Neither is it a status of independence which comes from having fought a war of liberation.

N Z: When you go through those areas, you see how space was abused to provide each white family with a big acre of land. Then you go downtown to an area like Mbare and you see the huge ghettoes where people are crowded, and somebody will say how in that small house there are families of six or seven or fifteen people. Yet whites are in an acre of land with a swimming pool. The solution to the problem is not that more blacks should occupy that kind of apartheid structure. The solution is: how are we going to get rid of the apartheid structure itself? I think that the revolution is incomplete. Lots of people, when you talk to them, feel very unhappy about the land question.

I A: Is there an open debate, formal or informal, on the question of land?

N Z: According to the discussions we had with people in Zimbabwe, the Lancaster House Agreement forced the government to suspend the question of European ownership of land for ten years. The understanding is that you have to have a willing seller in order for the government to acquire those lands. Yet everybody we talked to was aware of the history of how that land was acquired by the whites. We talked to a young man whose parents and grandparents come from an area which is owned by Europeans, called Mazowe, where they produce a lot of oranges, and they remember being forced off that land in 1948. They want to go back there. We went into a district called Rusape, and when we were going into the rural area, the person who was taking us could demarcate the road. Here was the European commercial land. We drove for 50 kilometers right alongside the European commercial land, and as the road deteriorated he said we were on the small African farmland, and as the road deteriorated further it became the African communal land. So the whole thing is stratified not only in the volume of land but also in the quality of land and the quality of the roads.

We asked, for example, if it was not the Africans who were running the municipal councils. We were told, no, that it was not Africans running the municipal councils, because they had more white councillors based on the amount of land-ownership than the community, the township of Rusape which has about four or five times the numbers. Because it is not based on counting

heads but on property. So even the quality of the roads you get really resides in the hands of the wealthy farmers. So the crisis is there and it is critical because there is inadequate provision of land for normal human activity. African families are still confined to small plots, dry land, infertile land in which it is difficult to be productive.

I A: How do the ex-freedom-fighters feel about all this?

A: There was a particular one that we met. He was talking to us with a lot of anger. He was saying that some of the land that Africans were given to work was barren with a lot of stone. It looked as if it was deliberate because they knew that it was going to fail. Yet not far from there, whites had the best type of land.

N Z: They were using them as game reserves and rearing ostriches and saying that they were not going to produce food anymore. In some ways, they're laughing at the African people.

A: They are laughing, but you see, the thing is that when they are debating in Parliament, you hear them say that the Africans make a mess of some of the co-operatives. If they are talking about these kinds of land that we've described of course they'll fail. People from all over Zimbabwe talk about the land thing and that they've been tricked. Even where the ex-fighters have been given land to form co-operatives, they didn't work. But these are not enough excuse for the government to want to try the IMF way. The whites are pushing this because that is joining the whites in Zimbabwe with the rest of white power in the world.

I A: They want to get Zimbabwe into financial debt like the rest of Africa.

N Z: Zimbabwe is going to go the same way as Nigeria or Trinidad or others who have tried Structural Adjustment. I think that what is cynical about Structural Adjustment is that it is being described as an attempt to bring black people into business. It is not really being described in Zimbabwe as an IMF plan. It is being described as some kind of opening up of the door of private enterprise for black people to join in and be joint managers and set up joint ventures. But I think that if you don't have the land, then you don't have any basis for controlling business and investment, and all that because somebody else has the capital and people don't just give things away. The country had to be wrested politically from the whites. They didn't give it to you, and they're not just going to come and give you their money and be joint partners with you in business ventures. In any case, those business ventures are going to leave the large majority of the African population still disenfranchised. A few businessmen controlling trucking or controlling cars, or railways, and so on, are not going to solve the basic productive problem of African people for the need for food, clothes, and shelter. African people will provide themselves with food, clothes, and shelter if they have the land as a resource to work and to be autonomous.

I A: That seems very interesting, because if we look at the South African situation, you can see parallels there; that as soon as news spread that Mandela

had come out of apartheid prison, and that apartheid was being dismantled, rural Africans, particularly the peasantry, began to move back to their land. So it seems that connection and the ability to reclaim land is, in the minds of the peasantry, the measure of liberation, and that is what they are fighting for. So, we see these two processes of the peasantry believing that if apartheid has ended, or if the war has been won, or if liberation has been achieved, it means that they can move back to their ancestral land. Then there is the other process whereby we, the elites, see independence, or the achievement of liberation, as the ability to move into the house where de Klerk used to live, or put on the same suits that de Klerk wore, or enter the same Mercedes, or be able to talk at that level of performance.

N Z: Yes, and it is precisely at this level in society that you are getting the arguments about the need for management and the need for whites to be able to do the commercial farming.

I A: So really, they are seeing liberation or independence in terms of the production of an elite that would manage Africans and not in terms of self-government, autonomy, and production for self, and grassroots leadership.

N Z: I think that that elite that has been produced has absolutely lost confidence in the ability of African people to be autonomous, and that is why they are so frightened. They are almost frightened of losing the whites from the country, and there is almost a sense that they are permitting whites to come back.

I A: Do you really think it is them losing confidence in the ability of Africans to manage themselves, or is it the fact that if Africans manage themselves, then there'll be no role for them. They are two different things. The ability of Africans managing themselves could be a threat to the management role that the elites have allocated to themselves, for they would have no relevance. How do you see the difference?

N Z: You see, I think that one of the things that this elite has to do is to subject itself to the discipline and order of African society, and they are not prepared to do that. So they slip out in many different ways. One of the sharp ways in which they slip out is the crisis between men and women. It is not that for that elite there isn't a role if African people are autonomous. To me the critical question is, when African people are autonomous, the elite has to be subjected to the discipline of the people; the elite has to be accountable to them. Their lifestyle, the way they live, how they behave, have to be subjected to the morality of that society. What has happened in the process of this apartheid and this disintegration of our people is that that group wants to escape from the discipline of African people's morality. They want to live in both worlds.

I A: For example?

N Z: For instance, when it suits them they call on the traditional values, and they say this is our tradition. When they say this is our tradition, they most often

say this in relation to the subjugation of women. This is where the tradition is called upon most strongly.

A: They also used the tradition in order to pursue that struggle. That was before the women's issue came into conflict with the struggle.

I A: You are saying that this calling upon the tradition is not simply for the subjugation of women, that they also used it as a resource for the struggle.

A: Yes, that was done during the struggle and one of their main spirit mediums was a woman whom they moved to Mozambique.

I A: Yes, I see what you are saying; that they exploited it because it was effective then.

A: I don't want to say that it was exploitation. It was necessary. It was not exploitation because people were putting their lives at risk, and a lot of people who were following the spirit medium are the same people who are leaders today in independent Zimbabwe. There were a lot of people who died for their genuine belief in what Nehanda laid down that the land comes back to Africans.

N Z: And I think that we mustn't forget what she also said. She also said that we must forsake the European ways. During the struggle, people had to refrain from eating their food, driving in their cars, and so on. There were certain stipulations during the course of that struggle, and the woman was absolutely clear that it wasn't just a struggle to regain your land, but a contest between our culture and their culture. And she drew a line.

I A: It is the culture that will determine what you will do with the land.

N Z: Yes, and I think that what has happened now in Zimbabwe is that that elite does not want to be subjected to that kind of discipline where the mass of the population would be able to say from different autonomous groups that we want this done, we want that done, and we want our society to be run in this way. They want to be free to run to the IMF and talk about Structural Adjustment when the country is actually politically being run by them. Yet when the country wasn't being politically run by them, they were running to the people and talking about our ancestors, the spirits, the traditions. Now to run the economy, they don't go to the people and ask how they are going to incorporate the ancestors and the spirits, our African history, our African view of how we are going to run our lives, with the present political order.

I A: How do you think we can describe this attitude of the elites? Do you call it opportunism or betrayal?

N Z: I see the elite as a parasitic group, really. I think one of the critical issues for all African people struggling today is how we are going to regain the right to have some kind of recourse and to be able to discipline this elite that we keep throwing up. One of the clear examples that was given to us on the day-to-day level was the question of the crisis of AIDS in the society. There is a high incidence of AIDS, and there was some random testing of patients on the medical ward in Harare hospital, and more than 50 per cent of them are HIV positive.

I A: What do you think is responsible for this?

N Z: I tried to discuss that question from many angles. One of them is the fact that Zimbabwean people are still living under an apartheid system of work whereby they are migrant workers in their own country. So that when you go to a lot of those villages, the men are working in Harare, and they are working on white farms all over the country. They only come home for five days of the month. The distances are long, transportation is poor, so that some of them might even skip those five days and not see their families for three months or six months at a time. So that large numbers of people in that country don't have what in Europe would be regarded as a normal family life, where they see their children and their wives on a regular basis. Obviously that is going to promote sexual stresses on both the men in those faraway places and the women in the communities. So these diseases are being brought back into African villages as a result of this forced migrant labor that still exists internally as the work system in the country.

I A: There are definitely a lot of very serious social problems.

N Z: Yes. A second problem is the question of the young people in the society who are being educated and the abuse of the *lobola* system, whereby if a young man wants to marry a young woman, the parents of the young woman would have to receive a certain amount of money or heads of cattle and so on. That system is still recognized and accepted as a marriage bond. This doctor that we were talking to was saying that a lot of university students come in pregnant and when he says to them that this is your second pregnancy and you are only halfway through your course and your parents have made so much sacrifice, why is it that you keep getting pregnant? And they would say, 'Oh but he's paid *lobola*.' The paying of the *lobola* implies that he is entitled to have proof from her that she can have children. So I said to him if he's paid lobola and they are operating within the traditional norms of the society, surely parental intervention and discussion within the family could help to break that tendency to demand that a woman should get pregnant. And he was saying that this saying that he paid lobola is only a cover up because a lot of these girls have sugar daddies, the rich and older men, and this is an excuse. I said well, since people still refer to their traditions how is it that a parent can't intervene to talk about the promiscuity of a young girl to kind of protect and shield these girls and to discuss the problem? Surely in the traditional system there must have been a method for dealing with this? His wife said that if in a family, this is the first person who's been to university, the person has a command of English, they have a degree in French or they have a degree in biology. They have so much information. They are going to have much more earning power than their parents, how can these parents now come and subject them to the traditional discipline? That person is now looked up to. You almost can't talk to her in the same way that you would talk to a daughter who is still on the farm who is not getting European

education. Really, I think that puts the finger on the crisis in African society, that for the first time, we really have produced generations of people from whom the parents, the old order or the accumulated knowledge of society must take guidance, like parents obeying the children. That is new. In our society, children must take guidance from the parents because the parents constitute the accumulated knowledge of the society to date.

I A: I see the symbolic analogy between that and the new class of European-produced elite, as against the whole archive of African history and African culture stretching over thousands of years which, overnight, we've thrown aside because of an elite that is linked to European super-powers, European imperialism, and so on.

N Z: I always give an example from my own personal experience because it is important to go back to the specifics to understand how these processes work in reality. When I went to high school in Trinidad, it was a big thing because I was going to achieve great things. Coming out as a young woman at that time meant pressing your hair. When I started to press my hair, I went to my grandmother who didn't used to press her hair and I said, 'Mama, why don't you modernize your hair? Let me press your hair for you,' and I started pressing her hair. When I came to England and became a self-conscious black person and stopped pressing my hair, I went back to Trinidad, my grandmother said to me, 'A bright young modern girl like you, what are you doing with your hair in that state?' I was dumbfounded. I couldn't answer, because I was the one who told her to modernize herself.

I A: Yes, you had tried to ... should I say ... corrupt her in the past.

N Z: Yes, and I had done it!

I A: But you needed to go to the source, to the very core of this other system to become conscious, and become disillusioned and be able to make up your own mind and realize the damage that you had already done.

N Z: And this is where our society is in crisis, where we have placed the resources of our own society at a disadvantage with respect to this information, because all European education is information. It is not knowledge or wisdom. It is information which we should utilize to build our society. But we are utilizing it to destroy our society.

I A: Some will argue that the way that European information is organized, it is systematically organized to do that to your own society, otherwise there will not be imperialism or colonialism. The latter had to debase your own culture and your own history in order to give itself that role of civilizers and enlighteners of your people. Obviously the processes of the reproduction of an elite is geared to produce them as agents to carry out that attack. The very status of being an elite produced out of that system is what puts that elite in opposition to their own culture as a debased Other in relation to the European culture. But the tragedy of it is that that Other is self, it is your roots, the ground on which

you will stand to struggle, given the racism of the European system that wouldn't absorb you. You know, the forsaken lover. And this takes me back to the beginning of this conversation, and the experience of FESTAC. Why was FESTAC such a spiritual experience for us? There was this celebration, this fantastic extravaganza, and celebration of African culture, and all of us trooped to Africa from everywhere. I remember that the common experience that we were expressing at that time was this feeling of strength, but it does not seem to have lasted.

N Z: Yes, we had the impression then that, at last, for the first time here was an African state. Of course, this was not the first FESTAC that was organized, there was a first one in Dakar, Senegal, but Nigeria is a wealthy country economically, and Nigeria is the country that contains one of the most populous populations in the whole continent of Africa. These two critical factors made that particular FESTAC something unique. Nigeria was going through an oil boom at that time. One had the feeling that here at last was a coming together of resources, human resources, material resources, spiritual resources, a recognition by African people that our culture was important, important enough to create an autonomous people, that we could celebrate this. African people from North America, from Canada, from the Caribbean, came together. What was striking about FESTAC also was that we suddenly realized that the culture was one. When you got to that stadium packed with people and Nigerians were calling for Sparrow from Trinidad, such a small place in terms of African people in the world, and yet they knew about Sparrow, they knew every song and could sing along with all the songs. Similarly, we were coming into Nigeria, seeing dances and rituals for the first time and could identify with them. Tears came to my eyes when I walked through the streets of Lagos and saw people pounding plantain and having a big pot of calaloo like we have in Trinidad, where it is our traditional Sunday food. African people all over the world made a connection that we have one culture and that we are in fact one people. For that to be backed by a state in one of the most populous countries, Nigeria, was critical. It made us feel that we could go forward.

I A: Do you think that that is one primary area in which Mugabe failed his people, that is, in terms of a strong assertion of African culture?

N Z: Absolutely. The statue of David Livingstone, with its inscription describing him as the liberator, is still standing overlooking Mosia oa Tunya. Livingstone insulted Africans by renaming it Victoria Falls! The arrogantly structural tombstone of Cecil Rhodes still stands in the Matapos – a holy place for the Ndebele. Troops were sent to prevent the peoples of the area from reoccupying their land because it is said to be a 'national park,' the main sightseeing feature of which is the grave of the imperialist Cecil Rhodes. I think that one of the things that insulted my eyes and we can rationalize about why this is so for a long long time, and we can make all sorts of excuses about it. One of the

most assaulting things about Zimbabwe was lack of an African clothes culture. To go into a hotel for a drink, they would say that you had to have on a tie. You see big African men in suits and ties. Alex had an experience. Perhaps he should talk about it.

A: The guy said to me that I was wearing sandals and that it was unacceptable. Eventually, he said that I could come in provided that I took my hat off. I felt that the conditions were too much. I was expected to dress formally. I don't even own a tie! I told the man that wearing sandals was part of my national dress.

N Z: I don't know how people stepping out of Nigeria would manage that because the little hat is part of your national dress.

I A: Yes, Islamic countries, formally, they have accepted that as part of their national wear and not tie and suit.

A: You see, those hotels are not owned by Africans. The security man who talked to me carries orders from an European.

N Z: The point that Ifi made is absolutely correct. The government has to take responsibility for much of this. This is not a new thing. People like Nyerere gave the leadership in terms of changing that image of dress for males in Africa. People like Manley in Jamaica. The shirt-jack became an acceptable form of wear even in parliament on all occasions.

I A: Even in Biafra we adopted Nyerere style as a national dress.

A: When Bernie Grant went to parliament here in England, he was wearing his *danciki*.

N Z: I think what is clear is that the Zimbabwean state has accepted European norms and mores and imposed them on African people. It is shocking that they fought a bush war for such a long time in which young African people died, and when you look at their parliamentary system on TV you see these big African people with the white wig. You can't tell me that this is simply a question of wearing a suit and tie. They've actually accepted and institutionalized these norms and mores of Europe and their system of dress and they've not gone to African sources to take those systems of thought on board in Zimbabwe. In their definition of land-ownership, they have not gone to African sources to rebuild Zimbabwe.

Latin American Lesbians Speak on Black Identity – Violeta Garro, Minerva Rosa Perez, Digna, Magdalena C, Juanita

Edited by Juanita Ramos

This piece is based on a presentation made by five Latin American lesbians who identify as black (i.e. African descent) at Las 'Buenas Amigas' Latina Lesbian Group (New York City, 1989).

Violeta

Hi everyone, my name is Violeta and I'm going to speak in a mixture of Spanglish porque. I'm comfortable in both languages but I'm not strong in either. I'd like to thank you for being here today. I'd like to start by saying that this is a sensitive and painful subject for us and we find it difficult to share about this in public. We feel that we're taking a risk to share these feelings right now. Its painful to admit not liking yourself, to be ashamed of your skin color and other physical features.

We decided to structure this workshop as a 'fishbowl' because it might be more comfortable and easier for us to discuss this topic in such a structured way. We will give each other ten to fifteen minutes to talk about being Latina and black. Then we'll discuss those things between us. While we are talking we'd like you just to listen. When we have finished we will open it up for general discussion and everyone can share whatever feelings they have or ask any questions they want. Juanita will start off, I will follow and then Minerva and Digna. We might have another woman join us.

Juanita

When we got together to plan this workshop last week there were things that we discussed then that we would not feel safe discussing in front of light-skin Latinas, that is, Latinas who have 'white-skin privilege.' We asked Violeta to make a short introduction about the format of this workshop to help create a consciousness that the white Latinas present do not have to tell us how we should deal with racism and internalized racism. Those are issues we sometimes prefer to discuss among ourselves. This attitude parts from personal experiences we have had. Recently I went to a conference in Chicago. While there I told a white

Latina that I wanted to attend the workshop on internalized racism. She said to me, 'Haven't you dealt with that already?' And I told her, 'No, I haven't finished dealing with it yet.' I didn't have the courage at the time, primarily because of the emotional energy it would have taken from me and the fact that I was not going to feel safe while speaking with her, to confront her ignorance about how much effort it takes on a daily basis to combat the racist messages black Latinas receive from family, lovers, friends, co-workers, social institutions, etc.

Although it is politically and culturally necessary for white Puerto Ricans to acknowledge their African heritage it seems that having black ancestors and relatives somehow absolves white Puerto Ricans for the benefits they have enjoyed as a result of their own white-skin, male, and/or class privileges. As of the last few years I've heard a few white middle-class Puerto Ricans take their black 'abuelas' out of the closet, that is, 'reclaim' their black grandmothers, mothers, etc.[1] Perhaps what is more destructive is that some feel that having black relatives entitles them to speak for or to ignore or distort the experiences of black Puerto Ricans. There is widespread denial that white and black Puerto Ricans do not necessarily experience what being Puerto Rican is in the same manner precisely because of racism and differences in skin color. The fact that it has almostly exclusively been white middle- and upper-class Puerto Ricans who have written about racism and black history makes it imperative for black Puerto Ricans to speak about their own lives. The same holds true for those of us who are women/lesbians, gays, and/or of poor and working-class extraction in our communities.

I wasn't sure that I wanted to discuss how I have felt about being black in an open setting. Therefore, I thought that the easiest and the safest way for me to discuss this topic was to first approach the subject from a historical and academic perspective and then to discuss some of the reasons why today I choose to call myself a black Puerto Rican lesbian. When naming myself in English I consciously list 'black' first in order to give it the visibility it has been historically denied. In Spanish I list Puerto Rican first for reasons that will become apparent further along in this talk.

Africans, both slaves and free, first arrived in what is now Latin America and the Caribbean with the Spanish colonizers. The main motivation for importing massive numbers of slaves to the Caribbean was the fact that the native labor force, on which the continuing success of the conquest and colonization depended, decreased alarmingly as a result, among other factors, of the massive murder of native peoples carried out by the Spaniards. Moreover, African slaves were brought to the western hemisphere because the colonizers argued that they were physically and, hence, racially, stronger than native peoples. As a result, they could endure harsh physical labor better. That is, Africans would live longer than Native 'Americans' under the same exploitative work conditions.[2]

In the book *La esclavitud en hispanoamérica*,[3] Rolando Mellate talks about how Africans were used in some Latin American countries to supervise 'Indian' labor

and/or to subdue rebellious Indians. In a few cases, there were Africans who owned Indian slaves and vice-versa. However, African slaves and native peoples frequently formed alliances for the purposes of rebelling against the Spanish. Throughout the period of Spanish colonization African slaves were imported to work in all areas of the Latin American and Caribbean economies. Hence, their widespread dispersal throughout the region. However, African descendants tend to be more visible in the Caribbean and the coastal areas of Central and South American countries where plantation economies were established.

In Puerto Rico we talk about being a mixture of African, Indian, and Spanish. In Cuba, contemporary historians, such as Moreno Fraginals, argue that Cubans are, in fact, a product of the mixture of Spanish and African. The Native American influence has been minimal, they argue, due to the virtual extermination of native peoples during the first 30 years of the conquest. In the case of Puerto Rico, it is customary to highlight one's 'Spanish' ancestors, language, and culture. When forced to acknowledge one's heritage 'of color,' most Puerto Ricans, as many whites in the United States, will opt to highlight the 'indio' (i.e. the Indian) and to ignore or downplay the African.[4]

Discrimination against blacks, as Isabelo Zenón Cruz has shown,[5] occurs at all levels of Puerto Rican society. All major Puerto Rican social institutions in Puerto Rico and in the United States are controlled by white Puerto Ricans who also happen to make up the overwhelming majority of the middle and upper classes in our communities. Perhaps one of the most insidious ways in which racism manifests itself on the island is shown by the numerous terms we use in our day-to-day speech to denigrate people of African heritage and/or which associate that which is 'black' with evil. In a book entitled *El texto libre de prejuicios sexuales y raciales*,[6] Isabel Picó and Idsa Alegría discuss racist and sexist terms which appear in textbooks used in public schools in Puerto Rico. These terms also appear in our literature, our music, and our historical texts. The samples I will be sharing with you today have been taken from their book, the work of Zenón Cruz, and my own personal experiences.

As I stated earlier, the color 'black' is frequently associated with evil and with negative events, such as death. If you are mourning, you dress in black. If you are participating in an evil mass it is called a 'black mass,' in which case you also wear black clothes. We associate black with 'bad luck' or 'black luck,' as in '*mi negra suerte*,' and bad luck with 'black cats' and 'black magic.' '*El cuco*' or 'the bogeyman' is frequently depicted as a black man. The sentence, '*Tengo las manos negras*' ('My hands are black') refers to someone who has committed an evil act with his/her hands. A few years ago we heard the term '*lunes negro*' (black Monday) which referred to the stock market crash.

Other racist phrases commonly used in Spanish are: '*alma negra*,' (black soul); '*oveja negra*' (black sheep); '*mercado negro*' (black market); '*lista negra*' (black list);

'*corazón negro*' (black heart); '*mi negro porvenir*' (my black future); '*la plaga negra*' (the black plague); and '*humor negro*' (black humor). In Catholic school I frequently heard the distinction made between '*mentiras negras*' (black lies) thought to be more serious than '*mentiras blancas*' (white lies).

Frequently, when white Puerto Ricans are being referred to the term '*el puertorriqueño* or *la puertorriqueña 'fulano(a) de tal*'' ('The Puerto Rican so-an-so') is used. However, when the person being spoken about is black he/she will be referred to as, '*El negro* or *la negra puertorriquena(o) 'fulano(a) del tal*'' ('The black Puerto Rican so-and-so'). This distinction implies both that Puerto Ricans are commonly white and that race, especially in the case of blacks, takes precedence over nationality.

It is not uncommon in the Spanish language to refer to people by using adjectives describing them by their skin color, race, or ethnicity. Such terms include, '*la blanca*,' (the white woman); '*la negra*' (the black woman); '*la mulata*,' (the mulatta); and '*la china*' (the Chinese woman). There are times when terms which refer to a person's black skin are used as terms of endearment. In these cases the racist connotations are clouded by the fact that feelings of fondness accompany the words used. For example, one of my father's uncles was called by family members '*Tio Negro*' (Uncle black) or '*Negro*' (black Man) both as terms of endearment and because he had very dark-skin. In fact, *Tio Negro* was the darkest member of his family. Another example which is more common is when the terms '*negrita*' and '*negrito*,' which literally mean 'little black girl' and 'little black boy,' are used when addressing someone in an affectionate manner. Ironically, these terms are also frequently used to refer to the darkest member of a white family even though that person is also white. Interestingly, when the terms '*la blanquita*' or '*el blanquito*' (little white girl or little white boy) are used in Puerto Rico, the reference to a person's white skin tends to be overshadowed by the fact that his/her class background is also being alluded to. That is, the terms *blanquito* and *blanquita* generally refer to attitudes and behaviors associated with moneyed people. Heterosexist biases are evidenced by the fact that the term '*blanquita*,' in addition to referring to a woman's class and racial/color make-up, refers to virtues, such as purity, beauty, and fragility, associated primarily white women. The terms *negrito* and *negrita*, on the other hand, are also associated with that which is ugly and worthy of pity and disdain.

There are also phrases in Spanish which are used to describe the skin color and physical features of blacks in such a way as to ridicule these and provoke laughter. For example, a very dark-skin black may be called '*negrito(a) violeta*' (violet black little man or little woman) or '*negrito(a) azul*' (blue black little man or little woman). Furthermore, his/her skin color is called '*carbón*' (carbon), '*tizne*' or '*betun*' (shoe polish). Thick black lips are labelled '*labios ordinarios*' (ordinary lips) or '*bembes*.' A person with large lips is said to be '*trompú*.' Our hair is alluded

to as: '*pelo malo*' (bad hair); '*pelo grifo*'; '*pasa*'; 'kinky'; '*abusao*' (abused); '*alambre*' (wire); '*rebelde*' (rebellious); '*pelo plancha*'; or '*pelo estrujao*' (wrinkled hair). A wide nose is also called 'ordinary' or described as a 'nose like an ox,' thus reducing us to the status of animals.

There are stereotypes that describe blacks as being more 'sensual' or 'sexual' than other groups of people. Other adjectives widely used are: '*salvaje*' (savage); '*primitivo(a)*' (primitive); '*vago(a)*' (lazy); '*bruto(a)*' (stupid); 'loud'; 'inferior'; '*negro(a) sucio(a)*' (dirty nigger); and 'superstitious'. We are seen also as being 'submissive,' 'lacking ambition,' and as 'always having children.' The latter implication being that we breed like animals.

Frequently in films the 'bad' or evil character dresses in black. Sometimes the 'bad guy' wears a black hat and cape and rides a black horse. In the case of clothing, however, the picture gets a bit more complicated where Puerto Rican lesbians and gays are concerned. For in Puerto Rico, lesbians, at least until the 1980s, frequently used to dress in black as a coded way of publicly 'coming out' of the closet to other lesbians. The man dressed all in white was frequently identified by other lesbians and gays as being gay.

Other ways in which racist stereotypes are passed on to Puerto Ricans from an early age are through the types of illustrations which appear in school textbooks. Frequently, these illustrations show all blacks as being of the same shade and as having the same texture of hair. Although black people tend to look different, certain physical features, such as wide noses and/or very large lips, are generally the only ones represented. Even these are distorted to ridicule them. Blacks are also generally shown as doing work which is considered subservient, low-skilled, and low-paying. They are not illustrated as occupying positions of power or as performing vocations which are considered 'respectful,' such as doctors, lawyers, etc.

In terms of religion, we find that those religions with African roots, such as santería, are usually considered 'superstitious'. The same holds true for those religions, such as espiritismo, which are seen as having Native American roots.

With regards to the socioeconomic and legal systems, we know that blacks and Native American peoples in Latin American and the Caribbean, as is the case in the United States, are both disproportionately arrested and imprisoned as well as overrepresented in the poorest sectors of society.

One of the few areas in which Puerto Rican blacks are thought to have made positive contributions is in the field of music. Still, the 'danza,' associated with the Spanish heritage and the Puerto Rican middle and upper classes, are still considered superior to the '*bomba*,' '*plena*,' and '*salsa*' identified with the poor and working-classes and with blacks. Still, music is one of the few ways in which the African influence has been acknowledged. That's why I had mixed feelings when I heard that two of the women who were unable to participate in this

workshop today were going to express their blackness by playing the congas. For although that has been one of the major ways in which they got in contact with their black heritage and their woman power, playing music is one of the few acceptable ways to 'be black.'

The last thing I want to speak about is why I identify myself publicly as a black Puerto Rican because I didn't always define myself that way. For a great part of my life I merely identified myself as 'Puerto Rican.' That had a lot to do with the fact that since I was a child I had been told that there was no racism in Puerto Rico because we were a mixture of diverse racial/ethnic groups. I felt real proud of being Puerto Rican whenever I thought that there was no racism in Puerto Rico like there was in the United States. When my family immigrated to New York I quickly became conscious of the fact that because of my skin color Anglos frequently thought I was African-American. As a result, as a child sometimes I spoke in Spanish or emphasized my Spanish accent. I thought that if people knew I was 'Spanish' they might treat me better.

At the same time I also felt that there was no reason to refer to my skin color because in Puerto Rico it wasn't supposed to matter. And so when I went to pursue graduate studies at the University of Chicago I was ill prepared for the sharp splits along race lines I discovered there. The university is located in the middle of a black 'ghetto' which it has been gentrifying for years. It was there that I discovered that African-Americans also identified me as 'black.' My reaction to this was one of bewilderment and joy as well as fear. It was the first time that I discovered that my skin color could be an asset rather than a liability, for it allowed me to instantly connect with thousands of people around me. However, my being identified by whites as black meant that I could not safely go into certain white neighborhoods in Chicago where blacks were frequently physically attacked. The threat of being physically attacked solely because of my skin color was something I had never confronted in Puerto Rico.

However, I am conscious of the fact that sometimes North American whites and African-Americans treat me differently because I am Latin American. That is, my heritage also includes something 'other' than black. The fact that I have a noticeable 'Spanish' accent when I speak in English contributes to my being treated differently once I open my mouth.[7] At times I receive better treatment than darker-skin Latinas(os) and African-Americans because I am a 'light-skin' black. However, I have also experienced the resentment of people who are darker than me because of the potential privileges attached to my lighter skin.

The process of embracing my African heritage is an ongoing one. As a little girl I don't remember being ashamed of my skin color but I remember wanting to have green eyes and a thinner nose. Sometimes I still feel shamed of the texture of my hair. As a teenager family members encouraged me to straighten my hair. In fact, I don't remember having been given a choice as to whether I wanted to do it or not. I have the bald spots to show the results of straightening my hair

all those years. For three years I wore a bandanna because I didn't know what to do with my hair. My mother, my grandmother, and my father still tell me that my hair 'doesn't look right,' meaning that it doesn't look straight. I still ask myself sometimes: Does my hair look 'too black'? Does it feel too coarse? Is somebody going to make fun of me because of the way my hair looks?

One of the first steps I took to reaffirm my African heritage was to begin to state publicly that I am a black Puerto Rican. Many Puerto Ricans do not understand why I choose to identify myself as black. To them I am just '*trigueña*' or 'brown-skin.' For them a black person is one who is very, very dark-skin. Also, because the term Puerto Rican is supposed to be inclusive of our black, Indian, and Spanish backgrounds they feel I am already acknowledging my black heritage by calling myself Puerto Rican. That might be the case if all these aspects of myself were conferred equal status in our community but they are not. Although racism may sometimes manifest itself differently in Puerto Rico than in the United States I, as a black woman, ultimately see both societies as being dominated by the same black/white racial dichotomy. In both countries people judge your worth by the color of your skin. Puerto Ricans of all colors frequently and openly express their racism and self-hatred.

As a result, there are Puerto Ricans who don't want to reaffirm their African heritage. They can't begin to imagine how one can feel pride in reclaiming the African. It's like those of us who are lesbians and don't want to come out of the closet either because we fear the rejection of others or because we feel ashamed to let ourselves and others know who and what we are. That is another reason why I feel it is important for me to publicly identify myself as a black Puerto Rican lesbian. By reaffirming those three aspects of myself I let others who might be experiencing the same conflicts know that it is okay to be who they are and to look the way they do.

I consider that embracing my black heritage is as much a revolutionary act as embracing my lesbianism, my feminism, and my working-class extraction. What makes it revolutionary is the fact that we live in a world which taught me to hate myself and others like me. Within such a context it is subversive to embrace all aspects of myself while forming alliances based on such identities to challenge oppressive power structures.

Violeta

I'm going to start from a personal angle. What I did was to write down a lot of things that I feel because when I start talking in public I tend to shut down and forget things that I want to say and just go blank. So if I don't give you eye contact, forgive me. I have to look at my papers here.

I want to start by saying that for the most of my life I was not happy with my skin color. Today I like it. I love it actually. But as a child, and this is clearly because of my family, I was ashamed of it. I come from a very racially mixed family and I am one of the darkest, if not the darkest persons within it. I have a sister that's white. And I don't mean mixed, I mean white. And my youngest brother is also white. And then, the three of us in between, my two brothers and I, are black. The message that I got from my family was that my sister and my brother, the ones that are white, were better. I was also told as a child that I would have a harder time because of my skin color. And I accepted that message.

I'm from Nicaragua. The part of the country that I'm from is called the 'Costa Atlantica, Zelaya.' That area is very cut off from the rest of what we call 'Spanish Nicaragua,' mainly because we were 'conquered,' as in 'colonized,' by the English before the Spanish. And we had a lot of freed slaves. That's actually what my background is. As a child we were called 'Creoles' and I spoke in English, but not this kind of English that I'm speaking now but the kind of English that you hear in Jamaica. It wasn't until I went over to the Spanish part of Nicaragua, to Managua, that I learned how to speak Spanish. Also as a child we were led to understand that we, the Creoles, the people of mixed black and European heritage, were better than the Indians, that they were lesser than us because they were less educated, etcetera. I still have a lot of those views and I struggle with them today.

Anyway ... back in the 1970s when I was a teenager in Miami I remember the 'Black is Beautiful' movement. I was in high school. And I remember it being somewhat of an enigma to me, this 'Black is Beautiful.' All of a sudden everyone started wearing afros and wearing the fists on their chains. It was really bewildering to me because I was not proud of being black so I couldn't understand why everyone else was strutting around being proud. The Black Panther movement was on and the black and red and green colors came into vogue.

What the Black is Beautiful movement became to me, and I just admitted this to myself yesterday, was a fashion statement. My hair at that time was really my pride and glory. Everyone in my family loved my hair because I don't have 'black hair.' What I have is curly hair and that's because of my mixture. And I had it down to my ass at that time. And it really looked good. So I went off and cut my hair, curled it up and I wore an afro. I started to fit in ... Everyone else had an afro, even the white people at that time were running around perming their hair trying to look black and wearing their *dashikis*. It was more like I said, a fashion movement for me. I was really not in contact with anyone who was what we would call 'politically correct' now.

I had some black friends growing up in Miami but I had mostly Cuban friends and white friends. The black friends that I had were involved in sports. I never felt as if I fitted in, in the American Black Movement. I couldn't relate. I didn't feel like I belonged. Actually I didn't feel like if I belonged to any one group

because I wasn't Cuban and I wasn't Latin light-skin. So I was always somewhat of an ... outsider, a reject. But ... anyway, I feel that in a way that was the beginning of my burgeoning black consciousness. I felt like, 'At least if I don't feel like them I could look like them and try to fit in.'

One thing I also remember is that with my black American friends I tried to dance to their music but I just really could not understand the steps. That was like the story of my life back then. But then I went back to Nicaragua in my late teens. I went back to my little town. And I remember going to parties and hearing this music that's called '*palo de mayo*.' It's wonderful music. It's a very African beat. It has a lot of drumming in it. Drumming is a lot of where you feel the African movement. And I remember listening to this music and listening to the beat and falling into it and wondering what was this that I could just fall into this movement, my body just followed. Looking back I think that was like starting to accept my Africanness because this *palo de mayo* is a ... sort of 'pagan' kind of music. It's wild. And no one who is shy or timid will dance this kind of music. It's basically a mating dance. It's very sexual and I loved it. And if you listen to congas or to Dominican music or to Puerto Rican music you will hear the same beat. We all have the same beat and it goes back to the African drums, period. That's why I was sort of happy that we might have some drums.

I want to talk a little bit more about my family background. When I was a kid we didn't talk about being black in my family. We talked about my grandmother who was white having a Swedish father. We talked about her mother being Spanish and how we could look at all the cousins and see their Spanish heritage, the blond hair, the pale skin. And then one day one of my aunts told me that she remembered as a child massaging the back of her great-grandfather who had been an escaped African slave. That's the first time I ever heard of anyone in my family being African. She told me that she used to massage him because he had whip scars on his back. He had jumped the boat off the coast of Nicaragua and swam into shore. Now, I was shocked by that news. I never knew that we had some Africans in the family. I asked my other aunts about it and they were instantly angry at my aunt for betraying that secret. Their reaction was that she must have been drunk, that, 'There are no Africans in this family!' I accepted their version that my aunt must have been drunk and maybe she dreamt that up. The fact is that it's not true. We can safely say that anyone who has any black in them has come from some kind of African descent, that we all are cut from the same roots which is Africa. And I for one am proud of it. It is me. It's part of accepting yourself.

What I'm trying to do for myself today is to try to integrate my black heritage with my Latin heritage because for a long time what I used to do, since I was ashamed of my black part, was to pass myself off as 'Nicaraguan.' If people asked me, 'Where are you from?' meaning, 'Why are you black?' I would say, 'I'm Nicaraguan' and that was it, end of discussion. And people would look at me,

look at my features. I have thick lips and that was part of my shame as a kid. My brothers used to tease me, they used to call me, and this is funny now but then it was painful, 'Long Lip Efilia!' Efilia was an old black woman who lived in town and she had big long lips. So my brothers used to make me cry, literally, by saying, 'Violeta looks like Long Lip Efilia!' When I was a kid I learned not to smile because I thought my lips got bigger when I smiled. So I learned to be serious.

What I do now is that I am integrating and owning my black Nicaraguan heritage. I don't want to emphasize being Nicaraguan anymore. I want to emphasize being who I am, and what I am is a black Nicaraguan woman. I was thinking of this story ... you see I have lots of aunts. My grandmother was white and her husband was black and most of my aunts came out very light-skin. My mother was the darkest out of twelve. Anyway, my aunts mostly pass as white. Some of them have curly hair but they're light-skin. They all came to this country in the 1930s and '40s. And my aunt Evelina, who I love dearly and is the one who enlightened me about my African ancestor whoever he is, told me this story about when they were in the South. When they came to this country they started out in New Orleans, which is Deep South as far as I'm concerned. In those days they were accepted as white and they had black friends. My aunt told me that this day she and some of her black friends went to a diner. And in those days it was black and white everything. And my aunt took her friends into the white part and her friends were afraid they were going to get kicked out of there because they were black. My aunt told them, 'Don't worry about it, just say, "Sí" and "No". And that's what they did. My aunt spoke to them in Spanish and her friends said, 'Sí.' 'No.' 'Sí.' 'No.' And they didn't get kicked out. That's placing social value on your skin. And that's what white America is part of, that it's better to be accepted as Latina than black. And I know that's what happened to me. That's why I always preferred to say that I was Nicaraguan rather than I was black. It's much more acceptable. You pass easier. It just makes life so much more simpler. That's why it's been a big issue for me to deal with accepting myself as a black person.

Yo escribí este poema en el '86 when I was really feeling down. I just dug it up the other day when we had the planning meeting. It's not the way I feel today but it's how I felt then. The name of it is 'Odd.'

Odd
Ashy skin, bushy hair, hairy eyes
Odds stacked against me
Running sores, running nose, running eyes,
Odds stacked against me
'Open your legs. Feels good, doesn't it?
Don't tell mommy, she'll get angry.'

Odds stacked against me
'Little black bitch, look at your little white brother.
Learn to be good like him'
Odds stacked against him
Passing out, falling down, strange beds, strange men,
stranger women
Odds stacked against me
Lying, passing, pretending, acting,
Learning slowly to be myself, like myself, slowly
Odds stacked against me
Blood, sweat, toil, tears, come, shit
Odds stacked against me

Minerva

My name is Minerva and I just really need to say that this is very difficult for me to do. As everyone here is discussing this topic, I'm getting in touch with so much of my internalized racism which is some of what I'd like to share with you. I was brought up by a mother who had come from Puerto Rico to New York under the illusion that being in New York and making money and acting like a white person was going to bring true for her all the dreams that she had. I think she had the American Dream of having a house, two cars, and televisions. I don't know what that was about … I'm still not totally clear as to how racism has affected my family. I'm just beginning to hear the word racism and think about what that has meant for me.

But anyway, my mother at a very early age *me estiraba el pelo*. (Does everybody here speak Spanish in case I go into this bilingual thing?) You know, she used to straighten my hair. She used to dye my hair. She used to pick my eyebrows. She used to talk to me about shaving my legs. She used to do everything to change me from who I was. I recall that at the age of 13 I had red hair and I had hardly no eyebrows. And, you know, something about this felt normal to me because *she* did it. She favored my sister. My sister has straight hair. *Ella era una india.* Being *una india, teniendo pelo lacio* was more desirable than being black in my household. That I can recall. *Mira, una vez cuando vino el* Black Movement, my mother called my afro a 'beehive.' She said, '¿*Y que tu tienes en la cabeza? Parece un … ' cómo dice* beehive *en español* anyway?
Magdalena: *Panal.*
Minerva: *Eso mismo.*
I just thought about this, one of the things that I was uncomfortable with in terms of body image was the size of my ass. But I still did not know this to be a racism thing. I think now I know why I was very self-conscious about the way that my body was shaped, the size of my behind, the size of my shoulders, you know, my body features.

When I started to have black friends I recall my mother saying to me, '*Tu no debes janguear con esas muchachas de color. Esas no son las amigas para ti*'. *Y yo siendo bien rebellious de jovencita cuando ella me dijo, '¿Por qué tu tienes de amigas esas morenas? ¿Por qué esas son tus amigas?*' *Yo le dije, como* she was so religious, '*Porque Dios nos hizo pa' estar to'a juntas*.' I figured that I would use her religion to get to her.

I was brought up on programs like 'Ozzie and Harriet.' I believed in 'Ozzie and Harriet' and 'Father Knows Best' and all those programs about white families. When I started watching television there were no blacks on television. And the movies they had about black people were like people in the jungle with big lips killing white people. There was this image that black people were very aggressive, very hostile, very savage. I was also brought up with programs like 'The Lone Ranger' and all those people that were always killing Indians. That's where I came from.

And, *cuando yo me fui de mi casa yo dije entre mi, 'Yo no voy a ser puertorriqueña. Yo no voy a salir con mujeres puertorriqueñas. Yo no quiero na' de ver con puertorriqueñas*.' And I did everything in my power not to act like a Puerto Rican. I felt that I needed to get an education, that I needed to be astute, that I needed to act a certain way, that that was going to bring me some kind of acceptance ... I remember that when I left home another one of the things I said was, 'I am never, never going to put plastic covers on my furniture. I'm not going to paint the walls with any ...' what you call, *esos rolos de pintura*, because for me that was ignorant. *Por muchos años yo estaba bien ignorante de lo que era ser puertorriqueña. Mira, yo una vez vivía en* Brooklyn Heights *y yo tenía esta clase de parties en donde aqui estaban los* philosophers, *aqui estaban la gente 'grande'*, you know, *esa clase de ambiente. Y yo*, you know, trying to keep up with Bach and Beethoven and reading up on the latest books *porque yo estaba* convinced *que eso era* fashionable.

And the only time I thought about the black Panthers and Angela Davis was when they got in trouble 'cause I liked to be a radical too, that was stimulating me very much. But when I think about it, part of me was trying to be upper middle class or middle class, bourgeois, whichever way you want to put it. It had a lot to do with pleasing my mother. (I'm really nervous. This is really kicking my ass.) And I would say to people, '*Mira, que yo vivo en este neighborhood. Y mira yo tengo estas amigas, esta escribió un libro y esta ...*' you know, that kind of stuff.

The other thing I stopped doing was wearing clothes that had any flowers on them. That was not the look, honey! If you want to be preppie and Ivy League you don't walk around wearing all those flowers. Unfortunately, I was one of the loudest persons in Brooklyn Heights. I made a lot of noise and I used to put my speakers out the window. I acted like what I used to think Puerto Ricans should not act like.

How I came into power and into discovering my heritage and my color had to do with a relationship I had with a woman that started about four years ago. She was a black woman. She used to say to me that when she met me I looked

like an 'asexual Ivy League' person. In other words, I had no body language. You know, *cuando uno es blanco tiene que estar reservado.* You can't raise your voice. You can't act out. Educated people don't act out. So I had like no body language. I didn't walk like a dyke. I didn't walk like a woman. I don't know what I walked like but she told me I had no sex identity.

And then, you know, I had this real conservative haircut, the 'Presley look.' This woman really keyed in and zeroed in. She was really into her blackness and she was about bringing that out. You know, about adoring that and really getting into it. So she started to key into those aspects of me. She used to take me shopping for clothes and help me with make-up. But ultimately what she did is she brought color into my life, a whole lot of color. I was colorless.

I also found out a little bit more about 'our' medicine and where we are as women of color and I found out a little more about black women's history. I hate reading history but this woman talked to me about these things. She also took me to cultural things. I got involved in going to a lot of cultural events sponsored by the Caribbean Cultural Center and other places. And I started to appreciate this stuff. And then I also got into drumming. (I'm one of the drummers that is not playing today.) And then one day I just realized how powerful what I was doing was, how every time I'd start playing and every time I went to one of those Caribbean cultural things, I felt high and good about my color. And that's where it all really started for me. You know, I started to acknowledge and recognize that, not only did we have a history, but we knew a lot more about medicine than whites did. And I went back and read about my history and that's what's help me to really appreciate what I was doing.

The other thing that I found out about was the Yoruba religion. I got a lot of controversy at first because I wore white for almost an entire year. Not because someone told me but because I knew that it was a part of our medicine or, at least religious-wise, it was part of what I knew would help me to continue to get in touch. And people would look at me and say, '*¿Pero que hace esta mujer en blanco? ¡Pero que si esta nevando afuera y esta usando blanco!*' I had to go through this controversy because that is part of what gave me the power. And once I started on a path, not just acknowledging who I was but also participating in who I was, that's when all the shit hit the fan. That's when I really recognized how afraid people were of the fact that not only was I Puerto Rican and not only was I outspoken, but I dared to be different. *Y asi fue que yo note el racismo. Y to' el mundo estaba paniqueo. Pero yo seguí vistiendo como yo tenía que vestirme y yo seguí empujando pa'lante hasta que yo me desarrollé. Pa' mi lo que paso fue que yo me tuve que desarrollar y decir, ' ¡Esa soy yo y se terminó!' Otra cosa es que yo no había notao es que bella se ve una mujer con ropa de flores.* I had forgotten what it was like to wear all those colors. Now I wear red shoes, yellow this … I had forgotten *la belleza de la cultura que yo vengo. Yo no veía mi belleza. Yo no veía que yo era bonita. Yo no veía mi cara. No veía el pelo.* So to me there's more to this. It's not just a

question of color. It's not a question of just black and white. I think it's a question of accepting the beauty that's mine. See ... this is my heritage. I like to wear these colors and I like to come out one day and look like I just stepped out of a campo in Puerto Rico. At one time I would say, '*¡Mira esa jíbara que tiene unos zapatos colorao!*' '*¡Mira que color es ese traje!*' I was a racist, '*¡Pero mira esa bruta que gritando en* the top of her lungs, 'Felaaaaaa!" There were all of these things that Spanish people did I couldn't handle. When I heard the white people say, 'These ignorant little' whatever, you know, I wanted to be with the whites because I didn't want to be rejected. That's what it boiled down to. I mean there was so much negative connotations around being Puerto Rican and there still are.

Today I work with battered women and a lot of our population are black and Hispanic. And it amazes me sometimes how the white population on my job is still trying to tell me how to take care of my people. And that is where I continue to experience my personal power. Because *yo era una pendejita*. I didn't want no controversy. But now I'm in a controversial place. I don't know how I got there. And this is where I'm beginning to learn about racism because I think that what happens is that I trigger into being white, very unconsciously. But because of a set of circumstances that I allowed myself to experience I really got in touch with who I am and now I'm really seeing things the way they are. But it is really hard because I find that racist conditioning is really a serious thing.

For me also identifying myself as black liberated me. I have found that within our culture there's so much racism. There's so much of that, '*Ay, que tu eres mas negra*' It's sad enough that I have to hear white people say that I'm lower-class and that I have no education and I'm just a loud, rowdy individual, hot-blooded, who wants to have 100 lovers a day. That I also have to hear it from Puerto Ricans it's like a double whammy.

What helped me liberate myself was to see the power of who I was and where I came from, to really see that power fully and not be afraid of it, not be afraid of being different, not be afraid of dressing different. Sometimes I wear nothing but African attire. I still have some racism. I still can be very judgmental. I don't think that's something that I'm just going to get over quite so easily because it's been imbedded in me. But I'm much more conscious of it than I used to be.

The last thing is *yo no hablaba español. Yo dejé de hablar español porque yo no quería hablar español. Recientemente yo tengo una amante que es hispana. Y yo he notao que este es un lenguaje bien fantástico. Yo no sabía que era tan caliente este lenguaje. Y sigo descubriendo y amando esta cultura. Eso es lo que me está pasando a mi. Que sigo descubriendo y amando y apreciando todo lo que yo soy. Y soy mucho. Porque antes yo creía que yo no era na. Mientras yo estaba tratando de ser blanca, siempre estaba tratando, no llegué a donde tenía que llegar. Ahora que estoy aceptando lo que soy es muy, muy diferente para mi. No me siento como si me falta algo. No me siento vacía. Me siento,* you know like, '*Si, esa soy yo, ¿y qué?*'

DIGNA

My name is Digna. First of all, I'm kind of nervous. I came to this group about a month ago. And when I came I felt uncomfortable because even though I'm Spanish, I'm black and I walked into a place where I felt like I was the only black Hispanic. I came with a couple of other black people but I still felt uncomfortable. Once I settled in I felt more comfortable see ... because most of the problems stem from me. I tend to think that I'm not prejudiced but sometimes I am. And I like to be truthful about that.

I'd like to start off by reading something that I wrote which deals with this and then I'll tell you a little bit about myself. I started writing this ever since I spoke to Violeta that day that I came to Las 'Buenas Amigas' to read some of my poems and I finished writing it yesterday. I was late because I called my mother from the train station to help me write some of this Spanish stuff down correctly and she wasn't going fast enough. I said, 'Mom, the train is coming and I'm late already!' But she did it, you know. This poem is titled, 'I Thought You Was Black.'

I Thought You Was Black
'I thought you was black,'
that's what I was always told.
'You don't even look Spanish.'
Again they were bold:
'Say something in Spanish and prove it to me.'
Then I would say in my normal English voice,
'Why, you don't believe me stupidy?'

Then they would ask if I'm West Indian.
I said, 'We don't all come from there you know.
If you want to know where I'm from just ask me and I'll tell you.
Soy de Honduras. Naci alli y creci aqui.'

I enter a store owned by Latinos,
'Can I help you?'
'No thank you. I know where it is.'
'*Oye, cuida esta morena que no robe nada.*'
Yes, some of us steal, but some of us don't.

'*Cuanto es la cuenta?*' I ask in Spanish.
'Oh, *tu hablas espanol?*'
'*Que te importa? Que es la cuenta?*'
'$2.23, *señorita.*'

'Pues tengo suficiente dinero pero no le voy a pagar.
Tiene que tener cuidado como hablar al frente de la gente
porque soy morena pero soy hispana. Primero soy una persona.'

People judge me and accuse me because of my skin color.
People like me for being Spanish not because I'm black.
Then they like me because I'm black not because I'm Spanish.
Unos me quieren porque soy hispana no es porque soy morena
y otros me quieren porque soy morena no es porque soy hispana.
Cuando me van a aceptar por mi?
When will they accept me for me?

Like I said, I was born in Honduras and I came here when I was six years old. In my country we speak English in the house and when we go outside we speak Spanish. You know, just like a lot of times here people go to mommy's house and they speak Spanish and go out on the street and we speak to our friends in American language.

Most people never know that I'm Spanish or foreign until I tell them. And a lot of times I choose not to tell them. I just want to be looked at as a person, period. Once I get close enough to you, if I feel I can tell you that I'm lesbian then I'll tell you that I'm Spanish 'cause then we're getting to know each other and I can give you more information about me.

I would go up to places and my friends would say, 'Speak Spanish,' and I wouldn't. The reason is I don't feel I need to use my language to get over. And sometimes I catch myself doing it and I don't like it because I use it to get over, to get accepted. What I read here has happened to me in a couple of instances where I go into places and people don't know that I speak Spanish. I was coming on the train just now and these religious people were sitting across from me with their Bible and talking about my pants. They had a full conversation. And when they got off the train I told them to have a nice day in Spanish. And it's like I said, you have to be careful of what you say. I am very careful as to how I speak in front of black people. I try not to speak in front of black people that I think don't speak Spanish because if I'm black like this then what makes me think that somebody else doesn't speak Spanish?

I came to the United States when I was six. So I was a kid and I had a very childish vocabulary in Spanish. Coming to America that's when I first found out my name was Digna. I didn't even know what my first name was. I was called by my middle name which is Carolee in Central America. So when I came here I learned that name Digna and I hated it because people called me anything else but Digna. I don't even want to get into that because I'd hate it if you ever called me that. I went through a lot behind it.

I never spoke Spanish after the first grade. The reason why is because I got called Puerto Rican for like three years of my life and I thought it was a curse. I didn't know Puerto Rico was an island. I refused to speak Spanish. I also refused to speak in my English voice which Violeta said is like a West Indian accent. I refused to speak like that because I was called West Indian and I know that I wasn't from the West Indies. I went through a lot with that also. I only spoke a certain way when I was at home. I never brought kids up to my house because they would hear the way my mother spoke. I always tried to be a good kid in school because I didn't want my mother to come up to my school and they would know that I was foreign. I did a lot of that to be accepted in the United States. I wanted to be an American so bad I tried to fit in as best I could. And I denied my heritage.

Not until I got to junior high school did I start speaking Spanish again. And the reason was because I wanted to get over. I took French all through junior high school but when I got into high school the French classes were real hard. So I figured I needed credits and I would go into Spanish classes. The teachers told me, 'You're going to be behind all the rest of the students.' I said, 'Don't worry I'll catch up.' And for the first couple of months I learned like everyone else. I always knew how to read it a little bit cause my mother always gave us books but I never knew how to conjugate verbs, that's why I needed some help today. And when I got into class, like I said, for the first three months I was a regular person learning how to speak Spanish. So it was like, 'Sí, señora,' and stuff like that, 'gracious' instead of 'gracias.' I had to do all of this in order to get over. By the end of the term I was pronouncing the words so beautifully. I was getting everything right. My oral test was perfect. I still had problems with writing but I passed on my oral exam alone. After I got my mark I confessed to my teacher that I'm from Honduras. After that we were friends and I gained a lot of Spanish friends from South America.

In my house, like Minerva was saying, I couldn't wear an afro. That was called, 'the bush.' And my mother would say she didn't want us wearing no bush in her house and, 'When you move out then you could wear these bushes.' My hair was also always straightened.

I always considered myself as just being black until I got older and saw the discrimination from my peers, from being around black Americans and West Indians and other Hispanic people. That's where I brought out in the beginning that I know that there's a prejudice within me because that's how insecure I felt when I walked into the room the last time, even though I have individual Spanish friends. When I got into a room where I thought I was the only black Hispanic I felt very little until Violeta walked up and spoke to me. Like she's known me for a couple of years and we've never really spoken until we found out that we were Spanish and we had that common bond.

I felt real nervous about coming here today like I said. We had a little discussion about this last week at Violeta's and I said that I was getting depressed just speaking about this subject. I took my mother to an African festival that was out in Brooklyn during the 4th of July weekend and I told her, 'I forget this is where our people are from.' She said, 'Whose people?' Oh, she cursed me! She said, 'Who the hell told you that my people are from Africa?' And I said, 'The white people educated you wrong.' I said, 'They just didn't give you the right education so, therefore, you stayed ignorant about it.' I used that word and it was like I was ready to get backhanded so I just dropped the subject. I was feeling real depressed because my mother denied the fact that we're of African descent, because I guess she thinks that's the lowest part. In my family I've heard my last name is an Irish name. We were told that my grandfather's mother or my grandfather's father was Irish and that's they way we got the last name but I want to know how my people got to Honduras.

My mother's been sick for the last couple of weeks and we've been getting closer because she needs me. So we've been talking a lot more lately and I told her how upset I felt when she abruptly disregarded that we're from Africa. And she told me that she would look into getting some history books on Honduras. I said, 'Because I want to know why you don't know about Africanism.' So she told me that she would get me the books. And that kind of made me feel good, that I was able to discuss that with her and that now she's interested in it.

Violeta

What I wanted to say real quickly is that most of you here get some validation from our countries and from our families about who you are. For example, if you're chilena your family is probably proud of your European history or Spanish history. But for most of us, for me and for Digna for example, our family is ashamed of our African history and I could never, ever, lay any claims to it. It's always been a question mark in my background. I'm filling that hole now and it's making me feel more whole. It's validating myself as a person, as a whole human being.

Do any of the panelists have any other comments? If not, then we'll open it up to the group.

Magdalena

If I may I'd like to share a little bit of my own experience. Originally I was going to be a part of this panel. Violeta kept calling me and I kept saying, '*Yo la llamo mañana.*' And I really believed in my heart of hearts that I would call her. You haven't gotten that call yet, right, Violeta? And I watched the process of myself going through this daily denial saying to myself, 'How come I haven't called Violeta?' This is days we're talking about here.

For those of you that don't know, I'm a recovering alcoholic and my first priority is to stay sober, so I go to recovery meetings. Today I went to a meeting before I came here and I said to myself, 'This is my first priority.' I've gone to millions of recovery meetings but for some reason this one right before the workshop was more important. And I'm watching the process and saying to myself, 'Okay, *ya empezaron*. I'll go as soon as the meeting finishes.' Nothing was going to rip me away from that meeting! And then I said to myself, 'Okay, look at what's happening with you, you don't want to talk about this topic. You're afraid.' And I have to say that I honor all of you that had guts enough to come out and be there for yourselves in a way that I was not able to do. But while you were all talking I was saying to myself, 'Fuck this shit, I'm just going to share what I can because I'm doing what I can do today.'

Like Minerva and Juanita *yo soy puertorriqueña también*. My family background is a very strange one. I always felt very different. I mean, that's a characteristic of alcoholism to feel that you're different, that you don't belong but it's also a characteristic of how I grew up in my family. I'm part of a group of brothers and sisters who had different fathers. So *tenemos la misma mamá pero diferentes padres*. Now ... if you were to look at this family it looks like a rainbow. My oldest brother *es indio, color canela* with straight black hair. My sister next to him has straight black hair but is fair-skinned. My other sister, María, has black curly hair and fair skin. I come and I've been called by some loving cousins in my family, 'A white nigger' because my skin was more fair than now but my hair was kinky. And then my baby brother is blond but he does have negro features. What does that mean? His nose is wide. He has wide lips *pero* he passes as white. So this is the mish-mash. In this family I felt like I was different because, in fact, I was different. And that was a very, very painful place to be. I never felt like I belonged, never.

I was raised by *una tía* who was very dark with straight black hair. She does not identify herself as black. She doesn't identify herself as anything which is very painful. When we moved to this country, I was mostly raised in Philadelphia in an Irish-German neighborhood. There was more of that feeling that, 'I don't belong.' I didn't have any black friends except for one young girl who was mixed, German and black, and who, very interestingly looked a lot like me. I couldn't figure it out. I didn't know what I was. I knew I wasn't black, in my mind. *Tu sabes, pa' ese tiempo* I wasn't black. I knew I wasn't white. But what was I? I was Puerto Rican. So that's what I identified with. To save my ass, many times in Philadelphia I said I was Puerto Rican *y me dejaban quieta*.

I was raised very strict. *Me estiraban el pelo a mí también*. I had very long hair and they made sure that it stayed that way. *Me jalaban el pelo pa'trás* so it could look real straight. *Me hacían una trenza larga* and all this bullshit. I'm very angry about it. But, anyway, we came to New York and it was the afro era and I cut my hair. *Me quite la trenza. Me quite to.* And I had an afro up to like this.

At this time my disease became active so I was getting high and drinking and I was taking all kinds of geographics. What that means is that I hitch-hiked a lot in those years. So, for once in my life I actually had a tan and I thought about how dark my skin could get. I was amazed by this. I had no idea. I felt wonderful! First of all, my hair wasn't pulled back stretching my eyes making me look like this. I felt comfortable for once. *Fui a la casa de mi mamá* one morning, on one of my drunks, with this afro and this dark skin and she says, '*¿Qué te paso á ti?*' I said, 'What do you mean?' '*¡Tu no eres mi hija!*', *¿Qué te paso en el pelo mi'ja?, yo que tanto* ...' This is the insanity of what racism can do to a family, to a culture. But I flaunted the afro and the darker I got the better I liked it.

I then went into the service, the army, and I encountered a very interesting situation. They wanted to know what race I was. I had to face a situation where I really didn't know what I was going to say because I really didn't know which category I belonged to. So I'm not going to lie to you and say that I said I was 'Negro' 'cause I didn't say that. I put down that I was 'Caucasian' and that's exactly what my papers read today. What did that afford me? I have to tell you that that really hurts, me just saying that. Admitting that is a son-of-a-bitch but I can't live my life on lies today. I spoke to my sister about those years when I was in the service and she said, 'Well, that's alright. That's what you are.' Again the denial. Because in fact that's what she may be but that's not what I am. I guess I feel guilty about that. But I'm not a bad person for the things that I didn't know how to deal with. I just want to say that for myself and listen to myself say that because I'm just not responsible for all the stuff that I had thrown at me that I didn't know what to do with. I am responsible today, from this moment to be completely who I am.

So I went through that whole thing, you know, making believe I was white, not really white. I never said that I was English or any of that bullshit but I said I was Puerto Rican. It somehow gave me a ticket, especially in the South where they didn't know what a Puerto Rican was and I looked different enough that they didn't believe I was black *pero algo extranjero,* so that was okay. I identified a lot with Juanita when she says speaking Spanish can be a ticket. I did that a lot. I've had a lot of internalized racism and I have been racist in my own way, in ways that I didn't even know were racist ...

So I got sober and not only did the denial break that I was an alcoholic and a drug addict, but the denial broke that I was different. And when I looked into the mirror I saw a different face. *Vi que la cara de mi hermana no era la cara mía. Vi que la cara de mi hermano no es la cara mía. Somos diferentes, igual y diferente.* And I began to ponder what that meant exactly.

As a lesbian I went out with a Puerto Rican woman but she broke my heart so bad that I was never to go out with another Hispanic for many years after that. And I thought, of course, it was because *era puertorriqueña.* So I stuck with very safe women which were, for me, Jewish women. And I learned their culture

better than they knew their culture. And it was in that process of teaching them their culture that I began to question who I was. Who are you, Maggie? You're telling your lover who she is, but who are you? And I began to delve. Again, it's only because I was sober that I was able to have the strength to really turn that mirror to myself. Because sobriety afforded me some tools. One of those tools is self-inventory. On a day-to-day basis I have to see where I am and who I am. And after a while you just can't deny things. So I began to learn about the history of Puerto Rico and the people and about the different kinds of people. I began to look at my own family and say, 'Yeah, *pero esperate, sí mi abuelo vino de España …,*' which they always emphasized, of course, 'Okay, fine. But how *come mi tía* is so *trigueña?* How *come mi papa es tan trigueño?* Why? They can't all be Indians. There has to be Africans in here somewhere.' And indeed there are. What are their names? We have no idea, certainly I don't. They are invisible but they're not unfelt. I feel those ancestors in here somewhere.

Sometimes when I'm in my quiet time I begin to ask who they are and where are they and how they got lost. And I know how they got lost because the only *abuelo* I had is *un abuelo español, un abuelo blanco.* But *mi otro abuelo, mi abuela, toda persona africana y india pero especialmente africana,* they speak to me in ways and in languages that I feel. And I know that they are there still, calling my name and touching me, calling out to me. And I feel that.

So there's a very deep sadness within me too that those women, those very beautiful, brave men and women that make up who I am today, I don't know who they are. I don't have a picture of them. Nobody thought them beautiful enough to take a picture of them. Nobody felt proud enough to say, '*Esta era tu abuela la que se casó con el español,*' who I understand was a very strong woman. But nobody says that she's black which is why they didn't want him back in Spain. But I'm here to say it and I hope she's here listening to me. I'm here to say that, at least in this generation, the buck stops with me. I'm here to talk about her, to talk about them as I cherish and honor who I am.

Notes

1. In Puerto Rico the phrase, '*¿Y tu abuela donde está?*' ('And where is your grandmother?') is frequently used to imply that a white Puerto Rican is hiding his/her African heritage by not acknowledging the fact that some relatives are black-skin. The African heritage is implicitly transmitted through the woman and is particularly made evident by the texture of her hair.

2. Jalil Sued Badillo and Angel Lopéz Canto argue that Spanish colonizers first imported free Blacks and African slaves from Spain, not because they were physically or intellectually superior to the Indians, but because they had already acquired language and artisan skills which were easily transferable to the

colonies. Moreover, they argue, African slaves were less reluctant to engage in mining operations than were native peoples. Jalil Sued Badillo and Angel López Canto, *Puerto Rico Negro* (Rio Piedras: Editorial Cultural, 1986), p. 67.

3. Rolando Mellate, *La esclavitud en hispanoamérica* (Buenos Aires: Editorial Universitaria de Buenos Aires, 1987).

4. I believe internalized racism, along with heterosexism and class biases, play a major role when people emphasize the contributions of one racial/ethnic group over another to the formation of what is called the Puerto Rican 'national identity.' For example, the 'ideal' Puerto Rican to whom authentic Puerto Rican values and culture are attributed is *'el jíbaro puertorriqueño.'* He is the antithesis of the 'black grandmother.' Male, heterosexual, white, and a small rural property owner, until recently he was thought to be primarily of Spanish descent. However, recently some have argued that *el jíbaro puertorriqueño* may have been more the product of the mixing of African and Spanish blood than previously thought.

5. Isabelo Zenón Cruz, *Narciso descubre su trasero (El negro en la cultura puertorriqueña),* (2 vols) (Humacao, Puerto Rico: Editorial Furidi, 1974).

6. Isabel Picó and Idsa Alegría, *El texto libre de prejuicios sexuales y raciales (Guía para la preparación de materiales de enseñanza)* (Rio Piedras, Puerto Rico: Centro de Investigaciones Sociales de la Universidad de Puerto Rico, 1983).

7. In Puerto Rico, I have also been singled out and made fun of because I speak Spanish with what is called a 'Nuyorican' accent, that is, the 'English' accent associated with Puerto Ricans who have been born and/or raised in the United States. Until Nuyoricans began to reclaim the term as a positive statement of who they are, it was primarily used as a derogatory term to distinguish between Puerto Ricans 'from' Puerto Rico and those born and/or raised in the United States.

Chiriboga: A Conversation

Carol Beane

A personal, professional, and literary biography: Chiroboga, raised between Quito and Esmeraldas. Esmeraldas, a fragrant flower!: 'I always remember its sea and its river. My parents, my brothers and sisters lived in Esmeraldas; it is the most tender shoot that rises in me.'

Enrolled in the School of Biology, specialized in biology at the Universidad Central in Quito, Ecuador.

Author of the novel, *Bajo la piel de los tambores,* (*Under the Skin of the Drums*) (1991; soon to be available in English translation); a novel that confronts questions of race, color, class in the life of a young mulatto woman in Ecuador; a novel that moves from Esmeraldas, on the Pacific coast of Ecuador with its concentration of people of African descent, to Quito, in the Andean highlands, with its population of mostly Creoles, indigenous peoples, and mestizos. The protagonist's geographical dislocation – from coast to highland – allows the novel to explore issues of racial and class identity. It follows the life of Rebeca González as her parents send her away from an unsuitable young man to Quito where she is enrolled at a boarding school run by nuns, has an affair with a priest, and various other sexual encounters. In Quito, also, however, she meets and learns from the black nun, Sor Inés del Rosario. She returns to Esmeraldas and we learn of her life there, of her search for identity, of her realization of her full self as she acknowledges her African ancestry.

Fragments of Chiriboga's novel are included in the anthology *Erotique Noire* (*Black Erotica*) (1992), and in the magazine *Cultura* (Venezuela). She has also published *La contraportada del deseo* (1992), a collection of erotic poetry. Chiriboga's short stories and articles have appeared in *Cultura,* a publication of the Banco Central of Ecuador; in *Letras del Ecuador,* the journal of the Casa de la Cultura Ecuatoriana Benjamin Carrión; and in *Debora,* a publication of the Literary Workshop Pablo Palacio. Her work was awarded a prize in the short story competition José de San Martín, Buenos Aires, 1986. Forthcoming books are *La noche está llegando'* (*Night is Coming*), (a piece for children's theater); *Los ojos se le nublan por el llanto,* (*Eyes Filled with Tears*) (short stories); *Las voces de la vida,* (*Voices of Life*), (poetry for ecology). Most recently she has published *Manual de Ecología,* 1993; another novel, *Aguas turbulentas* (*Rough Waters*), is in press.

Chiriboga has been involved in conferences on black culture in Cali, Colombia, and Panama, and a Conference of Black Women, held in Esmeraldas, Ecuador. In addition, she has participated in a Symposium on Afro-Hispanic Literature, which took place at the University of Missouri, Columbia. She was invited to Chile to participate in the centennial celebration for the Chilean poet Gabriela Mistral, who in 1945 received the Nobel Prize for Literature.

An impressive reader of her erotic poetry, Chiriboga is equally moving when she reads passages from her novel. Chiriboga: a woman committed to working for the good of women and children, for the good of her race, and for the well-being of Nature.

These conversations took place in Washington, DC, between Luz Argentina Chiriboga and Carol Beane, Department of Romance Languages, Howard University, 15–16 April 1992. The cherry trees were blooming; the trial of Rodney King was in its final days ...

Carol Beane (C B): Argentina, how and when did you begin to write? And why?

Luz Argentina Chiriboga (L A C): When I was a little girl my older sister used to sit me on her lap and read poetry to me. This awakened in me a great love and passion for literature. Besides, my father, who is over a hundred years old, is a wonderful story-teller of literary and historical legends, and anecdotes, all of which immersed me in a magical world. You asked me for what reason and for what purpose do I write? I write in order to free myself from the solitude that sometimes grips my throat. My characters have all the patience in the world with me; they listen to me; they even sleep with me sometimes. We sit down together to tell each other our problems, our existential conflicts; sometimes, they bust out laughing at me; sometimes, they cry with me; but I know that deep inside they love me, just as I love them. Another reason that moves me to write is in order to communicate with my peers, in order to give free rein to my fantasy, to this magical world I carry within me, that I inherited from my people in Esmeraldas.

C B: What is your connection with things Afro-Hispanic?

L A C: To reaffirm my own connections, my own roots with the past and integrate myself into that history in order to confront our origins wth dignity; to regain my thoughts and the teachings of grandparents in order to resonate with their legends, their myths and to find myself again. The African roots that I inherited from my parents, from Esmeraldas, from my people there, was the crucible where I forged my personality. These elements run in my veins; they left a mark on me that comes and declares itself in everything I write.

C B: Getting into literary tastes, what are your favorite books; who are your favorite authors, and why?

L A C: Without a doubt *Don Quijote de la Mancha*, the greatest monument of the Spanish language. I have also enjoyed reading Gabriel García Marquez for the problematics his works involve; I read Julio Cortázar for the manner in which he confronts his themes, and Mario Vargas Llosa for the fluidity of his style. Also I enjoy reading some North American writers, for example, John Steinbeck. We have Angela Davis for her courage in taking on the anti-racist struggle. Another Colombian writer whose works I find interesting for his style, Manuel Zapata [Olivella]. And there are some others who left their mark on my reading as an adolescent and up to now, I continue to savor and reread their books.

C B: How do you go about writing? Please, tell us something about your creative process, your sources of inspiration.

L A C: For me, writing is as if I unfurled the sails of my ship and I set them to travel on the windswept paths of stormy seas. I transfer to them my hopes, the hopes of a whole people. Their aberrations, their periods of exhaustion; these beings walk through my insomnia and live with me for a long time. I live with

a writer and before we began this interview you had asked, 'What is it like living with "works in progress"?' We both maintain a certain independence, a certain distance from each other when we write, to avoid influencing one another. We each live with our respective 'work in progress.'

C B: What are your sources for the events, the humor, the tragedies that one finds in your first novel, *Bajo la piel de los tambores?* Do you imagine them or invent them; do you reconstruct them?

L A C: For me writing is a vital experience; it is as if by going through these spiritual gymnastics you can taste all the life experiences: humor, sadness, sensuality. This job has taught me to understand the conflicts of society. Sometimes it's as if I try to throw out a bridge from other people towards myself, in order to understand myself better and to have a broader vision of the cosmos. All that grew and was transformed, according to the circumstances in which I developed the character. The way of experiencing the problems of the world is the same for the novel as for poetry; what makes the difference, of course, is the way in which I express myself.

C B: What are your favorite themes or concerns? What makes you choose some and not the others, some events and not others? I remember that when you were in Washington, DC, you did a poetry reading at the Anacostia museum and you read some of your erotic poetry. Where does that type of writing fit in your literary trajectory?

L A C: I cannot tell you exactly why a particular incident, an emotion, an event, transform themselves and become guests in my head. They become an obsession, and I can only make them disappear by setting them down on a sheet of paper. That's when I go looking for persons, dates, and, why not say it, gossip.

I bury myself in that reality in order, from there, to be able to awaken the facts, to give them another connotation, to project my fantasies. Sometimes I think that it is not I who seek out themes, but rather the themes that come to find me, as if they fit with my personality, as if the shoe fits … Then I believe that it isn't I who look for them; they are the ones that look for me.

Sensuality is, for me, one of the strongest and deepest roots of civilization. It is present in all manifestations of culture, in art, painting, dance, literature. It is a vital energy all beings possess that is reflected in all their daily tasks; it is a kind of breeze that imbues us all with waves of dynamic energy.

C B: What in life determines your interests as a writer?

L A C: What motivates me to write is the desire to extend my solidarity with my people, with my dusty streets, with my city, Esmeraldas, that has no potable water, with my river, with my ocean. I write so that children will become aware of the necessity to protect this immense house which is Nature, this universal home. I write in order to defend our natural resources. I write because I am committed to my race; I write in order to unmask white historians who deny the significance of the contributions of Afro-Ecuadorians in the Wars of Inde-

pendence, of those people who fought side by side with Simón Bolívar for our freedom [from Spain]. I write in order to emphasize the fact that peoples of African descent also have contributed to the development of our country.

C B: And now, to the novel. Tell us something about the title of your first novel, *Bajo la piel de los tambores*, in English, *Under the Skin of the Drums*, which critic Nelson Estupiñán Bass described as an 'expressive and descriptive [title], exactly because it is trying to give a new face to realism, to reveal that which seems hidden, invisible, but which, in fact, is on the surface, and which becomes visible by means of the bifrontal narration we find in this work.'

L A C: 'Under' refers to that which is hidden, even though it is really out in the open; the 'Drum' is an African instrument, *the* African instrument. They are the ancestors of Rebeca González who rise from within the deepest part of her, from her blood, who come forth to tell her, *'I am here' with all your African heritage*.

C B: It's said that every first novel is strongly autobiographical. Is this the case with yours?

L A C: No; absolutely not. Because, as I tell the few people who have asked me this question, I have never had relations with a priest. No, very simply because, well, because you go along absorbing the problems, the realities of a whole people, and all this in its turn changes and is transformed. It brings us closer to a reality in order to give it a little bit of fantasy afterwards, without any autobiography at all; perhaps because it is written in the first person, but that's no reason to think it is my autobiography.

C B: How long were you carrying this novel around with you?

L A C: Well, I was planning how to work out the characters for about eight months. They were waking me up at night, tip-toeing around, they would come into my head, and I felt the necessity to write the novel because they were disturbing me too much; they were always present; I would have conversations with them. So I really felt the urgency of writing this book. At first I planned, with pencil and paper, how the novel should begin, how many chapters it would have; what the ending should be like. I sat down to write it like that when my inspiration just dried up. All that would be about a month. This is the result. I began to read it, to classify it, to see what would be usable, positive; I made a clean copy, and the characters were more or less set. I rested about two weeks, and then I kept on reading; and now, I got back into my characters, returned to my creative process. I worked on it another two months or so; then I reread it, threw a lot of it into the waste basket, until little by litttle, what was worth keeping in it floated to the surface, and the rest, well, it disappeared ...

C B: Let's keep on talking about your characters. Does the same thing happen with them as it did with your characters as you just said, did they go looking for you?

L A C: First I create a world and I install the characters in my mind; they are guests for a long time. I give them their unusual qualities; I make them take care

of themselves; they fight; they kill each other. Some of them curse me for their role; I end up accepting their challenge. In this creative process, I become a sieve for details; I search out the big mouth, the almond-shaped eyes, a gesture, a style of dress. I cause the elements of the personality of the characters to take shape. In this way, I go along creating, shaping a world, and afterwards, these characters have taken me by the hand to wherever they wanted me to be. They already had their autonomy.

C B: Tell us about the protagonist of your novel, Rebeca González. Is she black or mixed, mulatto? Is speaking about identity in these terms as problematic in Ecuador as it is in the rest of Latin America?

L A C: Yes, it is, Carol. In Ecuador people who are mixed, who are mulattos, and who have money, think that they are white. In the case of Rebeca González, she is mixed with strong, obvious black features. I'll tell you that it is difficult in Ecuador to categorize people by their race, because we have strong complexes. People who are sometimes more black than white, because they have money, think they move into another category. They believe that money makes them 'white.' Right? A Creole, criollo [a person of white European ancestry, but born in the Americas] or mestizo [a person of Indian–white ancestry], would rather be called a 'Son of a bitch' than 'black' or 'Indian.' Now that's something! People don't want to recognize their identity. Even in Esmeraldas where there is a good-sized black population, people no longer want to belong to the black race. Some of them think that because they have gone to university, they have overcome what they think is the problem. There is a lot of imitation of white culture. No one dances to the marimba any more, for example; it's left to be 'just folklore.'

C B: The figure of the black nun, Sor Inés del Rosario, is very interesting. It's the first time I've encountered a figure such as she in my reading. More about her, please.

L A C: The black nun represents the desire for change in the society. The intent to reform the social system, a project for reforming the well-being of the dispossessed classes. She represents solidarity with what is just, with what is fair, and with the desire, also, for change, or to apply in the proper way the principles of Catholicism that, in truth, are sometimes, nearly always based on an injustice, and which hide a social reality. I created the black nun precisely so she would serve as a mirror of how members of religious orders should act. Because in my country the majority of the population is Catholic, but 'Catholic' only when it comes to listening to mass, not when it comes to practicing principles of solidarity with your fellow human beings. This nun is revolutionary; she changes the principles of the Church which have been encysted for centuries in order for a new image of religion to be seen, a religion that reaches out to the people.

C B: In the third part of the novel you write about family intimacies. Would you elaborate on the familial and the generational relations that we find here, in particular those of mother and daughter, also those of father and daughter

which are also very important. Then there is Rebeca's relationship with her grand-mother, who is such an essential person for her; Rebeca always returns to her grandmother.

L A C: Rebeca González symbolizes a woman liberated from influences and complexes about the opposite sex. There is, of course, the impression with which her father left her and which awakened in her a certain sense of equality with men. Rebeca González enjoys love fully; she believes in it, and feels love to be a vital part of her personality. This is the atmosphere in which the rest of the characters develop. She sends a message to young women, a message against the machismo of which we women are victims. This was the message I wanted to project with Rebeca González's character, in order to see if it would effect any modifcation in men's behavior.

C B: Now, what about her grandmother?

L A C: Yes, of course. It was she who with her memories touched Rebeca, made her come back to reality from that invented world in which she was living, a world all on the terms of white folks, and made her accept her identity.

C B: In your novel you have set forth and handled relationships between the female characters very perspicaciously. Now, since you write how you feel, you as racially mixed woman, a black woman from Esmeraldas. What about these matters that deal with race and with women which are points of departure for the perspective that we find in the novel?

L A C: You'll see. In Ecuador racism exists in a very camouflaged way. It's a ghost that it is impossible to attack front on, because everyone says that there isn't any. Also we live under a very macho society. Being a woman, and being black, you feel the problems in a deeper way. Even though one might try to overcome them, they are present on a daily basis, in one form or another, in the streets, on the buses, in the supermarkets. You feel them like a sign that you carry. Then when you start writing, these problems that are right there on the surface just flow out. I tried to depict a character who was a victim of these problems we experience daily. I refused to make a poster sign of the rights that we have as women. My novel has its roots in social injustice, and the reader sees the different movements of the novel projected through this problematic; the protest and demand of the black women of Esmeraldas are implicit.

C B: Argentina, do you perceive any differences in the representation of events, themes, images, characters depending on whether their creator is male or female? Would you say that the discourse of your novel has a decidedly 'feminine' tone? If so, what makes it this way? And could you tell us about discussions going on in Ecuador about feminism and feminist literature? How would you describe your novel? Do you see it fitting in in these discussions, and if so, where? Where do the critics place it?

L A C: A female writer can handle the characterization of a male character very well. She can also create a female character as skillfully as a male writer.

For me, it depends on the talent and the soul of the person writing. A work is 'good' or 'bad' without taking into account the gender of the author. Now, about your second set of questions. There are a number of groups in Ecuador fighting to change the civil and penal codes. Since it has been the groups from which the oppression of women comes that have run the economy of the country and control the means of communication, these groups elect themselves as representatives to the National Congress, the place where laws are made and passed. As a result the laws have a very macho character to them and they go against the lower classes. Feminist groups are battling to change these laws. They've had some success; it's an arduous battle, the road is long, but we keep on with this fight. Most of the society believes that Nature intended women to do domestic work and nothing else. It imposes obedience, modesty, and a reclusive home-life on her, since the men are accustomed to arriving home and finding the meal prepared and their clothing laid out. The idea of woman as Mother, Wife, Daughter, still persists.

The critics place my novel as the work that initiates literary eroticism in Ecuador. The problems of feminism on which I focus are a veiled denunciation of the violence against women. Without going too far afield, I have attempted to convert the facts into literature. When I denounce the social system, I have also tried to have the characters with their psychological strength propose certain changes in male behavior, without falling into questionable moralistic concepts, and without constituting itself as a proclamation of women's rights.

C B: Are you working on another novel? Have you others planned?

L A C: Yes, of course. I've had running around in my head a historical theme, about an African woman who was sold in one part of El Chota, a region in Ecuador where a lot of African slaves ended up. When she was eight years old this little girl was bought by a man named Simon Saenz, the father of Manuela Saenz. Manuela Saenz was the lover of Simon Bolivar, the Liberator. This African woman, named Jonatas, influenced the development of her young mistress's revolutionary character. She sowed in her the first seeds of liberty. White and mulatto historians, even though they know that Jonatas accompanied her mistress during the most difficult times, hardly, if ever, mention her. They only have her figure as Manuela's slave, but, in the decisive days, when she helped the Liberator to survive, they shunt her off to the margins. My task in this novel is to put in relief the importance that this African woman had, this African woman named Jonatas – last name: lost to History.

C B: Here's hoping this novel appears soon; it'll be a welcome addition. Meanwhile, for readers who are unfamiliar with your work, could you tell us something about the range of themes you take on in *Under the Skin of the Drums*? What's the role of the search theme in it?

L A C: Rebeca González gives free rein to her libido, which, for her, means freedom, freedom to look at life from another perspective, in order to neutralize

the interior labyrinth that emotionally moves her. Let me just say that it's a coming to conscience about negritude, a mainstay of her personality.

C B: Quests, time, memory; what are their roles in this novel? When I read it I was struck by their presence; it seemed to me that Rebeca was looking for something and that memory was essential in regaining that which was lost.

L A C: Time is a very important element in my novel. It forms concentric circles in order to avoid the monotony of linear time. Memory is fundamental because while Rebeca is in the capital of the Republic, in the convent school, any word she hears that she has heard at home on the ranch makes the memory of it leap out at her. She mentally removes herself to that rural life. Her country origins are with her at all times, right on the surface. She compares her town and its trees with the dank, heavy air of the boarding school; she feels its heaviness; she experiences the cold, the damp, the flat tastelessness of the atmosphere around there, since she's comparing it with the cool air perfumed with plant and flower scents of her country life.

At the beginning Rebeca swims between two waters because she wants to gain access to and rise up in the white folks' system, in which you acquire points and become more important if you're white. At first she tries to deny that she is black. But the love and affection of her grandmother and the memory of her African heritage constitute a very strong influence in the life of the protagonist. Then the moment comes for her to decide; she decides and is true to her grandmother, to her roots. And the roots that before were very painful and problematic to her, now no longer cause her anguish; she calls them forth with pride; she abandons her complexes; she defines herself truly. She sees that her parents are good people and that she has no reason to hide her blackness, her heritage, it is something of which to be proud, this African heritage she has received.

C B: Was it the return home that provoked this reaction in her?

L A C: Furthermore, at the beginning of her return visit home in the company of several school-mates, Rebeca felt ashamed of her town which was very poor, and had no drinking water and no electric lights. But she also saw that she had found wonders in her town, that barefoot children played on the beach, that you could breathe fresh clean air, that there were many trees, that people lived in close contact with Nature, and the rivers had many fish. Her town was a gemstone, a diamond, and she had no reason to be ashamed of her people. This was a coming to terms with her birthplace.

C B: Can you comment on how you incorporate questions of race, color and class in your work? It seems to me that you do it very subtly and in a way unlike that which a male writer would choose to do.

L A C: I come back to this question you've asked me in a number of ways. The economic situation of blacks in Ecuador is a difficult one. They are poor and sometimes have no work. I'm going to tell you about a very blatant example so you can see how racism works in Ecuador. In the north of our province of

Esmeraldas there is a place called San Lorenzo which has a very large black population. But, what happens? The President appoints all officials who are either white or mulatto. There is a bank, the Bank of Credit, that gives loans to farmers. When the blacks go to apply for loans they are turned down; when whites go, they get the loans. Or, if the blacks are not turned down outright, they have to go through a series of obstacles that have been put in their path, forms to be filled out, so very complicated that people give up. These obstacles are to discourage the blacks and make them go away so that the money will be there for those people who are in favor. There is also a branch of the Institute of Agrarian Reform that before it will lend money requests a title to the property. But these [black] people don't have any titles because for centuries they have been the owners of those properties; they have passed them down from father to son over the generations. Since they have no titles, the law takes their lands away and gives them to the white folks. This is going on today.

There are logging companies, and the black peasant can't get his products out to sell them because the transportation – the buses, trucks – only carry the goods of whites or mestizos. All this discrimination is taken up in my novel. When Rebeca goes to ask the railroad employee for space for her animals so she can take and sell them elsewhere, she thinks that perhaps because she's got some education and asks him politely, she'll get it. But not so; the man tries to take advantage of her before he will give her the space.

I want to tell you, Carol, that the racist elements in my novel do not appear front on. I refused to do it that way; instead they become more apparent as you read. Sometimes I play with symbols, for example, the drum. I didn't want to copy; I avoided the influence of the other authors who have written *negrista* literature. I sought out other means in order to avoid similarities or imitation. My intent was to pose a coming to terms with her awareness of these African roots, but the elements with which I play are not direct; they are more subtle and gradual.

C B: Are there other authors, women of color, whether of African descent or elsewhere in North or Latin America and the Caribbean, with whom you are in contact, or simply other friends who are writers? What is the importance of these relationships for you as an artist?

L A C: Let's see. Ecuador is, as we say, in quotes, 'an island of peace,' because you should see the underlying violence that there is in my country, the racism. There is a decided lack of communication; it's very difficult to maintain a literary friendship with people, whether male or female. None the less, I do have important friendships with Dr Henry Richards, with Ian Smart, Stanly Cyrus, Manuel Zapata [Olivella], Nelson Estupiñán; and in Ecuador, I am friendly with Adalberto Ortiz, Antonio Preciado, and with the poet Gladys Ballesteros. I belong to several literary workshops. Do you have them here in the States? Open varied spaces accessible to whomever is interested in creating literature. Every

Friday we get together […] everyone's spirit is open to the most varied anxieties. My intent as a writer is to express my own anxieties and those of society. Unfortunately, I have not read the works of any of the African American women writers about whom you asked me [Toni Morrison, Sonia Sanchez, Gloria Naylor, Paule Marshall, Terry MacMillan, Alice Walker, et al.] with the exception of Angela Davis. The others I would have to read in Spanish, and translations are very difficult to come by. In part, it's a problem of distribution; also, books in my country are extremely expensive. It's too bad because I would like to be able to have such an exchange; we are Sisters and write of common causes and struggles.

C B: Talking about your novel, but also about poetry, do you think that a new poetic image of women has been created?

L A C: Yes, indeed; naturally. Precisely on account of the battles we women are winning. In spite of the fact that the percentage of women attending university [in Ecuador] is low, barely 20 per cent, women are aware of their progress. Women work a lot as teachers, and in the intermediate professions such as secretary, bank employees, nurses. Women recognize these changes and this affects their way of seeing life. […]

C B: Are there other authors currently writing who are concerned with the themes of black life and culture, or with the position of the black woman in Ecuador?

L A C: The problem of negritude is only taken up by Adalberto Ortiz, Nelson [Estupiñán Bass], and now, myself. It seems that the economic situation of Latin America attracts the attention of writers. For example, the Cuban Revolution was a turning point for Ecuadorian writers. Another instance was Pinochet's coup in Chile. For many years that event affected the path of many writers' work. There are writers who think that the racial problem is of no imporance, that it's all over with, that with having gone to the university and obtained a big job in government they have overcome the race problem. They have forgotten the African roots in a […] negation of their identity.

C B: How do you know when you have reached the end of a poem, or a novel, and how do you feel when you complete a project?

L A C: Well, I know when I've arrived at the end because from the moment I conceive a work I'm working out how it will end, how to finish it off. Even though I'll tell you that with this novel I couldn't find the right way. I'd be walking in the streets, going about my business, trying to figure out how to end, how to end, how to end my novel, an ending that wouldn't be ordinary, that would fit perfectly, that wouldn't be moralistic; that would end like an ebbtide, gently into the sea. I sketched out many versions of the ending and I wasn't satisfied. At a reception I was chatting with several friends; I was listening intently, because I always had this problem of the ending hanging over my head, lurking around corners of the words, and right in the middle of this conversation with

these two friends, I said to myself, 'Aha! That's how I'm going to finish it off!' The man was smoking and smoking; he was really spewing out smoke; meanwhile I was all ears. And I think that I am satisfied with this ending. I feel a great upheaval when I finish something like my novel. A mixture of jubilation and nostalgia because I am abandoning those characters who have accompanied me for such a long while, who have made me laugh, suffer, and, sometimes, made me so angry that I've pulled my hair. I look at them as my children; now they are capable of going out into the world because they can stand on their own two feet and take care of themselves. This way when it comes time for the comments and the criticisms, all that doesn't affect them and it doesn't affect me. They are vigorous enough to protect themselves. And if they don't, 'I'm sorry.'

'Affirming the Right to be Revolutionary.' Assata: An Interview

Rosemari Mealy

When the great black abolitionist and ex-slave Frederick Douglass called on blacks to volunteer and fight in the Union Army, his rationale was more than a lament. 'Better to die free than to die a slave,' he said, prompting the consciousness of thousands of blacks to shoulder the rifles of the Union Army.

Assata Shakur, author of *Assata: An Autobiography* (Lawrence Hill, 1987) was a committed participant in the 1970s black liberation movement. Under J. Edgar Hoover's counter intelligence program (COINTELPRO), whose aim was to destroy the movement by criminalizing activist-organizers, Shakur was charged with crimes she did not commit and hunted like an animal. This strategy was seen as an attempt to use her as an example to those who dared to challenge racism and to fight against the oppression as experienced by blacks in the USA.

On 2 May 1973, Assata and several companions were stopped by state troopers along the New Jersey turnpike. The horrifying event left one black man, Zayd Shakur (no relation), and a trooper dead. Three bullets were pumped into Assata Shakur by one of the troopers. She was savagely dragged through ditches on the side of the road and then left to die. Despite this, Sister Assata survives to this day (with one of those bullets lodged in her chest). While it was clear Assata could not have pulled the trigger, she was convicted of felonious homicide and sentenced to life imprisonment. The jury's decision was based on the sole

testimony of one James Harper, the other trooper present the day of the incident, rumored to have fled in panic when bullets began to fly.

But the story would not end here, as her autobiography reads: the prison ordeal ringed of unmatched terror. Her captors were just marking time before they would relish the joy of her assassination.

On 2 November 1979, from a dungeon cell at the Clinton Maximum Security Prison in New Jersey, Assata was freed. The black Liberation Army took responsibility for the dramatic raid.

Thirteen years later, from exile in Havana, Cuba, and, like Douglass, a 'so-called fugitive,' Assata continues to affirm the right to be a black revolutionary in the United States, while calling on each of us to join the black liberation movement in whatever capacity so long as it serves to elevate people of African descent from the slavery of the twentieth century. Moreover, she reminds us that it is our historical task to carry on the tradition of those who sacrificed their lives and gave courage to a people whose bondage from chattel slavery came about through struggle and not from the proclamations of their enslavers.

Rosemari Mealy (R M): Please reflect on your thirteen years of being free and could you specifically address a message to our movement and to the youth.

Assata Shakur (A S): It's been a very long 13 years just learning how to live and recovering from the realities of prison and the viciousness and repression that our brothers and sister are living with. I have been able to experience what it is like to live in a socialist country and a Third World underdeveloped country. You get to see how people are forced to live under imperialism and how people are exploited and oppressed. People were able to change that here in Cuba. That is important for me to see and live because the changes that are happening here everyday are not the result of magic. They are the result of the organization, the struggle, the dedication of a people to take power over their lives and be free. It's a big contrast to what I would be doing, thinking, and feeling if I were living in the States. Cuba is a different kind of place. There is no level of great luxury. You have what you need basically but it's not a materialistic, consumer-oriented society. What you enjoy is the peace and to let your mind roam, a freedom to trust people. That's one thing that is very hard to do in the States. Life and its contrasts there are vicious. People are forced to survive under so much pressure. They have to go to work and they can't be one second late or they will lose their jobs. They must hurry and pay their rent or they might be evicted. People are dealing with that and suffering from that. To those of us who are not there [the USA] any more it just seems to be worsening. The prices go up and the quality of the people's lives go down. The education system is turning out a whole generation of drop-outs. There is this contrast and pain that I see from here and that makes me angry. We are dealing with a society that is hostile toward black people, Puerto Rican people, toward Chicano people, Haitian,

Native American. The government is not covertly hostile as it used to be but overtly hostile.

We have no other choice but to struggle and to elevate our struggle; these 13 years our struggle has undergone a development, it has grown. There is a great deal of unity among black people. Even when Jessie Jackson ran for president in 1988, 95 per cent of black people voted for him, not based on thinking he was going to win. America is a racist country and I think a majority of people who voted for him knew that it was a racist country and knew he had very little possibility of becoming president, but they voted for him nevertheless because he represented something other than the double negative of the Democratic or Republican parties. He represented someone who was concerned about the issues that affected black, poor, or oppressed people; that he was pushing forward a program that would have talked about a solution to the problem and tried to alleviate the pain that is going on right now in the United States. That showed a maturity in our movement and among our people. People are seeing the need for unity; to use any vehicle available to struggle for political power. I think our struggle has grown also because we do not see ourselves isolated as we used to see ourselves. In the 1960s we saw ourselves as the civil rights struggle and we did not really have a worldwide picture of ourselves; how we relate to a whole community. There is a whole world of oppressed people who are often affected by the same government system that is oppressing us. And it is to our benefit to understand that a victory for liberty that occurs anywhere around the world is a victory for us. In the long run it will help our struggle.

R M: Could you give us an example of some of the situations or movement or issues on an international level?

A S: The struggle of our sisters and brothers in South Africa has been important. The situation in South Africa and South Carolina are connected. The same huge corporations that continue to participate in the system of apartheid in South Africa also maintain racial genocide as it relates to the black community in the United States. We also must do more to demand an end to the Zionist slaughter of our Palestinian brothers and sisters.

International racism is on the rise. I think that one of the most concrete connections or situations that clearly exposed how the racism of the Reagan era was exported occurred with the invasion of Grenada. Here was a situation where the United States attacked a tiny country that represented no threat to the United States government, simply because the US was against the Grenadian people determining their own destiny, working together to solve their problems of unemployment, and to a large extent to improve medical services. In a short time Grenada accomplished so much. The only reason the United States attacked Grenada was not to protect the people but to destroy their revolution. The basis of it was imperialism and racism – as if to say: 'What do you niggers want? How dare you even attempt to take control of your lives. We control you. Your island

exist to serve our tourists, to make our holidays sun-filled. Your existence as a people who need education, health-care, jobs – that is unimportant to us. What is important to us is that you fall under our control. You carry out our will. You are there for us to suck your blood.' What was happening in Grenada under the leadership of Maurice Bishop was a demonstration that black people in this hemisphere were capable of getting together and changing their lives. That movement was, to many of us, an important lesson in what the US government's attitude is regarding black self-determination, about liberty, freedom … And then, we saw a continuation of that with the Bush administration's callous implementation of a foreign policy which brought us the invasion of Panama; the bombing of Iraq while witnessing the United Nations become a rubber-stamp for implementing the 'New World Order.'

R M: What are some of your pressing concerns or issues that you would like to see the movement address or unite around?

A S: We must concentrate our effort and work with our youth because our youth represents our future. I think that in terms of the struggle against drugs in the black community we've really got to struggle against drugs on all levels. We have to struggle especially against the kind of mentality that leads to drug abuse. We have to struggle against the day-to-day escapism that they are always pushing on us as people. *We have to educate our youth to see that we are not on this planet to escape.*

We are an oppressed people and they are oppressed children. They are people who are not inheriting a freedom but who are inheriting a state of oppression. And as an oppressed people we must incorporate the struggle into our lifestyle. We must understand that the only thing that will keep our families together, that will keep our minds together, that will keep our bodies together is struggling, dealing with our reality. That there is no way humanly possible to escape from this reality. There is no way humanly possible that we can avoid the struggle. The point is to struggle together and to struggle not for individual crumbs, trifles, and trinkets, but to struggle as a people for our liberation. We need to instill that concept among our youth.

We have got to take the responsibility for educating our children politically. We have got to take the responsibility for educating our children in not that they can wear this sneaker or put on these clothes but that they are strong people, capable people, that they are serious people, and that they are dedicated people. These are values that we have to teach our children. We cannot let them be brainwashed by television. We cannot let them fall victim to the commercialization of their lives. We cannot let them have values that are so distorted that they are consumer slaves who will buy anything. Not only buy anything, but the brand. They will kill each other for sneakers. They can't just wear this sneaker but a brand that the average parent cannot afford. And since we cannot afford them, where are they going to get them from? They are forced into a situation

by consumerism where they feel they have to steal to get some brand that some large corporation has convinced them they have to buy. That is an important issue that we have to address.

Another issue that we have to address is that our struggle is a world struggle. As a people we live on this planet and we are part of a worldwide body of people who are struggling for liberation. I think that as a people we have to support oppressed peoples and their struggles worldwide. We have to fight against the contras whether in Nicaragua or in Angola.

We have to support our people and denounce the United States' intervention and imperialism wherever we find it. As the United States increases its hostility towards Cuba, we must denounce the recent Cuban Democracy Act, which is a virtual declaration of war against Cuba, by imposing penalties and restrictions on her trading partners. The US government is attempting to starve the Cuban people, and basically deny an entire nation the right to its own sovereignty and self-determination.

Another thing that is extremely important is for us to unite, within ourselves and outside of ourselves, to push for unity. The need for us to carry within ourselves the seed of unity so that it can grow and reach out to others.

Finally, I would like to talk a little about the significance of my liberation. My liberation is not a result of one person or one action but the result of a whole movement of people for liberation – internationally as well. I am here today in Cuba free not because we begged for freedom, not because of any appeal to any court, not because of any pleading, not because of any begging but because of the concerted, organized effort of a people to be free. No one is going to give us our freedom. Any freedom given is not freedom. We have to internalize in our lives that *we* are the ones that will free us and in order to do that we need unity, we need to study, we need to prepare, and we need to believe that we can win our liberation.

Part II

Critical Responses

Orishas Circling Her House: Race as (Con)Text in Morejón's Poetic Discourse

Miriam DeCosta Willis

Cuban poet Nancy Morejón wrote in the prologue to her 1974 collection of critical essays on Nicolás Guillén:

No pocos críticos han querido encasillar la obra de Guillén ... en los límites de la denominación de poesía negra ... No entendieron jamás que se trataba de la aparición de una poesía que hablaba al negro y del negro para hallar su justo papel en la cultura nacional y para definir su aporte a ella. No es el negro como elemento aislante sino como elemento integrante.

(Many critics have wanted to pigeonhole the work of Guillén ... within the confines of what is called Black poetry. They never understood that it dealt with the emergence of a poetry that spoke to the Black and about the Black in order to determine his proper place in the national culture and to define his relationship to it. The Black is not an isolating element, but an integrating element.)[1]

In her carefully worded caveat, Morejón underscores one of the underlying tensions in contemporary criticism: the distances between the ideological intention of the writer, the extra-literary meaning of the text, and the informed interpretation of the literary critic. The problem of interpretation raises an ethical question: whether scholars, in their attempt to understand a work through the medium of a controlling idea, code, structure, or critical theory, are justified in imposing a subjective and intuitive reading on a text, particularly when such a reading is clearly at variance with the implied or stated intention of the poet. Some mis-readings are honest errors. As readers, trained and professional though we may be, we bring to a work of literature our own lived experiences, so that when we read the works of writers from countries and cultures other than our own, it is difficult not to read into those texts meanings related to our personal experiences and political ideologies, particularly when those experiences touch on our subjective perceptions about emotionally charged constructs such as race and gender. In this regard, Henry L. Gates, Jr recommends the defamiliarization of the black text (that is, distancing it, stepping away from it, making it strange), so that the critic can 'see the text as a structure of literature and not as a one-to-one reflection of [his/her] life.'[2]

Other mis-readings are an act of hubris. Many post-structuralists assert that the literary theorist not only has the right to disregard the intentions of the author, but also to create a critical text that competes with the literary work being analyzed. At least one perceptive observer has called this 'privileging' of the critical text

a 'kind of guided rape.'[3] Such a view is prevalent in widely diverse camps. Deconstructionist G. Douglas Atkins writes, for example, that 'theory may actually *become* literature, self-consciously displaying its fictive nature and exploiting an impressive arsenal of stylistic devices,'[4] while feminist critic Dorin Schumacher says: 'Literary criticism is also an artistic process in the sense that through it, the critic actually *creates the meaning* of a text' (emphasis added).[5] The idea that a text should be read completely in isolation without any consideration of authorial intent, historical context, or intertextual relationships severely limits the critical perspectives that can be brought to bear on interpretation. Such a limitation is particularly ironic at a time when there is such a proliferation of literary theories.

In the case of Nancy Morejón, the task of the critic is facilitated by the fact that she is not only a poet, but also a literary critic who has written extensively on the work of others. Her critical essays are particularly important for what they reveal, indirectly, about the poet: her poetics, her ideology, and her hermeneutics. She brings to poetry a thorough knowledge of Cuban, Caribbean, and European literature and literary criticism, for she studied languages and literature at the University of Havana. She believes that Cuban literature cannot be analyzed with theories formed to explicate foreign works. She implies that literary theories are text-specific when she states that '*no es posible aceptar mecánicamente para* nuestra *literatura categorías que se forjaran en relación con literaturas metropolitanas*' ('it is not possible to apply mechanically to *our* literature categories that were shaped in relation to metropolitan literatures'), and she is particularly averse to theories which isolate the text, pointing out that, '*Un error ... de la crítica y la investigación literarias es el de tratar de aislar al texto de su contorno sociohistórico.*' ('One mistake ... of literary criticism and research is that of attempting to isolate the text from its sociohistoric milieu.')[6] She maintains that there is a contextual relationship between the Word and the World, given that language is shaped by sociohistoric forces. Furthermore, she believes that literature has an ethos, an ethical value, a humanistic function, that transcends its cultural significance.

It seems to me that a reader who attempts to explicate the poetry of Morejón must approach the work within the context of Cuban history and culture in order to understand the poetic world of the writer. In that respect, a concept like race, with its various permutations – personal, social, and historical – permits the reader to discover extended meanings for that idea in the words of the text.

The Aesthetic of Restraint

> menuda en el espíritu
> voraz morena
> eres cañón carbón descuartizado carne
> hulla lastimosa de la noche
> '*Presente Brígida Noyola*'

Race is a constant and significant theme in Nancy Morejón's work; it outlines the contours of self and highlights the figurations of her two worlds: the interior and the exterior. In early poems such as 'Presente Brígida Noyola,' 'La cena,' 'Aliento para los desvelados,' and 'Adonde iremos, viaje,' she describes an inner space – what J. Michael Dash calls 'the confined world of the "jardín"'[7] – closed, intimate, hermetic, haunted by childhood memories and peopled by familiars. In 'La cena,' for example, the first-person narrator, the unidentified and impersonal '*yo*,' stands at the periphery of a closed circle observing the action – the arrival of, first, the uncle and, then, the father – before entering the family group. Distracted and pensive, she tries desperately to reach her mother:

> *yo entro de nuevo a la familia ...*
> *sigo sin mirar fijamente ...*
> *distraída*
> *pidiendo con urgencia los ojos de mi madre*
> (I enter again into the family ...
> I go looking about aimlessly ...
> distracted
> urgently seeking out my mother's eyes)

Hers is a family of typical, working-class blacks, whom she celebrates in a series of poems, including 'Presente Brígida Noyola,' 'Presente Angela Domínguez,' 'La cena,' 'El café,' 'Madre,' and 'Richard trajo su flauta.'[8] Her maternal grandmother, Angela Domínguez, now dead, is evoked through dreams, fantasies, and images of troubadours and bamboo ships, while her paternal grandmother, Brígida Noyola, is described very realistically as a feisty *morena* with nouns like quartz, coal, cinder, suggesting the color of her skin and the strength of her character. In 'La cena,' the men of the family wear plain shirts and hats, while their dark arms and calloused hands characterize them as ordinary, hard-working laborers.

The people represented in these poems are a part of the poet's subjective reality – of her personal history – but they are also objective correlatives of the Cuban underclass before the Revolution. The political subtext is apparent in the lines:

> *me detengo ante la gran puerta*
> *y pienso*
> *en la guerra que podría estallar súbitamente*
> (I stop before the big door
> and think
> of the war that could break out suddenly)

and in the following ominous premonitions:

nadie podrá con todo esto ...
permanecemos en silencio
reconocemos que un intrépido astro desprende
(no one can handle all this ...
we remain silent
realizing that an intrepid star is falling)

The subtext is also evident in the ironic juxtaposition of contradictory feelings: '*todos temblorosos y amables*' ('all tremulous and loving') and '*ese mirar atento y triste de mi madre*' ('that attentive and sad look of my mother').

Through irony, paradox, and detachment, the poet successfully mediates the space between the subjective 'I' and the collective 'We,' between personal memory and historical past, between the ordered garden of the psyche and the disordered wilderness of the external world. Morejón makes clear the importance of this dialectical movement when she writes: '*el yo poético no es un yo sino un nosotros, cultural o épico – un monólogo plural casi*' ('the poetic I is not an I but a we, cultural or epic – almost a plural monologue') (*Recopilación*, p. 14). Here, she discusses Guillén's poetry, but her words apply equally to her own work, because many of her poems are also narrated in the first person. This point of view gives her work an intimate and dream-like quality as these lines from various poems indicate:

yo te diría que la noche tiene un encanto medieval
(I should tell you that the night has a medieval magic)

que voy de nuevo entre las calles, entre orishas,
(for I wander again between streets, among orishas)

Vuelvo al mar, vuelvo al mar, despedazándome
(Returning to the sea, returning to the sea, I break into pieces)

The narrator moves into a closed inner space where she reflects lyrically on the question of race, gender, class, and nationality in order to expand her consciousness outward. This narrative circle, this spiraling movement within in order to expand outward in what might be called a poetics of interiority, is evident in many other poems such as 'Mujer negra' and 'Amo a mi amo,' which will be examined later. Julio Rodríguez-Luis points out the importance of this process in poetry: 'because poetry reproduces the synthesis of a historically determined cultural reality through an interiorization process that transforms it into a linguistic experience, it has been ahead of the novel and the theater ... in expressing national identity and political awareness.'[9]

This process finds expression in what can be called Morejón's *aesthetic of restraint*: her subjective reticence, her distanced and inarticulate personas, her imprecise and surrealistic landscapes. This restraint is particularly apparent in her treatment of race. A black woman, she seldom portrays herself directly in her verse, although on occasion the poet/persona refers to her racial identity with

descriptive tags such as '*mis manos arrobadas y negras*' ('my enraptured black hands') in 'El poema ridículo,' and she uses figures of speech from Afro-Cuban culture: metaphors and similes such as '*esclava de las aguas*' ('slave of the waters') and '*como un fetiche*' ('like a fetish') in 'El parque Villalón.' She offers this self-portrait in 'Aliento para los desvelados':

> *piel negra, ojos y pestañas que crecen irremedablemente,*
> *torso indomable, cabeza en nubes, risa o sonrisa, lengua de víbora*
> *güije en silencio, temblor en manos, pies andando La Habana*
> *risa y sonrisa, amor a la sagrada historia (Richard* p. 48)

(black skin, eyes and eyelashes that grow incessantly,
indomitable torso, head in the clouds, a laugh or a smile, viper's tongue,
silent *güije*, trembling hands, feet pacing Havana,
a laugh and a smile, love for the sacred history)

How different is Morejón's modest and unassuming self-study from Nicolás Guillén's passionate and exuberant portrait of his friend and protégé, in the prose piece 'Nancy.' He writes:

> *Yo amo su sonrisa, su carne oscura, su cabeza africana ... Me gusta verla, oírla (un susurro es lo que percibimos cuando habla). Soy su partidario, voto por ella, la elijo y proclamo. Grito, desaforado: '¡Viva Nancy!'*
> (I love her smile, her dark skin, her African head ... I like to see her, to hear her [a whisper is what we hear when she speaks]. I am her supporter, I vote for her, I elect and acclaim her. Outrageously, I shout: 'Long live Nancy!')[10]

The poet is the subject of another poem, 'Amor, ciudad atribuída,' ('Love Attributed City') in which the question '*quien soy*' is rendered as a statement rather than a question. The narrator wanders through an urban landscape of *orishas* and blacks, streets and automobiles, seaports and cathedrals, establishing contact with things and people outside herself: the city and her family.

Morejón is proud of her family and of her African cultural heritage, as the long, narrative poem 'Richard trajo su flauta' ('Richard Brought His Flute') suggests. The reader is drawn into the intimate, mythic world of the poet's childhood, a world marked by the synthesis of African and European cultures, where grandfathers recount tales of the old country and children listen to the music of Count Basie, but where the young also learn solfege and play Mozart's concerto for flute. The 14- or 15-year-old narrator of the poem lives in a modest house in a black neighborhood near the old city, which Kathleen Weaver describes: 'The tall colonial buildings, elegant in their day, are now corroded by time, humidity and salt, blackened by centuries of heat and dust, the narrow winding streets just wide enough for a carriage to pass, whose original pavings show through where the asphalt has worn away.'[11]

The poet/persona notes, parenthetically, that all the neighbors are black, including the laundress who scolds them publicly for being late for their French lesson:

> si nos miraban otros vecinos
> negros como nosostros casualmente
> entonces
> 'no hay por qué preocuparse son así en estos casos'
> (if other neighbors
> black like us by the way
> looked at us then
> 'there's no reason to worry that's how things are in these cases').

Surprisingly, in the poems about her growing-up years, Morejón never treats the racism of the Batista era, as did other writers such as Guillén and Cabrera-Infante. She must have remembered that period of Cuban history because she was 14 years old at the time of the Revolution, but, in her poetry, memories of the past are problematic. In 'Aliento,' for example, the poet writes, *'lo poco que recuerdo de mi infancia/se lo llevan los ruidos de la noche'* ('the little that I remember about my infancy / is carried away by the sounds of the night'). In 'Mujer negra,' ('Black Woman') the black woman asserts, *'La noche, no puedo recordarla'* ('The night, I cannot remember it') (*Parajes*, p. 18). A few lines later, however, she qualifies that assertion with the adverb *acaso*: *'Acaso no he olvidado ni mi costa perdida ni mi lengua ancestral'* ('Perhaps I have not forgotten either my lost coast or my ancestral language'). According to RoseGreen-Williams: 'the use of "*acaso*" has the effect of diminishing the notion of [African] continuity ... [and of minimizing] the inescapable reality of African retentions in language, as well as the African–European syncretism now accepted as the constitutive element of many aspects of Cuban culture'.[12]

The topos of forgetfulness is, apart from its political ramifications, an important element of Morejón's style and of her aesthetics, for such indefiniteness under-scores the transience of historical reality – both the personal history of the individual and the collective past of the ancestors. Indeed, it is her style, what many critics have characterized as her intimate, somnambulistic style, which permits Morejón to mediate successfully the distance between the black self and the larger Cuban society.

Carnation and Conjuration: Jugglers and Masqueraders in Verse

> ... a centrifugal rage within
> churns below the surface and the
> verses come up from the challenge

of the depths, escorted by jugglers
and masqueraders and furiously true
to the context that inspired them.

Miguel Barnet

A first reading of Morejón's poetry suggests that allusions to African divinities function in her writing like exotic *leit motifs*, as decorative appendages to a more serious text. References to Yoruba deities such as Eleggua, Olofi, Oshún, Changó, Yemayá, Olokún, and Ochún are scattered through her poems, and seem to be a part of the surrealistic *mise en scène*. Such reification of the gods would place her poetry in Brathwaite's category of rhetorical literature, which treats the theme of Africa in a static, unreal, and arbitrary manner even when it offers a positive recognition of African roots and acceptance of a dual cultural inheritance: African and European.[13] This reading, however, is inconsistent with Morejón's statement that exoticism or *paisajismo* – what she calls a 'tendency toward the external,' characterized by 'evocations, full of nostalgia for an aphrodisiacal past' – is common among metropolitan writers who view the Caribbean superficially.[14] In her essay on Caribbean poetry, she opposes the 'eye of the colonizer' (European, North American, Canadian) – or, by inference, his mimetic surrogate – to the authentic 'eye of the Antillian,' whose poetic landscape is rooted in sociopolitical reality.

In a footnote to his essay, Brathwaite explains the metaphysical significance of an African religious ritual, and this meaning offers a way of interpreting Morejón's use of Yoruba mythological archetypes. He writes that the congregation becomes:

an active community which celebrates in song and dance the *carnation of powers/spirits (orisha/loa) into one or several of themselves*. This is therefore a social (interpersonal and communal), *artistic (formal/improvisatory choreography of movement/sound)* and eschatological (possession) experience, which erodes the conventional definition/description of 'worship.'[15] (emphasis added)

The artistic experience, then, is metaphorically embodied, incarnate as it were, in the transformation of spirit into body, of word into flesh, of *orisha* into poet. Morejón's long poem 'Richard Brought His Flute' makes clear this spiritual origin of art, for in the final section of the poem it is the *orishas* who circle the house where Richard plays his flute, it is the *orishas* who vibrate around the fingers of the flautist. She writes:

> *los orishas nunca se hicieron eco de nuestras voces*
> *sabíamos que rondaban la casa*
> *y que amedentraban como güijes toda la maldición*
> *alquien estaba o residía*
> *soberanamente*

un simple palo o bejuco era su atmósfera
soplar por él con toda la fuerza de un negro enamorado
los orishas oscilaban tranquilos alrededor de los dedos
los dedos de la mano derecha disminuían el ritmo
 lentamente
el esperado trae su flauta
todos pedíamos su presencia alrededor de la mesa caoba
el oro del hogar se derrumbó sobre sus hombros
 misteriosamente
maravilloso estar entre nosotros Richard
 con esa flauta sola (Richard, p. 35)
(the *orishas* never echoed our voices
 we knew that they circled the house
and that like *güijes* they drove away evil
someone was there or lived there
 empowered
a simple stick or reed was his ambient
and he blew through it with all the force of a Black lover
the *orishas* vibrated calmly around his fingers
the fingers of his right hand decreased the rhythm
 slowly
the one we awaited brings his flute
we all seek his presence around the mahogany table
the gold of the hearth thrown across his shoulders
 mysteriously
marvelous for Richard to be among us
with that solitary flute)

The spirits in this poem have two functions. They protect their own, for this is a house of the initiated, the devoted, the practitioners who, on Mondays, light the *'gran vela semanal para Eleggua'* ('large weekly candle for Eleggua') and leave rum by the door as a libation. The spirits also enable Richard – a powerful and mysterious juggler (*jongleur*, poet/singer) – to create a music that transforms the raw emotion of love into art. Embedded in the language of the text are the signs and symbols of an Afro-Cuban landscape: its magic, rituals, totemic animals, and art forms:

> *los relatos de Juan Gualberto en la nación antigua*
> (the stories of Juan Gualberto in the ancient land)
>
> *a Count Basie Duke Ellington y el trio Nat Cole*
> Count Basie, Duke Ellington and the Nat Cole trio
>
> *una serpiente se levanta ahora al caer la noche*
> a serpent rises now at nightfall

la felicidad consistía en todo aquel placer de escuchar
sometidos a la hegemonía de una magia
(happiness consisted in all that pleasure of listening
lost in the spell of a magic)

Morejón consciously shapes an etiology of art based on African rather than classical mythology; in her poetry it is Eleggua and not Orpheus who churns beneath the surface driving the verses up from the void, as Barnet so intuitively terms that 'occult and enigmatic power that provides clarity.'

In Morejón's poetry, Eleggua is the trickster figure, who manifests the 'occult and enigmatic power' of the writer, the power to unify opposites, to resolve paradoxes, to mediate distances. As Henry L. Gates, Jr. points out, the trickster Eshu-Elegbara is a topos in black vernacular traditions throughout the New World:

He is 'master of style and of stylus, the phallic god of generation and fecundity, master of that elusive, mystical barrier that separates the divine world.' He connects 'truth with understanding, the sacred with the profane, text with interpretation, the word (as a form of the verb *to be*) that links a subject with its predicate.' He connects the grammar of divination with its rhetorical structures.[16]

The masquerader, the African trickster god, appears as a seminal figure who assumes different guises, in two other poems of Morejón. In 'Los ojos de eleggua' ('Eleggua's Eyes'), he again embodies the active principle, but this time as a warrior god who represents the unification of two diametrically opposed forces: the one, constructive, symbolized by the white coconut tree; the other, destructive, because he is imagized in the stone. His tongue red with blood, Eleggua bursts into shouts and grazes space with a copper dagger, but he is also a poet because he imagines songs (*'imagina los cantos'*) and knows the song of birds. In this poem, Morejón broaches the possibility of the loss of the mythological African world — its gods, rituals, totems, magic swords — and she expresses this possibility linguistically with the future of probability, *no sabrá* (translated 'he might not know'), and the past subjunctive.

si los ojos de eleggua regresaran
volverían a atravesar el río pujante
donde los dioses se alejaban donde existían los peces (*Richard*, p. 15)
(if the eyes of Eleggua should look back
they would again sweep over the powerful river
where the gods distanced themselves where the fish used to live

Significantly, she uses the imperfect *se alejaban*, a descriptive tense which also expresses continual action in the past, to suggest a gradual moving away of the gods. Thus, the language of the text, specifically the verb tenses, creates a surreal

landscape where the line between the past and the future, between reality and fantasy, is deliberately blurred.

In a love poem, 'Cuento la despedida' ('Saying Goodbye'), Eleggua embodies yet another life-force – the phallic – which at once separates and joins the lovers. Gates points out that he is often 'characterized as an inveterate copulator possessed by his enormous penis,' for he is 'the ultimate copula, connecting truth with understanding.'[17] Morejón depicts him as a paradoxical figure: a traveler from afar who knows the streets of Havana; he is a religious icon to be placed by the door, and a trickster who gives the lovers a hard time. A powerful conjurer, he curses the lovers for their deceit, declaring, *'traigo todo el augurio y el poder'* ('I bring all divination and power'). Eleggua is a mystical creature, an oneiric figure, who oscillates, like love, between being and not being, between seeing and not seeing, between reality and illusion. The woman, who still loves, laments:

> *pero tú y yo nos miramos ahora*
> *y vemos claramente*
> *el no estar vemos tan sólo a eleggua* (*Richard*, p. 67)
> (but you and I look at each other now
> and we see clearly
> not being we see only Eleggua)

Ontologically, Eleggua is being in the fullest sense of the word – being in love – but, conversely, he is also not being. The woman concludes:

> *ahora presiento que amarnos era cuestión de orishas*
> *no para seres de muerte negra como tú y como yo*
> *te mencionaba a eleggua hace un momento Marcos*
> *para que nos reúna nuevamente*
> *a pesar de que somos entes de carcajada* (*Richard*, p. 69)
> (now I have a premonition that our loving was a question of *orishas*
> not for creatures of black death like you and like me
> I mentioned Eleggua to you a moment ago Marcos
> so that we could come together again
> in spite of the fact that we are creatures of boisterous laughter

The African god, a consummate conjurer, the source of all 'divination and power,' facilitates the 'coming together' of woman and man, of flesh and spirit, of life and death. In Nancy Morejón's poetry, this seminal figure of her African past symbolizes the creative force that infuses all art.

Language and the Historical (Con)Text

> *Del siglo dieciseis data mi pena*
> *y apenas lo sabía*
> *porque aquel ruiseñor*
> *siempre canta en mi pena.*
>
> *'Mirar adentro'*

The four-line poem 'Looking Within' is a meditation on history, which bears the imprint of Morejón's unique style. Written in sparse, naked, unsentimental language without adjectives or other rhetorical flourishes, the poem is taut and terse with meaning that must be intuited. A skillfully crafted lyric, rich with alliterative sound and rhythmic variations (*'data mi pena/apenas/canta en mi pena'*), it is a very cerebral poem with recondite references to slavery. This oblique and indirect treatment of the theme mutes feeling by distancing the reader from the text. Ironically, Morejón uses the nightingale, a symbol of beauty and creativity, in a poem about violence, alluding thereby to the transformative power of art. A gull, discerned in the dark night of the Middle Passage, takes on the same symbolic resonances in 'Mujer negra:' *'La noche, no puedo recordarla ... Pero no olvido al primer alcatraz que divisé'* ('The night, I can't remember it ... But I can't forget the first gull I saw in the distance'). This juxtaposition of bucolic and violent images is evident in much of Morejón's work. In 'Apenas héroe,' for example, fragrant orange trees spill raindrops on a cadaver, and in 'Un manzano de Oakland' an apple tree shelters the heads of the lynched. This combination of positive and negative valances is an intrinsic part of the aesthetic of restraint so characteristic of Morejón's style.

She employs the same restraint in the short poem 'el loto y el café' ('Lotus and Coffee'), which deals with two old slave women who travel through the streets of a city in their mistress's carriage. The poem is steeped in mystery: the city is identified only as *'la misma ciudad'* (the same city), and the women, bearing an oriental lotus and coffee from Santiago, are nameless creatures of the twilight, of *'la noche [que] va a caer.'* The meaning of Morejón's poem surfaces in the lines:

> *Las dos esclavas están*
> *en el vehículo, y sin embargo necesitan el sol,*
> *necesitan el alba. (Richard, p. 41)*
> (The two slaves are
> in the vehicle, and *yet* they need the sun,
> they need the dawn.) (emphasis added)

The *yet*, the *sin embargo*, linguistically separates the past from the future, the dark time of slavery from the bright day of freedom. The slaves, privileged to ride in the carriage of a wealthy mistress, are trapped in a twilight darkness of material well-being, *yet*, they want something different: the sun, symbol of beauty, and

the dawn, sign of a new day. This meaning is confirmed at the end of the poem when the first slave gets out of the carriage because she wants to look at the stars, and the second walks alone until she reaches the oldest square.

Morejón's style – particularly, the detached treatment of themes such as slavery, war, and violence; the distances of the subjects; the juxtaposition of contradictory images; the use of naked, unadorned language; the creation of dream-like and surrealistic landscapes; the topos of forgetfulness; and the use of adverbs like *acaso* and *sin embargo*, which express possibility or contradiction, and of verb tenses that suggest doubt or probability – reveals much about Morejón's concept of the relationship between poetry and history. Poetry, she explains, develops out of a particular (individual and collective) historical context, as the work of Guillén demonstrates. She writes: '*El contexto histórico … ha tenido el sitio idóneo; pero consideramos no haber desatendido ni traicionado el espíritu esencialmente poético – o literario – que determina la creación de Nicolás Guillén.*' (*Nación*, p. 12) (The historical context … has had its proper place, but we have not ignored or betrayed the essentially poetic – or literary – spirit that determines Nicolás Guillén's creation.) In this statement, Morejón suggests that poetry is created within a particular historical context, but that the creative process of the poet is different from that of the historian.

The poet does not *record* history. She *interprets* history, using the images, symbols and structures of poetic language to transform specific historical events, such as the enslavement of Africans by Spaniards or Castro's assault on the Moncada barracks or Guinea-Bissau's war of independence, into universal expressions of man's humanness in all of its myriad forms. Morejón articulates the humanistic intent of her poetry when she writes: '*En nuestro caso, poesía, literatura y crítica deben suministrar al hombre sus más espléndidas y naturales definiciones*' (*Nación*, p. 20.) (In our case, poetry, literature and criticism must provide man with his most splendid and natural definitions). The historian uses expository language, objective and verifiable, to impose order on the chaos of human events, structuring 'facts' into a logical, linear, chronological sequence, and using a diachronic model of cause to effect. The poet, on the other hand, uses figurative language, subjective and verisimilar, to explore the complexity and simultaneity of human events, to understand the historic past, and to re-create the past metaphorically as a process rather than as a *fait accompli*. Language, then, or the medium of expressivity, is the differentiating factor.

Morejón is a creative writer with a deep understanding of Cuban history, as is evident not only in her poetry with its allusions to national figures like Maceo and Plácido, but also in her work of oral history *Lengua de pájaro*.[18] It is significant that she treats racism directly in only two poems, 'Freedom Now' (published in *Richard trajo su flauta*, in 1967) and 'Un manzano de Oakland' (published in *Parajes de una época*, in 1979),[19] both of which deal with racism in the United

States. The first, written at the time of the civil rights struggle in this country, is an ironic comment on the Southern states with their

> *ciudades misteriosas llenas de gente*
> *que lincha negros y pisa cucarachas*
> (mysterious cities full of people
> who lynch blacks and step on cockroaches)

Morejón, like Guillén, suggests that racism is the product of a capitalist society like the United States, where blacks must struggle against their oppressors. She does not treat racism in the Cuban context, even in poems that allude chronologically to the pre-revolutionary period. Morejón must be aware of attacks against the Castro regime by detractors such as Carlos Moore[20] and John Clytus – black nationalists or Cuban expatriates, for the most part – who maintain that racial discrimination still prevails in Cuba, but she also supports government efforts to eliminate institutional racism and sexism. Castro was the first Cuban revolutionary leader to attack racism: in 1959, he outlined a three-part program for eliminating racial discrimination; in 1966, he linked the revolutionary struggle of blacks and women; and, in 1975, he declared Cuba a Latin-African country, noting that '*El que no tiene de congo, tiene de carabalí*' ('He who isn't part Congo is part Carabalí'). Castro indirectly acknowledges what scholars like Gordon K. Lewis and Jorge Ibarra have recently documented: that the roots of Cuban nationalism and revolutionary philosophy of *cubanidad* or Cubanism, lie in the Mambisian ideology of nineteenth-century Afro-Cubans. A century ago, Jose Martí, the architect of Cuban nationalism, called for the full incorporation of blacks into Cuban life, while Antonio Maceo, the black hero of the Wars of Independence, wrote: 'I place the interests of race ... beneath the interests of humanity.'[21] According to Lewis, this nineteenth-century ideology 'lays down the leading imperative of all Cuban nationalist thought ever since, reinforced by the official line of the *fidelista* revolution a century later: that Cuba is to be seen, not as a pluralist society in which the different ethnic groups nurture their own separate cultural sovereignties, but as a unitary society with all owing fealty to the national mainstream culture. Ethnic diversity gives way to national patriotism. The group gives way to the nation'.[22]

Morejón is in accord with *cubanista* (Cuban nationalist) ideology, as her study of Guillén's poetry suggests, for she states in the passage cited earlier that the black is an integrating, not an isolating, element in the national culture. An examination of Morejón's poetry, however, reveals that the Cuban poet has both a strong racial awareness and a well developed feminist consciousness. In her two most sustained treatments of race, the poems 'Mujer negra' and 'Amo a mi amo,' Morejón underscores the racial *and* the feminist dimensions of Cuban nationalism by making the black woman the central figure – the protagonist as it were - of the Revolution. The significance of this choice is both *historical*, for Mariana

Grajales, a black woman, and others played an important role in Cuba's first war of independence, and *political* because she consciously elevates the most oppressed element of Cuban society to a position of significance. According to Elizabeth Stone:

Before the revolution, discrimination against Black women was severe. Segregation existed in public areas and facilities such as hotels and beaches, and Black women had an even harder time than their sisters in getting a job. Black women were excluded from some of the more sought-after occupations such as nursing.[23]

'Mujer negra' and 'Amo a mi amo' are two of the most artistically crafted of Morejón's works: they are lyrics in which language, form, and theme are inextricably blended. In 'I Love my Master,' the ironic play on words (*amo*, 'I love' and *amo*, 'master'); the juxtaposition of lyrical images (blue eyes, gentle as a lamb, softest powders) and acts of violence (bites, subjugates, threw me down); and the use of understatement, irony, and emotional detachment all combine to create a moving and powerful statement about the triple oppression of poor black Cuban women during slavery. The poet re-creates a particular period of Cuban history with allusions to overseers, whip-blows, a sugar-mill, food-plots, and horse-drawn carriages, but this is a poetic world, undefined by time or place. The past is dramatically re-created in the present through the use of verb tense (I love; I live; I serve). The poet does not identify either the woman or her master because the poem is not a historical document; it is a literary text in which the writer interprets history from the point of view of a slave woman. In the final section of the poem, in an ironic reversal of two literary topoi, the *lugar ameno* ('la vereda florida hacia el cañaveral') becomes, in the woman's mind, the locus of murder. Love and death are thus conjoined in a final act of violence.

Morejón is not a facile poet; the profound thoughts and questions which undergird her exquisitely crafted verse are deep and complex, and her views on race reflect this depth and complexity. A woman of African descent, she was brought up in an Afro-Cuban family and community which cherished its ethnic identity, and this ethnicity is reflected in poems about self, family, and her neighbors. But Morejón is first and foremost a Cuban poet, committed to the revolutionary ideals which have transformed Cuban society and elevated the socio-economic status of blacks, women, and workers. It is, therefore, within the context of contemporary Cuban history that her views on race must be interpreted.

Notes

1. Nancy Morejón, *Recopilación de textos sobre Nicolás Guillén* (Havana: Casa de las Américas, 1974), p. 10.
2. Henry Louis Gates, Jr, *Figures in Black: Words, Signs, and the 'Racial' Self* (Oxford: Oxford University Press, 1987), p. xxiv.

3. Alison Lurie, 'A Dictionary for Deconstructors,' *New York Review*, 4 January 1990.
4. G. Douglas Atkins and Laura Morrow, *Contemporary Literary Theory* (Amherst: University of Massachusetts Press, 1989), p. 2.
5. Dorin Schumacher, 'Subjectivity: A Theory of the Critical Process,' in *Feminist Literary Criticism: Explorations in Theory*, 2nd edn (Lexington, KY: University of Kentucky Press, 1989), p. 30.
6. Nancy Morejón, *Nación y mestizaje en Nicolás Guillén* (Havana: Unión de Escritores y Artistas de Cuba, 1982), p. 12–13.
7. J. Michael Dash, 'The World and the Word: French Caribbean Writing,' *Callaloo* 11 (winter 1988), p. 127.
8. 'La cena,' 'Presente Angela Dominguez' and 'Richard trajo su flauta' were published in *Richard trajo su flauta y otros argumentos* (Havana: Instituto del Libro, 1967); 'El café' in *Poemas* (Mexico: Universidad Autónoma de México, 1980); and 'Madre' in *Piedra pulida* (Havana: Letras Cubanas, 1986).
9. Julio Rodríguez-Luis, 'Literary Production in the Hispanic Caribbean,' *Callaloo* 11(winter 1988), p. 144.
10. Nicolás Guillén, *La rueda dentada*, reprinted in Efrain Huerta's introduction to Morejón, *Poemas*, p. 16.
11. Kathleen Weaver (ed.), *Where the Island Sleeps Like a Wing. Selected Poetry by Nancy Morejón* (San Francisco: Black Scholar Press, 1985), p. xiii.
12. Claudette RoseGreen-Williams, 'Re-writing the History of the Afro-Cuban Woman: Nancy Morejón's "Mujer negra,"' *Afro-Hispanic Review* 8 (September 1989), pp. 7–13.
13. Edward Brathwaite, 'The African Presence in Caribbean Literature,' *Daedalus* 2 (1974), p. 82.
14. Nancy Morejón, 'Poesía del Caribe,' *Revolución y cultura* 82 (1979), p. 57.
15. Brathwaite, 'The African Presence,' p. 74.
16. Henry Louis Gates, Jr, *The Signifying Monkey: A Theory of African-American Literary Criticism* (Oxford: Oxford University Press, 1988), p. 6.
17. Gates, *Monkey*, p. 6.
18. Nancy Morejón, *Lengua de pájaro* (Havana: Instituto Cubano del Libro, 1971).
19. Nancy Morejón, *Parajes de una época* (Havana: Editorial Letras Cubanas, 1979).
20. See, for example, Carlos Moore, *Castro, The Blacks and Africa* (Los Angeles: Center for Afro-American Studies, 1989).
21. Jorge Ibarra, *Ideología mambisa* (Havana: Instituto Cubano del Libro, 1972), p. 292.
22. Gordon K. Lewis, *Main Currents of Caribbean Thought* (Baltimore: Johns Hopkins University Press, 1983).
23. Elizabeth Stone (ed.), *Women and the Cuban Revolution* (New York: Pathfinder Press, 1989), p. 23.

Joining Our Differences: The Problems of Lesbian Subjectivity among Women of Color

Gladys M. Jiménez-Muñoz

Lesbians of color want to share the complexities of our multiple identities. It takes a lot of integrity and courage for us to be 'out' – much more than our white lesbians sisters – because not only are we concerned about sex and sexuality, but we are concerned about race and class as well.

Barbara Smith[1]

Everyone asks: Why do we have to talk about homophobia? Why can't we be quiet about it? The fact that we have to talk about it means that a lot of people don't want to hear it. And as soon as there's something they don't want to hear, its very important that we say it. I learned that as a Black person.

Jewelle L. Gomez[2]

I am a woman of color: jabá, Boricua, latina, a 'Third World' Woman, la tercermundista, lo obscuro, lo exótico; the analogue of 'the Oriental' (E. Said), insofar as I am an-other example of that 'imaginative geography' that separates the North from the South and the West from the Rest (of the World); one of the others of the other of the other, hasta el infinito. This is my point of departure.

Latina lesbians figure prominently among Latin American and Caribbean forms of alterity. They are the subject matter of many a cautionary tale within Latino/Latina communities. Being a Latina was bad enough: beware of being confused with a 'cachapera,' 'tortillera,' 'pata,' and so on. It was against them that straight Latinas could cling to and locate whatever scraps of propriety and decorum straight Latinas were accorded after being used and abused, not only by whites in general, but also by their Latino brothers, fathers, husbands, lovers, etc.

Nevertheless, some Latina lesbians have made a significant impact on the ways in which the realities of all Latinas are analysed, perceived, and lived. For instance, it has been Latina lesbians who have been in the forefront of much of the re-conceptualization and problematization of the discourses of identity politics within the struggles against sexism, racism, and colonialism in a country like the United States.

The work of Gloria Anzaldúa is a case in point. She has brilliantly articulated the difficulty of being *in*, but not being *of*, North America: as racially oppressed women, with multiple desires and plural sexualities; as linguistic fugitives and sexual outlaws who speak in transgressive and combined tongues; as beings who

are neither here nor there, as the song goes '*ni soy de aquí, ni soy de allá*,' thus, locating us – all of us – as perpetual travellers, continuously crossing borders/frontiers, belonging to many of, what my friend Mayra Santos calls, the 'trans-local nations'.

This is one of the important factors that eventually has led me to fight the heterosexism and homophobia within the Latino/Latina community in general and among Latinas in particular. The work of Latina lesbians such as Gloria Anzaldúa, Cherríe Moraga, Luz María Umpierre, Juanita Ramos, Carla Trujillo, and others has bridged my comprehension of the situation and resistances of other sisters of color, particularly of other lesbians of color. Barbara Smith, Audre Lorde, Jewelle Gomez, as such other-ed women have taken the lead in the struggle against gender oppression, white supremacy, national–cultural and socio-economic hierarchies in the US. Additionally, the writings of these lesbians of color have helped me articulate and reach a deeper understanding of the limits of what is otherwise known as 'the women's movement' in this country. It would not be an overstatement if I said that it was through the writings of lesbians of color that I have found my critical voice as a woman of color within and with respect to the US 'women's movement.' These are some of the texts that have helped me fully appreciate the need of coalition building and to perceive the limits of narrowly defined women's struggles. Here lies the primary focus of this paper.

Sexuality, race, class, culture, and ideology are some of the crucial and disputed areas in the relations between women. They constitute troublesome and recurring issues within feminism. In the epigraphs above, Barbara Smith and Jewelle Gomez advance that sexual identity and race, along with the discourses that construct these categories, are critical sites constituting specific subject positions. Discourses of sexual identity and race work to position what is spoken and unspoken, and mobilize communities of agreement and disagreement. And as Smith and Gomez suggest, discourse requires both the speaking and listening subject. Barbara Smith proposes that lesbians of color – particularly those who are feminists – inhabit a more precarious and less secure terrain of subjectivity than white lesbians, even though the latter may also be feminists. The former may in fact have more to lose by declining to subscribe to an essentialist agenda: as feminist lesbians of color, the identities in question are multiply inscribed, thus definitively marking this thing called 'the women's movement' and/or 'feminism' as the intersection of highly conflictive spaces.[3]

Writing Differences

My emphasis is on the way lesbians of color construct the meanings that structure these contradictory subject positions as an uneasy dialogue of subordinations: racially/nationally inscribing an oppressed sexual identity and sexually identifying oppressed races/nationalities. Lesbians of all races and nationalities, particularly lesbians of color, are hardly a homogeneous social reality. However, racially

oppressed lesbians perceive and live difference in ways that are oftentimes distinct from the rest of the experiences shared with a broader sexual community hegemonized by white lesbians. Like the broader 'women's movement' within which it is contradictorily located, the white lesbian community – despite being sexual outlaws – has traditionally reproduced the dominant racial position as the universal signifier. The mirror that is socially inherent to this specific form of subjectivity – that is, lesbian identity – appears to embody mainly white reflections. Thus, lesbians of color are at the intersection of a re-enforced and re-inscribed invisibility that frames this experience of difference and displacement: on the one hand, within and without lesbian and feminist communities that reflect the racial codes of the broader white society and, on the other hand, within and without racially/nationally subaltern communities that reflect the sexual codes of the broader heterosexual/sexist society.

The construct of difference raises important questions about the problems faced by all women of color with respect to historically existent feminism: issues that bring to the fore struggles over multicultural voice, agency, community, solidarity, and diversity, as well as struggles over the contradictory racialization of all subject positions (including that of mainstream [white] feminists). Yet, in the same way, historically existent feminism has also been criticized for its tendency to assume that most/all women are heterosexual. Although many of the initial (white) lesbian texts that arose during the 1970s and early '80s critiqued the extant homophobia within the mainstream feminist movement, they tended not to address directly the question of Eurocentrism and white supremacy. In either case, each position depends upon the expression and suppression of subaltern identities. For the white lesbian feminists, sexualization obscured the process of racialization.

The category of essence and essential categories of the body can be used tactically and in a radical way, taking into account real conditions of marginality. Its radical character depends, to a great degree, on who is utilizing it, on the historical moment, and on where its effects are concentrated.[4] In this sense, Audre Lorde's phrase 'meeting across differences' approaches and reclaims the power of convocation that essentialist categories have and suggest:

> It is not easy for me to speak here with you as a Black lesbian feminist, recognizing that some of the ways in which I identify myself make it difficult for you to hear me. But meeting across difference always requires mutual stretching, and until you can hear me as a Black Lesbian feminist, our strengths will not be truly available to each other as Black women.[5]

The beauty and simplicity of Audre Lorde's suggestion is that such an effort (that is, the linkage of disparities) should not, in and of itself, erase the disparities being joined. The purpose of a bridge is to span the gulf between opposite shores. It would be something else entirely if the two shores were demolished and the bridge erected itself as a new, independent structure – which would

no longer be a bridge. This, in fact, is what makes essentialism the sinkhole that it is.

In other words, a return to essentialism as 'a strategy'[6] must be a cautious return: there is the double danger of essence repressing other constructions and of refusing to recognize itself as a construction. What Andrew Ross has termed the 'historical effectiveness' of clearing a space for the identity of a particular group must necessarily be intertwined with the self-awareness of the sociohistorical, *contingent* character of this identity. The problem is that the clearing of such a space is nevertheless politically necessary or, as Elaine Marks has phrased it: 'there must be a sense of identity, even though it is fictitious.'[7] The difficulty of the project involved, in terms of the corresponding production of subjectivity, has already been succinctly outlined by Jane Gallop in a much more general context: 'Identity must be continually assumed and immediately called into question.'[8]

The Politics of Identity and Feminist Writers

The category 'women' is another troublesome classification on the grounds of historical and discursive construction[9] because women come from different classes, races, cultures, ages, levels of education, sexual identities, religions, etc. By taking into account these differences, sexual inequality and sexual oppression definitely cannot be explained exclusively in terms of class and economic exploitation. As a persistent voice with respect to (gender) difference, feminist perspectives must also respond to the tremendous effort of reconceptualizing the multiple specificities and intersecting differences that constitute 'women.'

The latter process has encountered great opposition from some feminists because it has been seen as undermining feminism as a whole. Part of the current uneasiness stems from the inadequacy of predominant theoretical constructs in terms of explaining the complex and contradictory specificity of a woman's experience. And part of this apprehension is translated into a dismissal of post-structuralist currents of thought. At first sight, the relation between this resistance and a European/North American cultural hegemony is evident insofar as the stability of the white national–cultural supremacy is at stake. As Paul Ricoeur has noted:

> When we discover that there are several cultures instead of just one and con-sequently at the time when we acknowledge the end of a sort of cultural monopoly, be it illusory or real, we are threatened with the destruction of our own discovery. Suddenly it becomes possible that there are just 'others,' that we ourselves are an 'other' among others.[10]

It is this kind of decentering that is typically resisted by the group which is located as dominant within a relation of power.

Yet some feminists have questioned the belief in the necessity of a unifying experience as a basis for a common voice, insofar as it negates differences within the feminist movement. Trinh T. Minh-ha clearly points out that:

> Yearning for universality, the generic 'woman,' like its counterpart, the generic 'man,' tends to efface difference within itself. Not every female is 'a real woman,' one knows this through hearsay ... Just as 'man' provides an example of how the part played by women has been ignored, undervalued, distorted, or omitted through the use of terminology presumed to be generic, 'woman' more often than not reflects the subtle power of linguistic exclusion, for its set of referents rarely includes those relevant to Third World 'female persons.'[11]

One of Audre Lorde's critiques of Mary Daly contributes further to this general analysis. While Mary Daly insists on universalizing women's oppression without taking into account the specificity of racial oppression, Audre Lorde underlines the impossible stability of such universalist desires among so-called mainstream feminists:

> to imply ... that all women suffer the same oppression simply because we are women, is to lose sight of the many varied tools of patriarchy. It is to ignore how those tools are used by women without awareness against each other ... as women, those differences expose all women to various forms and degrees of patriarchal oppression, some of which we share, some of which we do not ... The oppression of women knows no ethnic nor racial boundaries, true, but that does not mean it is identical within those boundaries.[12]

Common to each of these voices is an understanding of the tenuous constructions that constitute identity, not as some fixed given, but as a delicate weave on the verge of becoming undone. At first glance, this is the terror suggested by Paul Ricoeur. Yet from the vantage of Trinh T. Minh-ha, it is also the space of new possibilities.

The challenges from various feminist/lesbian writers of color, together with the ideological enterprise that they have undertaken around the issues of identity and difference, have also contributed to the general debates within the various expressions of feminism. Many of these texts – by feminist lesbians of color – are questioning the representation of sexuality within society at large and within the women's movement(s) in particular. They raise issues of eroticism, sensuality, and propriety, and in doing so continually (re)define, question, and (re)construct what it means to be recognized as 'a woman' and as 'a female.' Oftentimes, these efforts take into consideration the ways in which the dominant social structures have defined and constructed these categories and the practices that constitute them, as well as the ways in which women have positioned themselves (in resistance) within these social structures.

Jewelle Gomez's poem 'Our Feminist Who Art in Heaven,' for example, dismantles some of the fissures within the more traditional feminist morality regarding sexuality/sexual-identity:

> Bless me sister
> for I have sinned.
> It has been too long
> since my last confession.
> I lied once for non-political reasons,
> I swore three times
> (saying God
> instead of Goddess).
> But the most mortal
> sin of all: politically incorrect sex.
> Just a little thing,
> it took only a moment[13]

And, likewise, Luz María Umpierre, a Latina lesbian poet, contests conventional notions about gender roles and sexuality – in this particular case the heterosexual construction of sex. One of her poems is explicit in this sense:

> todo por Margarita
> siempre por Margarita,
> para poder besar,
> uno a uno
> los labios de su amarillo sexo.[14]

As Lourdes Torres has observed, in this poem 'the struggle is between the woman who demands the right to her sexual identity and those forces in a heterosexist society which seek to repress homosexual love.'[15]

But there are other difficult matters that lesbian writers of color have assumed and that further problematize the issue of identity from the perspective of women of color: this is the question of how an oppressed subject can also, simultaneously, be an oppressing subject. Cherríe Moraga points out as much: 'the Radical Feminist must extend her own "identity" politics to include her "identity" as oppressor as well.'[16] Or as Barbara Smith put it, recently:

> One of the challenges we face in trying to raise the issue of lesbian and gay identity within the Black community is to try to get our people to understand that they can indeed oppress someone after having spent a life of being oppressed. That's a very hard transition to make.[17]

Identity and the Critique of the Unitary (Lesbian) Subject

The writings of Gomez, Lorde, Moraga, Umpierre, and Smith, among others, have raised additional questions in relation to how the identities of lesbians of

color are produced, intercepted, and inscribed by class, race, and gender as sites of difference. As Michelle Barrett explains, sites of difference are also places where power operates.[18] Oppressed subjects (individual and collective) should not fall prey to petrifying their own respective identities (gender, class, sexual identity, race/nationality, etc), despite the defensive and survival character and tactical/'historical effectiveness' that originally motivated such a maneuver; otherwise, identity runs the risk of indirectly reproducing the ahistorical rigidity of the dominant culture's construction of the Other. Here lies the political need to call 'identity into question' *from within* the subordinate position, even as it is called into question *from without*.

Such delicate work should be the starting point of any politics of identity – all women of color, included. The difficulty remains, on the one hand, in realizing the need of such intermittent displacement and, on the other hand, in simultaneously clearing the space for the identity that is taken to be one's own. Thus 'clearing [of] space' always requires the invention of a space. Equally imperative is reassessing the timing and the terrain of such moments of displacement and of redefinition.

From this conceptual point of departure we can better understand and explore some of the difficulties encountered by a number of the feminist writers who are lesbians of color. Here I am referring to the (re)construction of authorial voice: changing pre-established borders, challenging institutional conformity, and inventing one's own identity. Listen to Audre Lorde's view of these transformations:

> As a Black Lesbian feminist comfortable with the many different ingredients of my identity, and a woman committed to racial and sexual freedom from oppression, I find I am constantly being encouraged to pluck out some one aspect of myself and present this as the meaningful whole, eclipsing or denying the other parts of self. But this is a destructive and fragmenting way to live.[19]

To which she adds:

> My fullest concentration of energy is available to me only when I integrate all the parts of whom I am, openly, allowing power from particular sources of my living to flow back and forth freely through all my different selves, without the restrictions of externally imposed definition. Only then can I bring myself and my energies as a whole to the service of those struggles which I embrace as part of my living.

Certainly it can be pointed out that, for women of color, the politics generated by these positions cut through the seamless narrative of a common feminist political purpose. But it also expresses some troublesome oppositions that affect specific women-of-color writers: white/racially subaltern, western/'Third World,' self/other, mother/daughter, heterosexual/homosexual, and center/margin.

The opposition is helpful in that, according to Diana Fuss, 'it reminds us that a complex system of cultural, social, physical, and historical differences and not a set of pre-existent human essences,' constitute and position the subject.[20] None the less it also can be problematic in the sense that we can disregard the 'differences within essentialism.'[21] As Theresa de Lauretis has argued, the question of identity becomes, not a goal but rather,

> the point of departure of the process of self-consciousness, a process by which one begins to know that and how the personal is political, that and how the subject is specifically and materially engendered in its social conditions and possibilities of existence.[22]

'All the Lesbians are White, All the Racially Oppressed are Heterosexual ... '

However, in the case of feminist lesbians *of color*, decentering, identity formation, and displacement as points of departure are even more crucial because, among other things, it establishes a common space that is relatively unburdened of constant explication and defensive validation with respect to white lesbian feminists. This is clearly illustrated in the following statement by a Chinese lesbian collective in the UK:

> The Chinese Lesbian group came about after three of us met at a Lesbian Sexuality conference in London in 1983. We called ourselves the Chinese Lesbian group even though there was only three of us – you have to begin somewhere. *Having had enough of the white lesbians, it was wonderful to be able to say exactly what you wanted to without having to explain a whole history of colonialism and racism and so on.*[23] (emphasis added)

Chrystos, a Native American lesbian writer, in her poem 'Maybe We Shouldn't Meet if There are No Third World Women Here,'[24] summarizes very powerfully indeed some of the very same contradictions and issues that have paved the way for autonomously organizing these expressions of group identity:

> You're the ones who don't print your signs in Spanish or Chinese
> or any way but how you talk You're the ones standing three
> feet away from a Black woman saying
> *There are no Third World women here*
> Do you think we are Martians
> All those workshops on racism won't help you open your eyes & see
> how you don't even see us
> How can we come to your meetings if we are invisible
> Don't look at me with guilt
> Don't apologize Don't struggle

with the problem of racism like algebra
Don't write a paper on it for me to read or hold a meeting in
which you discuss what to do to get us to come to your
time & your place
We're not your problems to understand & trivialize ...
(emphasis in the original)

But establishing this as an autonomous common space does not in any way dissolve all the differences within the particular lesbian–racial/national community involved. In other words, it 'is not a goal,' a site empty of social contradictions, or unhelpful constructions. Rather, it is the space where these other social contradictions can be addressed and worked through, insofar as it is the space where these contradictions become visible: for example, in terms of levels of education, generational issues, degrees of physical ability, questions of motherhood vs. the refusal to bear children, and so on.

It is this place of departure, of creating and reinventing spaces, that is crucial because as *lesbians* of color oftentimes this meant being located in positions in which one could not take for granted the social solidarity characteristic of racially-oppressed/cultural–national families and communities in Europe and North America. For instance:

Many of us in the Chinese Lesbian group put distance between ourselves and our families *because of how we have chosen to live*. As a result we have only ourselves to fall back on; all the more reason for valuing each other and for organizing ourselves, particularly in the way we have children and take care of them. Moreover, at least we have the security of knowing that we are not the first, or by any means the last.[25]

Re-creating spaces in this manner gives rise to new forms of sociality and solidarity. Sexual identity then becomes the prism through which to re-examine what it means to belong/not-belong to such a racial/national community.

Nevertheless, there are ever-present – and however contradictory – moments in which these common threads (and threats) of oppression shared by all women of color can and should be the elements that bring us together in the construction of a common identity. Audre Lorde, for example, notes in this regard that: 'As a group, women of Color are the lowest paid wage earners in America. We are the primary targets of abortion and sterilization abuse, here and abroad.'[26] And, elsewhere, she comments: 'When I say I am a Black feminist, I mean I recognize that my power as well as my primary oppressions come as a result of my Blackness as well as my womanness, and therefore my struggles on both these fronts are inseparable.'[27]

The Combahee River Collective has also made similar observations. As a black-lesbian activist group mobilized around the issues of racial, sexual, heterosexual,

and class oppression, this organization became one of the earliest to endorse among lesbian-feminists the idea of race/nationality identity politics.[28]

Yet there are multiple and problematic ways in which creating such autonomous spaces is relevant to the question of 'meeting across differences' vis-a-vis the identities of feminist-lesbians of color. As Diana Fuss argues:

A series of unanswered questions pose themselves as central to any current discussion of identity politics. Is politics based on identity, or is identity based on politics? Is identity a natural, political, historical, physical, or linguistic construct? What implications does the deconstruction of 'identity' have for those who espouse an identity politics? Can feminist, gay, or lesbian subjects afford to dispense with the notion of unified, stable identities or must we begin to base our politics on something other than identity? What, in other words, is the politics of 'identity politics'?[29]

Once again, this raises the issue of having to bridge these disparities in order to construct, however consciously, such a common identity. While, on the other hand, it raises the issue of the necessary contingency of identity politics, if indeed the uncritical and rigid underpinnings of essentialism are going to be surpassed.

(Re)departure, Marginality, and Identity

The ethico-political glossary provided by Trinh T. Minh-ha[30] provides significant insights into the ways in which these problems and contradictions have oftentimes been engaged by lesbian feminists of color. According to Trinh T. Minh-ha, the key concepts regarding (feminist) women of color as a whole are (re)departure, marginality, and identity.

(Re)departure pertains to a 'return to the source,' yet such a return is always an approximation. This is because the truly essentialist, univocal, and universalist pretention of finding/reaching *the* source is an impossibility: there is no ultimate, all-encompassing, and definitive 'there' to return to. Thus the purpose of this return is rather a tactical one: to redirect one's bearings only to necessarily depart-again. Otherwise with respect to subordinate subject positions, the mystifying riveting of one's site would reinforce the dominant culture's confinement maneuvers.

Marginality, for subordinate subjects refers to the necessary relocation/transformation of this subjectivity : shuttling back and forth, from one moment of (re)departure to another, in-between frontiers, at times shut-off and at times recuperated by the various communities that intersect the multiple dimensions of oppression. It is through this perennial displacement that the subordinate subject continues to question what is taken for granted – about herself and about other Others – thus intermittently un-naming and re-naming herself and her-selves.

Identity is that which describes and defines this contingent and displaced subjectivity. It is not and cannot be anchored, once and for all; its grounding is always shifting and provisional. Yet identity demands the re-creation of momentary alignment: it must clear a space for the various specificities that constitute the subordinate subject; it must draw lines of demarcation that trace the boundaries of the (individual and group) self vis-a-vis those subjectivities that are excluded at that particular moment, and only to clear an-other space later on, redraw new lines of demarcation, redefine existing boundaries.

It is possible to read feminist lesbians of color against these formulations by Trinh T. Minh-ha for ways in which 'identity politics' has been lived. By continually asserting (re)departures, women like Audre Lorde, Chrystos, Barbara Smith, Jewelle Gomez, Alice Lee, Cherríe Moraga, Luz María Umpierre, Gloria Anzaldúa, et al. perennially 'return to the source' to reinvent each of their multiple sources. And they seem to be doing this by redrawing, for example, what being lesbian means for a Chicana story-teller who has never borne children vis-a-vis what being a lesbian means for an Afro-Caribbean poet and essayist who is a mother, vis-a-vis what being a lesbian means for a Native American woman activist and writer vis-a-vis ... And all of this, while, for example, intermittently clearing the space of, within, and for Chicano ethnicity from the perspective of a feminist lesbian; and/or while intermittently retracing the boundaries of womanhood as lesbians, while simultaneously redefining lesbian identity from the perspective of being non-white in a Euro-American dominant culture. Admitting such complexity can move beyond the dreary anchor of a unitary self. That fiction can only suppress the delicate contingencies of who each of us is becoming.

Thus to trace such movements requires one to be concerned with the contingent perspectives that define the perimeters of subjectivity: at times being shut-off from other women for being a lesbian, but at times being recuperated by them for being a woman; at times being excluded from other feminist lesbians for not being white, yet at times being inclusively recognized precisely for being a feminist lesbian; at times being rejected by all whites for not being one of them, and at times – and specifically for the latter reason – being recuperated by her own minority/ethnic community; at times being banished by most of the communities pertaining to the predominant subjectivities, while at times having more and more diverse communities to turn to than the various mainstreams. What I am suggesting is the delicate discursivity of boundaries, of crossing boundaries, of not being anywhere in particular (i.e. any-'where' that is considered valid/dominant), and being always yet provisionally located in-between. Recognition is with the shifting, or realigning, and the regrouping momentarily, only to relocate again. The permanency then resides in the political process of reconstructing, renegotiating, and readdressing all of these multiple and at times contradictory sites of oppression.

In this manner, the growing literature – and the broader social practices – framing the contradictory positionality of feminist lesbians of color embody the multiple ways in which race, gender, class, and sexuality have become burning questions within the women's movement(s). To a large extent, these emergent texts and individual/group actions have significantly contributed to the political and theoretical renovation of one of the key concepts of current feminist discourse: namely, the very notion of 'difference' – of *all* difference. As I have shown, these texts/practices have also raised important issues that question the ideology and concrete examples of the ways in which community and solidarity have been produced within the women's movement(s). At the same time, they bring to the fore the urgency of addressing these problems.

Notes

The theorethical framework for this paper is based on a reading of certain poststructuralist theories and particularly on the work of Diana Fuss, Trinh T. Minh-ha, and bell hooks. But most of all, I have benefited greatly from my discussions with my friends Deborah Britzman, Kelvin Santiago, and Carole Boyce Davies, as well as from the course 'Black Women's Writing and Feminist Discourses' taught by Carole Boyce Davies in the spring of 1990 at SUNY-Binghamton.

1. Barbara Smith, 'Historic Symposium on Lesbian Writers of Color,' *Gay Community News* 17, 31 (18–24 February 1990), p. 6.
2. Jewelle L. Gomez, 'Taking the Home of Homophobia: Black Lesbians look in their Own Backyard,' *Out/Look* 8 (spring 1990), p. 37.
3. I am well aware of the fact that even in countries such as the United States or the United Kingdom, each of these very broad categories (i.e. 'white feminist lesbians' and 'feminist lesbians of color') encompasses extremely complex and heterogeneous forms of subjectivity. There are differences between white Christian lesbians and white Jewish lesbians; between white university-educated lesbians and white working-class lesbians; between white Southern lesbians and white Northeastern lesbians (in the US); between white lesbians who became adults during World War II and the 1950s vis-a-vis lesbians that came of age during the 1960s and '70s.
 Similarly, there are differences between Native American lesbians and African American lesbians; between the lesbians of the different nationalities of origin which at times are grouped together – by themselves as well as by demographic officialdom – as 'Hispanics' (in the US), as 'West Indians' (in the UK), or as 'Asians' (in both countries); between lesbians of color who are socially constituted as physically able and lesbians of color who are socially constituted as disabled; between lesbians who belong to the first

generation of migrants to the urban centers of the US or of the UK, and
those who belong to subsequent generations (e.g. in terms of language use,
education, and even overall ethnic identification). Despite such differ-
ences, in countries such as the United States and the United Kingdom there
exist historically major pan-ethnic categories that work to reconstitute
culturally all peoples of European descent as the dominant racial position.
In this manner, boundaries are drawn so as to produce whiteness as the socially
privileged category that stigmatizes people of non-white/non-European
descent as Other.

4. Andrew Ross, (ed.), *Universal Abandon? The Politics of Postmodernism* (Min-
neapolis: University of Minnesota Press, 1988), pp. xi–xii.
5. Audre Lorde, 'I am Your Sister: Black Women Organizing Across Sexu-
alities,' in *A Burst Of Light* (Ithaca, NY: Firebrand Books, 1988), pp. 19–20.
6. Gayatri Chakravorty Spivak, *In Other Worlds: Essays in Cultural Politics.* (New
York and London: Routledge, 1988), p. 207.
7. Elaine Marks, 'Feminism's Wake,' *Boundary 2* 12, 2 (winter 1984), p. 110.
8. Jane Gallop, *The Daughter's Seduction: Feminism and Psychoanalysis.* (Ithaca,
NY: Cornell University Press, 1982), p. xii.
9. See Denise Riley, *'Am I That Name?': Feminism and the Category of 'Women'
in History* (Minneapolis: University of Minnesota Press, 1988).
10. Paul Ricoeur, 'Civilization and National Cultures,' in *History and Truth*,
trans. C. A. Kelbley (Evanston: Northwestern University Press, 1965), p.
278.
11. Trinh T. Minh-ha, *Woman Native Other: Writing, Postcoloniality and Feminism*
(Bloomington: Indiana University Press, 1989), p. 97.
12. Audre Lorde, 'An Open Letter to Mary Daly,' in *This Bridge Called My
Back: Writings by Radical Women of Color*, ed. Cherríe Moraga and Gloria
Anzaldua (New York: Kitchen Table, Women of Color Press, 1981),
pp. 95, 97.
13. Jewelle L. Gomez, *Flamingoes & Bears* (New Jersey: Grace Publications, 1986),
p. 21.
14. Luz María Umpierre, 'Transcendence,' in *Third Woman: The Sexuality of
Latinas* Vol. IV, ed. Norma Alarcón, Ana Castillo, and Cherrié Moraga
(Berkeley, CA: Third Woman Press, 1989) p. 39.
15. Lourdes Torres, 'Risking All for Margarita,' in *Third Woman*, pp.166–167.
16. Cherríe Moraga, *Loving in the War Years* (Boston: South End Press, 1983),
p. 128.
17. See Jewelle L. Gomez and Barbara Smith, 'Taking the Home out of
Homophobia,' p. 32.
18. Michelle Barret, 'Some Different Meanings of the Concept of "Difference":
Feminist Theory and the Concept of Ideology,' in *The Difference Within:
Feminism and Critical Theory*, ed. Elizabeth Meese and Alice Parker
(Amsterdam/Philadelphia: John Benjamins, 1989), p. 42.

19. Audre Lorde, 'Age, Race, Class and Sex: Women Redefining Differences,' in *Out the Other Side: Contemporary Lesbian Writing*, ed. Christian McEwen and Sue O'Sullivan (Freedom, CA: Crossing Press, 1989), 273–4.

20. Diana Fuss, *Essentially Speaking: Feminism, Nature, and Difference* (New York: Routledge, 1989), p. xii.

21. Ibid.

22. Theresa de Lauretis, 'Feminist studies / Critical studies; Issues, Terms, and Contexts,' in *Feminist Studies/ Critical Studies*, ed. T. de Lauretis (Bloomington: Indiana University Press, 1986), p. 9.

23. Alice Lee, 'Spinsterhood and the Chinese Lesbian Group: A Visit to My Aunts,' *Out the Other Side*, p. 7.

24. Chrystos, *Not Vanishing* (Vancouver: Press Gang, 1988), p. 13.

25. Lee, 'Spinsterhood,' p. 6.

26. Lorde, 'Age, Race, Class and Sex,' p. 273.

27. Lorde, 'I am Your Sister,' p. 20.

28. Combahee River Collective, 'A Black Feminist Statement,' in *Feminist Frameworks: Alternative Theoretical Accounts of the Relations Between Women and Men*, ed. Alison M. Jaggar and Paula S. Rothenberg, 2nd edn (New York: McGraw-Hill, 1984), pp. 204–5.

29. Fuss, *Essentially Speaking*, p. 100.

30. Trinh T. Minh-ha, 'Race and Gender in Spectatorship,' lecture delivered at Cornell University (1990). What follows is a paraphrasing from notes taken at Minh-ha's lecture which has been subsequently published as 'Cotton and Iron' in *Out There: Marginalization and Contemporary Cultures*, ed. Russell Ferguson, Martha Gever, Trinh T. Minh-ha and Cornel West (Cambridge, MA: MIT Press, 1990).

Women's Writing and the Politics of South Africa: The Ambiguous Role of Nadine Gordimer

Thelma M. Ravell-Pinto

> When black people are talked about the focus tends to be on black *men* and when women are talked about the focus tends to be on *white* women
>
> bell hooks[1]

As feminist theorists, we would like to believe that women's writing introduces new dimensions in literature and, as Umeh states, is 'engaged in demystification

and complete liberation'.[2] In contemporary African literature the emergence of women writers like Bessie Head,[3] Buchi Emecheta, Nawal el-Sadaawi, Ama Ata Aidoo and Mariama Bâ, for example, has introduced different frames of reference to African literature. The writings of women have also brought about a re-evaluation of the existing canon and a questioning of the underlying notions of canon formation. Women have not only introduced new paradigms, but are, moreover, changing the existing paradigms.

This change, in some areas where certain women writers have become prominent, has erroneously led some to believe that all women writers address oppressive structures wherever and in whatever form they may occur. Such an expectation implies a superior moral stance on the part of women merely on the basis of their gender, which would of course negate the influence of class, racist indoctrination, and self-interest on the part of women. Thus, Umeh's assumption holds true only for women writers consciously engaged in feminist politics of liberation and who join hands with other women and progressive/feminist men cross-culturally so as to work towards the liberation of all people.

Most African, Asian, and Latin American women have to address the legacy of patriarchal traditions compounded by economic and political exploitation by the West. Consequently, many women are still engaged in the struggle against poverty, illiteracy, and poor health facilities. For them, in the words of Trinh T. Minh-ha: 'writing, reading, thinking, imagining, speculating ... are luxury activities, ... permitted to the privileged few, whose idle hours of the day can be viewed otherwise than a bowl of rice or a loaf of bread less to share with the family.'[4]

In South Africa, where the majority of the population has been involved in a life-and-death struggle for national liberation, the voices of women have been subsumed under the colonial/racist discourse. Those women writers who have been able to publish are further silenced by South Africa: government and press, in collaboration with the outside world. The assault on the black South African women writers largely takes the form of a conspiracy of silence about their writings. They and their literary productions become virtually invisible, whether in book review supplements, scholarly discussions, literary journals, or in bookstores. This subtle censorship has far-reaching consequences, not only for the South African women writers themselves, but also for canon formation.

It is a function of this suppression that makes it possible that a writer like Nadine Gordimer, for example, can be hailed as the best writer from South Africa in terms of her literary skills. The Zimbabwean critic Piniel Shava, in *A People's Voice: Black South African Writing in the Twentieth Century*, uses Gordimer's writing as a frame of reference with which to compare all black South African novels:

> her objectivity, her great formal skill and her ability to see deep into her characters set her apart from other writers ... Significantly, her objectivity lends credence

to and enhances the impact of her implied rejection of the whole South African regime.[5]

Ironically, Shava's book not only leaves out all black South African women novelists, but, as Huma Ibrahim correctly points out, 'fails to examine black South African writing as artistic in any way while it unabashedly praises white writers like Gordimer for their artistic prowess.'[6] In using Gordimer as a point of reference, which is curious in this context, Shava fails to address the extent or significance of what Clingman has called 'Gordimer's social alienation from a black South African world in general.'[7] Furthermore, Shava seriously distorts the reality of South African literature in the twentieth century by deliberately leaving out significant writers such as Bessie Head, for example.

The misconceptions and misrepresentations of a Shava are reinforced when, for example, *My Son's Story*[8] by Nadine Gordimer is reviewed on the front page of *New York Times Book Review* (21 October 1990), while the new novel by Lauretta Ngcobo, *And They Didn't Die*,[9] for example, is not even mentioned, let alone reviewed. This deliberate omission from major literary journals and literary reviews relegates works by black South African women writers like Ngcobo, Wicomb, Karodia, Tlali, House, and many others to virtual invisibility. At the same time a Gordimer becomes the recipient of numerous prizes and glowing reviews by critics and academics in South Africa and abroad. She has been on public radio and television in the United States as the mouthpiece for South African women writers. Her works are not only more available in South Africa but, moreover, both in the United States and Europe, you can find her books prominently displayed in almost every bookstore. In glaring contrast, many of the works of black South African writers are either banned or totally unavailable in South Africa because bookstores practice their own restrictive import policy on books published abroad. Furthermore, and equally reprehensible, European and American booksellers, newspapers, and literary reviews aid and abet this practice by collaborating with South Africa in this silencing of black South African writers.

As a South African, I have always, almost religiously, refused to discuss the works of white South African writers precisely because I did not wish to be part of the racist reception situation which focuses exclusively on the white writers as spokespersons for South Africa. However, it is time that we demystify a Nadine Gordimer by examining the ideology prevalent in her discourse with regard to women and racism in South Africa. Therefore, I have, reluctantly, decided to analyse *A Sport of Nature*[10] in this chapter and define Gordimer's place in the canon of South African literature, as well as in the canon of women's writing as a whole.

As the later novels of Nadine Gordimer, *Burger's Daughter* (1979),[11] *A Sport of Nature* (1987), and *My Son's Story* (1990) all seem to have as their main theme

liberal white politics juxtaposed with black leadership and interracial relationships, I will look at *A Sport of Nature* as an example of Nadine Gordimer's work to see how she, as a woman writer, addresses women's issues and the politics of South Africa and where these two themes coincide.

A Sport of Nature focuses on the life of Hillela, an 'unconventional' white South African woman. This free-spirited young woman is perceived as a threat by the white establishment in terms of her unorthodox attitude towards sexuality: 'sexual knowingness proclaimed itself in her laugh' (p. 108). She is, furthermore, described as having 'no political sense, no convictions, not the faintest idea' (p. 127). This blatant disregard for entrenched societal norms and structures sets her apart from others.

Hillela's life, which forms the central theme of the novel, is varied and eventful. Her journey starts as a high school drop-out and ends as the wife of an unnamed African head of state. She traverses Africa, East and Western Europe and the United States. Her exile from South Africa coincides with the arrest of Walter Sisulu, Govan Mbeki, Ahmed Kathrada, and others and the beginning of the Rivonia Trial (1964). The use of the names of these major political figures here and those of other celebrities like Nelson Mandela, Bram Fischer, Kwame Nkrumah, and Indira Gandhi is without any political or literary finesse. By employing these names, Gordimer tries to evoke an historical frame of reference, consciousness, and expectation by the reader, which remains unfulfilled. Her focus on the progressive tradition is systematically undermined by peripheralization which deteriorates into becoming only a background scenario to the feats of an illusive and ill-defined protagonist.

Hillela goes into exile after her apartment is ransacked by, she assumes, the South African security police. Later she learns that the boyfriend who abandons her in East Africa, actually worked for the South African government. In exile in East Africa, Hillela is confronted with different challenges: how do you survive without the protection all whites enjoy in South Africa? And how do you cope without the family allowance? She has recourse to her body/sexuality only. The white South Africans here are like Pauline and Joe, her progressive aunt and uncle in South Africa, only they appear more solid in their commitment to a liberated South Africa. It is the Afrikaner woman, Christa, who takes pity and assumes responsibility for the abandoned Hillela and who draws her into the circles of the African National Congress (ANC). Yet all the time it is her sex appeal that gives her entree not afforded to other exiles. Nadine Gordimer undermines Hillela/women's sexuality by the portrayal of her excessive sexual prowess and seems to be using the patriarchal model here. Hillela's social and political mobility is entirely dependent on her sexuality:

> it was not only the water-jewelled breast, down to where the yellow swimsuit just covered the stiff nipples, that surfaced, but also the thick index finger and fist of his penis and testicles under their pouch of wet blue nylon. They saw

what there was to see of each other, while feeling identical delicious coolness and heat. (p. 142)

It is this encounter, interrupted by a black man with news of the killing of a comrade, that later gives Hillela access to the ANC when she is in Ghana. Conventions between desire and political power notwithstanding, what we have depicted here is a very patriarchal model indeed.

All the sexual scenes in *A Sport of Nature* are juxtaposed with serious political events, a juxtaposition which implies that South African liberation politics can be seen as a reductionist sexual game. The ambiguity which is prevalent is carried through particularly with regard to Hillela. Here is a protagonist whom we assume to be positive because she totally rejects the racist and patriarchal norms of society, yet she is also portrayed as 'the kind of girl whom people, on very short acquaintance, invite to parties' (p. 113), and as someone who looked 'well-fucked' (p. 114). Gordimer's portrayal of her as so utterly available sexually is a sexist way of looking at women. By the juxtaposition of erotic sexual scenes and political events, this novel shows strong similarities to *Mating Birds*[12] by the South African male novelist and critic, Lewis Nkosi. Both novels depend heavily on sexual and political voyeurism.

It is the artificiality of the character of Hillela, almost made for a black man, that is problematic. Her focus on her own sexuality appears contrived; she changes her sexual partners like she changes her clothes. Yet after a brief encounter with Whaila Kgomane, executive member of the ANC, she becomes pregnant. How do we explain her sudden monogamous fidelity to this black man whom she marries? Furthermore, if Hillela really is free from racist indoctrination, how do we account for the fact that she shares the same white voyeurism with regard to the dimensions of the black man's genitals? 'There's always a lot of sniggering about the size of the black man's thing, but no-one's ever said they weren't entirely black' (p. 185).

If being 'a sport of nature' implies that you have somehow been able to develop outside the ideological parameters of a given society, which in South Africa would mean free from racist and patriarchal indoctrination, then Hillela falls short on both counts. She echoes the racist myths of black male sexuality and expresses an explicit dislike for African hair and with it the African aesthetic, which clearly shows her adherence to the hegemonic Eurocentric paradigm. A similar negative reference to African hair already surfaced in *Burger's Daughter* where it is compared to 'a lumpy mattress' (p. 30). The location of this discourse in *A Sport of Nature* concerning African hair and genitalia, in bed, after a sexual encounter, reduces even these entrenched racist attitudes to a sexual game.

This same peripheralization of the African aesthetic is reflected in *Mating Birds* by Lewis Nkosi, in which the narrator is totally obsessed with the 'white woman' and seeks to invoke sympathy for the unfortunate black man who is unable to exercise his free choice and satisfy his desire in racist South Africa:

> I had felt her breast crushed against my breast. I
> had felt the brush of her hair against my face. And
> the girl, tremulous and gleaming with her invincible
> color and excitement, had smiled into my face. Those
> huge green eyes, so modestly sheltered behind
> flickering eyelids. (p. 116)

The obsessive preoccupation with the body of the white woman as object of black male sexual desire, as seen in both Nadine Gordimer and Lewis Nkosi, reduces the white woman to the status of a sex object and by the same token peripheralizes black women and black male sexuality. Such a depiction reinforces the patriarchal model of woman as object/body geared entirely towards the needs and expectations of men. Veronica, the main female character, in *Mating Birds* speaks only in court when she testifies in her own defense after the alleged rape. She is the proverbial silent female whose communication is through seductive body language. The major part of the novel centers around Sibiya, the narrator's, adoration of this white woman who is either in a horizontal position on the beach or described in a chance encounter as: 'the full white throat above the low-cut dress, the high magnificent breasts beneath the flimsy cloth [which] begin to throb like a swell of a large ocean wave' (p. 116).

In Nkosi and Gordimer's novels, as in novels by other white South African writers like Andre Brink, for example, it is appropriate to ask: where are the black women? The fact of their absence, their silence, invokes a clammering for their presence. Black women are servants or anonymous wives, not focused on at all. Gordimer peripheralizes black women the same way the black male writer, Lewis Nkosi, does and for similar reasons: to focus on the white woman. Sasha, the son of Pauline, on hearing about the marriage of Hillela to a black man, appears shocked by the idea. He cannot envisage ever being attracted to a black woman himself, an attitude not prevalent among white men generally. Historically, white men had few reservations about liaisons with women from different cultural/class backgrounds. bell hooks, the African–American feminist, links the hostility of white women to black women to white men: 'By flaunting their sexual lust for the bodies of black women and their preference for them as sexual partners, white men successfully pitted white women and enslaved black women against each other' (pp. 153–4).

The Immorality Act in South Africa is an example of how legislation was passed to control and outlaw sexual relationships mainly between white men and black women. Most of the trials concerning interracial relations in South Africa have been about white men having sexual relations with black women. Writers like Gordimer and Nkosi thus unwittingly become players in the white male patriarchal game. bell hooks, furthermore, correctly observes that alliances such as those explored by Gordimer and Nkosi do not in fact pose any real threat to existing racist patriarchal systems: 'Since white women form a powerless group

when not allied to powerful white men, their marriage to black men is not a great threat to existing white patriarchal rule' (p. 64). This is in complete contradiction to what Gordimer portrays in *A Sport of Nature* when the African president who marries Hillela, as 'the beginning of ... [his] second access to power' (p. 345). In *A Sport of Nature*, we encounter no female alliances or insights, just a subtle and implicit attack on the African aesthetic and a devaluation of the sexuality and womanhood of black women.

Gordimer's portrayal of the white women who are in interracial marriages is problematic too. Hillela, in *A Sport of Nature*, is a reject, almost an aberration; yet she is able to propel herself into the upper echelons of African society. Is Gordimer implying that African men are happy to settle for the rejects of the white man as long as they are white? Isn't it generally true, or am I assuming too much to assert that men invariably marry down – either in age, in educational level, or in economic and social status? Women who marry down are criticized severely by society. The ideology of marriage as an institution implies that a woman should look up to her man.

Ironically, the electoral slogan, 'Do you want your daughter to marry a black man?' was used by the Nationalist Party in South Africa in the 1950s and '60s in order to curb white liberalism. This was seen as a fate worse than death and enough to make whites vote for the Nationalist Party. It is true that some black men have internalized the racist ideology that pervades South Africa with regard to the inaccessibility and alleged superiority of the white woman. We see this manifested in *Mating Birds* by Lewis Nkosi. Yes, men are sexually vulnerable and more susceptible to flattery than women, but black men and white men are no different in this regard. What Gordimer does in *A Sport of Nature* is a deliberate attempt to discredit the liberation movement by indicting black male leadership. By linking liberation politics with the desire of black men for white women, the novels of Gordimer and Nkosi are by implication perpetuating the racist myth that black men are fighting for liberation so that they can have sexual access to white women. The literary undermining and subverting of the political struggle by defining the motives of the leadership in terms of interracial sex is irresponsible and reactionary.

Interracial relationships in South Africa have many other dimensions than those focused on by either Gordimer or Nkosi. In *You Can't Get Lost in Cape Town*,[13] a novel by the black South African woman writer Zoe Wicomb, there is an interracial relationship between a white man and a black woman. Zoe Wicomb links the very controversial theme of interracial relationship to female sexuality, unexpected/unwanted pregnancy and the choices women make. Frieda, the main character/narrator, is involved with a white man whom she is ashamed to introduce to her family. They have a three-year relationship which results in an unexpected pregnancy. For Frieda, the high-point in their relationship has passed and even though he wants to marry her and leave the country, she

decides to have an abortion. Symbolically, this is also an abortion of the relationship they have had. Wicomb shows how the mental agony of an abortion, heightened by racism and illegality in South Africa, becomes a veritable nightmare. The ironic racist encounter with the white woman, who performs the abortion only because she assumes that Frieda is white as well, provides comic relief in an extremely traumatizing, physically painful, and potentially life-threatening situation. This incident, which occurs in the title chapter of *You Can't Get Lost in Cape Town*, deals with the other dynamics of an interracial relationship and its psychological repercussions in a racist society. Wicomb has no stereotypes, no easy solutions, and no winners. Here we see the broader spectrum of how politics and racism impinge on all areas of the lives of South Africans. This kind of approach in which the problematic nature of even a 'good' interracial relationship is highlighted, one does not come across in *A Sport of Nature*. Also, and maybe more importantly, in Wicomb's novel we have a relationship between a black female and a white male. This relationship explored by Wicomb is female-centered and more threatening to racist/patriarchal structures.

Gordimer not only objectifies women in her portrayal of Hillela, but also objectifies black people. The nuances of black life in South Africa are not focused on and blacks are portrayed as ungrateful objects of white patronage, a theme already present in *Burger's Daughter*. Gordimer's real concern seems to be that blacks realize the severe sacrifices that whites are making on their behalf. Is she implying that blacks, as victims of the oppressive structures, should be solely responsible for the destruction of these structures? The whites are seen as having guilt feelings, but there is no serious realization of their complicity in the creation and retention of the status quo. Pauline, Hillela's progressive aunt, goes out of her way to assist black fugitives, even those who resent whites. The patronizing attitude, though couched in a form of criticism of the role of white liberals, is none the less normative and thus reinforces the stereotypical idea of blacks as being objects in need of white patronage and assistance.

Another aspect in *A Sport of Nature* that should be examined more closely is the qualitative difference between the kind of criticism meted out to white progressives/Afrikaners and that directed at blacks. While whites are criticized for their ambivalent position and for working against their own interests, white supremacy, black men are indicted on issues of personal integrity: their attitudes towards their own wives and children; their attitudes towards other women. Blacks have little or no regard for their families, as seen in the portrayal of Donsi who leaves his wife and children outside Pauline's house in the car, while he drinks beer and dances inside. Black family life is only portrayed as erosive. When Hillela's marriage to a black South African becomes known, Pauline, the progressive white liberal's servant comments: 'Black men are no good for husbands. He'll run away, you'll see' (p. 94).

Furthermore, black men, like Alpheus, are still portrayed as 'boys', especially when it is the young fourteen-year-old white teenager who is sent to repair the electricity in the garage while the black man is present: 'he had bought what he did not want his benefactors to know about, because he had no business spending money on such things as hi-fi equipment, any more than he should have burdened himself with a family' (p. 87). And, as we see from the above quotation, black parenthood is viewed as obsolete. Even the young son of Pauline, the liberal white woman, seems to assume that a black man needs permission to have a family. This is very much in keeping with the apartheid ideology which separates black families and makes black children illegal in the urban areas. In its extreme form this ideology justifies the killing, imprisonment, and torture of young black children by the police and soldiers in South Africa as happened during the Soweto uprising (1976) and afterwards when hundreds of schoolchildren were shot down in cold blood.

It is Gordimer's subtle and invidious criticism of the liberation movement and liberation politics in South Africa which becomes suspect. Because of the way in which she does this, she is supporting the present system and underpinning the racist ideology and mythology, both about the weaknesses of blacks and about the supposed natural superiority of white men. Even though South Africa becomes liberated in *A Sport of Nature*, it is to white male expertise that we will have to turn, in the final analysis, and not to those 'deluded' ones who choose for the liberation struggle. The sons of Olga, the conservative aunt of Hillela who kept herself away from any kind of political involvement, become financial and scientific advisers to the new South African government. They have acquired technological expertise while Sasha, the son of Pauline, the liberal white, foolishly distracted into liberation politics, was imprisoned and afterwards had to flee the country. Also in *Burger's Daughter*, Rosa, the main character who is the daughter of the famous white political activist, Lionel Burger, ends up in prison. The white liberals in Gordimer's works who become active in real liberation politics in South Africa, when they cannot be discredited for moral decadence, are punished by exile, jail or death. The overt message for white South Africans is obvious, it is foolish and dangerous to become involved in liberatory politics.

With regard to Hillela, I agree with the assessment of Linda Weinhouse who writes: 'Hillela has achieved prominence, but her role has remained the same.'[14] The primary focus has been on Hillela's sexuality which, though overemphasized and exploited, is not as odd as her emotional stagnation. She has no emotional ties to anybody, not to her daughter, nor to her long-lost mother, nor to any of her sexual partners. All the descriptions of her relationships to the various men are given in terms of the sexual relationships. *A Sport of Nature* does not explore female sexuality as a theme, but only presumes that a woman can

be so totally absorbed in the sexual act that it becomes her only frame of reference.

The progress of Hillela is measured by the expectations of the men in her life, her African dictator husband, the General, whom we are told, 'she has never ceased to please and still surprise ... she is a match for him in this way [*sexually*] as in all others' (my emphasis, p. 347). Here, again, it is obvious that a good wife is one who keeps her husband satisfied sexually, and the patriarchal assumption seems to be that the happiness or success of a woman is to be measured by the status of the man she is married to. The general has had his share of extra-marital affairs, but we are explicitly told about only one affair that he has had in which the woman concerned is even whiter than Hillela: 'She was unrelievedly blonde, with blue eyes that showed a wet pink rim at the lower lids and a skin so fair it shone in the dark gardens of State House in the evening, when the reception spilled outdoors' (pp. 346–7). Here, again, we have to ask why the whiteness of this 'passing fancy' (p. 346) is so significant and why there are no descriptions of the black women he has affairs with. The challenge that Hillela poses to her husband is one of finding as many sexual partners as he does and being equally discreet about it.

Hillela, unlike Sasha, does return to South Africa after liberation, but as the 'ambitious wife' (p. 350) of the Chairman of the OAU who officiates at the transfer of power in South Africa. The last picture we have of Hillela at the independence celebration of the liberated South Africa is cynical and ambiguous. Her pose, we are told, comes from her 'training in attendance at great solemn occasions' (p. 354). The irony of this statement is further compounded by the final description of her in the novel: 'her hands hang at her sides a moment and then are lightly enlaced in front of her thighs in the correct position. Her face is the public face assumed, along with appropriate dress, for exposure' (p. 354). It is not on herself or her daughter, Nomzamo, but on her ex-husband, 'Whaila's country' (p. 354), that she reflects when the flag of the new South Africa is hoisted.

In conclusion, we can say that Gordimer's work as exemplified in *A Sport of Nature* is *normbevestigend* (norm affirmative) with regard to the racist/patriarchal ideology in South Africa. This conclusion has far-reaching implications. For, not only is Gordimer the most canonized South African woman writer, but she is, moreover, the most cited South African writer in Europe and the United States. This leads us to the realization that racist/patriarchal views are still being rewarded in academia. What I have done is question the ideology and market which determine what is called 'good' literature even when it demeans and undervalues the major part of humanity. I will take the risk here and predict that Gordimer's writings in question will not in time be characterized as great works of literature, norm-shattering or liberatory; at best, they may be designated later as early laborious attempts at addressing entrenched racist ideology while still remaining within the racist/patriarchal paradigm.

Nadine Gordimer can best be characterized, in the words of the French feminist philosopher Elizabeth Badinter, as someone who 'has lost [her] old reference points but ... [is] not sure yet of ... [her] new ones.'[15] Badinter is, of course, referring to the roles of men here. On the surface, it may appear as though Gordimer's novel uses the Badinter model 'the one is like the other', by making Hillela 'like a man'. It is, however, only in the area of her sexuality or sexual appetite that Hillela is compared to a man. And even this comparison is lop-sided as men's sexuality is never evaluated in terms of how satisfying it is to their partner(s) – not that it should not be. It would appear as though Gordimer is implying that sexual pleasure is an undisputed male preserve.

If, in the words of Trinh T. Minh-ha, the purpose of women's writing is to 'communicate, express, witness, impose, instruct, redeem, or save – at any rate to ... send out *an unambiguous message*,'[16] then we will have to say that Nadine Gordimer, in *A Sport of Nature*, has subverted this goal rather than meet the challenge outlined for women writers.

Notes

Paper read at the Africian Studies Association Annual Conference, Baltimore, MD, 1–4 November 1990.

1. bell hooks, *Ain't I a Woman: Black Women and Feminism* (Boston: South End Press, 1981), p. 7.

2. Marie Umeh, 'Poetics of Thwarted Sensitivity,' in *Critical Theory and African Literature,* ed. Ernest N. Emenyonu (Ibadan: Heinemann Educational, 1987, p. 195.

3. South African writer Bessie Head's prolific output includes the following: *When Rainclouds Gather* (London: Gollancz, 1968); *Maru* (London: Gollancz, 1971); *A Question of Power* (London: Heinemann, 1974); *The Collector of Treasures and Other Botswana Village Tales* (London: Heinemann, 1977); *Serowe, Village of the Rainwind* (London: Heinemann, 1981); *A Bewitched Crossroads: An African Saga* (Johannesburg: Ad Donker, 1984); *Tales of Tenderness and Power* (London: Heinemann, 1990); *A Woman Alone: Autobiographical Writings* (London: Heinemann, 1990).

4. Trinh T. Minh-ha, *Woman Native Other: Writing Postcoloniality and Feminism,* (Bloomington: Indiana University Press, 1989), pp. 6–7.

5. Piniel Shava, *A People's Voice: Black South African Writing in the Twentieth Century* (London: Zed Press, 1989), p. 68.

6. Huma Ibrahim, *African Studies Review* 33, 2 (September, 1990), p. 224.

7. Stephen Clingman, 'Writing in a Fractured Society: The Case of Nadine Gordimer,' in *Literature and Society in South Africa,* ed. Landeg White and Tim Couzens (Harlow: Longman, 1984), p. 162.

8. Nadine Gordimer, *My Son's Story* (New York: Farrar, Straus and Giroux, 1990).

9. Lauretta Ngcobo, *And They Didn't Die* (London: Virago, 1987).

10. Nadine Gordimer, *A Sport of Nature* (London: Penguin, 1987).

11. Nadine Gordimer, *Burger's Daughter* (New York: Viking, 1979).

12. Lewis Nkosi, *Mating Birds* (Johannesburg: Ravan Press, 1987).

13. Zoe Wicomb, *You Can't Get Lost in Cape Town* (New York: Pantheon, 1987).

14. Linda Weinhouse, 'The Deconstruction of Victory: Gordimer's *A Sport of Nature*,' *Research in African Literature* 21, 2, (summer, 1990), p. 99.

15. Elizabeth Badinter, *The Unopposite Sex. The End of the Gender Battle* (New York: Collins and Harper & Row, 1989), p. 153.

16. Minh-ha, *Woman, Native, Other*, p. 16.

LA 'PRISE D'ECRITURE' DES FEMMES FRANCOPHONES D'AFRIQUE NOIRE

Irène Assiba d'Almeida

Pour déterminer la place des femmes francophones d'Afrique noire dans le discours et la production littéraires, il est indispensable de se situer dans un cadre diachronique qui permettra de tracer l'évolution de la démarche qui a mené ces écrivaines à une 'prise d'écriture.'

Les femmes sont arrivées tard sur la scène littéraire pour ce qui est de l'écrit puisque leurs oeuvres datent seulement des années 1970. On sait qu'il n'en est pas de même dans 'l'orature'[1] où les femmes jouaient déjà un rôle important. Un domaine de la recherche qui reste encore insuffisamment exploré est celui de la participation féminine à cette orature, participation dont il faudrait cerner l'ampleur. Au point où en est la recherche actuelle, on met aujourd'hui beaucoup l'accent sur les femmes en tant que conteuses dans la tradition orale, mais des enquêtes plus approfondies s'avèrent nécessaires pour déterminer leur participation aux autres formes d'orature et notamment leur rôle en tant que griottes.

Nous nous proposons donc ici d'aborder ce que nous appellerons 'la prise d'écriture' des femmes francophones et ceci en trois temps didactiques. Le premier consistera à donner un bref aperçu de la manière dont les femmes ont été perçues dans la littérature masculine et que nous définissons tout simplement comme littérature écrite par des hommes, le deuxième tracera l'itinéraire de la

venue des femmes à l'écriture et exposera l'originalité de leur approche de ce mode d'expression; le troisième enfin tentera d'analyser comment ces femmes ont pu se servir idéologiquement et artistiquement de l'écriture en prenant pour exemples concrets, Aminata Sow Fall[2] et Werewere Liking.[3]

L'image des femmes dans la littérature masculine

De nombreuses études ont été faites sur l'image des femmes dans la littérature masculine et toutes ces études tendent à prouver que la femme est presque toujours présentée sous deux angles caractéristiques.[4]

1. *La mère*. Idéalisée, notamment à cause de son rôle sacré de porteuse de la race. Cette image s'étendant métaphoriquement à la terre en général et à la terre africaine en particulier, la femme/mère devient donc un archétype, le symbole de vie; non plus simplement mère, mais La Mère, la Mère Afrique. Image obsessive de la poésie de la Négritude et véritable cliché de la littérature masculine.

2. *Le faire-valoir*. D'autre part, la femme est rarement un personnage principal aussi bien dans la trame narrative que dans la thématique où elle occupe une place tout-à-fait secondaire, se situe donc à l'arrière-plan et ne se trouve définie que par rapport aux hommes.

Il y a cependant des exceptions à ces tendances générales. La plus frappante étant sans doute celle de Sembène Ousmane dont les personnages féminins jouent un rôle tout-à-fait prépondérant dans les luttes socio-politiques du continent. En effet, l'étude de la majorité des oeuvres de Sembène Ousmane montre qu'il a pour sa part, toujours donné de la femme une image à la fois réaliste et tournée vers le progrès.

La venue des femmes à l'écriture

En 1948, l'*Anthologie de la nouvelle poésie Nègre et Malgache de langue française*, de Léopold Sédar Senghor[5] ne comportait aucune femme. En 1972, le *Who's Who in African Literature: Biographies, Works, Commentaries* de Janheinz Jahn et alii,[6] ne comprenait que sept femmes et parmi elles, une seule francophone, Annette M'Baye d'Erneville du Sénégal. En 1983, le *Dictionnaire des oeuvres littéraires négro-africaines de langue française* dirigé par Ambroise Kom[7] ne mentionnait toujours que douze femmes.

Mais les choses ont changé depuis lors et c'est maintenant un nombre grandissant de femmes écrivains qui s'expriment dans tous les genres: poésie, théâtre, roman, nouvelle et aussi dans le genre de l'essai. En effet, en 1985, Christine H. Guyonneau publie 'Francophone Women Writers from Sub-Saharan Africa', bibliographie qui comporte le nombre impressionnant de trois cents soixante sept titres.[8] Cette bibliographie exhaustive regroupe des écrivaines dans tous les

genres établis et aussi des auteures d'autobiographies, de journaux, d'essais, de notes de lectures, d'interviews, de thèses.

Les femmes sont venues tard à l'écriture à cause de la conjonction de la colonisation d'une part, et des croyances traditionnelles de l'autre. L'école coloniale en effet, a été un domaine ouvert aux hommes d'abord.[9] De leur coté, les forces de la tradition ayant une conception bien définie des rôles des hommes et des femmes dans la société ont également freiné l'accés des filles à l'éducation. Mais ici aussi, les choses ont changé. Après avoir été réduites au silence littéraire pendant si longtemps, les femmes procèdent à une véritable 'prise d'écriture' pour faire revivre le rôle qu'elles jouaient dans la production de l'orature. Aujourd'hui cependant, elles racontent leurs histoires modernes par l'intermédiaire de l'écrit. En effet, de même que l'on prend la parole pour parler, de même que l'on prend position pour une cause, de même que l'on prend des décisions qui affectent notre existence et celles des autres, de même, la femme prend l'écriture pour écrire et surtout s'écrire. Cette prise d'écriture s'inscrit donc dans un mouvement parfaitement conscient; un acte dans le sens le plus complet du terme.

Mais quelles sont les femmes qui écrivent et quelle est au juste leur conception de l'écriture?

Les écrivaines se situent dans la diversité. Femmes africaines vivant en Afrique pour la plupart, femmes africaines vivant en Europe comme Calyxte Béyala ou afro-françaises comme Catherine N'Diaye,[10] femmes des Antilles vivant ou ayant vécu en Afrique et dont l'univers romanesque a souvent pour toile de fond le continent africain, comme Myriam Warner-Vieyra ou encore Maryse Condé. Pour elles, écrire est un moyen de se trouver, de définir sa propre place dans le monde. Comme le dit Calixthe Beyala:

> Je crois que dans l'écriture, on cherche avant tout à se connaître, à communiquer quelque chose qu'on a découvert et qu'on ne peut garder pour soi. C'est à la fois un accomplissement, une remise en cause permanente de soi et des autres. (85)[11]

A partir du moment où les femmes se mettent à écrire, elles ne sont plus perçues, ni même étudiées de façon mythique ou symbolique mais comme de vrais êtres humains de chair et d'os, des êtres à part entière. C'est dans cette perspective que Mariama Bâ affirme: 'Les chants nostalgiques dédiés à la mère africaine confondue dans les angoisses d'homme à la Mère Afrique ne nous suffisent plus' ('Fonction,' 7).[12]

Mais l'écriture c'est aussi une oeuvre d'art qui se veut exigence comme en témoigne Werewere Liking:

Je n'ai pas une écriture conventionnelle. Elle est difficile à faire accepter, parce qu'elle travaille sur elle-même en tant que forme d'art . . . Les écrivains africains se souciaient plus, jusqu'à présent, du fond que de la forme alors que la littérature est un art. Du grand art. Le texte doit atteindre une certaine sensibilité des fibres, plus importante que la soif d'anecdotes. ('La Femme' 70)

Catherine N'Diaye pour sa part, réitère cette idée du travail de l'artiste, idée exprimée en des termes qui pourraient passer pour élitistes, mais qui en réalité réclame la dose d'exigence nécessaire pour atteindre au véritable 'métier' d'écrivain:

En quête d'identité, nos écrivains croyaient souffrir d'un manque. Ils ont cru qu'ils avaient le devoir de répondre à un besoin – de boucher un creux. En fait, ils voulaient inconsciemment, naïvement, oblitérer la littérature. Oublieux qu'ils étaient de ce que le désir d'écrire ne peut jamais naître du simple besoin – de ce que l'art ne saurait surgir d'un manque trivial. (1) Il y a une condition *sine qua non* à l'effet esthétique, c'est cette conversion du besoin en désir. C'est à cette condition qu'on invente une autre beauté; il faut convertir le manque d'être jusqu'à le rendre méconnaissable.

(1) Le désir ne s'oppose pas tant au besoin parce qu'il est fantasmatique et que le besoin s'adresse au réel – mais c'est surtout que le besoin est grégaire, collectif, commun, tandis que le désir est unique, singulier. Cette opposition conduit à celle de la langue et du style. La langue du besoin, c'est la langue de tout le monde, la langue commune; elle n'a rien à voir avec le style, c'est-à-dire l'invention d'une écriture qui fait le véritable métier d'écrivain ... car ce n'est jamais qu'un métier. Les professions de foi et les recueils d'anecdotes ne sont donc pas de la littérature. (159–60)

L'écriture, c'est enfin une force de libération. Dans les textes de sciences humaines qui se consacrent à la femme africaine il semble toujours y avoir une dichotomie entre espace privé et espace public. Les femmes, en Afrique de l'Ouest tout particulièrement ont toujours été présentes dans l'espace public même si elles devaient parfois se soumettre à quelques restrictions au sein de cette même sphère. Cependant, l'avantage principal que semble présenter l'écriture c'est de lever ces restrictions. En d'autres termes, ce que l'on ne peut pas faire, ce que l'on ne peut pas dire, on peut l'écrire. L'écriture permet donc de 'dire' l'interdit. C'est sans doute pour cette raison que les femmes utilisent le langage artistiquement mais pour faire passer un message. C'est encore Mariama Bâ qui affirme: 'Les livres sont une arme, une arme pacifique peut-être, mais une arme tout de même' (Interview, 214).[13] Les femmes profitent donc de l'avantage que leur donne ce nouveau mode d'expression pour se voir non plus en tant qu'objet, mais en tant que sujet. Non plus à la périphérie mais au centre pour débattre de sujets qui les intéressent, qui les préoccupent, qui les émeuvent, pour aborder les problèmes

de sexe, de race, de classe dans une perspective souvent fémino-centrique et avec une conscience très nette d'appartenir à un prétendu 'Tiers-Monde.'

Que font donc les femmes de cette nouvelle arme qu'est l'écriture?

Abordant un vaste champ qui tourne autour de sujets divers, il semble que chez les francophones, le passage de l'oral à l'écrit se soit traduit, dans un premier temps par des écrits autobiographiques qui se contentaient de narrer des vies, sans remettre en question ni les institutions, ni la place que la femme y occupait. C'était donc une thématique 'sûre' et peu susceptible de bouleverser l'ordre établi.[14]

Le deuxième temps de la prise d'écriture des femmes est au contraire caractérisé par une attitude plus radicale qui repense, de façon plus critique, tout ce qui concerne la condition féminine: la place de la femme dans la société, les relations humaines en général et la manière dont elles affectent les femmes au sein des institutions telles que le mariage et la polygamie, la maternité, l'éducation des enfants.

Cependant, de plus en plus, ces femmes vont au delà des problèmes purement 'féminins' pour aborder ce que nous appellerions la problématique de l'"existence authentique.'

La problematique de l'"existence authentique'

L'authenticité est une notion importante parmi les colonisés. Dans le discours du quotidien, est authentique, ce qui est vrai, réel, ce qui est attesté et certifié conforme à l'original; c'est ce dont la réalité, la 'vérité' ne peut être contestée. Or à l'ère du mouvement de la Négritude, être authentique, c'était être fidèle à l'Afrique des origines.

Comme on le sait, le concept d'authenticité a été utilisé comme outil politique dans des pays tels que le Zaïre et le Togo pour n'en citer que quelques uns. Cette authenticité nous paraît aujourd'hui plutôt cosmétique et superficielle en ceci qu'elle consiste à adopter très *officiellement* des vêtements africains, à se débarrasser des noms occidentaux dits 'de baptême' pour des noms africains, etc.

Nous reviendrons plus longuement sur ce sens de l'authenticité qui, même s'il a servi de force de manipulation, même s'il est à présent devenu un terme 'usé' et lourd de connotations de tous genres, n'en demeure pas moins une préoccupation importante des colonisés reflétée, en partie, dans la littérature féminine. Au préalable nous voudrions nous pencher sur l'authenticité telle que l'entend David Holbrook dans son ouvrage théorique intitulé *The Novel and Authenticity*[15] (Roman et authenticité) et dans lequel, se plaçant dans une perspective interdisciplinaire faisant appel à la philosophie, l'anthropologie et la psychanalyse, il explore le concept d'authenticité dans le roman britannique des XIXe

et XXe siècles. Selon Holbrook, la littérature serait un mode particulier de connaissance qui repose en grande partie sur un élément d'intégrité, lui-même lié au concept du 'vrai moi' ou du vrai soi (the true self). Concept qu'il emprunte à D.W. Winnicot. La plus grande contribution de Winnicot, 'penseur contemporain le plus créatif dans le domaine de la psychothérapie depuis Freud' (15-15), dit Holbrook, a sans doute été de nous donner le concept du 'vrai moi,' c'est-à-dire ce moi conscient de sa réalité et de son intégrité et cherchant à développer toutes ses potentialités.[16] De façon parallèle existe un 'faux moi' (false self):

'... Quand, au delà d'un certain point, le vrai moi est écrasé et appauvri par son environnement, il crée pour son propre bien et pour celui des autres, une alternative, un *faux moi* ... Celui-ci se conduit comme un 'gardien' du vrai moi, le cachant, le protégeant, dans l'espoir qu'un jour les circonstances deviendront peut-être suffisamment favorables pour qu'il puisse retourner dans le monde.' (15)

Cependant, si ce phénomène se reproduit trop souvent, le 'vrai moi' n'a plus l'occasion de se développer pleinement par lui-même et c'est pourquoi 'le but du thérapeute est d'encourager le rejet des toutes ces parties de la personnalité qui entravent un développement sain.' En d'autres termes: 'On doit se débarrasser de ce qui est faux et stérile' (15).

Pour en revenir à la littérature, Holbrook affirme que:

Le roman peut servir à enregistrer la quête de la réalisation du vrai moi, soit chez un personnage avec lequel le romancier s'identifie, soit en utilisant le roman comme une sorte de rêve créateur dans lequel les problèmes du vrai moi sont explorés. (16-17)

Il est certain que, choisir comme point de référence le concept Holbrookien de 'l'authenticité' qui se base sur la distinction que fait Winnicott entre le 'vrai' et le 'faux' moi pourrait porter à controverse, à une époque où la critique littéraire post-moderne consacre la fameuse 'dissolution du sujet' et dénie l'existence du moi. En effet, les concepts de Holbrook/Winnicot sont tirés de la psychologie du développement du sujet inspirée par Freud. Or, comme l'affirme Jean le Galliot: 'La notion du moi unitaire et stable, lucide et responsable avait été mise en pièces bien avant Freud' (12).[17] Cette notion a été attaquée plus vigoureusement par Lacan qui considère la notion de vrai/faux moi comme étant une dangereuse illusion. La critique post-lacanienne se fait plus incisive et plus décisive encore. Julia Kristeva par exemple, réfute, avec les féministes post-modernes, le présupposé selon lequel il existerait 'an essential unity of self through time and space termed *self-identity*' [une unité fondamentale du moi – à travers le temps et l'espace – que l'on pourrait appeler *identité du moi*] car 'the notion of a unified, or integrated, self is challenged by the idea that the self is fundamentally split between its conscious and uncounscious dimensions'

[la notion d'un moi unifié ou intégré est récusée par l'idée que le moi est fondamentalement divisé par des considérations liées au conscient et à l'inconscient] (Tong, 219).[18] Il est cependant important de dire que l'idée de 'dissolution du sujet' a elle-même été remise en question. Tout en montrant combien ce concept a été mal compris et mal interprété, Stanley Corngold par exemple relève les contradictions des tenants de la disparition du moi.[19] Nous plaçant dans une perspective plus résolument idéologique, nous ferons bien remarquer que la critique occidentale a été, pendant des siècles, tournée vers la recherche du moi. Il a fallu que les groupes opprimés se mettent à chercher leur identité, leur moi, pour que l'Institution littéraire en proclame la mort. Sans vouloir entrer dans ce débat qui n'est pas notre propos, il convient de noter que pour notre analyse, le choix du concept du vrai moi ne s'inscrit point dans la ligne d'une étude psychanalytique. De plus, rien ne nous oblige à faire de cette 'mort du sujet' un phénomène universel.

Ici, être authentique c'est donc être fidèle à soi-même, ce qui dans ce contexte s'ignifie être fidèle à son potentiel humain et vouloir réaliser ce potentiel. Vivre une existence authentique c'est se placer dans le monde de telle manière que l'on puisse enfin réaliser son 'moi.' Si nous tenons à l'importance du 'moi', nous percevons cependant le danger qui consisterait à souscrire entièrement à la dichotomie vrai/faux moi car c'est là une distinction arbitraire et relative.

Les réflexions qui précèdent suffiraient à justifier, s'il en était besoin, notre utilisation des concepts de Hollbrook/Winnicot car ces notions nous semblent être au coeur même de l'écriture des femmes. Elles préconisent en effet la formation d'un être authentique, en quête d'un 'vrai moi' et c'est autour de ces notions mêmes que nous voudrions analyser les oeuvres de deux romancières: *L'Appel des arènes* et *L'ex-père de la nation* d'Aminata Sow Fall d'une part, *Elle sera de jaspe et de corail* et *Orphée-Dafric* de Werewere Liking de l'autre.

Aminata Sow Fall

Ecrivaine sénégalaise, Aminata Sow Fall a produit quatre romans et plusieurs essais de critique littéraire. Romancière active, elle est présidente de l'Association des Ecrivains du Sénégal.

Son roman *L'appel des arènes* raconte l'histoire d'un jeune garçon, Nalla, qui est attiré par la lutte mais qui ne peut se rendre aux arènes parce que son père Ndioguou et sa mère Diattou ne lui permettent pas de s'y rendre. Le jeune garçon est cependant fasciné par la lutte et par tout ce qui se déroule dans le monde des arènes: les sonorités mystérieuses des tams-tams, les exploits des marabouts, l'éloquence des griots, l'enthousiasme des foules, l'adresse des lutteurs, les réactions des spectateurs. Cependant, Nalla doit renoncer à tout cela parce que ses parents, membres de la nouvelle bourgeoisie africaine, pensent que ce sport

que l'on devrait 'laisser aux gens grossiers qui n'ont aucune civilisation' (65) est bien trop barbare pour ce fils dont Diattou veut faire 'un modèle conforme à sa propre conception de l'âge moderne' (61).

Aminata Sow Fall utilise cette histoire à l'intrigue plutôt mince pour montrer ici comment le 'vrai moi' est contrecarré chez l'enfant lorsque ses parents ont eux-mêmes perdu leur 'vrai moi.' Cette perte est parfaitement résumée par Monsieur Niang, le maître de Nalla, qui note dans son carnet de bord:

L'aliénation est assurément la plus grande mutilation que puisse subir un homme ... Le désordre qui bouleverse le monde a pour cause l'aliénation collective ... Chacun refuse d'être soi-même ... L'homme perd ses racines et l'homme sans racines est pareil à un arbre sans racines. Il se dessèche et meurt. ... Le refus de Diattou et de Ndiogou, leur obstination à vouloir détourner Nalla des tam-tams, c'est le rejet d'une partie de leurs racines ... Et ils renieront progressivement d'autres parties de leurs racines sans jamais réussir à les compenser par des racines appartenant à d'autres. Ils se trouveront alors dans la position inconfortable de celui qui trébuche éternellement sur un fil suspendu dans le vide, ne pouvant poser le pied ni à droite, ni à gauche ... C'est cela l'aliénation, et c'est ce qui guette ce couple ... Déséquilibre physique ... Déséquilibre spirituel ... Déséquilibre mental. (67)

Ce déséquilibre ronge petit à petit le couple mais il s'incarne de façon plus marquée en Diattou que Ndiogou avait épousée parce qu'il avait cru reconnaître en elle 'une intelligence ... capable de prendre ses distances par rapport au passé' (100). Diattou en effet s'est empressée de rejeter le passé en bloc, et d'adopter des principes nouveaux sans les avoir assimilés, adaptés, repensés, mis à l'épreuve. Le résultat est bien sûr catastrophique. Ndiogou et Diattou se coupent de tous liens familiaux et engendrent un fils d'abord insatisfait et malheureux puis antagoniste et rebelle.

Sow Fall montre bien que le 'vrai moi' ne peut se réaliser qu'au sein même de certains paramètres culturels. Considérer ses propres racines comme un 'faux moi' revient à initier un déséquilibre de la personnalité. Diattou qui s'est isolée elle-même est à son tour isolée par les autres, notamment à la maternité où elle travaille mais ne peut plus exercer ses fonctions de sage-femme car elle est accusée d'être une 'demm' ou une sorcière 'mangeuse de bébés.' Cette réputation lui est venue après un incident où elle chasse de sa maison Birama, camarade de jeux de son fils. Peu de temps après, l'enfant tombe malade et meurt. Devant les accusations dont elle est l'objet, Diattou déménage, puis veut quitter la ville. Elle devient névrosée, et ironiquement, se retrouve paralysée par des croyances qu'elle jugeait autrefois rétrogrades et irrationnelles, mais qui aujourd'hui influent sur sa vie au point d'en faire une recluse incapable de mener une vie familiale, sociale ou professionnelle.

Dans l'univers romanesque de Fall, les arènes ont donc une portée qui va bien au delà des jeux qu'elles abritent. En effet, Malaw, grand lutteur, roi des arènes surnommé 'Lion du Kajoor' ne se livre pas simplement à un sport. Il remplit aussi la mission que lui avait confiée son père face à la désintégration de Diaminar, leur village:

Assieds-toi, Malaw. Je veux te parler ... Diaminar se meurt. Tous nos fils sont allés se perdre dans la grande ville. L'euphorie passera ... La solitude les frappera tous ... Ils seront au bord du précipice. Il faudra les sauver avant qu'ils ne s'y engouffrent ... Sauve-les mon fils. Va à Louga. Ouvre des arènes et remue-les. Fais-y bouillonner le tam-tam comme une mer en furie ... Qu'il gronde, et qu'il gronde! Ils l'entendront, et ceux qui ne sont pas les damnés éternels finiront par venir parce qu'ils ne pourront pas résister à l'appel de la terre. (128)

Les arènes on l'aura compris deviennent donc une métaphore de la tradition, la pierre angulaire de l'être, une métaphore de la terre-mère elle-même, soubassement essentiel de la recherche du 'vrai moi' régénéré. On pourrait ajouter que les arènes sont aussi sur le plan social, la métaphore d'un nouvel humanisme qui ne sera possible que lorsque chaque membre de la société contemporaine aura accepté de trouver son 'vrai moi' et de mener une existence authentique en recherchant un équilibre fécond entre les valeurs d'antan et les exigences d'aujourd'hui.

L'Ex-père de la nation en revanche met en jeu Madiama, ancien infirmier qui s'insurge contre certaines pratiques irrégulières perpétrées dans le dispensaire où il travaille et écope six mois de prison pour avoir osé parler. Au sortir de prison, il forme un syndicat qui le mènera à la députation puis à la présidence, et c'est là qu'il montrera sa très grande propension à ne pas être fidèle au 'vrai moi' tel que l'avait défini auparavant Winnicott.

Madiama a pourtant tout pour réussir sur le plan humain. Issu d'une famille aux fondations solides et profondes, son père l'avait envoyé à l'école pour 'y acquérir assez de savoir pour laver la terre d'un peu de ses souillures' (95) et c'est pour ces mêmes raisons que plus tard, il choisira la profession d'infirmier. Armé de sa devise 'Humanité, Justice, Vérité' (48), il est en effet plein de bonnes intentions mais se retrouve très vite à la tête d'un régime politique bien plus répressif et corrompu que ceux que, jadis, il critiquait et combattait. A la fin de son règne, relégué dans le cachot où l'a conduit un coup-d'état, il avoue: '... Moi, Son Excellence en désillusion, je poursuivrai mes détours dans le labyrinthe de ma conscience obscurcie par huit années de règne, de sécheresse, de faim et de malheur' (8).

Tout le drame de l'absence du 'vrai moi' se joue à nouveau dans le personnage fort ambigu de Madiama. Cette ambiguïté est reflétée dans les traits contradictoires qui constituent sa personnalité. Madiama est d'une effrayante naïveté pour un homme d'état qui se propose de jouer le rôle de 'Père de la Nation.' Il pense,

à cet égard, qu'il suffit d'aimer son pays et d'avoir du coeur pour mener à bien la tâche qu'il se donne dès le début de son mandat : conduire son peuple vers le bonheur. Très tôt sa mère lui avait inculqué la notion selon laquelle 'le plus grand champ de bataille se trouve dans le coeur' (60), et son père lui avait affirmé que 'sans le coeur, le savoir n'est rien' (95). Madiama très naïvement a intériorisé ces valeurs positives mais ignore que le coeur, à lui seul, ne saurait suffire à fonder la raison d'état.

Madiama témoigne d'une grande naïveté en ceci qu'il ne perçoit jamais les dangers réels qui l'entourent et ce manque total de clairvoyance précipitera sa chute. En effet, il ne s'imagine pas d'ennemis mais seulement des adversaires; il sous-estime gravement la détermination du peuple à mettre un frein aux atrocités du régime. Alors que la foule déchaînée marche sur son 'château,' il attribue ce déchaînement à un simple défoulement et prépare dans le calme son message de démission en rêvant à la 'belle sortie' qu'il se propose de faire. De surcroît, il se leurre en pensant que, dans une période transitoire, l'administration qui prendra la relève lui prêtera une maison en attendant de pouvoir récupérer la sienne mise en location. Il se voit redevenu infirmier pour 'donner l'exemple' et allant jusqu'à dire: 'je reprendrais aussi mes activités au Syndicat pour faire triompher des principes et non pour faire de la politique politicienne' (116).

L'aveuglement de Madiama éclate aussi dans ses rapports avec les membres de son entourage auxquels il accorde une confiance absolue. Il lui arrive cependant d'avoir des doutes, mais préfère adopter la politique de l'autruche. A force de compromis, il glisse très vite sur la voie des compromissions.

Le grand paradoxe de Madiama est qu'il a en même temps un sens très élevé du devoir et de la moralité et désire gouverner dans la 'propreté,' valeur importante revêtant une signification toute particulière dans sa famille; il avait fait le serment de ne jamais trahir le peuple; d'éviter la honte, de haïr la laideur. Cependant, il y a d'énormes lézardes dans son édifice de moralité: il flirte avec 'l'autorité coloniale' personnifiée par Andru son conseiller spécial; il cède aussi à la tentation de la violence et de la répression et une fois cette machine mise en marche, Madiama est pris dans un engrenage qui rend désormais l'escalade de la violence inévitable. Son régime passe de la répression à la dictature, puis à la tyrannie.

Dans ce roman, la question pivot que se pose précisément Aminata Sow Fall est de savoir 'comment naissent et se maintiennent les tyrannies' (157). Et très vite on en vient à comprendre qu'il y a dans cet assujettissement des peuples une responsabilité collective: celle des tyrans bien sûr mais aussi celle de ceux qui se laissent ainsi tyranniser. Pour Madiama, 'c'est le peuple qui fait les tyrans' (157) par sa passivité, son acceptation de faits et d'actions inacceptables:

Ça grognait sous cape … Ça grognait mais personne ne bougeait … On s'était habitué aux chars aux coins des rues, aux policiers armés, partout; aux fouilles méthodiques avant d'accéder à un ministère, aux files interminables au com-

missariat pour payer l'autorisation de voyager ... Tout pouvait faire croire que les restrictions étaient devenues une espèce de routine qu'il n'était plus question de remettre en cause ... (150)

Cependant, le peuple n'est pas tout-à-fait passif. Une résistance s'organise menée par Dicko dont le nom rappelle celui de Steve Biko, le résistant assassiné par la police d'Afrique du Sud. Comme lui, Dicko refuse de se faire acheter par le régime. De plus, il fait montre d'une telle force de caractère que Madiama et Andru hésitent à exécuter leur plan machiavélique qui consiste à le 'suicider.'

Il faut dire que même avant l'escalade irréversible de la répression, Madiama avait fait son propre examen de conscience et décidé de démissionner. Ses compromissions l'ayant rempli de honte et de dégoût, il avait avoué: 'Il m'était clairement apparu que moi-même j'avais maintes fois dévié de la ligne que je m'étais tracée' (81). Ceci montre bien à quel point Madiama reste conscient de ses propres actions. Il est même d'une extrême lucidité pour juger ses limites. Il est évident que Madiama sait qu'il a un 'vrai moi.' Il a en lui un idéal, une conscience, un énorme potentiel. Mais, pas plus que son peuple, Madiama ne s'est hissé à ce degré de vertus morales et civiques nécessaires pour réaliser ce potentiel, créant ainsi un hiatus immense entre ses idéaux et sa praxis. Ni lui, ni le peuple qu'il était sensé gouverner n'ont réussi à mener une existence authentique. Les conséquences sont tragiques pour Madiama lui-même et la nation en général car Madiama qui aurait pu être *l'expert* de cette nation, n'est réduit qu'à en être *l'ex-père* déchu.

Aminata Sow Fall a réussi un véritable coup de maître en choisissant Madiama comme héros central de son roman. Grâce à une analyse à la fois très sévère mais très humaine de ce personnage, elle a montré de façon magistrale que l'ambiguïté et la complexité de Madiama n'ont d'égales que l'ambiguïté et la complexité de la condition socio-politique de l'Afrique contemporaine. La solution pour briser cette chaîne de malheurs et d'injustices ne se situe ni dans les bonnes intentions, ni dans la facilité. Trouver son 'vrai moi,' vivre une existence authentique sont des entreprises d'une extrême exigence. L'échec de Madiama représente dans l'esprit de Sow Fall la faillite de toute entreprise dès lors qu'elle est coupée des vraies valeurs du moi authentique.

Werewere Liking

Werewere Liking pour sa part est une artiste dans le plein sens du mot. Elle n'est pas seulement romancière, elle est également poète, dramaturge, essayiste, peintre, chercheur. Son oeuvre est un cri de colère contre une société à laquelle elle reste cependant farouchement attachée, une société qui malgré tout lui est chère et, bien plus passionnément que toute autre, elle préconise une recherche sans relâche du 'vrai moi' tant au niveau collectif qu'à celui de l'individu.

Toutefois, Liking est prescriptive en ce sens que ses personnages affirment, par leurs paroles comme par leurs actes, que la réalisation du potentiel humain passe nécessairement par le rituel, par la redécouverte de la spiritualité.

Dans *Elle sera de jaspe et de corail*, les voix narratives se multiplient, se succèdent, s'interrogent et se répondent pour se faire entendre mais aussi pour opérer, comme par un chant incantatoire, une transformation si radicale qu'elle devrait changer nos vues fondamentales sur le langage lui-même, sur l'histoire, la culture, les valeurs, la 'vérité.'

Ce roman est loin d'être un roman 'traditionnel' et le paratexte annonce que l'ouvrage est un chant-roman, titre justifié par les envolées lyriques qui parsèment le texte; un chant-roman qui est aussi un journal composé de neuf pages d'un impitoyable réquisitoire de l'Afrique, le journal d'une 'misovire,' mot forgé par Werewere Liking pour désigner 'une femme qui n'arrive pas à trouver un homme admirable' ('A la rencontre', 21).

D'autre part dans son introduction ou 'avant-verbe,' la narratrice nous révèle qu'elle se livre à un texte-jeu, jeu qui ne relève pas vraiment du domaine ludique puisqu'il n'a rien d'amusant, bien qu'il soit plein d'humour par endroit. Il s'agit plutôt d'un jeu créateur, donc d'un jeu sérieux, à la fois cruellement satirique et plein de compassion, désespéré et rempli d'espoir.

Ce chant-roman/texte-jeu/journal d'or-de-bord décrit Lunaï, village imaginaire d'Afrique qui symbolise l'Afrique entière. Lunaï nous est offert, telle qu'il est vu par la narratrice-misovire, telle qu'il est vécu par Grozi et Babou, 'couple singulier' d'intellectuels qui devisent, impuissants, sur Lunaï qui s'appelait autrefois 'berceau en coeur' ou 'coeur en berceau' car cette terre avait emergé – en forme de coeur – après une catastrophe qui l'avait engloutie. Mais, grâce à l'envahisseur et aux autochtones eux-mêmes il a dégénéré pour devenir 'un village merdeux et merdique' (13), 'un village fangeux et lubrique' (14), un village 'trop-mot': 'On dit toujours les mêmes mots à Lunaï et à n'importe qui toujours les mêmes mots à n'importe quel moment. C'est normal finalement: Lunaï c'est déjà trop mot!' (38). C'est aussi 'un village fatidique' peuplé de tsé-tsés et où cohabitent misère et opulence. On y manque désespérément d'inspiration, de désir, d'art autre que 'l'art autobiographique' (113) puisqu'il n'y a plus de langage efficace et que 'tout est marchandise' (111). On y est réduit à marcher yeux et oreilles fermés et à s'ennuyer à mourir.

Face à cette chronique non-vie, la misovire va créer, par le biais de l'écrit, une nouvelle race, celle qui, comme l'indique le titre de l'ouvrage, sera 'de jaspe et de corail ... de souffle et de feu' (10). Pour que naisse cette nouvelle race, la misovire elle-même symbole de l'Afrique devra en toute lucidité et sans complaisance 'se raconter en se redécouvrant après s'être laissée ballotter entre le diagnostic du mauvais départ et celui de l'étranglement' (Makhele, 42).[20]

Afin de dénouer l'étranglement et de se lancer sur la route pour un nouveau départ, il faut très fermement croire à une possibilité de régénération car 'un peuple

ne tombe jamais totalement en faillite' (9) s'il consent à la rigueur de l'initiation puisque 'Ce qu'il nous faudrait à nous / C'est une Initiation / Rigoureuse comme un couperet' (151), s'il consent à l'effort consistant à retrouver les richesses de son 'vrai moi':

> Les sources sont intarissables qui puisent dans l'utilisation des cent pour cent des potentialités humaines. On les découvrira par le système de l'initiation et elles seront aussi variées que les individus et leur différents génies. (32)

Le peuple entier sera alors en mesure de mener une existence authentique, de 'tout repenser, tout reformuler, tout reconstruire.' (33) Si Liking met l'accent sur le rôle de la communauté dans *Elle sera de jaspe et de corail* bien que ce soit la misovire qui 'conscientise' la collectivité, dans *Orphée-Dafric*, la responsabilité du 'vrai moi' incombe avant tout à l'individu.

Orphée-Dafric qui est une réadaptation du mythe antique d'Orphée retrace l'histoire d'un homme lui aussi dénommé Orphée et de sa femme Nyango qui, voulant la bénédiction de leur parents, de leur société et de leurs dieux, acceptent de passer par une épreuve. Celle-ci consiste à traverser sans encombre le Fleuve Blanc. Mais c'est la saison des crues et leur kayac chavire. Orphée parvient à regagner le rivage, mais Nyango elle, est engloutie par les eaux. Le fleuve rend toujours ses victimes au bout du troisième jour, mais le neuvième jour passe sans qu'il n'y ait eu la moindre trace de Nyango. Celle-ci est présumée morte. Orphée refuse cependant de croire à la mort de Nyango et se met en route pour retrouver sa bien-aimée. Son voyage devient un voyage initiatique où les enseignements des ancêtres prennent une place de choix. Orphée se souvient par exemple d'une opposition fondamentale que faisait alors son père entre les concepts de l'*être* et de l'*avoir*.

> *Autrefois*, disait mon père, le verbe 'être' prédominait: il fallait être digne de son clan, de sa tribu, être fier de soi ou être honteux de ses actes. L'ambition la plus haute? Etre un ancêtre, c'est-à-dire maîtriser suffisamment de connaissance à transmettre à la tribu, pouvoir la protéger et lui permettre plus de créativité.
>
> *Aujourd'hui*, nous n'attendons de la vie que ce qui entre dans le cadre de l'avoir: avoir des honneurs même si on en est indigne, avoir des richesses même si on est égoïste et ingrat, même si on est idiot, avoir l'amour des autres même si on est salaud, avoir la puissance même si on est un danger public. (35)[21]

Werewere Liking en appelle à une régénération du moi par le biais de cette métamorphose existentielle que la quête d'Orphée, la 'quête de l'essentiel' rend possible. Au terme de son voyage, les ancêtres révèlent à Orphée qu'ils avaient fait disparaître Nyango pour l'obliger à aller jusqu'au bout de ses propres limites, au bout de son 'vrai moi.' La quête est donc véritablement double: quête de l'autre et quête de soi.

Comme Fall, Liking montre que la tâche est solitaire et semée d'embûches, que 'Le chemin a des creux / profonds et dangereux' (48), mais que les résultats sont inestimables, permettant d'accéder à un nouveau mode d'existence. Cette régénéressence pourrait se faire selon Liking par l'intermédiaire d'une forme de spiritualité, celle que l'on trouverait par exemple dans le silence: Orphée se souvient ainsi que son père lui disait: 'Chaque homme devrait s'imposer au moins un mois de silence dans sa vie, pour prendre conscience, pour comprendre la vie, et pour savoir pourquoi il y a un Dieu' (20). Ayant réalisé cette expérience, Orphée propose au lecteur d'en faire autant, suggérant par là-même une réflexion terme à terme quant à la nature de ce 'bruit':

> Quand on se tait, on est assailli par le bruit … Faites donc l'expérience: taisez-vous! Le bruit est en vous. Il aspire à la vie. Vous devez la lui donner. Vous êtes né pour créer, pour donner, pour renouveler la vie. (20)

Il s'agit là d'un bruissement du 'vrai moi' par rapport au tintamarre des fausses valeurs. Cependant, autant le silence est important pour la qualité de la vie intérieure, autant l'est la parole qu'il faut savoir écouter, prononcer, maîtriser. Cette parole composée de 'mots-force' a une portée insoupçonnée car 'un mot tisse une chaîne de réactions qui se poursuivent jusqu'à l'infini' (20). Pour utiliser plus judicieusement les mots, il faudrait redécouvrir la 'grande parole', celle qui fonde la sagesse ancestrale, retrouver 'le verbe perdu', celui-là même que les 'manieurs de la parole thérapeutique' utilisaient autrefois pour maîtriser le mal 'par la 'juste' combinaison des sons, par le poids du mot 'juste'' (23).

Le silence intérieur, comme la parole lourde de sens, sont une forme de spiritualité préconisée par le père d'Orphée lorsqu'il remet en question 'l'humanisme africain' auquel Orphée, disciple inavoué de Senghor, croit – sans pouvoir expliquer ce que cette notion recouvre de façon concrète. Son père l'invite donc à remplacer cet humanisme informe par une vie venue du dedans:

> Et ton humanisme? Ne pourrais-tu pas te réjouir de trouver Dieu en toi alors que le monde le cherche au ciel? N'es-tu pas heureux d'éponger la souffrance et de toujours essayer de la remplacer par l'harmonie et la paix? (43)

Il est toutefois important de souligner que la spiritualité qu' entrevoit Werewere Liking n'a pas grand chose à voir avec un Dieu quelconque et qu'elle n'est pas une invite à la passivité qui consisterait à attendre, bras ballants, que la manne nous vienne du ciel:

> Il faudra une puissance supérieure pour régler nos problèmes, mais elle n'est pas ailleurs qu'en nous-mêmes … Il s'agit de la réveiller, de la mettre en action, et les arbres pousseront à notre appel, et les montagnes se déplaceront au son de notre voix. (58)

Il est donc évident que Werewere Liking met l'accent sur le voyage initiatique comme forme de réappropriation de la connaissance dévoilant à l'individu le travail à accomplir, travail qui passe avant tout par la participation individuelle. Orphée exprime cette réalité en avouant son désir d'être lui-même et non tout un peuple. De surcroît, il désire se libérer de sa société elle-même car cette dernière n'est plus fidèle à ses propres valeurs. Dès lors Orphée affirme sa nouvelle prise de position: 'Je m'empoigne à pleines mains et me vide de l'indigéré, du non-assimilé. Je me râpe, me cure, j'extirpe. Et nu, je me relève. Je repars' (51).

Ayant passé par l'apprentissage de l'équilibre, de l'amour, ayant réfléchi sur la voie à suivre, il est en effet à même de repartir sur de nouvelles bases. Il a compris qu'un nouveau départ s'imposait mais qu'il fallait pour cela se préparer, redéfinir son idéal en le plaçant le plus haut possible, reformuler la notion de progrès, réinventer les valeurs, répartir comme le voulait Aminata Sow Fall les tâches entre dirigeants et dirigés, retrouver le 'code,' redéfinir l'humanisme africain pour le rendre plus efficace, plus performant. Il aura fallu au préalable 'accepter de payer, de compenser nos dettes. Accepter la rétribution de nos action ... chercher les causes, pour mieux comprendre les effets' (52).

Une conscience aiguë de toutes ces exigences acquises, Orphée pourra désormais être celui qui guide, car 'les dirigeants doivent être des initiés' (56). Ayant passé par toutes les épreuves qui mènent à la maturation, Orphée affirme avec Nyango:

> Sans trêve nous indiquerons la voie
> Et tant pis pour ceux qui regardent le doigt
> Plutôt que l'objet indiqué ... (68)

Orphée mérite sa fonction de nouveau guide car il a réalisé son 'vrai moi' en se laissant pénétrer des sages paroles des ancêtres: '... Toi, tu dois être/ celui qui dépouille, analyse/ celui qui sélectionne, synthétise/ celui qui réadapte et actualise' (44), et il a fait sien cet enseignement-conseil clé:

> Il n'y a rien de mieux à faire
> Qu'à être profondément soi-même
> Comme on est
> Quant on l'est ...
> Découvre-toi va
> Va et sois ... (64)

C'est quand l'individu aura réalisé son 'vrai moi' que, à l'instar d'Orphée, il deviendra un membre plus efficace du groupe qui s'en trouvera lui-même fortifié au point de pouvoir réussir les transformations profondes dont dépend sa survie.

Conclusion

Pour terminer, nous voudrions revenir à Holbrook qui affirme que:Le roman ne peut accéder à la grandeur que s'il prête attention à ce problème de l'authenticité, au sens d'une totale intégrité. Cela veut dire, en termes plus traditionnels, que le vrai roman ne peut qu'être écrit à partir d'une préoccupation morale qui n'est pas tant synonyme de bon ou de mauvais comportement que de ce que les êtres humains perçoivent comme étant la fidélité à leur moi. (18)

Et c'est là que se situe la différence car, chez les écrivaines africaines, la recherche de l'authenticité comme celle de l'intégrité a une portée hautement morale. Dans leurs écrits, le 'vrai moi,' semble être, d'une part, le refus de la tradition lorsqu'elle est au service de la manipulation sociale, lorsqu'elle sert d'échappatoire à la responsabilité individuelle, et de l'autre, l'adhésion à la tradition, dans ce qu'elle a de positif, dans ce qu'elle peut offrir à l'individu de régénération. L'existence authentique devient donc la réalisation intègre, pleine et entière de ses potentialités en tant qu'individu.

Alors que les écrivains africains insistent plus généralement sur la communauté, les écrivaines elles, mettent l'accent sur l'individu, non pas pour prôner l'individualisme, mais pour mettre ses potentialités au service de cette même communauté. A cet égard, exister c'est être dans le monde, mais dans le sens que Merleau-Ponty[22] donne à l'ex-istence, c'est-à-dire une 'sortie de soi' pour faire retour à autrui.

Alors que les écrivains semblent chercher un nouvel ordre économique et politique, les écrivaines sont à la recherche d'un nouvel ordre moral restitué par la quête individuelle du 'vrai moi.' Comme nous l'avons vu, il convenait, bien sûr, de nuancer cette notion de 'vrai moi' car, après tout, ce 'vrai' ne renvoie qu'à des vérités locales, personnelles, ponctuelles et à une recherche identitaire donnée dans un contexte socio-politique bien déterminé. Cette nuance ne devrait toutefois pas empêcher de comprendre que dans la perspective étudiée ici, mener une existence authentique revient à se resituer dans le monde pour soi et pour les autres et à réaliser ses propres potentialités dans la complétude et l'intégrité. Ainsi donc, les écrivaines africaines, en se servant de l'écriture pour développer de nouveaux paradigmes de critique morale fondés sur le rôle prépondérant de l'individu comme facteur de changement de la société, partagent bien la conviction d'Adorno[23] pour qui l'art d'écrire ne se situe plus simplement dans le domaine de ce qui est, mais également dans le domaine de ce qui est possible.

Notes

1. Mot-concept forgé par l'écrivain kenyan Ngugi wa Thiong'o et formé par la juxtaposition des mots oralité et littérature. De même que la littérature

152 *Moving Beyond Boundaries*

est l'ensemble des écrits, l'orature est l'ensemble des manifestations artistiques orales. Le mot orature est un excellent substitut du terme 'littérature orale' qui a un caractère anachronique et qui subordonne l'oralité à l'écriture.

2. Aminata Sow Fall, *L'Appel des arènes* (Dakar, Les Nouvelles Editions Africaines, 1982); *L'Ex-père de la nation* (Paris, L'Harmattan, 1987).
3. Werewere Liking, *Orphée-Dafric*, Roman & Manuna Ma Njok, *Orphee d'Afrique*, Théâtre Rituel (Paris, Editions L'Harmattan, 1981); 'La Femme par qui le scandale arrive,' interview recueillie par Sennen Andriamirado, *Jeune Afrique* 1172 (22 juin, 1983); *Elle sera de jaspe et de corail* (Paris, L'Harmattan, 1983); 'A la rencontre de ... Werewere Liking,' Propos recueillis par Bernard Magnier, *Notre Libraire*, 79 (1985).
4. Voir Anne Lippert, *The Changing Role of Women as Viewed in the Literature of English Speaking and French Speaking West Africa*, thèse de doctorat, Université d'Indiana, 1971; Sonia Lee, *L'image de la femme dans le roman francophone de l'Afrique Occidentale*, thèse de doctorat, Université de Massachusetts, 1974; Arlette Chemain-Degrange, *Emancipation féminine et roman africain*. Dakar: Nouvelles Editions Africaines, 1980. Voir aussi l'introduction de *Women Writers in Black Africa*, Lloyd W. Brown, Westport, Connecticut: Greenwood Press, 1981.
5. (Paris, Presses Universitaires de France, 1948, 2e ed., 1972).
6. (Tubingen, Federal Republic of Germany, Horst Erdmann Verlag, 1972).
7. (Sherbrooke, Editions Naaman & Paris, Agence de Cooperation Culturelle & Technique, 1983).
8. Subtitled 'A Preliminary Bibliography' and published in *Callaloo* 24 (1985): 453-83. Cette bibliographie recense des oeuvres de femmes exclusivement. Cependant les notes de lectures, mémoires, thèses et essais critiques sur leurs oeuvres sont écrits par des femmes comme par des hommes.
9. Voir par exemple, Diane Barthel. 'Women's Educational Experience under Colonialism: Toward a Diachronic Model,' in *Signs: Journal of Women in Culture and Society* 11,1 (1985) 137-54.
10. *Gens de Sable* (Paris, P.O.L., 1984).
11. 'Interview' dans *Amina*, 223 (novembre, 1988).
12. 'Fonction des littératures africaines écrites,' *Ecriture française dans le monde*, 3,5 (1981): 3-7. See also 'Interview avec Barbara Harrell-Bond,' trad. Olivia Jamin, *The African Book Publishing Record*, 6 (1980): 209-14.
13. Mariama Bâ, 'Interview avec Barbara Harrell-Bond,' *The African Book Publishing Record*, 6 (1980): 209-214. Cette interview, enregistrée en français a été traduite en anglais par Olivia Jamin, puis retraduite ici par l'auteure de cet article.
14. Il est intéressant de noter que contrairement aux anglophones chez qui l'autobiographie est beaucoup moins courante, les femmes francophones ont développé ce genre. Voir: Aoua Keita, *Femme d'Afrique. La vie d'Aoua Keita racontée par elle-même*. Paris: Présence Africaine, 1975; Nafissatou N. Diallo,

De Dakar au Plateau, une enfance dakaroise, Dakar: NEA, 1977; Andrée Blouin, *My Country Africa: Autobiography of the Black Pasionaria*, New York: Praeger Publishers, 1983; Akissi Kouadio, *Impossible amour: une ivoirienne raconte*. Abidjan: INADES-Edition, 1983; Adja Ndéye Boury Niaye, *Le collier de Cheville*, Dakar: Les Nouvelles Editions Africaines, 1983 et plus récemment, Kesso Barry, *Kesso, Princesse peuhle*, Paris: Seghers, 1988.

15. David Holbrook, *The Novel and Authenticity* (London, Vision Press Limited, 1987).
16. Voir D.W. Winnicott. 'Ego Distortion in Terms of True and False Self,' in *The Maturational Processes and the Facilitation Environment*. London: Hogarth Press and the Institute of Psycho-Analysis, 1966.
17. Jean Le Galliot et al., *Psychanalyse et langages littéraires. Théorie et Pratique* (Paris, Editions Fernand Nathan, 1977).
18. Rosemary Tong, 'Postmodern Feminism,' *Feminist Thought. A Comprehensive Introduction* (Boulder & San Francisco, Westview Press, 1989). Voir aussi Linda J. Nicholson, ed. *Feminist Postmodernism*. New York & London, 1990.
19. Stanley Corngold. *The Fate of the Self. German Writers and French Theory*. New York, Columbia University Press, 1986. Voir en particulier l'introduction de cet ouvrage, pp. 1-19. Voir aussi l'introduction de Philip Beitchman. *I am a Process with No Subject*. Gainsville: University of Florida Press, 1988, pp. 1-26.
20. Caya Makhele, 'Werewere Liking, *Elle sera de jaspe et de corail*', Note de lecture, *Notre Librairie*, 79 (1985).
21. Le souligné de certains mots sont le fait de l'auteure de cet article.
22. Maurice Merleau-Ponty, *Existence et dialectique*, Textes choisis par Maurice Dayan (Paris, Presses Universitaires de France, 1971).
23. Theodore Adorno, *Aesthetic Theory* (London & Boston, Routledge & Kegan Paul, 1984).

History, Identity and the Constitution of the Female Subject: Maryse Condé's *Tituba*

Jeanne Garane

Maryse Condé is not the first to take an interest, however slight, in the historical personnage Tituba. In fact, she has several predecessors within the realm of letters. Henry Wadsworth Longfellow, in *Giles Corey of the Salem Farms*, William Carlos

Williams in *Tituba's Children*, and Arthur Miller in *The Crucible* have each chosen Tituba to play a role, however minor, in their plays, and Ann Petry has written a historical novel about her for young people, entitled *Tituba of Salem Village*.[1] Tituba also figures briefly in many of the accounts of the Salem outbreak of 1692, since she was one of the first three women to be accused of witchcraft in that community. Nevertheless, whether because of lack of interest or lack of information, Petry, writing in 1964, is the only writer before Condé to have made any attempt to 'reconstitute' Tituba fictionally in detail and, in so doing, bypass the uni-dimensional and often stereotypical nature of her characterization both in the historical documents and in the works of the aforementioned authors.

In 'The Metamorphosis of Tituba,' Chadwick Hansen[2] complains that in the literary works mentioned above (he does not mention Petry's work), Tituba has gradually been transformed from Carib Indian to African, implying that this transformation is racist. While I don't agree with him for a number of reasons,[3] his problematization of Tituba's 'origins' provides a context within which to study Condé's own treatment of Tituba. Hansen traces the gradual changes in Tituba's 'race'[4] from the moment she first appears in Salem Village, to her characterization in Arthur Miller's *The Crucible*. According to Hansen, Tituba was:

> a Carib Indian woman … and the slave of the Rev. Samuel Parris, who had brought her and her husband John to Salem Village from Barbados. She was involved in some of the occult experiments that began the Salem affair, although she was probably an assistant in these experiments rather than an instigator of them. The experiments themselves are identifiably English rather than Indian in origin. (p. 3)

Hansen notes further that, over the years, the magic Tituba practiced has been changed by historians and dramatists from English, to Indian, to African. Currently she is being represented (as in Arthur Miller's play, *The Crucible*) as a Negro practicing voodoo. There is no evidence to support these changes. Hansen states that the magic practiced was English in origin. In one case it involved divining by staring at egg-whites in a glass, as one would a crystal ball. In the other case, Tituba reportedly baked a 'witch-cake' at the suggestion of Mary Sibley, the aunt of one of the afflicted girls. 'Rye meal was mixed with the girls' urine to make a cake, which was baked in the fire and fed to the Parris dog, presumably on the theory that the animal was a familiar – a messenger assigned to a witch by the devil.' (p. 5) According to Hansen, then, there is no historical documentation to prove that Tituba was of African origin, or that she was practicing African or Indian magic.

Why then, and how, does Condé herself participate in the transformation of Tituba?[5] In its problematic dependence upon ocular observations of Tituba by the very colonists who imprisoned her, Hansen underscores the fact that Tituba's own voice is virtually non-existent. The only trace of her is in the transcription

of her 'confession' during the witch trials and there is really no way to know what her 'true origins' were. Thus, like her predecessors, Condé creates a history for Tituba which is only partially represented in the records of the Salem outbreak. Without trying to divine authorial intention, then, I examine Tituba's metamorphoses by juxtaposing Condé's novel with her own critical work on Caribbean women writers, *La Parole des femmes*.[6] By doing so, Condé the critic helps interpret Condé the novelist, and places *Tituba* in a corpus of works by Caribbean women writers that Condé herself helped to identify.

In danger of being forgotten by History, Tituba becomes a figure of a Caribbean history which the colonial archives either ignored, or never recorded, and which can only be (re)created through the imagination. In fact, Tituba repeatedly laments her omission from the official archives:

It seemed I was gradually being forgotten ... I would only be mentioned in passing ... there would be mention here and there of 'a slave originating from the West Indies and probably practicing 'hoodoo'. There would be no mention of my age or personality. I would be ignored. (p. 110)

Why was I to be ignored? ... Is it because nobody cares about a Negress and her trials and tribulations? Is that why? I can look for my story ... but it isn't there. (p. 149)

Tituba's historical anonymity can also be linked to the West Indian dilemma of identity. Speaking of the 'French' Antilles in particular, Alain Brossat sums up the West Indian predicament as follows:

The originality of the Antillean situation is precisely the absence of a pre-colonial homeland to which Antilleans can refer as though to their own history ... When Antillean nationalism wishes to evoke the historical roots of its fight, they are hidden and dispersed; they can only refer to myths, to an imagination which is more parabolic than historical.[7]

As the daughter of a white European and a black African, Tituba symbolizes West Indians who can look neither to Africa nor to Europe (nor, in Tituba's case to North America) for an affirming mirror. Rejected by her African mother because she is born of a rape by white European, Tituba incarnates the problem of West Indian identity. Born collectively of imperialist aggression, many West Indian nations are an 'offspring' rejected both by the aggressed (here, Africa) and ignored by the aggressor (Europe), and misunderstood by both. Because of this is(le)olation, West Indians must search for an independent identity, looking neither to Europe nor to Africa, but to a West Indian past for its (fictional) origins. Since this 'history' has been undocumented or lost, another must be created. In Tituba's case, Condé posits in her epilogue that 'the intentional or unintentional

racism of ... historians' (p. 183) is such that no one researched what became of Tituba after being released from prison in 1693. She goes on to say, 'I myself have given her an ending of my own choosing' (p. 183). By inventing Tituba's history, Condé participates in the creation of a West Indian history and identity. In this context, what modifications become operative when a West Indian woman pursues the problematic of history, subjectivity, and identity? According to Clarisse Zimra: 'of necessity, heroines have to redefine themselves both against the white and the black worlds, because they are women and because these worlds have been defined by men.'[8] Condé's historical invention thus inscribes itself within a double context: the West Indian search for identity and the quest for female subjectivity. As such, Condé's text could be defined as 'auto-gynographical' (borrowing Domna Stanton's term), inasmuch as the text 'constitute[s] the female subject,' but with an added dimension: it constitutes a female subject which has not only been seen as other in a phallocentric system, but also as 'racially' other within this system. To employ Stanton's theory further, in Condé's text, 'the "graphing" of the "auto" [is] an act of self-assertion that denie(s) and reverse(s)' Tituba's negative status. This 'autograph' gives the 'female "I"' substance through the inscription of an interior and an anterior,'[9] because, at last, Tituba's inner history is inscribed in History, albeit a mythical History. Here, then, Condé's use of the autobiographical 'I' is not merely to furnish an added touch of authenticity to her narrative. By choosing the 'I,' she allows Tituba, so long silenced and trivialized, to speak. Tituba is no longer a minor character in a historical document or play. Nor is she any longer Ann Petry's well-behaved but unjustly accused slave. Rather, in Condé's novel she embodies a revolutionary voice which speaks the complexities and problematics of West Indian identity. In the epigraph to the novel, the inscribing author states, 'Tituba and I lived for a year on the closest of terms. During our endless conversations she told me things she had confided to nobody else.' Tituba's ultimate creative act is the communication of her silenced story to the inscribing author, who then sets it down in autobiographical form. Tituba's struggles to attain the status of speaking subject when faced with objectification and anonymity thus contribute to reversing the objectification of an entire people and (re)creates a missing history, rooted in the Caribbean itself.

> In the West, traditional healers are called 'witchdoctors.'
> I always wondered how a doctor could be a witch.
>
> Miriam Makeba

Tituba becomes a figure who opposes white patriarchy in multiple ways, and in a manner which is consistent with a certain female tradition as perceived and related by Condé in *La Parole des femmes*. In that work, Condé writes, 'the role of women in liberation movements before and after the abolition of slavery has been greatly repressed' (*Parole*, p. 4). She concludes that beyond the two examples

of Nanny of the Maroons and Mulâtresse Solitude 'there are others that should be rediscovered' (*Parole*, p. 4). Condé carries out her own imperative by 'finding' Tituba's story, and inscribing it in a West Indian context. Condé thereby reverses the accusations levelled against Tituba, showing that for a woman from the Caribbean, 'witchcraft' was not something evil, but was simply an element of cultural praxis misunderstood and feared by westerners. Conrary to Ann Petry, whose Tituba possesses no supernatural abilities, Condé embraces the accusation, and makes it the very space from which Tituba opposes both patriarchal colonial discourse and cultural imperialism. For it is only when she comes into contact with Christianity, figured by the Reverend Samuel Parris and Susanna Endicott, that her particular religious practices are condemned as evil and satanic. As Tituba says: 'I do not belong to the civilization of the Bible and Bigotry' (p. 176). When her future husband, John Indian, calls her a witch (one indication that he is complicitous with the colonizers) she asks herself:

> Isn't the ability to communicate with the invisible world, to keep constant links with the dead, to care for others, to heal, a superior gift of nature that inspires respect, admiration, and gratitude? … Shouldn't the witch (if that's what the person who has this gift is to be called) be cherished and revered rather than feared? (p. 17)

Tituba's questioning of western Christianity's view of 'witchcraft' is rooted in a non-western value system. Her ability to communicate with the supernatural and her cultivation of this ability to the level of an art belong to a set of cultural practices brought from West Africa. In the African and West Indian context, communication with the supernatural combined with healing abilities have traditionally been religious in nature. Thus, her revolutionary discourse is centered in and grows out of thaumaturgy which is also, in a West Indian context, a theology. Thus, it is easy to see how Tituba, by practicing her art within and against an imposed western value system, becomes a threat to it.

The western conception of women as witches and, consequently, as potential threats to male power, must be compared and contrasted with Afro-Caribbean shamanism. Carol Karlsen writes in *The Devil in the Shape of a Woman* that, in the West,

> the story of witchcraft is primarily the story of women … Especially in its Western incarnation, witchcraft confronts us with ideas about women, with fears about women, with the place of women in society and with women themselves … It is associated with old age, frightful ugliness and female wickedness on one hand, with youth, beauty, and female sexual power on the other.[10]

African and Caribbean magical practices adhere to a different conception of women as 'witches.' In *La Parole des femmes* Condé explains:

It is a natural religion based on an intimate understanding of nature and of life, on a complicity with them … witches are not thought to be evil but are rather considered the natural intermediaries between the visible and the invisible worlds. (*Parole*, p. 54)[11]

In *Moi, Tituba, Sorcière*, Tituba is raised by a benevolent mother-figure who possesses 'the fine art' (p. 9) of communicating with the invisible. She teaches Tituba that 'everything lives, has a soul, and breathes. That everything must be respected. That man is not the master riding through his kingdom on horseback' (p. 9). According to Condé, in Africa and the Caribbean, such women, although reputed to be in communication with the supernatural, 'do not maintain any pact with evil spirits and are never considered to be outside the bounds of social behavior. On the contrary. They are included in a society which reserves a special place for them,' (*Parole*, p. 55), for there is 'an ancient tradition which sees women as the favored vehicles of supernatural powers' (*Parole*, p. 73). Once these differences are recognized and taken into account, it is nevertheless possible to construe Tituba's magical practices as subversive to white power structures. In this context, Tituba's powers create a space in which to say 'I' by opposing the religious and patriarchal ideology of the white oppressors both in Barbados and in New England and by affirming a religion where women are empowered. She thereby affirms her own subjectivity while working to found an identity for her people. Symbolically, after her death she becomes 'one and the same' (p. 177) with her island, and her opposition to white colonialist patriarchy ultimately culminates in an organized slave rebellion which she aids and abets through her powers.

According to Michelle Cliff, under white supremacy and under patriarchy, women of color suffer a 'double objectification.'

Objectification is 'the process by which people are dehumanized, made ghostlike (read: satanical), given the status of Other … The actual being is then denied speech: denied self-definition, self-realization [and] … selfhood … A group of human beings – a people – are denied their history, their language, their music. Their cultural values are ignored.[12]

When Tituba moves from the wilderness to the city, this process of objectification begins. By entering voluntarily into slavery in order to be with her husband John Indian, she is forced by her 'mistress' Susanna Endicott to study the catechism in preparation for an eventual conversion to Christianity. This is the condition under which Susanna Endicott will allow Tituba and John to remain together. John Indian tells her that 'not a year ago, Governor Dutton had two slaves who had been accused of dealing with Satan burned in the square at Bridgetown. For the whites that's what being a witch means … !' (p. 27). The implication is that if Tituba continues to practice her own religion, she, too, may be burned. For Tituba, converting to Christianity as Susanna Endicott wishes

her to, is not only to renounce her own culture but to pay allegiance to her oppressors by worshipping their god. Tituba vacillates on this issue until, one day, Susanna Endicott and her guests speak of Tituba as though she were nothing more than an object:

They were talking about me and yet ignoring me. They were striking me off the map of human beings. I was a nonbeing. Invisible … Tituba only existed insofar as these women let her exist. It was atrocious. Tituba became ugly, coarse, and inferior because they willed her so. (p. 24).

She is moved to revenge, in spite of the imprecations on the part of her 'invisibles' not to, since such an act would bring her down to the level of her oppressors. Nevertheless, Tituba opts to afflict Susanna Endicott with a debilitating and humiliating case of diarrhea which catches her in the presence of visitors. On her deathbed, Susanna Endicott vows to avenge herself: 'I know it's one of your spells that has put me in this condition … I want you to know that you may triumph today, but my turn will come tomorrow and I shall get my revenge. I shall get my revenge!' (p. 33). Indeed, throughout the novel, Tituba feels that perhaps her bad luck is in fact Susanna Endicott's revenge. Nevertheless, this somewhat burlesque example illustrates my point: through the practice of thaumaturgy Tituba transforms herself into an active subject and escapes objectification.

In her essay 'In Search of Our Mother's Gardens,' Alice Walker asks, 'What did it mean for a black woman to be an artist in our grandmothers' time? In our grandmothers' day? It is a question with an answer cruel enough to stop the blood.'[13] For Tituba it eventually means death by lynching because she has used her 'art' to heal slaves. After returning to Barbados, Tituba instigates an uprising with her lover Iphigene. The manner in which she is punished demonstrates her importance. In a perverse way, her executioners 'honor' her by choosing to make of her an example, a warning to the other slaves. Yet, Tituba is not really being lynched for establishing a supposed pact with the devil, but because of her revolutionary, liberating powers. The planter Errin sneers,

'Well witch! What they should have done to you in Boston, we're going to do here!' … I was the last to be led to the gallows, for I was to be given special treatment. The punishment that I had 'escaped' in Salem was now going to be inflicted on me. (p. 171)

Significantly, Tituba's executioners use the charge of 'witch' in its western misogynist sense, clearly demonstrating what Mary Daly posits in *Gyn/Ecology*: that the healing powers of midwives and herbal doctors made women direct threats to male authority. According to Daly:

During the witchcraze, the solution was to attribute female power to the 'fact' that they were tools of the devil, the rival of the Christian god, that is, of males

themselves. Thus the combination of spiritual and medical knowledge made good witches the epitome of 'evil' to the Christian persecutors.[14]

Tituba is thus lynched for rivalling the Christian god by practicing the cult of ancestors which gives her power, and for opposing white male patriarchy.

Hester to Tituba: 'I'll never make a feminist out of you!'

From the minor role assigned to her by historians and men of letters, Tituba's metamorphoses are many. Yet there is one transformation that Tituba never undergoes. She never becomes a 'feminist.' This is not to say that 'feminist' discourses (as critiques of male power structures) do not circulate within the novel. Tituba has several affairs, and at the beginning or end of each she hears this constant refrain from Abena: 'why can't women do without men?' and Mama Yaya remarks that 'men do not love. They possess. They subjugate' (p. 14). These remarks are especially pertinent to Tituba, because the woes that befall her, albeit within a colonial context, are due to her unfortunate relationships with men.

What is 'feminism' for Tituba? There are several answers. Condé states in *La Parole des femmes* that she does not write 'didactic novels' and thus not 'feminist' ones. Indeed, in *Moi, Tituba, Sorcière*, Condé opts for contradiction, as she did in the portrayal of Véronica in *Hérémakhonon*.[15] As in the case of *Hérémakhonon*, Condé perhaps could say, 'I thought that I should simply represent a very complex reality and allow the reader to chose by himself [sic]' (*Parole*, p. 127), perhaps finding that this open-endedness also corresponds to the ambiguities of West Indian identity. Condé's refusal of western feminism could also be due in part to the fact that *La Parole des femmes* was written during a period when western feminists were constructing a myth of global sisterhood that ignored differences among women. It was also during this period in the late 1970s that radical feminist separatism was prominent. In *La Parole des femmes*, Condé writes:

> one could search in vain in novels by Caribbean women writers for the noisy echo of feminist demands and for hatred of males who are perceived as dominant. It is much more a question of subtly critiquing the state of male–female relationships, of considering their problems or their degradations … this women's literature … is situated at the heart of preoccupations with the entire society. (p. 39)

While this view of western feminism as 'hatred of males' is inadequate, it is this view, I think, which informs both the term 'feminist' and the character Hester, and explains Tituba's refusal of 'feminism.' In this light, I read the differences between Hester and Tituba as exemplary of a certain relationship between womanism and feminism.

In her essay, 'White Woman Listen! Black Feminism and the Boundaries of Sisterhood,' Hazel Carby argues that simple parallels between racism and sexism deny 'the fact that women of color are subject to the simultaneous oppression

of patriarchy, class and "race".'[16] According to Carby, in order to account for the historical and contemporary position of women of color, 'some of the central categories and assumptions of recent mainstream feminist thought' must be challenged. Carby thus rejects a Dalyian radical feminist concept of a universal patriarchy which oppresses all women in like manner, such as that which Daly elaborates in *Gyn/Ecology*. Citing Audre Lorde's 'An Open Letter to Mary Daly,'[17] as an instance of response to this homogenizing tendency, she attemps to complexify the very general term 'patriarchy' by pointing out that 'racism ensures that black men do not have the same relations to patriarchal/capitalist hierarchies as white men.' Similarly, Alice Walker's definition of 'womanist' as one 'committed to survival and wholeness of entire people, male and female. Not a separatist ... ,' (p. xi) echoes Carby's statement about the relation of black males to white male patriarchal and capitalist hierarchy. It suggests that radical feminist separatism is unacceptable until all members of the oppressed group are liberated.

Carby thus wishes to complexify the concept of patriarchy in (radical) feminist thought to include racism as a structuring element in the oppression of women of color by white men and by white women. She suggests that 'both white feminist theory and practice have to recognize that white women stand in a power relation as oppressors of black women' (pp. 213–14). In *Tituba*, this power relation informs many of Tituba's relations with white women as well as with white men. Even though the white women are not feminists, and cannot be considered as emblematic of radical feminism, they are emblematic of a fact that western feminism has tended to ignore, that is, that white women have had a role in exploiting women of color. Thus, Tituba is oppressed because of 'race' and because of gender. The history of oppression by white masters, male and female, shared with others of African origin, male and female, consequently eliminates western (radical) feminism as a possibility for Tituba.

As such, Alice Walker's concept of 'womanism' more accurately describes a context in which to understand Tituba's ambiguous relationships with male and female white masters, as well as with Caribbean males. Whites in the novel, with the exception of Hester, a radical feminist, and Judah White, a witch, sooner or later perceive Tituba as an evil other whose alterity is immediately perceptible to them; she is black and thus wears the mark of the 'Black Man,' a term used by the Salem villagers to designate Satan. Indeed, while Tituba is chained in the corridor of Ipswich prison, Sarah Good asks her, 'Why did you leave your hell, Negress?' (p. 103) thereby conflating blackness with evil, and undermining any possible solidarity among women based on the ideal of 'sisterhood.'

Nevertheless, Tituba's opposition to feminism does not exclude the possibility of dialogue. In fact, Hester is Tituba's only real female friend (Mama Yaya and Abena are ancestor spirits). Tituba and Hester even seem to engage in a sexual relationship which remains more or less implicit. Further, after her suicide

Hester will continue to manifest her spirit to Tituba, thus continuing their friendly dialogue. The encounter between Tituba and Hester is placed at the center of the narrative. Imprisoned for the crime of adultery, Hester has Tituba brought into her own cell. She is positively coded by the narrator as having 'a mass of thick hair, black as a crow's wing ... her eyes were black ... like the benevolent shadow of night' (p. 95). Hester's black hair and eyes are the external signs of a complicity between the two. Indeed, Hester exclaims, 'what a magnificent color she's got for her skin' (p. 95). From the outset of their friendship, then, it is blackness which binds them. Sincle black is the color of sin in Puritan and, indeed, in western society, both are considered deviant. As Tituba remarks, the color of Hester's hair was 'itself the color of sin for some people and worthy of punishment' (p. 95). Thus, both are branded; Hester by the 'A,' and Tituba by her color, 'B.'[18]

While both are rejected by Puritan society, they also reject it themselves. Hester declares, 'it is not my society. Aren't I an outcast like yourself? Locked up between these walls?' (p. 196) As a radical feminist, Hester rejects the patronym, saying to Tituba, 'you accepted the name a man gave you?' (p. 96) When Tituba asserts the positive qualities of witchcraft Hester answers this question by mocking Cotton Mather's discourses. In so doing, she questions the patriarchal authority of the Church which allows miraculous power to be held only by 'emissaries of the Lord' (p. 96). Despite this solidarity between the two women, many differences remain. For example, Hester's scornful condemnation of Tituba's name as one coming from a man can in no way take into account the fact that Tituba is not a patronym, nor was it given to her by her 'real' father, the English sailor who raped Tituba's mother. Rather, it was her mother's African husband, Yao, who named Tituba:

> He took me in his big bony hands and annointed my forehead ... holding me up by the feet, he presented me to the four corners of the horizon. It is he who gave me my name: Tituba. Ti-Tu-Ba ... Yao probably invented it to prove that I was the daughter of his will and imagination. Daughter of his love. (p. 6)

Yao's desire to name the child, to claim it as his own, is also an attempt to repair the humiliation of his people. 'It seemed to him that the child's humiliation symbolized the condition of his entire people: defeated, dispersed, and auctioned off' (p. 5). Consequently, there can be no comparison between a western feminist rejection of the patronym and the process of naming as empowerment in the context of the diaspora. This is especially true in Tituba's case, since her mother is unable to look at her without remembering her assailant.

The difference between womanism and feminism here lies in context. In the African diaspora, a separatist society of women would be unthinkable for Tituba, who in the end will die for the liberation of her people as a whole. As has been

noted, the circulation of feminist discourse in the novel seems to be a 'subtle critique of male-female relationships' (*Parole*, p. 127). Nevertheless, as Condé points out, difficulties between West Indian men and women are first and foremost the result of colonial interference. Slavery, immigration, and neo-imperialism prohibit 'normal' relations. Condé writes in *La parole des femmes* that 'it is the social structure of a domination, the exploitation of which black people are victims that do not allow people to be happy and which destroy couples' (*Parole*, p. 35). This is why, if there is an oppositional discourse that could be generally defined as 'feminist,' it is primarily directed toward white males.

In the end, then, Tituba implies that white western feminists must help alter an exploitative imperialist society. In the epilogue to the novel, Tituba declares that Hester 'is pursuing her dreams of creating a world of women that will be more just and more humane' (p. 178). Yet, each woman 'remains on her side of the ocean' (p. 178). Indeed, Tituba remains active in her struggle for the liberation of Barbados as she beomes one with the island and its people.

Finally, it is in the context of the colonization of an entire people that Condé's fictional inventions can be understood. If Tituba has indeed been transformed in Maryse Condé's novel, then she has changed in a manner that is particularly fitting to the Caribbean from whence she came.

Notes

1. See Henry Wadsworth Longfellow, *Giles Corey of the Salem Farms* (Boston and New York, 1910); William Carlos Williams, *Tituba's Children*, in *Many Loves and Other Plays* (New York: New Directions, 1965); Arthur Miller, *The Crucible* (New York: Penguin, 1977); Ann Petry, *Tituba of Salem Village* (New York: Crowell, 1964).

2. 'The Metamorphosis of Tituba, Or Why American Intellectuals Can't Tell an Indian Witch from a Negro,' *New England Quarterly* 40 (1 March 1974), pp. 3–12. The title alone is problematic in that it assumes 'race' to be an essential category. Further, one could posit that the inhabitants of Salem Village, in calling Tituba an 'Indian Woman,' were simply designating her by her place of origin, the West Indies. They also could have been designating her by her husband's last name, which was 'Indian.' Finally, according to Peter Hulme in *Colonial Encounters: Europe and the Native Caribbean, 1492–1797* (London: Methuen, 1986), by the time the British arrived on Barbados, the native population had completely disappeared.

3. 'More startlingly,' writes Hansen, 'her own race has been changed from Indian, to half-Indian and half-Negro, to Negro'(3). Hansen seems to be conflating these transformations from 'Indian' to 'Negro' with a *degradation* rather than insisting on the stereotypical portrayals as degrading.

4. I place the term 'race' in quotation marks to indicate that I use it under erasure. See *'Race, Writing, and Difference,'* ed. Henry Louis Gates, Jr. (Chicago: University of Chicago Press, 1986), a series of essays which investigate and/or deconstruct 'race' as a category.

5. Maryse Condé, *Moi, Tituba, Sorcière Noire de Salem* (Paris: Mercure de France, 1986).

6. Maryse Condé, *La Parole des femmes. Essai sur les romancières des Antilles de langue française* (Paris: L'Harmattan, 1979). All translations are mine.

7. Alain Brossat, 'Fin de l'Histoire?' Introduction to *Les Antilles dans l'Impasse?* (Paris: Editions Caribéennes, 1981), pp. 43–4. My translation.

8. Clarisse Zimra, 'Patterns of Liberation in Contemporary Women Writers,' *L'Esprit Créateur* 27, (1977), p. 103.

9. Domna Stanton, 'Autogynography: is the Subject Different?' in *The Female Autograph. Theory and Practice of Autobiography from the Tenth to the Twentieth Century* ed. D.C. Stanton (Chicago: University of Chicago Press, 1987), p. 14.

10. Carol Karlsen, *The Devil in the Shape of a Woman. Witchcraft in Colonial New England* (New York: Norton, 1987), pp. xi, xii.

11. Although Condé uses the word *sorcière*, ('witch') this term should be understood as referring to a traditional healer or shaman. As Ina Césaire shows in her study of women in traditional Antillean folktales, evil witches are not absent from the Antillean imaginary. As in the West, the witch, or *la diablesse* or *guiablesse*, is both old and ugly and young and beautiful, and is capable of seducing men and then killing them. See Ina Césaire, 'La Triade humaine dans le conte antillais,' *Présence Africaine* 121–2 (1982), pp. 142–53.

12. Michelle Cliff, 'Object into Subject: Some Thoughts on the Work of Black Women Artists,' *Heresies* 15 (1982), pp. 35–40. I refer to Cliff in spite of her problematic use of terms such as 'actual being' and 'the real experience of being,' because she helps elucidate the effects of cultural imperialism.

13. Alice Walker, *In Search of Our Mother's Gardens* (New York: Harvest/HBJ, 1983), p. 233.

14. Mary Daly, *Gyn/Ecology. The Metaethics of Radical Feminism* (Boston: Beacon Press, 1978), p. 194.

15. Maryse Condé, *Hérémakhonon* (Paris: Union Générale des Editions, 1976).

16. Hazel Carby, 'White Woman Listen! Black Feminism and the Boundaries of Sisterhood,' *The Empire Strikes Back. Race and Racism in '70s Britain* (New York and Oxford: Oxford University Press, 1987), p. 213.

17. Audre Lorde, 'An Open Letter to Mary Daly,' in *Sister Outsider* (Freedom, CA: Crossing Press, 1984) pp. 66–71.

18. Of course, in the novel, 'B' is for burglary.

Strategies of Identity in Afro-Ecuadorian Fiction: Chiriboga's *Bajo la piel de los tambores/Under the Skin of the Drums*

Carol Beane

not too good, not too bad; not too beautiful, not too common looking; not overly intelligent, not excessively stupid; not too white, not too black ...[1]

... the uncenteredness associated with psychic and physical oppression can often be overcome or helped by reconnecting with the personal narratives of the past.[2]

In Latin America, considerations of class are primary factors in how people define color; definitions of race are most frequently a function of color. The ambiguity and ambivalence of color definitions contribute to prejudice and discrimination which are consistently more subtle and imprecise than direct. When complex issues of race, color, and class appear in literature, the author clearly has set for himself or herself problems of literary strategy: how to incorporate these subjects into a work of the imagination? How most effectively to present characters in situations in which they respond to various constructs of race, color, and class?

There are numerous routes towards this end. Nelson Estupiñán Bass and Adalberto Ortiz are the two twentieth-century Ecuadorian authors who most persistently have written race, color, and class into their fiction.[3] Themselves Afro-Hispanic, these prolific writers, whose literary production extends over some forty years, have contextualized race, color, and class in political settings and by means of economic activity.

In contrast to their approaches to these subjects, we can examine the more personal, less epic exploration rendering of them that another writer, Luz Argentina Chiriboga, also of Afro-Hispanic background, has contributed to her country's literature, and to the corpus of fiction about blacks in Latin America, in her novel, *Bajo la piel de los tambores* (1991).

Many manifestations of women's creativity have begun on or at a kitchen table. Alice Walker, Paule Marshall, Gloria Naylor, Toni Morrison, Barbara Christian, bell hooks, Gloria Hull, Hazel Carby, Carole Boyce Davies, and numerous other writers and critics have demonstrated and discussed how African American women writers have centered their texts in the homeplace, the proverbial 'kitchen table' with its complex resonances of family, particularly mothers, grandmothers, and girlfriends.[4] Generational bonds acquire a special weight. Mothers with daughters are important; however, the grandmother and grand-

daughter relationship is an especially privileged one in the writing of many African American, Chicana, Latina, Asian American, and Native American women.[5]

bell hooks in *Yearning: Race, Gender, and Cultural Politics*, elaborates on the significance of homeplace for black women writers. She acknowledges it as a space fraught with tumultuous memories of the Middle Passage, of separations; sometimes, it has been a place of abuse, a source of confusion. The concept of homeplace for blacks and whites conflates: for blacks it might also be place where they did work for whites; the Big House, homeplace for whites, was workplace for blacks, and sometimes, too, it was homeplace. However, for women, and particularly for black women, historically, it has been the locus of sustenance and nurturing for the individual and the family. hooks explores literary responses to conditions, deliberately organized during slavery times and perpetuated in the post-slavery periods, to extirpate humanity, compassion, family, time, place, and history of one's own, to destroy creativity. Survival depended on the homeplace where black women affirmed self and culture, organized subtle schemes of resistance. It afforded protection. It was there where women prepared food, braided hair, spun and wove, stitched garments and pieced together quilts, read; where they taught their children with stories, which, like the quilts, contained memories of intimate tales and events, which encompassed other threads and other kinds of histories – the social, the economic, the labor, agricultural, botanical, aesthetics, music. Names, dates, places, phrases. Both the oral and the written become the fabric of telling, of transmitting inherited history, lore; forming stories that strive to merge into a continuous fabric of identity and knowledge. 'Grandma's stories' as Trinh T. Minh-ha calls them.[6] To come to these stories, told often around the kitchen table, is to return to the root, to learn calm and quietude. With words, characters destroy and create. Words create space, structure place, manifest desire, urgency and affirmation. As readers informed by history, we are cognizant of the multiple significances of homeplace.

Given the historical common ground of slavery which peoples of the African diaspora share, it is not surprising to encounter this point of departure, the homeplace, expressed in various ways in diaspora literature. Cuban poet Nancy Morejón has said that she always begins her poetry readings with a poem about her mother, profoundly centered in a sustaining home. In the works of other Latin American women authors, variations in theme, story, detail, and strategy emerge as consequences of the authors' imagination and circumstances. The necessity to articulate certain perceptions of life resolves itself. Homeplace, as a concept, assumes new configurations.

We find one such example in the work of Luz Argentina Chiriboga. Motivated first by her desire to express her perceptions of experiences as a woman, Chiriboga writes about identity and place. Being a woman from Esmeraldas, the region of Ecuador having the greatest population of people of African descent, and having used Esmeraldas as one of the two places where she situates the action of her

novel, the experiences Chiriboga describes necessarily address race, color, and class.

The action of *Bajo la piel de los tambores (Under the Skin of the Drums)* moves between Esmeraldas on the Pacific coast and Quito in the Andean highlands. Its protagonist, Rebeca González, is a young mulatto woman of modest background. As a student at a convent boarding school in Quito – microcosm of Ecuadorian society – with school-mates who find her accent from the coast intriguing, Rebeca indulges in liberating sexual adventures. At the same time she remains cautiously reticent about her family and social circumstances. While she forges her alternative identity at school, she keeps as her touchstones, remembrances of small details of the home and family she has left behind (pp. 12ff). Only a visit home and a confrontation with a woman panning for gold on the beach enable Rebeca fully to accept who she is. Place is essential to her articulation of identity.

In this first novel Chiriboga extends the meaning of homeplace that hooks has formulated to include hometown. Using the protagonist's dead grandmother as the dominant structuring principle in her character's development, the author creates a situation wherein the grandmother's influence ultimately is responsible for altering Rebeca's attitudes towards herself as affected by class and color. As the novel unfolds, we see how Chiriboga presents the Afro-Ecuadorian 'homeplace.' Chiriboga's encompasses more than the familial space of the protagonist's parents' modest home: the kitchen where plantains are roasted – the fragrance is evocative, despite being stated rather than described (p. 104); the small room with its glass windows and view of the river to which Rebeca's mother retreats to watch the sunsets in tranquil solitude (p. 101). Homeplace extends to the town, to the region. Every object, person, sensation, and action provoke memories which are both private and yet rich with public historical allusions. Both aspects – the personal and the societal – are necessary in order for memory to conduce to a realization of the protagonist's more complete identity. Chiriboga gives us not so much Grandma's stories, as fragments of and allusions to Grandma's world.

When Chiriboga writes about place and identity she does so by conjuring the dynamic energies – physical, sensual, mental, historical, spiritual – that inform her characters' minds and bodies, making them creative, aware, and critical of the constraints and possibilities their lives offer them. She writes obliquely and forcefully of race, class, and color and their insinuatingly subtle effects on identity and society. To be a racially mixed person and to deny one part of one's racial or ethnic heritage in favor of another is to be of a mind in need of decolonization – resonances of Fanon and Ngugi wa Thiong'o. This is Rebeca González's condition at the beginning of the novel. The author approaches the significance of possessing a space wherein the one decolonizes the mind, restores self, and protects family in an elliptical way. She supplies the reader's consciousness with

minimalist details which are none the less weighty with connotations and associations. This is also her strategy for presenting issues of race, color, and class. Utilizing the evocative presence of home, the conventional metaphor for self/ego/identity, Chiriboga encumbers it with assumptions and complexes about color, class, and race; these are the problems to be resolved.

In Quito, for Rebeca, physical signs of race as markers of identity diminish in importance due to ambiguities; codes of behavior insert themselves, signifying class, and implying color and race. There she fills her life outside class with masquerades and revelry, adventures of sensuality and exploration. This is the way she responds to her self in the city, in that silence without stories, dispossessed of the colors and sounds that the vivid, textured descriptions of life in Esmeraldas bring to her soul, as we read in the novel's final section. However, the convent school ambience does allow Rebeca to control information about herself and her life prior to school; her strategies are suppression, omission, and reticence. This internalized, oppressive behavior imposes constraints on her, the resolution of which occurs in the novel's third and final section. When Rebeca's schoolfriends arrive in Oriki to visit her parents, the entire house and everything on the trip – the wharf, the beaches, the river, the crowds on the steamboat, her family, of course, but also the washerwomen on the river banks, the young boys fishing, the women panning for gold – complicitously challenge Rebeca's silences about herself and her world. Historical allusions, though imprecise, are essential to Chiriboga's formulation of Rebeca's identity and her taking possession of her self.

The novel depicts her hometown through her eyes, and also those of her friends. They see as outsiders, responding with astonishment and amazement to what, for them, is the unfamiliar. However, we see Rebeca savoring other details that her friends do not perceive: the rich brown color of the young boys fishing on the shore (p. 101), the dark, glistening skin of the women washing clothes, and those who pan for gold (p. 104). The reader participates in Rebeca's perceptions of emotion, sensation, and color, which, experienced in the strong light of tropical regions, are particularly intense and complex. This setting, this place, exerts a more substantial authority over Rebeca than does the boarding school. The homeplace elicits responses from her that oblige her to break the silence and to cease obfuscating her identity. Never mind that her friends may never realize that the wealth implicit in pastures filled with grazing cattle and the fine china – rented from a neighbor – they see on the table in Rebeca's home are fictions of class and aspirations she has elaborated. In the context of Rebeca's earlier reticences, we can read the misrepresentations as signs of dissatisfaction with the family possessions, viewed as extensions of herself. However, countering and undermining all moves to disassociate from a social class – her family appears to be of modest circumstances – are the stories that Rebeca's father tells, and her mother's routine, with its interludes of calm.

Chiriboga takes advantage of the mother's respite from household actvities to narrate the story of Rebeca's maternal grandmother, the adventurous one, the woman who traveled. It was, perhaps, a requisite journey to the Continent to 'finish' properly young people of a certain social class. However, since Rebeca's story does not mention a companion or chaperone, this detail leads us towards a different class interpretation of the grandmother's European tour. We are told that, in Paris, she did see 'all those things that must seen …'. One remembers that in Paris, in the 1920s, she also might have seen the ethnographic collections of the Museé de l'Homme with its eclectic holdings of empire. For the young woman from Ecuador, though, Paris itself would have sufficed as exotica; the artifacts in the collections might have struck her as uninteresting and too familiar.

As if to emphasize the granddaughter's suppression of memories and presences that belie any connection with her African heritage, the text offers us very few anecdotes about Rebeca's black grandmother. None the less, the reclaiming of connections proceeds schematically and metonymically. The objects of memory Chiriboga employs are rife with associations. Let us first examine those contained in the narrative frame of Rebeca's encounter with the women panning for gold. During colonial times, Ecuador, together with modern-day Colombia, was known as New Granada. The region of Esmeraldas is an example of formerly isolated communities of black peasants and fishermen who maintained their distinctive culture well into the twentieth century. In the eighteenth century, as slavery declined in the region, its population of free blacks and mulattoes increased.[7] Mining for gold had been established by the Spanish Crown as one of the primary slave-based economies of New Granada; to this day, mining continues in the area, although with greatly diminished yields. As an historical gloss, however, Chiriboga's reference to mining, to the specks of gold glinting in the sunlight (p. 104), evokes the slave revolts and maroon attacks that occurred in the gold fields of New Granada throughout the eighteenth century.[8] The reference then becomes a statement of character: the women panning for gold are physically and spiritually strong, despite their poverty and low social class.

Although employing the vaguest of allusions, Chiriboga's treatment of this encounter nevertheless provides Rebeca's grandmother with an anecdotal narrative space, one which posits an adversarial relation based on race and class identity between the black women and the Creole elite. The pretensions with which Rebeca receives her guests from Quito ally her with this elite. None the less, her own knowledge about the lives and history which constitute her hometown – not only her family, but her friend, black Adela, whose father died in a saw-mill strike; the woman who had been carried off the steamboat in a hammock, deathly sick from diving for pearls in the mangroves; the women on the beach and their gold nuggets – all subvert Rebeca's urge to disconnect from her homeplace.

The encounter between Rebeca and the women on the beach is an encounter of identities. They know who she is. They will express their identities in terms of family and family history. As Rebeca confronts this generational exposition of identity, she moves beyond the fiction she has woven for herself at school. We learn that there has nearly been a wedding between one of Rebeca's nieces and the father of the woman looking at Rebeca, trying to place her. However, it has been broken off when the man's daughter finds out that the prospective bride '... *was an Uyanga.*' The surname is a linguistic and cultural marker which has direct associations with Africa. The simple phrase also implies class aspirations and social mobility, for the African-sounding name would be associated with darker skin and lower social class.[9] Moreover, the surname appears in a context concerning marriage, family, children. A preoccupation with the physical appearance of the progeny intrudes in the narrative; this gives rise to the speculation that although the niece may have been fair-skinned, she might none the less have produced a black child. The phrase, '*when she [the woman on the beach] found out that she [Rebeca's niece] was [an Uyanga] ...*' (p. 104), also suggests denied family relationships and secrets.

There are other objects of memory in the scene that represent the crucial encounter and confrontation. At the beginning of the incident, Rebeca expresses anxiety and turmoil. This discomfort is a consequence of the self-censuring attitudes she has internalized. She has listened silently to her school-mates' remarks about the preferential attention and service they received on the trip to Rebeca's because they were white; there have been other such moments as well at school. However, as the black woman on the beach speaks, Rebeca remembers her grandmother, whom the author specifically associates with kite-flying and songs '*learned in Africa ...*' – conceivably a form of story-telling. At the end of the encounter the grandmother has been invoked and the young woman feels herself a part of 'everything that had ever happened to her' (p. 104). Afterwards, Rebeca experiences an inner calm: '*After that, everything was easy.*' With her confession, she reclaims place and converts her homeplace from fiction into truth. Her declaration, that she belongs to her grandmother, facilitates her own ironic knowledge of her origins – the poverty of the region, but also its beauty and humanity as embodied in her parents. Chiriboga proceeds by means of indirect statements that replace the protagonist's silences with memories. In this way Rebeca's hometown becomes a place of sustenance for her, of empowerment and protection; it becomes a provider of strength, a healer of wounds. Rebeca, in acknowledging her grandmother, turns away from oppressive situations: the two primary ones being her sexual relationships with men and her silences about herself. Her liaisons, while liberating on one level, on others are restricting and potentially exploitive; reticence about her family and her background likewise has oppressed her. After the encounter on the beach, Rebeca begins to

talk more openly about her grandmother, '*each time finding more strength in the memories of her*' (p. 104).

Chiriboga describes how the black woman staring at Rebeca, trying to place her '*stepped back, trying to document memory with other facts*' (p. 104). The stance and actions parallel the narrative strategy the author utilizes as she incorporates color and class in her writing. Memory is documented, enriched with historical allusions and economic references. For example, the commentary about the gold the women have panned and that her friends have so minutely examined; Rebeca's narrating voice, serving as coda, states matter-of-factly: '*It will all be bartered for food at the store*' (p. 104).

The incident of the women on the beach marks the first phase of Rebeca's enlightenment. Having resolved the personal dilemma, the character is cleansed, prepared to engage in more confrontational collective action. This episode of identity concludes with the radical black nun, Sor Inés del Rosario, clandestinely trying to organize the women pearl-divers into unions; the meetings are to be held at the marimba-maker's house. Once again Chiriboga juxtaposes place with an object having African connotations in order to represent personal and political desires. Rebeca tries to explain to herself the urgency Sor Inés feels as she sets out to redress injustices. It is compunction such as this that leads the nun to the house of the marimba-maker. The marimba is another African percussive instrument, like the drum. Association enables the reader to find in this selection ritual, communication, commentary, and satire. The marimba, with its empowering rhythms and signifying sounds, also shares with the drum a subversive indecipherability from the point of view of the white master. The marimba is more than folklore; it is a sign of cultural affirmation; sign and instrument of resistance to injustice, historically validated and authenticated in legend and story. Chiriboga uses the marimba to assert the subversive intent of African culture in the face of Creole elites. This is the incident that provides closure for Rebeca González's call to conscience.

The simple statement, '*I am her granddaughter*' connects her to the past – to family; to previous generations; to the women doing laundry in the river with its echoes not only of domestic service, but also of manumission processes whereby a slave might purchase freedom with day wages earned; to women washing the mud for shining gold specks, with their echoes of revolt. Rebeca's declaration clears the way for her stronger self to appear, asserting knowledge, power, truth. Her statement is one of initiation and regeneration. In the development of her protagonist, Rebeca González, Chiriboga realizes, on an intimate level, the 'quest for relevance' about which Ngugi writes. To struggle militantly and establish primacy of, in this case, African references and cultural expression presupposes a resolution of conflict surrounding identity; it assumes a conviction about identity. These begin in the soul. Rebeca's statement speaks to a calming of the voices of doubt, denial, ignorance, a silencing of those on whose backs

she walks. No longer desiring to manipulate the physical ambiguity with which she lives, '*not too white, not too black,*' she responds to the memories of her grandmother; she declares her relationship, '*defiantly.*' Her militant posture at the end of this episode is a declaration that Rebeca has assumed what Ngugi calls 'the real language of humankind. The language of struggle. The language underlying all speech and words of our history. Struggle ... that ... begins wherever we are, in whatever we do.'[10] These are the sentiments and impluses implicit in Rebeca González's coming to terms with her self and her African heritage. At the end of the novel her grandmother's ineffable being, the memories, the 'Grandma's stories' obliquely inserted in the narrative, elliptically presented, make possible a more complete manifestation of Rebeca's identity. She is, for the first time, more fully a woman of her region, of her class, of her color, of her race. For Chiriboga's protagonist, the saying is the telling is the calling into being is the healing is the protecting is the change is the continuity.

Notes

1. Luz Argentina Chiriboga, *Bajo la piel de los tambores* (Quito, Ecuador: Casa de la Cultura Ecuatoriana Benjamin Carrion, 1991), p.12. All bibliographic information in this article refers to this edition. Translations are my own, unless otherwise indicated.

2. Maurice Berger, *How Art Becomes History* (New York: HarperCollins, 1992), p. 103.

3. Nelson Estupiñán Bass, b. 1910, Esmeraldas; Adalberto Ortiz, b. 1914, Esmeraldas. See Richard L. Jackson, *The Image of the Black in Latin American Literature* (Albuquerque: University of New Mexico Press, 1975) and his *Black Writers of Latin America* (Albuquerque: University of New Mexico Press, 1979). Bibliography on these two writers is considerable and one can also consult *The Afro-Hispanic Review* (Columbia, Missouri) for material pertaining to them. For information on the region of Esmeraldas, consult Julio Estupinan Tello, *El Negro en Esmeraldas* (Quito: Talleres Graficos Nacionales, 1967).

4. bell hooks, 'Homeplace: A Site of Resistance,' in *Yearning: Race, Gender, and Cultural Politics* (Boston: South End Press, 1990). Again, extensive bibliography is available. Some good points of departure are Alice Walker, *In Search of Our Mothers' Gardens* (New York: Harvest/HBJ, 1973); bell hooks, *Ain't I a Woman: Black Women and Feminism* (Boston: South End Press, 1981); Cherríe Moraga and Gloria Anzaldua (eds), *This Bridge Called My Back: Writings by Radical Women of Color* (New York: Kitchen Table, Women of Color Press, 1983); Mari Evans (ed.), *Black Women Writers: 1950–1980* (New York: Anchor Press, 1984); Marjorie Pryse and Hortense J. Spillers (eds), *Conjuring: Black Women, Fiction and Literary Tradition* (Bloomington: Indiana

University Press, 1985); Carole Boyce Davies and Elaine Savory Fido (eds), *Out of the Kumbla, Caribbean Women Writers* (Trenton, NJ: Africa World Press, 1990); Margaret Busby (ed.), *Daughters of Africa* (London and New York: Pantheon, 1992).

5. In addition to the references above, for examples see Alma Gomez, Cherríe Moraga, Mariana Romo-Carmona (eds), *Cuentos: Stories by Latinas*. (New York: Kitchen Table, Women of Color Press, 1983); Evangelina Vigil, (ed.), *Woman of Her Word: Hispanic Women Write*. Houston, Texas: *Revista Chicano-Riquena* Vol. XI, Nos 3–4 (1983); Beverly Howling Wolf, *The Ways of My Grandmothers* (New York: Quill, 1980); Paula Gunn Allen (ed.), *Spider Woman's Grandaughters* (New York: Fawcett-Colombine, 1989). For Asian women writing, consult bibliography in *This Bridge Called My Back* (above) and also periodical, *Bridge: An Asian American Perspective*, San Francisco, CA.

6. Trinh T. Minh-ha, *Woman Native Other: Writing, Postcoloniality and Feminism* (Bloomington: Indiana University Press, 1989), p. 119.

7. Herbert S. Klein, *African Slavery in Latin America and the Caribbean* (New York and Oxford: Oxford University Press, 1986), p. 88.

8. Ibid., p. 207.

9. Indeed, later in the novel, Rebeca will visit Yazmin, a former class-mate who could and did pass for white; her marriage is in crisis because of the black child to whom she has given birth (p. 150).

10. Ngugi wa Thiong'o, *Decolonizing the Mind* (London: Currey/Heinemann, 1986), p. 108.

The Search for Identity in Afro-Brazilian Women's Writing: A Literary History

Celeste Dolores Mann

Black women in Brazil have written poetry, short stories, *crónicas*, essays, journalistic articles, scholarly papers, and novels. These black women's writings encompass many themes: sociocultural criticism, blackness, nature, womanhood, love, friendship, and sexuality. Through literature, black Brazilian women explore their relationship to the dominant white male society. Like women writers of other cultures, they engage in a constant process of debunking myths, deconstructing cultural paradigms, attacking stereotypes and defining their own voice or language. Moreover, much of the writing is a search for racial, cultural, or

female identity. Because of the dominant society's concept of racial identity, its myth of racial democracy, sexism, and paternalism, this quest is extremely complex for Afro-Brazilian women.

Post-colonial women write from a precarious position, belonging to 'marginalized' groups: female and, in this case, Third World, black and Brazilian, citizens of the only Portuguese-speaking nation in a Spanish-speaking continent, but at the same time sometimes forming part of the dominant society because of education or monetary status. Trinh T. Minh-ha writes: 'Differences do not only exist between outsider and insider – two entities. They are also at work within the outsider herself, or the insider, herself – a single entity.'[1] Sônia Fátima da Conceição addresses this question when she realizes that many of the educated blacks in Brazil have been preoccupied with their relationship with whites:

> And this preoccupation does not allow us to move, it doesn't allow us to find ourselves next to our people because the distance between us 'the educated blacks' and our community which is found mostly in the Brazilian slums, is as great as the distance between us and some whites ... Is it that we are really black, or that we so much want to be because our skin will always be so?[2]

Miriam Alves comments on the self-censorship that occurs among Afro-Brazilian writers, caught between the need to assert their own identity and the popular and literary images promoted by the dominant sector:

> Because the whites look for exoticism in our work, we also go in search of it. While looking for it, we don't create or recreate other forms and codes that would reveal us, show us, communicate us. We still are afraid of offending our 'cultural godfathers' and losing the opportunity to be recognized by those who believe themselves to be (and who we also believe to be, it appears) powerful and who imagine themselves as the cultural dictators.[3]

In this essay, I will summarize the history of black women's literature in Brazil, and describe translations of several poems which explore blackness, womanhood, and the act of writing – facets of self-definition. Black women were writing in Brazil as early as the eighteenth century. However, much of this literature is not well known within Brazil or abroad, and black women have continued to write in silence, without support from the general readership or the literary and publishing establishment. Most black women published and continue to publish their work with their own funds. The works of Afro-Brazilian women who do not publish remain hidden in desk drawers, under mattresses, or locked in private journals.

The reasons for the invisibility of Afro-Brazilian women's literature throughout the centuries are similiar to those for all women: a high illiteracy rate, lack of money and power in the society, and male domination of the cultural sector.

For Afro-Brazilian women the opportunities to voice their opinions and publish their craft have been even more scarce due to slavery and racial discrimination in a society which for many decades (if not centuries) has claimed that it is not prejudiced. Both black men and women in Brazil encounter damaging racial stereotypes, devastating economic crises, repressive authoritarian governments, and the ideology of a 'racial democracy,' which within the intellectual, political, and cultural sectors has often denied the existence of a race problem, and has promoted a patronizing attitude towards blacks.

At present, there are many sociological works which attack Brazil's racial democracy myth, pointing to discriminatory practices in employment, politics, and social interaction and attitudes.[4] However, there are a lesser number of literary studies which have examined an 'Afro-Brazilian literature.' Books and articles on racial stereotypes and images in Brazilian canonized literature abound,[5] but the intelligentsia has not yet fully accepted a distinct Brazilian literature written by those of African descent. The Afro-Brazilian writer and critic Cuti affirms: 'Parallel to the great literary schools of this century, crawls the production of the Black Brazilian, maintained, for various reasons, at the 'subliterature' status.'[6]

In her monograph 'Escritoras Negras resgatando a nossa história' ('Black Women Writers Ransoming Our History'), Maria Lúcia de Barros Mott delineates a history of Afro-Brazilian women's writing. She begins with Rosa Maria Egipcíaca de Vera Cruz, who was an ex-slave born in Africa. Her collection of poems has been lost, but Mott cites Luíz Mott, who claims it had more than 200 pages and was entitled: *Sagrada teologia do Amor Divino das almas peregrinas.*[7]

Maria Lúcia Mott lists various women in her study who would be considered 'black' by US standards, but may or may not have acknowledged their African roots. It is difficult to determine which past women writers actually belong under the title 'Afro-Brazilian,' because of lack of sufficient evidence and the ambiguity inherent in Brazilian race relations, and therefore in the term (Afro-Brazilian or black) itself.[8] In addition, Brazil's many color distinctions have resulted in a large body of literature written by those struggling to characterize themselves within such a system. In some cases, such as that of Machado de Assis, the work is not regarded as Afro-Brazilian if the author does not emphasize his/her blackness, or if the work does not reflect black issues. Often such work is absorbed into the mainstream, the 'white' canon of literature, and the author is accepted as white. M.L. Mott describes the work of Teresa Margarida da Silva e Orta (1711 or 1712–93) *Aventuras de Diófanes* (1752), Luciana de Abreu (1847–80), Auta de Souza, (1877–1901) *Horto*, and Antonieta Barros, (1901–52) *Farrapos de Idéias* (1971), women writers who are seen as either white or black depending upon the literary critic.[9]

Among those women who wrote militantly or considered themselves black, the first Afro-Brazilian novelist is Maria Firmina dos Reis who was born in 1827 in São Luís do Maranhão, in the far northern Brazilian coast. In 1859 she

published the book, *Ursula*, under the pseudonym of 'uma maranhense.' According to M.L. Mott, the main characters were not black slaves, but *Ursula* critiqued and attacked the institution of slavery.[10] With respect to more recent writing, M.L. Mott cites Carolina Maria de Jesus, Ruth Guimarães, Laura Santos, Vera Tereza de Jesus, and Anajá Caetano. The most internationally famous Afro-Brazilian woman writer is Carolina Maria de Jesus, a poverty-stricken woman who resided in a São Paulo favela (slum), whose books have been translated into several languages. She has published three works which are testimonies of her wretched life plagued by starvation, discrimination, and despair: *Diário de Bitita, Pedaços de Fome,* and *Quarto de despejo.* Ruth Guimarães writes from São Paulo, and has published *Agua Funda,* and books on folklore and other subjects, but Mott admits that her writing is not committed to the Afro-Brazilian struggle.[11] Of the other contemporary writers whom Mott treats, only Anajá Caetano in *Negra Efigênia, paixão do senhor branco* (1966) dedicates her work to Afro-Brazilian issues, such as the Church and slavery, discrimination and the relationship of the black female slave to the white master.[12]

Since the 1980s, there has been an increase in the publication of Afro-Brazilian literature, for three major reasons. First, due to the shift of the Brazilian government from a repressive military regime to a more liberal democracy, censorship has diminished and blacks are now able to discuss their heritage more freely. During the military dictatorship which began with the coup of 1964, this type of activism (and anything else considered subversive by the government) was stifled.[13] Second, Brazilians of African descent were influenced by the civil rights movement in the US in the 1960s, its fashions and music, and the idea that 'Black is Beautiful,' even though they could hardly express these beliefs until after the dictatorship. Currently there are more Afro-Brazilians who publicly affirm their African heritage. In the 1980s, groups such as the Movimento Negro Unificado (United Black Movement) promoted Afro-Brazilian ideology, art, and culture. Lastly, *Quilombhoje,* a literary group created by black writers in São Paulo in 1980, has annually published the *Cadernos Negros* (*Black Notebooks*) and other works by black writers. Its members have also participated in conferences and events whose focus is Afro-Brazilian literature and culture.[14]

Most of the poems which I have selected for translation in *Moving Beyond Boundaries,* Vol. 1 have recently appeared in *Cadernos Negros.* The emphasis on womanhood, blackness, and writing has prevailed. Afro-Brazilian religion, which is based on Yoruba practices, is intrinsic to Afro-Brazilian literature. Esmeralda Ribeiro, Conceição Evaristo and Lia Vieira subvert traditional stereotypes in their poems 'A Rainha Ayo,' 'Eu-Mulher,' 'Auto-biografia', and 'Mãe Negra,' by replacing them with more positive images, and recalling Afro-Brazilian religious tradition. For example, in 'A Rainha Ayo,' Esmeralda Ribeiro's black woman is Ayo, who resents being called 'mulata.' She is not the quintessential dehumanized sex object which the term has come to imply, but rather a queen and

daughter of Xangô, one of the orixás. Her followers are *nagô*, which means Yoruba and her legend is spread by *agogô*, an Afro-Brazilian musical instrument. Sônia Fátima da Conceição, Miriam Alves, and Conceição Evaristo examine the difficult situation of Afro-Brazilians in 'Devolver a Alma Branca,' 'Tempos Difíceis', and 'Vozes Mulheres.' Lia Vieira and Roseli da Cruz Nascimento explore the creative writing process in their poetry, recalling Fernando Pessoa, a twentieth-century Portuguese poet, and the concept of cultural 'cannibalism,' introduced to Brazilian literature in the 1920s by modernist Oswald de Andrade.

This essay is an introduction to black women's writing in Brazil. However, this list of authors and themes is hardly complete. I have chosen to translate only selected poems because of their accessibility and space considerations. This represents a reduced sample of the literature.[15] *Quilombhoje* also publishes short stories in its *Cadernos Negros*. Moreover, black writers from different regions of Brazil have independently published complete collections of short stories and poetry, as well as drama, novels, essays, and children's literature. I hope that this summary and the translations will generate interest in Afro-Brazilian women's literature, and in the authors' quest for self-definition and their constant struggle for equality.

Notes

1. Trinh T. Minh-ha, 'Not You/Like You: Post-colonial Women and the Interlocking Questions of Identity and Difference,' *Inscriptions* 3/4 (1988), p. 76.
2. Sônia Fátima da Conceição, 'Ser Negro, Povo, Gente: Uma Situação de Urgência,' *Reflexões* (São Paulo: Quilombhoje and the Conselho de Participação e Desenvolvimento da Comunidade Negra do Estado de São Paulo, 1985) p. 89. (*E esta nossa preocupação nos impede de caminhar, nos impede de nos encontrarmos junto dos nossos, porque a distância de nós 'negros letrados' é tão grande quanto a de alguns brancos... Será que somos negros realmente ou queremos muito o ser, só porque é inevitável diante da cor?*)
3. Miriam Alves, 'O Discurso Temerário,' *Criação Crioula, Nu Elefante Branco* (São Paulo, 1987) p. 86. (*Porque os brancos procuram o exotismo nos nossos trabalhos, nós também vamos à cata de exotismo. Enquanto procuramos, não criamos e recriamos outras formas e códigos que nos revelem, desvelem, comuniquem. Ainda temos medo de ofender os nossos 'padrinhos culturais' e perdermos a chance de reconhecimento por eles que acreditam [e nós também acreditamos, parece] que são os donos do poder e se imaginam ditadores das culturas.*)
4. See Abdias do Nascimento, *O Negro Revoltado* (Rio de Janeiro: GRD, 1968).
5. See for example, David Brookshaw, *Raça e Cor na Literatura Brasileira*, trans. Marta Kirst (Porto Alegre: Mercado Aberto, 1983). The book treats images of blacks in Brazilian literature and some black writers.

6. Cuti, 'Literatura Negra Brasileira,' *Reflexões* (São Paulo: Quilombhoje, 1985), p. 19.

(*Paralela às grandes escolas literárias do nosso século, engatinha a produção do negro brasileiro, tida e mantida, por diversas razões, num status de subliteratura.*)

7. Maria Lúcia de Barros Mott, *Escritores Negras Resgatando a Nossa História*, Papéis Avulsos 13 (Rio de Janeiro: CIEC, 1989) p. 2.

8. The distinction between black and white in Brazil does not adhere to US standards and may appear confusing to those not Brazilian. In Brazil those who have African physical characteristics are considered black. Those who appear European, regardless of ancestry, are white, depending on their social class. Poorer Brazilians are more likely to be considered 'black' or 'colored,' but this does not mean that the distinction is strictly economic and independent of skin color. For more information see either Carl N. Degler, *Neither Black Nor White: Slave and Race Relations in Brazil and the U.S.* (New York: Macmillan, 1970), or Thomas Skidmore, *Black Into White: Race and Nationality in Brazilian Thought* (New York: Oxford University Press, 1974).

9. Mott, *Escritores*, pp. 4–6.

10. Ibid., p. 4.

11. Ibid., p. 10.

12. Ibid.

13. James H. Kennedy, 'Recent Afro-Brazilian Literature: A Tentative Bibliography,' *Current Bibliography on African Affairs* 17 (1984–85) p. 328.

14. Such conferences include: the Third Conference on Black Culture of the Americas, 1982, PUC-São Paulo and the First Meeting of Black Brazilian Authors and Writers in São Paulo, September 1985.

15. For a more extensive bibliography see Kennedy, 'Recent Afro-Brazilian Literature,' pp. 327–45.

Commercial Deportation as Rite of Passage in Black Women's Novels

Joyce Hope Scott

Early Afro-American 'novels of Privilege,' as Robert Bone referred to them, sought to counteract - through solid truths about the black experience - the images in Southern Antebellum literature that developed standard stereotypes of the Afro-

American in the United States. Black women writers in particular, from Frances E.W. Harper in *Iola Leroy* (1892) to Jessie Fauset and Nella Larsen of the Harlem Renaissance, depicted the fair-skinned Afro-American lady of the upper class in opposition to the image of black women as seductive and impure, the loose woman of plantation fiction. The image of black women in this literature, as Barbara Christian notes,

> reveals ... not only ... the Southern attitude about black people but also their definition of woman. The image of the delicate alabaster lady in a patriarchal system required another female image. Thus each image of the black woman [as mammy, tragic mulatto, brown seductress, and conjure woman, she argues] was created to keep a particular image about the EuroAmerican woman intact. Aspects of woman that had negative connotations in the society were ascribed to black women.[1]

Christian goes on to suggest that with Gwendolyn Brooks's *Maud Martha* (1953), Afro-American women shift their focus to an emphasis on 'reflecting the process' of self-definition and understanding rather than on refuting the general society's definition of them. Brooks's novel focuses on what Christian sees as 'phase one' of this shift, that is, portraying what early women's novels omit: the complex existence of the ordinary, dark-skinned woman who is neither an upper-class matron committed to idealized womanhood nor a downtrodden victim totally at the mercy of a hostile society.[2]

Unlike the protagonists of Afro-American men's novels, particularly Ellison's *Invisible Man* and Wright's *Native Son* and *The Outsider*, black women's heroines carry out their quests in the traditional space of the Afro-American community, within their families with their husbands, lovers, children, and significant others of the community. The black male protagonist, on the contrary, often projects a male figure not unlike that often seen in Euro-American contemporary fiction: the lone figure searching for self in an alien, existential landscape.

Black women novelists of the period after 1953 consciously portray also a shift of focus where audience is concerned. For while Fauset and Larsen directed their works to a primarily white audience, these later writers began to direct their works to a primarily black audience. Exploration of the self is central at this point rather than marginal, as black women writers attempt to explore the full range of the black woman's complex experience in the United States. This radical envisioning of self as central allowed for the fuller exploration of gender relationships between black men and women, black women in relation to each other, black women and their experience of the social, cultural, and political structures constantly undergoing general disruptions and transformation. Such foregrounding of the Afro-American feminine self is manifest as a 'naming of self and the world.' The named self then attains agency as a subject rather than as

an object, an 'other' as she is often portrayed in the works of Euro-American and Afro-American men.

With the great migrations of Afro-Americans to urban industrial areas in the early part of the twentieth century, the geography of the Afro-American fictive world expanded to capture the drama of this change. Edwin R. Embree, writing near the turn of the century, wonders in *Brown Americans* what would happen to a formerly nature-bound people as thousands of them moved from their agrarian roots in the South to the urban ghettos of US cities. He wondered if something very vital to the nature of the Afro-American would not be violated and lost by this transmutation of historical landscape and, indeed, whether or not the very nature of the black psyche would not be altered and a new being altogether emerge, shaped and molded by the steel and concrete of the city.

Claudia McTeer, some fifty-odd years later in Toni Morrison's novel *The Bluest Eye,* tells about her hometown in the urban Midwest that, 'This soil is bad for certain kinds of flowers. Certain seeds it will not nurture, certain fruit it will not bear;'[3] and although she is referring literally to the marigolds that she and her sister have planted, the reader comes to understand, as the story progresses, that the figurative reference is actually to the potential of the environment to nurture and promote the healthy growth of black women. Morrison's narrator here, perhaps, provides the best direction to look for an appraisal of the experience that Embree talks about in his book; as a primary aim of Afro-American literature, and the black woman writer specifically, has been the authentic voicing/representation of the Afro-American presence in the United States.

Houston Baker notes about Afro-American fiction that it is a 'discourse originating in commercial deportation and the economics of slavery.'[4] This 'commercial deportation,' he points out, began at the auction block and continued with the transport of slaves from plantation to plantation by whites in their attempts to maximize the profits from the sale of their flesh and blood commodities. From the narratives of Frederick Douglass, Olaudah Equiano and Harriet Jacobs to the novels and stories of Richard Wright, Ralph Ellison, Toni Morrison, and Alice Walker, Baker sees the ultimate goal attainment of the black writer and those in his/her fictive worlds as the 'ascent of the propertied self from the hell of commercial deportation.' Baker writes:

> All Afro-American creativity is conditioned by (and constitutes a component of) a historical discourse which privileges certain economic terms. The creative individual ... must, therefore, whether he [she] self-consciously wills it or not, come to terms with 'commercial deportation' and the 'economics of slavery.' The subject's very inclusion in an Afro-American traditional discourse is, in fact, contingent on an encounter with such privileged economic signs of Afro-American discourse.[5]

In this article I argue that these mercantile endeavors are depicted as rites of passage for the black protagonist in Afro-American literature in general and that specifically for the Afro-American female character the rites of passage are characterized by the economics of slavery, transformed and codified to conform to the demands of modern American capitalistic society. The black woman's quest for liberation and expressive wholeness, then, becomes one of 'repossessing the propertied self' from the cycle of these economic exigencies. I examine here works by Ann Petry, Kristin Hunter, and Gloria Naylor for their depiction of 'commercial deportation' as rite of passage for black women. In essence, what their works reveal is that some of the women in their fictive worlds are able to negotiate the sudden transitions and violent disruptions of their world to achieve a degree of self-affirmation while others fail in the attempt.

Like their foremother, Zora Neale Hurston, these novelists position their characters so that they re-enact the apprehension and fear associated with their black womanhood where sex and race are concerned, an apprehension that is a communal given for an Afro-American girl 'coming of age' in the United States. And, as Gwendolyn Brooks offers about her female protagonist, these women manage to transform that 'little life' which is theirs into much more despite the limits set on them by family, husband/lover, race, or class. They manage, though barely, to become their own creators. For the Afro-American woman emigrant to the city, the first social and psychological aspect that characterizes her experience of transition is alienation.[6] The feeling of isolation that ensues results, in part, from the separation of the individual from the cultural center of the Southern community. And as the Afro-American woman is only 'marginally incorporated' as a paid worker in the city, her alienation originates in the determination to achieve the middle-class Euro-American lifestyle which she sees at work or in the media but finds painfully absent at home.[7]

Lutie Johnson in Ann Petry's *The Street*[8] is such a Southern emigrant who, through an absence of black communal connectedness, tries to approximate the values of her white employers, the Chandlers. Yet the more she tries, the more damage she causes to her family, as her husband 'increasingly feels his lack of power as she takes on the Chandlers' values.'[9] In this novel, Petry clearly 'indicts white society' and suggests that it methodically seeks to fragment the black family, for as was the case in the plantation economics of slavery, there is the 'man in the middle' who often succeeds in destroying the male–female relationship through arbitrary sale or relocation of the wife and/or child. Lutie's 'man in the middle' are the Chandlers. Her 'seeds of morality' and self-worth fail to take root in the urban wasteland of New York City, for it is painfully true in this fictive world, as it was on the slave plantation, that a beautiful black woman's only 'saleable commodity [was] is sex.'[10] Calvin Hernton argues that Lutie subscribes to a code of ethics emphasizing the black woman's prerogative to control her own sexuality – to govern the integrity of her body.

Articulating such a code in a violently patriarchal system is a monumental and dangerous accomplishment.[11]

Despite Lutie's personal vision of herself, Petry shows that she is inevitably defined by the institution of the city; Christian argues that because she is a maid, Lutie is transformed into the urban counterpart of the Southern black mammy, required by the design of the system to spend endless hours away from her husband and son.[12] Thus, the economics of her situation approximates that of the slave woman in the plantation schema. Like the attractive black woman on the plantation (as Linda Brent points out), 'her beauty ... as much as any other factor, helps to defeat her.'[13] The other, and perhaps most important, factor in Lutie's tragedy has to do with her lack of what Norman Harris refers to as 'historical literacy.' The preparedness that she receives from her grandmother and father does not equip her with the tools to negotiate the urban jungle. She has been taught to be morally upright, to work hard and everything will be all right, a white middle-class notion; yet the novel underscores the impracticality of such notions against the harsh and unrelenting sexism and racism of urban America.

Lutie winds up committing murder. She kills Boots, her potential employer, when he tries to rape her. But her crime, Petry seems to suggest, is inevitable in an environment which so dehumanizes and fragments human beings. Lutie is systematically forced into a quandary from which there is no 'loophole of retreat.' The superintendent, Jones, forces her son to commit a crime in order to get back at Lutie for not sleeping with him. In trying to get money to save her son from juvenile hall, Lutie goes to Boots, who is under orders from the white boss to steer Lutie to him for his own pleasures. In an age-old male battle for power through sexual conquest, Boots plots to get back at the boss by 'having Lutie first' in the attempted-rape scene. It is here that Lutie succumbs to violence against the only person who, at that moment, symbolizes her oppression. Petry succinctly captures Lutie's emotional state as the narrator tells us that:

A lifetime of pent-up resentment went into the blows. Even after he lay motionless, she kept striking him, not thinking about him, not even seeing him. First she was venting her rage against the dirty, crowded street. She saw the rows of dilapidated old houses; the small dark rooms; the long steep flights of stairs; the narrow dingy hallways; the little lost girls in Mrs Heges' apartment, the smashed homes where the women did drudgery because their man had deserted them. She saw all these things and struck at them.

Then the limp figure on the sofa became in turn Jim [her husband] and the slender girl she'd found him with; became the insult in the moist-eyed glances of white men on the subway; became the greasy, lecherous man at the Cross School for singers; became the gaunt Super pulling her down into the basement.

Finally, and the blows were heavier, faster now, she was striking at the white world which thrust black people into a walled enclosure from which there

was no escape; and at the turn of events which had forced her to leave Bub alone while she was working so that he now faced reform school, now had a police record.

She saw the face and the head of the man on the sofa through waves of anger in which he represented all these things and she was destroying them. (TS, p. 266)

Like her urban counterpart, Bigger Thomas in Richard Wright's *Native Son,* Lutie is conscious of the racism and institutional oppression of black people by white society. Unlike Bigger, though, Lutie murders a black man in an 'explosion of rage without forethought'[14] while Bigger murders two women. Thus through this representation, Ann Petry becomes the first person to show 'black men as the *levelers* of a significant measure of the [multiple layers of] oppression'[15] that affects black women in American society.

The other black women depicted in the novel are also migrants from the South, deported to New York through the promise of commerce by white business-men and speculators who lured blacks in the South to the cities in the early twentieth century. Yet, this debilitating environment, lacking the historical connectedness to the traditional black community, spawns a peculiar breed of black woman: there is Mrs Hedges who runs a whorehouse and waits framed in her window for her next victim, some unsuspecting black girl on 116th Street whose economic needs force her to put up for sale her one valuable commodity – sex; and there is Min, the psychically destroyed woman who 'took up' with Jones, the superintendent, and takes his malignant abuse because she is certain that she cannot make it in the world alone. Thus, she moves from one man to another in a search for security. Hernton says of Min's accommodationist stance that it is 'another version of enslavement'[16] and though in her soul she knows her decisions are wrong, she is too afraid and self-effacing to change. Lutie abhors both of these women's lives and tries frantically to escape.

As a protagonist, Lutie Johnson does not attain authentication in the novel. Her mercantile endeavors, in fact, prevent her from attaining voice, as she is essentially silenced by the brutal and unrelenting landscape of Harlem. In this hostile soil, without the benefit of the black sisterhood and wisdom of the ancients which inform the reality of the black woman in the traditional Southern community, she becomes, as Mary Helen Washington notes, 'like a strange plant trying to sustain herself without roots for nourishment.'[17] Calvin Hernton speaks to the bleakness of Petry's vision when he points out the following:

The Street ... shows the ghetto is not only a social, political, educational, and economic colony, but that the black ghetto is also, and foremost, a *sexual* colony ... [Black women] are a 'market', a reserve of slaves for white men who plunder and pillage them as sex objects in white homes and in 'brothels' inside and outside the ghettos; they are once more slaves of black men within the

confines of the ghetto, in their homes and along the public streets. In the last instance, black women are slaves of slaves, they are 'game' and 'sport' for black men who harass them, hold them hostage, batter them, hate, demean, oppress them, pimp, exploit and kill them.[18]

The black woman's struggle to negotiate the economics of the ghetto continues to appear in later novels by black women writers in the 1960s and '70s. Kristin Hunter's *God Bless the Child*,[19] like Petry's novel, is set in the urban ghetto. Her heroine, Rosie Fleming, is anti-patriarchal and anti-authoritarian. She rejects the customary expectation of her society, that of marriage and children, and stands alone in her quest. Her attitude and actions in the novel run counter to those of traditional Afro-American heroines of the nineteenth and early twentieth centuries in that Rosie does not espouse middle-class morality, Christian ideology, or ethics, as does Lutie Johnson. Her success, brief as it is, does not come through channels generally thought to be practical or reliable, and reminds us of the treadmill on which white society often places blacks who seek upward mobility and escape from stifling oppression. Rosie is like a rat caught in a maze as her frantic actions increase in momentum as the plot progresses until – burned-out from overwork – she falls dead in the place from which she has worked so hard to escape.

Rosie is not defeated for lack of courage and determination; she fails because she lacks the solid ancestral grounding in black survival consciousness. She opts for the hand-me-down dreams of the white world foisted on her by her grand-mother – a prototype of Malcolm X's 'house nigger.' Rosie's mercantile endeavors reveal a commitment to material things which she is denied growing up as a child of the slums. The novel depicts clearly the 'blunting of familial affections' due to the 'slave geography' of the urban ghetto. Rosie's granny, Lourinda Baxter, consumed by a desire to 'ape' white life, becomes an accomplice with the socio-economic system which destroys Rosie as she creates a dream world for her where white people live in luxurious palaces. Lourinda looks for a black version of the 'knight in shining armor' to marry her daughter and grand-daughter and is more impressed by the slick and glamorous Tom Tucker than she is by Larnie Bell, an honest and loyal man who loves Rosie deeply.

Hunter portrays Granny as a vain, self-centered woman, a tragic mulatto who infects Rosie with her disease and slowly drains the life from her. Lourinda's 'good white folks' display what Amiri Baraka calls 'liberal/missionary syndrome' which includes a falsification of history, a perpetuation of the myth of progress as a way of salving consciences, and the doling out of tokens, throwaways which they no longer want. Granny, like many 'house niggers' on the slave plantation, represents the 'lifelong retainer' whose first loyalty is to her white folks. She turns her back on her sick daughter Queenie to stay at the bedside of a comatose white woman who does not even recognize her. She has learned to ape the prejudices and opinions of her employers, the Liveseys, no matter how ridiculous they are

for a person in her sociopolitical position: 'For forty years she's supported Hoover and hated Roosevelt; refused Heinz and insisted on S.S. Pierce; snubbed the Italian help and bobbed her head to the English ones' (GBC, p. 41).

Never admitting her actual poverty, Lourinda tries to impose first upon her unimpressed daughter the genteel habits and attitudes of white children of wealth. And while Queenie always understands the falseness of Lourinda's mothering, this truth is entirely lost on her daughter Rosie who, as a child, dislikes and disobeys Queenie and awaits the weekly returns of Granny who always arrives bearing gifts taken from the Livesey house. Both the environmental and personal sources of conflict in the story interact in a fashion that reflects the taint of slavery. Rosie's incessant working and spending of money fails to lead to advancement or progress. Though drowning in dept, she frantically buys and impulsively gives away many exotic and vastly expensive items. Such buying and spending habits reflect a similar inability to identify what is worthwhile in her personal life. Trying to halt Rosie's headlong plunge into destruction, Queenie continuously tries to get Rosie to give up one of her jobs and other money-making schemes to marry Larnie. Perceiving the nature of Rosie's problem, Queenie remarks: 'The kind of gold that comes in a paint bottle - that's the kind she goes for, every time. Now real gold ain't that shiny. It's kinda dull. Rosie don't know that yet. But I do' (GBC, p. 42).

One pivotal scene reveals the soundness of Queenie's values and instincts and contrasts them with the false, self-delusional values of Granny. Tom Tucker, con-artist, numbers runner, and all-round undesirable, is favored by Lourinda over Larnie because of Tommy's mannerisms, which are those acceptable to middle-class white society. She treats him as a serious candidate for Rosie's hand in marriage and says with apparent innocence, remembering Rosie's two legitimate jobs and her illegitimate numbers business: 'You got a couple of nice positions, you can be a big help to him … He's gonna be a big man someday' (GBC, p. 43). The more perceptive Queenie, however, stares at Tucker and finally asks: 'Nigger … what you want with my little girl?' (GBC, p. 43). Granny's own wish to believe in the trickster Tommy outweighs any concern for her grandchild. For her part, Rosie is less seduced by Tucker than by her own need to believe in and please her grandmother and accept Granny's ideals. Even so, Lourinda's approval requires that Rosie reject her sense of reality:

> Tucker 'n me, she says, 'are gonna have a lot of money, Granny … More money 'n you ever seen. He's started investin' for us already.' She raised her chin and looked at Granny fiercely, half asking not to be believed. But the old lady nodded encouragingly. (GBC, p. 44).

Granny fails to carry forth the ancient survival knowledge of the African and Afro-American ancestors, as the black elder must do in order for the child to come to grips with the reality of her situation in the ghetto of America. In a

reversal of roles, though, Rosie becomes the giver of gifts to her grandmother. The desire to please Lourinda is the deeper reason for her ceaseless efforts to leave the ghetto. However, constant work and the wild spending cannot earn her the old woman's true affection. Even after she is retired and living with Rosie and Queenie, Lourinda has an insatiable greed for the gifts that remind her of her former life in the white Livesey home, and so, with naked avarice, she accepts each of Rosie's gifts:

> Granny advanced on the table. She picked up the box and deliberately extracted the fabulous fur mules. Squinting against the light, she examined them slowly and critically, picking the lining with her fingernails, sniffing the leather of the soles and finally, rubbing her fingers over the surface of the fur. 'Real Persian,' she said at last. 'Real well made, too, for these days.' (GBC, p. 45)

When Granny praises Rosie's taste after she has bought a bed-jacket of authentic Belgian lace, Queenie flings the jacket into a corner. In angry protest, she tells Lourinda: 'You wouldn't know something real if it hit you between the eyes' (GBC, p. 47). Then once again she tries to make Rosie understand what she has known all of her life: that nothing will ever satisfy Lourinda, for she has an abiding hatred for anyone who is poor and black. Thus, Queenie asks Rosie: 'Ain't you found that out yet? You ain't gonna be good enough till you turn white' (GBC, p. 47).

Rosie never recognizes that her grandmother's values are worthless or that her false affection originates in self-hate. Having been taught by Lourinda to see value only in material things, she is angry and contemptuous of her mother. She fails to respond to the man who loves her, and, most importantly, she drives herself beyond the point of exhaustion until she ruins her health: 'As Rosie got skinnier and more hollow-eyed and coughed more, she gradually got used to sleeping less. She had the wry strength of weeds and other undernourished forms of life, the kind that thrives on starvation and toughens on struggle' (GBC, p. 49).

Rosie finally achieves emotional liberation from Lourinda but only before the novel's last tragic reversal. For she is too emotionally and physically ill to cope with her discovery that, just as in the ghetto, her beloved home on Madison Drive is infested with roaches and termites. It is a cruel joke of the urban economy that leaves her hysterical, and she realizes that all her striving only completes a vicious circle.

Hunter's women all lack 'historical literacy' and solid connectedness to the lived reality of the Afro-American community, and without this legacy in the hostile soil of the ghetto, they are unable to find authentic wholeness. In the novel Hunter underscores the imminent danger that awaits the young black girl approaching womanhood, that of sexual and economic abuse by men both white and black. It is a dilemma as old as slavery and one which continues to plague the black woman across the decades. Rosie wrestles with another reality of black

women's lives: that of becoming a 'mule of the world,' carrying the burden of the family and the race. In fact, Rosie refers to herself often as a mule and, as such, she believes in her physical capacity to work 16 to 18 hours a day to acquire money for the material comforts so coveted by her grandmother.

Hunter exposes the role of the 'gate-keepers' of modern plantation patriarchy, both white men and black men: Benny, the 'man-in-the-middle' or modern-day overseer controlling the numbers racket in the poverty-stricken ghetto; Shadow, the pimp brokering the sexual exploitation and commodification of black women; Tom Tucker, foster child of the state whose hardened nature prevents him from loving any woman and allows him to manipulate Rosie and other black people for his personal gain. Rosie's quest is to break through this structure and carve out a niche as independent entrepreneur. But as Benny tells her when she asks him for a loan to pay off her clients who hit the number:

'Rosie, I've told you before, it's not a question of rules. It's a question of roles. Other people were born to play the fool. Not me.'
'Everybody's somebody's fool,' Rosie muttered.
'Yeah, so I hear,' he said. 'So you have learned.'
'Yeah,' she said. 'Maybe someday you will too.'
'I doubt it,' he answered calmly.
'Why not?' she growled. 'What right you got to be different from everybody else?'
'Divine right,' Benny said.
From the depths of her misery she looked up at him with numb incomprehension. Benny explained with a history lesson. 'My family has always been in charge here. My father was the Don, the ruler, in this neighborhood before me, and his father was the Don before him.' He waved a spatula encrusted with red and green peppers. 'My role is to rule.' He had the nerve to smile again as he pointed the spatula at Rosie's chest. 'You have a role too. You're supposed to take orders. If you played your role, your life would be easier.'
Rosie took in most, if not all, of this, and she did not like any of it. 'I hate you!' she finally screamed. (GBC, p. 227)

In short, the fixtures marking oppression and the economics of slavery always remain constant where the lives of Afro-Americans are concerned.

In an interview with Claudia Tate in 1983, Kristin Hunter says about her writing of *God Bless the Child*:

I knew a girl like Rosie ... I met her only once, and I knew she was working two jobs in order to buy a house. I went home and said I was going to write a book about her. Of course, nobody believed me.

[She further says of her writing]: I am committed to telling the truth. I think I've always been a realistic writer, and I'm not just into the agony and

happiness of black women. I am interested in the enormous and varied adaptations of black people to the distorting, terrifying restrictions of society ... I marvel at the many ways we, as black people, bend but do not break in order to survive. This astonishes me, and what excites me I write about. Everyone of us is a wonder. Everyone of us has a story.[20]

The Fleming family is an apparent matriarchy. Lourinda has driven off Rosie's father long ago, and Rosie refuses to establish a marriage and family with Tucker or Larnie until the very end of the story, but she is irreversibly ill. But in contrast to the Moynihan male-destroying amazons of social-scientific research, the Flemings are a complex, confused and misguided group of women severed from the traditional life-affirming wisdom of the ancestors found in the historical Afro-American community. Having followed her white folks North from their Southern homestead, Lourinda relegates her own family to the level of a footnote in the vast white script of superiority. Her frame of reference becomes the destructive greed and materialism of the 'American dream,' which is all she as pivotal ancestress can bequeath to her progeny.

Only a few early Afro-American women's novels focused on the black woman as mother, since popular perception all too often saw her in the role of 'mammy,' a left-over from plantation fiction. Instead of de-emphasizing the black woman's role as mother, however, Sarah Wright, like Kristin Hunter, probes into this phenomenon in *This Child's Gonna Live*.[21] Written in 1969, Wright's novel can be seen as a powerful artistic vision of the Afro-American's existence in the United States. Its added powerfulness inheres in the fact that the protagonist is a black woman of unparalleled heroism in the white, racist, male-supremacist society of Tangierneck, Maryland. The natural environment, the weather, and the landscape, are just as hostile and unrelenting as the whites. Here the ideology and economy of slavery still define the black–white relationships.

Using a mixture of Afro-American folk idiom and references to the biblical scriptures, Wright explores the conflict encountered by a black woman whose budding sexuality traps her in the age-old designated role of wife and mother. Mariah, the protagonist, is self-effacing as a result of internalizing the opinions of her moralistic family and community. She is castigated as a pariah because of her pregnancy at age 16 and because of her ability to analyse the misery of her own and her people's situation:

> Tangierneck'll kill anything that wants to live. Can't stay here no longer ... Tangierneck said I ain't got no right to feel nothing in my belly ... Committee of my judgement fixing to meet. It's a cross they're gonna nail me to ... Just me and the blistering yellow sun ... They're gonna hang me to a cross, bleeding, with my legs stretched open. Nothing clinging to my skin but the spit they hawk on me with nothing but whore rags covering my privates parts. (TCGL, pp. 92–3).

Mariah's only close friend Vyella advises her to turn to Jesus and tell him whatever it is she thinks she has done because he will forgive her. And so she does and, in this respect, Mariah expresses a truth of black women's response to oppression and alienation in the society – that of turning to the religion of Christianity for consolation and reassurance. However, Mariah is not a pathetic and down-trodden victim. She is like Rosie Fleming, a fighter, a paradoxical hard-cussing, God-fearing woman who believes in God but also believes in giving him a helping hand sometimes. That she can ultimately succeed in saving her unborn child and her remaining children from destruction in Tangierneck there is no doubt, for even her community sees her as a sort of conjure woman with unusual capabilities. This attitude begins when she is the only one of several pregnant girls to stand up in the church and 'confess her sin' of pregnancy despite the ominous repercussions. Pop Percy, her father-in-law, calls her 'a witch conjuring up doom' when she confronts him with the fact that he beat his lover Bannie and left her for dead.

Mariah is temperamental like her name, which means 'wind.' Symbolically the wind is air in its active and violent aspects and is held to be the primary element by virtue of its connection with the creative breath of exhalation. 'At the height of its activity,' J.E. Cirlot notes, 'the wind gives rise to the hurricane which is credited with the power of fecundation and regeneration.'[22] Likewise, we see Mariah as a high-spirited and fertile woman determined to improve the conditions of life for her children by getting them out of debilitating poverty in Maryland and to a better life in the North. She refuses to cower to her husband Jacob or anyone else in the community, and she struggles, just on the edge of insanity, against poverty and her knowledge that she is pregnant by another man.

In *This Child's Gonna Live*, Wright, like Hunter and Petry, reveals the slave geography undergirding the economics of the black community, for in the story the white lords of the land have tricked the blacks out of it through treachery. To challenge such trickery – which is what Mariah wants Jacob to do – is to risk a certain and horrible death, like the one suffered by Jacob's grandfather before him. The horror and stench of death in the novel is succinctly captured in the nursery rhyme which runs through Mariah's head: 'Carry me way from Tangierneck, Daddy, Daddy, Daddy. Don't want no buzzard picking at my neck, paddy, pick, paddy pick, paddy' (TCGL, p. 28). The terrible tune constantly reminds Mariah of her dead baby girl lying in Cleveland's Field, dead at 14 months because of a germy naval bandage laid on her belly by the midwife Lettie Cartwright. Like many plantation and post-Reconstruction black women, Mariah vacillates between the role of mother as nurturing and loving and mother as terrible and abusive in punishment. It is a punishment, though, which grows out of the black mother's fear for the life of her black manchild, who stands in danger of death constantly at the hands of whites, or who keeps a cold and worms most of his young life despite her feeble efforts to cure him.

Together with poverty and racism, Mariah is faced with the male chauvinism of her own community. And although it is taken for granted along with the landscape of Tangierneck, Mariah fights against it. Here Wright, like Hunter and Petry, exposes this chauvinism among black men as a gender-based antagonism related to economic oppression. But in her heroic stance against this attitude, Mariah is a revisioning of the ominous conjure woman whose presence often threatened to undermine the political and economic structure of the slave plantation:

> 'You too high-minded, woman,' her father says to her, 'too busy gazing for the stars to see the storm clouds right around us. Folks have to navigate their ways through the rough seas of life before they can set back and feast their eyes on the stars ... It's the time of a storm all over for the colored man. They lynching colored men everyday by the wholesale lot just south of this swamp, and up *there* in them cities too. But in a different sort of way.'
>
> 'But what about the colored woman?' Mariah tried to answer him back. 'All I keep hearing is you all talking about the hard time a colored man's got.' (TCGL, p. 8).

In the tradition of her radical foremothers of the slave plantation, Mariah demands that the world 'see her scars' too, alongside those of the black man.

Having no one with whom she can truly share her inner feelings, Mariah's development as a character proceeds by way of interior monologues in which she alternately talks to herself or Jesus. Like Rosie (but in a different way) she cannot turn to her mother for comfort. Mariah's mother, Mamma Effie, 'was like a whipping switch ... Her great dark eyes were always filled with lightning, and most of the time she never said a word to her children except something like, "I'll beat the living daylights out of you if you don't listen to your papa"' (TCGL, p. 9).

And beat the living daylights out of her is what Mamma Effie did when Mariah got pregnant by Jacob Upshur.

The black female psyche is complex, and Wright skillfully demonstrates this time and time again in the novel; there are no easy answers to the dilemmas they face in their lives: sexual exploitation and economic commodification part of which is carried out by the Euro-American society and part of which is carried out by black men and their communities. Mariah is alternately overcome with feelings of love and bitterness toward her husband Jacob, and, in this respect, Wright deftly depicts a continued struggle of the black women, that of loyalty to their gender or to their race.

Mariah's dual struggle is for economic liberation as well as for her self-respect. Ingrained deeply in the texture of the novel is the glaring truth that the land and the society are racist and sexist and that the black woman's struggle, every

day, is to negotiate this oppressive quagmire and carve out all the psychic and creative space that her 'little life' will permit.

In the 1970s, Gloria Naylor continues the theme of commercial deportation as rite of passage in her *The Women of Brewster Place*.[23] Her heroine, Mattie Michaels, like Mariah Upshur, attains the quest for wholeness that eludes Rosie Fleming and Lutie Johnson as she becomes the black matriarch and voice of ancient wisdom for the other women in Brewster Place.[24] Naylor places Mattie strategically in each of the stories in the novel and, in so doing, underscores Mattie's centrality to the work as she becomes the link to and reflection of psychic strength in each of the women and, indeed, of the community itself.

Because she brings with her on the route of commercial deportation to the North the communal wisdom and historical consciousness of the Afro-American sisterhood, her life, as outlined in the first story, becomes a 'tape' by which the neighborhood and its women can be measured and evaluated. As an older and wiser woman when her story begins, Mattie reflects on her past while moving into an apartment in Brewster Place. The rhythm and flow of the community help her to recall her girlhood when she disobeyed her father and became pregnant by the outcast Butch Fuller. When her deceit is uncovered, she is beaten and disowned by her father and thus moves to the North to provide for and raise her son. But as was the case in Petry's *The Street* and Hunter's *God Bless the Child,* the economics of the ghetto exacts its toll on the mother–child relationship. Forced like Lutie to spend many hours away from home working and subsequently over-indulging her son Basil out of excessive love and guilt, Mattie cannot bridge the unavoidable chasm that develops between them as Basil slowly becomes parasitic and irresponsible. His psychological and spiritual fragmentation ultimately lead him to criminality, which results in Mattie's losing her home and all that she has worked for.

Many years later Mattie is left alone to reflect on her unwise behavior with both Butch Fuller and Basil. Here, as Naylor shows, she eventually becomes a type of 'mythic matriarch' of the black community, a role which she began to develop as a result of her friendship with Eva Turner, her black mother/other mentor. When Mattie and Basil first arrive in the city with no money and no place to stay, it is Eva Turner who acts as a wizened black foremother to her, providing a safe haven and free advice, as older black women have traditionally done for younger black women of their community. Mattie is quick to recognize Eva's crucial importance in her life, as the narrator tells us:

> Mattie didn't know if it was the seasoned food or the warm air in the kitchen, but she felt herself settling like fire dust on her surroundings and accepting the unexplained kindness of the woman with a hunger of which she had been unaware. (WBP, p. 34)

In the other stories Mattie herself assumes a similar relationship with the younger women of Brewster Place. In the story 'Etta Mae Johnson', the reader is introduced to Etta Mae, a woman who has lived a free and easy life but who now must face the reality of getting older and losing her attractiveness. Etta breezes into town in an 'apple-green Cadillac with white vinyl roof and Florida plates' (WBP, p. 56). She has returned to the comfort of her oldest and dearest friend, Mattie Michaels: 'Etta and Mattie went way back, a singular term that claimed co-knowledge of all the important events in their lives and almost all of the unimportant ones, and by rights of this possession, it tolerated no secrets' (WBP, p. 59).

Etta has had many lovers and her latest quest is for the Reverend Woods in her hope of attaining a 'respectable relationship'. When she finds out that he is just like all the rest in that all he wants is quick sex in a rundown motel room, Mattie, in her quiet strength, provides a comforting sisterliness just as Eva Turner had offered to Mattie years earlier. True to the mythic tradition of the matriarch, Mattie's faithful friendship to Etta extends both women's experience of family, as vital in negotiating the hostile and alien environment of the urban ghetto as it had been for Afro-Americans attempting to overcome the soul-destroying ordeal of slavery and Reconstruction peonage.

Mattie plays a rather similar role in the short story 'Luciela Louise Turner.' When the story opens, Luciela, the granddaughter of Eva Turner, is a young woman with a year-old baby and a live-in lover. Mattie and Luciela are like family because of the long relationship between them through Eva Turner. The vital nature of Mattie's role is highlighted most clearly near the end of the story when Luciela, her child dead and her lover gone, loses her will to live. The mythical nature of Mattie's function enables her literally to 'bring Luciela back to life' in a ritualistic scene of rebirth which harkens back to the Bible:

> Mattie stood in the doorway and an involuntary shudder went through her when she saw Ciel's eyes. Dear God, she thought, she's dying, and right in front of our faces ... Like a black Brahman cow, desperate to protect her young, she surged into the room, pushing the neighbor woman and others out of her way ... She sat on the edge of the bed and enfolded the tissue thin body in her huge ebony arms. And she rocked. Ciel's body was so hot it burned Mattie when she first touched her, but she held on and rocked. Back and forth, back and forth – she held Ciel so tightly she could feel her young breasts flatten against the buttons of her dress ... She rocked her into her childhood and let her see murdered dreams. And she rocked her back into the womb, to the nadir of hurt, and they found it – a slight silver splinter, embedded just below the surface of the skin. And Mattie rocked and pulled – and the splinter gave away, but its roots were deep, gigantic, ragged, and they tore up flesh with bits of fat and muscle tissue clinging to them. They left a huge hole, which was starting to pus over, but Mattie was satisfied. It would heal. (WBP, pp. 102–4).

Carole Boyce Davies writes that:

> With this rocking, they embark on a journey back into Ciel's childhood. This symbolic rocking, repeated extensively in the narrative, empathetically engages the reader and provides the strongest description of mothering and healing in Black women's literature. After the source of Ciel's hurt is excised, Mattie bathes and purifies her, ritualistically performing rites of healing and renewal. In the process of mothering Ciel, Mattie also heals herself and achieves a kind of reciprocity she could not attain with her son.[25]

With this scene, then, Mattie resembles Mariah, the conjure woman/protagonist of *This Child's Gonna Live* as she takes on the mythic quality of the matriarch. As she empowers herself to heal both another woman and herself, her power is also transferred to Ciel, who can then leave Brewster Place and perhaps do for other black women what Mattie has done for her.

Despite Mattie's success in carving out meaning for herself through this ancient African/Afro-American psychic and spiritual rite, the community is not viable in the slave geography of the ghetto and fails even as Lutie's 116th Street fails in *The Street*. This failure can be seen as due partly to the refusal of the community to accept 'its own,' Lorraine and Theresa, and to protect them from emotional and physical abuse. In the story 'The Two,' even though Mattie recognizes that the love the two women have for each other is hardly different from the love she shares with Etta and Ciel, she fears their relationship and is unable – like the other members of the community – to give it 'definition' apart from one popularly assigned by the Euro-American society. Thus, when Mattie envelops Lorraine in her arms as she had done Ciel – after Lorraine has been raped and has murdered Ben – she is unable to heal her. The intrusion of alien will (white definitions) into the shared psychic bond of black sisterhood results in an alienation of affection which renders Mattie's healing powers impotent. Here again we have what Houston Baker has referred to as a disruption of sensibilities brought on by the 'man-in-the-middle,' agent and operative of the historical and modern economics of slavery, whose imposition disrupts the familial relationship. In this case it is the characterization of all close and loving relationships between women as lesbian and therefore aberrant.

Though Naylor leaves the reader with the unsettling observation that the community has failed, she does not conclude that there is no hope, as does Ann Petry in *The Street* and Kristin Hunter in *God Bless the Child,* for there is still the last story, 'The Block Party,' where Naylor envisions a re-situation of the community in restored unity through the symbolism of the riot, equally seen as a symbol of unity and rebirth. It is, in fact, Mattie's/Naylor's 'closing vision' which suggests that Brewster Place and its women can, through their strength of sisterhood and love, survive.

In essence, these writers all affirm the position here that the urban geography, as well as its attendant economics, is the slave economy transported into the modern world along with Afro-Americans, the commodities of commerce in the system. Works discussed here attest to Edwin Embree's fears that some new and alien character change would be exacted from the Afro-American as s/he re-positioned her/himself in the concrete jungles of urban America. For black women, as depicted in these fictive texts, success in such an environment can be achieved only through the historically life-sustaining and life-affirming institutions of their communities. Indeed, an historical literacy attained through this 'common stock of knowledge' becomes the primary tool with which she can lift herself from the 'propertied hell' of slave economics and 'commercial deportation' and find a route to expressive wholeness for herself and her race.

Notes

1. Barbara Christian, *Black Women Novelists: The Development of a Tradition* (Westport, CT, 1980), 18.
2. Marjorie Pryse and Hortense Spillers (eds), *Conjuring. Black Women, Fiction, and Literary Tradition.* (Bloomington: Indiana University Press, 1985), p. 238.
3. Toni Morrison, *The Bluest Eye* (New York: Holt, Rinehart and Winston, 1970), p. 160. Abbreviated here as TBE.
4. Houston Baker, *Blues, Ideology and Afro-American Literature. A Vernacular Theory* (Chicago: University of Chicago Press, 1984), p. 38.
5. Ibid., p. 39.
6. Susan Willis, 'Eruptions of Funk: Historicizing Toni Morrison,' in *Black Literature and Literary Theory*, ed. Henry Louis Gates, Jr, (New York: Methuen, 1984), p. 265.
7. Ibid.
8. Ann Petry, *The Street* (Boston: Houghton Mifflin, 1946). Abbreviated here as TS.
9. Christian, *Black Women Novelists*, p. 18.
10. Ibid.
11. Calvin Hernton, *The Sexual Mountain and Black Women Writers: Adventures in Sex, Literature, and Real Life* (New York: Anchor/Doubleday 1987) p. 52.
12. Christian, *Black Women Novelists*, p. 65.
13. Ibid.
14. Hernton, *The Sexual Mountain*, p. 62.
15. Ibid., p. 60.
16. Ibid., p. 70.
17. Mary Helen Washington, *Invented Lives: Narratives of Black Women 1860–1960* (New York: Anchor/Doubleday, 1987) p. 163.

18. Hernton, *The Sexual Mountain*, pp. 73–4.
19. Kristin Hunter, *God Bless the Child* (New York: Scribners, 1964). Abbreviated here as GBC.
20. Claudia Tate, *Black Women Writers At Work* (New York: Continuum, 1983), pp. 82, 84.
21. Sara Wright, *This Child's Gonna Live* (New York: Delacorte, 1969). Abbreviated here as TCGL.
22. J. E. Cirlot, *A Dictionary of Symbols* (New York: Philosophical Society, 1962) p. 373.
23. Gloria Naylor, *The Women of Brewster Place* (New York: Viking, 1982). Abbreviated here as WBP.
24. Anhie Gotlieb, 'The Women Together,' *New York Times Book Review* (22 August 1982), p. 11.
25. Carole Boyce Davies, 'Mothering and Healing in Recent Black Women's Fiction,' *Sage* (spring 1985), p. 41–3.

The Epistolary Voice and Voices of Indigenous Feminism in Mariama Bâ's *Une si longue lettre*

Angelita Reyes

I had rather speak five words with my understanding,
that by my voice I might teach others also, than ten
thousand words in an unknown tongue ... Let your women
keep silence ... for it is not permitted unto them
to speak.
 1 Corinthians 14:19, 34

Que mon conte soit beau et se déroule comme
un long *fil*.[1]
 Unwinding Threads

The late Senegalese novelist, Mariama Bâ, received the first Noma award in 1980 for her novel *Une si longue lettre*.[2] Her second novel, *Un chant écarlate*, was published posthumously in 1981. While *Un chant écarlate* is about the dynamics of an interracial marriage in Senegal, *lettre* depicts a Senegalese widow's emotional

and spiritual redemption after the death of her estranged spouse. Eldred Jones writes:

> Mariama Bâ's first novel offers a testimony of the female condition in Africa while at the same time giving that testimony true imaginative depth. The distinguishing feature of this novel is the poise of its narrative style which reveals a maturity of vision and feeling. *Une si longue lettre* deals with the theme of women's emancipation in West Africa. But to say that it explores only the subject of emancipation is an oversimplification.[3]

Mariama Bâ introduces Ramatoulaye Fall as a recent widow with twelve children who is impassioned and grieved by her husband's death. His passing opens old emotional wounds that had not completely healed. Through the writing of an intimate letter to her girlhood friend, Aïssatou, Ramatoulaye recaptures the story of 30 years of her life: 25 of marriage to her husband Modou and five years in an estranged relationship during which time Modou lives with a second wife.

Girlhood memories and rituals remain with the central character, Ramatoulaye, as she attempts to come to terms with herself and her society. Her testimony to her life, in part, celebrates sustaining ancestral customs. However, as a pathfinder, Ramatoulaye Fall also sees herself as part of a global society in which the modern currents and multiple voices of feminism are irreversible. Toward the end of her epistolary narrative, Ramatoulaye is undoubtedly aware of her social and ontological reflections as a mother-woman.[4]

Her perspectives encapsulate the difficult position of the contemporary non-western feminist caught between a valuable heritage that she will not forfeit and an opposing need to express herself as a progressive woman who can deny any patriarchal traditions that would be detrimental to her and the position of women in her society. In this respect, her world-view becomes all-encompassing: it moves from a heightened awareness of herself, of the family, of the nation/society, and then of her position in the global and feminist arena.

Thus *Lettre* depicts the emergence of an indigenous feminist discourse as it simultaneously formulates an epistolary structure. In this instance, the epistolary structure recognizably subverts disbelief in its fictive nature. That is to say, because of its structure readers may mistakenly perceive the narrative as a form of autobiography.

However, within the context of an epistolary narrative, Mariama Bâ's use of multivocality allows the central character to 'have a say' which is at once private, public, and affirming. In her essay 'Speaking in Tongues: Dialogics, Dialectics, and the Black Woman Writer's Literary Tradition' Mae Henderson formulates an African–American articulation of heteroglossia and glossolalia which address public and private voices of black female subjectivity.[5] Henderson appropriates

Mikhail Bakhtin's model of 'dialogism and consciousness'[6] to black women's 'dialogic of difference and the dialectic of identity':[7]

> What is at once characteristic and suggestive about black women's writing is its interlocutory, or dialogic, character reflecting not only a relationship with the 'other(s),' but an internal dialogue with the plural aspects of self that constitute the matrix of black female subjectivity.[8]

Although Henderson formulates this trope of speaking in an African–American feminist context, the meaning of having a say can be extended to include a collective of neo-African female identity. From this perspective *Lettre*'s multiple ways of speaking embodies a Senegalese female persona. On the one hand, Ramatoulaye speaks to gain her sense of being and place. On the other hand, public voices – other voices – speak in an attempt to silence her from having any voice. Instead of silencing her, these public voices paradoxically substantiate her convictions. She is able to claim an identity by defining her own 'form of self-relatedness.'[9] In this way Mariama Bâ highlights the dialogics of language in an epistolary narrative. In other words, the text represents a dialogue (rather than the soliloquy of a private journal) between two correspondents, *'J'ai reçu ton mot'* ('I received your letter'; *Lettre*, p. 4). And the style is clearly anti-linear as the narrator returns full cycle to the beginning when she then writes and reminds her reader that: *'Le mot bonheur recouvre bien quelque chose, n'est-ce pas? J'irai à sa recherche ... j'ai encore à t'écrire une si longue lettre ...'* ('The word happiness does indeed have meaning, doesn't it? I will go in search of it ... again I have to write you so long a letter ...'; *Lettre*, p. 131).

There is a conscious tension between public and private voices to which the narrator refers and through which the author is able further to create ideological commentary and develop an alternative logic. One kind of speaking that is presented in the novel takes the shape of gossip, or what Patricia Meyer Spacks refers to as verbal speculation.[10] Ramatoulaye speaks and is empowered through her own gossip and the gossip of others. Using the implications of the ways of speaking based on models from Henderson and Spacks, the essay here brings attention to Mariama Bâ's discourse of having a say in the context of indigenous feminism.

Use of epistolary fiction among post-colonial black women writers is often characterized by a plurality of speaking and private forms of discourse presented through illusion. For example, a personal journal is kept by a young Antillian woman undergoing a mental breakdown in Miriam Warner-Vieyra's novel *Juletane*.[11] Later, the journal is 'accidently' found by the psychiatric nurse, Hélène and the discourse of the novel centers on the dialogics of the journal and Hélène's response as she reads it. And there is the written but unsent letter in Ama Ata Aidoo's *Our Sister Killjoy*.[12] Sissie writes a long, self-exploring letter, but upon

arriving in Africa, a literal as well as rebirthing modality of arrival, she decides that the letter will not be posted. Celie, in Alice Walker's *The Color Purple*,[13] writes to God in her attempt to understand why she is subjected to painful physical and sexual abuse – even though the letters to God can't be posted. Celie's letters (in southern dialect) are supplications to God-the-father that lives beside her. When she transcends to being her own mother-woman, she finds the real letters from her sister Nellie in Africa that Mr.——— had kept hidden. These are the letters that speak (the answers to her prayer-letters?) and to which Celie listens and from which she finds healing. In all these examples the epistolary voice distinctly weaves an 'authenticity' that permeates and privileges the discourse.

The epistolary novel became successful in eighteenth-century England and France when European readers wanted to believe that published romances and stories of intrigue were 'real' and that the 'letters' had been confidentially and truthfully written. Ruth Perry's *Women, Letters and the Novel*,[14] analyses the relationship between epistolary writing and women's culture in eighteenth-century England. But certain textual features of epistolary fiction that Perry explores are applicable to *Lettre*. Foremost among them is the fact that in the epistolary novel there is an acute feeling of immediacy on the part of the letter writer – the addressee.

Undoubtedly, we see how Ramatoulaye writes about pivotal events in her life as she continues emotionally to relive and revision those same events. The letter is triggered by the recent death of her estranged spouse, Modou, and by the struggle to deal with traditional values that assail her. Writing then becomes for Ramatoulaye a kind of initiation into a critical assessment of herself. When assessed as a rite of initiation (in this instance, moving from emotional suffering to feminist rebirth), it can be seen how 'writing the letter' assists with the individual's affirmation.

In her essay 'Methodological Journeys Through Correspondences' Mireille Bossis points out how a paradox exists in that epistolary writing can be seen as 'truth' and 'for ideological reasons the critic may select a series of elements consistent with his or her subjective interpretation and, through a process of rationalization, may from them construct a figure which accords with what he or she expects to find.'[15] From such a perspective and given its epistolary structure, *Lettre* may be assessed as representative 'truth' rather than truth resulting in non-fiction. However, the very raw material of the authentic letter that lends itself to epistolary writing in fiction seems to make the reader feel obligated to seek and measure out truth.[16] Like the found diary motif, the epistolary narrative consciously extols the impression of reality that has not been censored.[17]

Béatrice Didier, however, contends that more than the diary, the authentic letter as an entity (rather than a series of entries) is characterized by '*le morcellement, le discontinu, l'absence d'élaboration et de composition*' ('fragmentation, discontinuity, the absence of development and formal arrangement').[18] Epistolary writing appropriates these often illusory characteristics in order to generate 'truth.'

Bossis maintains that dialectical meanings can develop out of reading authentic letters and 'concern a pragmatic approach which accepts the text as a document laden with information which is real, and therefore truthful because often verifiable ... Yet there are letters ... which serve another and equally vital function: that of creating illusion and fiction.'[19] In the dialectics of an epistolary novel the inverse occurs: fiction creates the illusion of authenticity. Readers suspend their disbelief and the epistolary novel becomes a dialectical trope for authenticity.

However, the sensibility of *Lettre* moves beyond the authenticity of a written letter. Bâ contextualizes aspects of traditional orality in order to empower an otherwise 'silent' female voice.[20] Adjusting to the circumstances of wanting to communicate to an intimate friend living in another country, wanting to reach out spiritually to that needed friend, '*Je t'invoque*' ('I conjure you up'), wanting to talk and to explore her own psyche, Ramatoulaye writes a letter – communication that partially substitutes for 'being there.' Aïssatou is not physically present but her spirit is conjured – brought to the immediate space – and indeed spoken to. Conjuring – here, meaning the symbolic empowerment of words – weaves its presence throughout the tone of the letter. The letter does not completely textualize the place of traditional oral communication. Nevertheless, Ramatoulaye's words transcend to *la parole*, the empowerment of Nommo, via pen and paper, and hence, the letter *ca parole*. Likewise, as Mae Henderson states: 'black women speak/write in multiple voices – not all simultaneously or with equal weight, but with various changing degrees of intensity, privileging one *parole* and then another.'[21] Ramatoulaye's psyche, *speaks* as it connects language and social reality. At the very juncture of pen and paper – '*En guise de reponse, j'ouvre ce cahier*' (By way of reply, I am beginning this diary'; *Lettre*, p. 4) – the intimate connections between the tangible and the spirit, between words and things, are established. Thus Ramatoulaye's letter (the initially 'non-verbal' thing) becomes an incantation ('*Amie, amie, amie! Je t'appelle trois fois*' [My friend, my friend, my friend, I call out to you three times']) and is 'spoken' and 'heard' at the juncture of writing.[22]

Because of the gravity and compassion of the occasion for needing to speak, this juncture is similar to, but more than, what Madame de Sévigné writes to her daughter: '*J'aime à vous écrire; je parle à vous, je cause avec vous*' ('I like to write to you; I speak to you, I talk with you').[23] It includes yet goes beyond Bakhtin's position that all literary forms implicitly involve the listener/reader:

> An active understanding, one that assimilates the word under consideration into a new conceptual system, that of the one trying to understand, establishes a series of complex interrelationships, consonances and dissonances with the word and enriches it with new elements ... Discourse lives, as it were, on the boundary between its own context and another, alien, context.[24]

Aïssatou, the one who listens and from whom a response is implied captures this discourse of 'active understanding.' Ramatoulaye consistently addresses or invokes the name of her confidante: '*Aïssatou, mon amie*' or '*Aïssatou, ma soeur*' or '*Aïssatou, Aïssatou …*' Aïssatou serves as the mother-woman who 'hears.' Her absence is a presence that helps guide Ramatoulaye into understanding the events that have occurred in her life. Furthermore, the intimacy and seriousness of the occasion is set through the privileged invocation, '*Amie, amie, amie! Je t'appelle trois fois,*' and the voice transcends to its personal oracle. The connection between spiritual and social empowerment is made accessible despite the distance between the two women. Ramatoulaye's letter generates empowerment because she is thus able to 'speak' her life and have a say.

What additional stylistic strategies does Bâ's epistolary narrative use to generate the redemptive vision of its central character? While *Lettre is* a well structured epistolary novel, it also challenges the conventions of most epistolary narratives that construct the appearance of a unified, controlling subjectivity. In her introduction to *Ngambika: Studies of Women in African Literature*, Carole Boyce Davies points out that 'the inclusion within the narrative of "small talk" is often considered a weakness in women writers who have not "mastered form"'.[25] Ramatoulaye tells a story (her own) as she simultaneously retells Aïssatou's story: '*J'ai raconté d'un trait ton histoire et la mienne*' ('I've related at one go your story and mine'; *Lettre*, p. 81). The story is told through Ramatoulaye's letter (the central letter that at one intermittent point directly speaks to Modou's spiritual presence), and through two assimilated letters (one from Aïssatou to Mawdo, and one from Ramatoulaye to Daouda), all of which carry the underlying medium of gossip as a vehicle for telling. Thus the author's use of the epistolary genre is a combination of assimilated letters (parts of other people's letters), excerpts from other discourses of hearsay, ideology, and self-reflexive acts of speaking and writing. Bâ consciously draws attention to these types of intermediaries in the text.

We well know how gossip is, in general, negatively associated with women's mode of speaking.[26] In Judaeo-Christian and patriarchal non-western cultures gossip is associated with the informal dissemination of information, frivolous speaking, and woman-specific insincerity. Patricia Meyer Spacks challenges those associations and beliefs. She maintains that gossip's verbal speculation has its positive qualities. Furthermore, in a unique relationship to literature, gossip should not be thought useless; its bad reputation has obscured its true moral, social, and psychological worth. Its participants use talk about others to reflect about themselves, to express wonder and uncertainty and locate certainties, to enlarge their knowledge of one another. Gossip may involve a torrent of talk, yet its most vital claims remain silent. Seldom does anyone articulate the bonding that it generates or intensifies. The sensibility that gossip helps to create is dual: a mode of feeling and of apprehending which rises, as it were, in the space between the talkers, enveloping both.[27]

The positive interpretation of gossip as oral and written discourse can be applied to the epistolary strategy of *Lettre*. I suggest above that Ramatoulaye's letter exists in the act of telling and speaking. By extension, the narrative strategy uses gossip in its substantiating characteristic. Gossip helps to provide Ramatoulaye's sensibility for self-exploration; she finds self-redemption. Through hearsay, the intimacy of 'small talk,' accidental discovery, and sincere listening, Ramatoulaye puts together certain events and incidents that inform her actions and, hence, the redemptive characteristics of her own speaking. She is able to attempt an understanding of the moral, social, and psychological worth of the women and men in her world: of mothers-in-law who destroy the initial marriages of their children, of 'rebel' daughters, of spousal infidelity, and of the foundations of love within the framework of family and community solidarity.

Gossip merges with collective and connective memories when Ramatoulaye recalls how Aïssatou decides to divorce her spouse, Mawdo, after he has taken the much younger Nabou for his second wife. Aïssatou leaves him a letter that defiantly states her position: *'Je me dépouille de ton amour, de ton nom. Vêtue du seul habit valable de la dignité, je poursuis ma route'* ('I am stripping myself of your love and your name. Clothed only in dignity, I go my way'; *Lettre*, p. 50). Although Aïssatou's letter was *'destinée à Mawdo'* it becomes apparent that Mawdo was not the only one who saw the letter and learned of its contents. Ramatoulaye acknowledges that she knows the exact words of Aïssatou's letter to Mawdo, since Aïssatou left the note on the bed, *'bien en vue'* (*Lettre*, p. 49). Aïssatou's letter draws from a distant past yet Ramatoulaye claims to remember its exact contents. Does she really remember? Why should she remember? Has she read the letter a number of times? If so, how? Does Mawdo know that Ramatoulaye knows? How is Aïssatou's letter useful to Ramatoulaye's reckoning? Ramatoulaye presents Aïssatou's letter back to her – another way that she conjures the sharing of their ideals. This letter of finality to Mawdo is assimilated into Ramatoulaye's own letter of memory and exploration. Epistolary license and the rites of gossip expand the boundaries of metaphorical surmise. That is to say, the fact that Ramatoulaye does not paraphrase the contents of Mawdo's letter confirms its importance to her not only at the time it was written, but at this point: when it is supposedly remembered and quoted. Gossip allows this license for remembering. Consequently, in the contextual framework 'surmise in the guise of certainty (or certainty in the guise of surmise) typifies gossip.'[28] Again there is the illusion of truth embedded in the dialectics and dialogics of the text. By reconstructing Aïssatou's letter, Ramatoulaye bears witness to its message, gives additional substance to it (a contrast to her own marital decision), and once more provides the raw material for telling and speaking.

Another assimilated letter emerges in the text when Ramatoulaye rewrites a letter previously sent to Daouda Dieng, the man who wanted to marry her during their youth. After a respectable length of time has lapsed since Modou's

death, Daouda again asks Ramatoulaye to marry him. Daouda Dieng, educated, handsome, and a kind person, already has a spouse. Because of his marital status and because she does not love him, Ramatoulaye rejects his proposal. She sends a short letter to Daouda through the griotte, Farmata, that reads, in part,

Tu crois simple le problème polygamique. Ceux qui s'y meuvent connaissent des contraintes, des mensonges, des injustices qui alourdissent leur conscience pour la joie éphémère d'un changement. Je suis sûr que l'amour est ton mobile, un amour qui exista bien avant ton mariage et que le destin n'a pas comblé ... A bientôt, n'est-ce pas?

(You think the problem of polygamy is simple. Those who are involved in it know the constraints, the lies, the injustices that weigh down their consciences in return for the ephemeral joys of change. I am sure that you are motivated by love – a love that existed well before your marriage and that fate has not been able to satisfy ... Shall I hope to see you again?) *Lettre*, p. 100.

Ramatoulaye's letter to Daouda is also recast in epistolary surmise (narrative information through the metaphor of guessing and speculation). But the question she poses, 'Shall I hope to see you again?' shows Ramatoulaye's naive attempt to compromise on emotions; that she can hope to continue a 'platonic' friendship when he wants marriage and to be a lover. Is happiness now disguised and exchanged for the flirtation and pursuit of mere desire? The letter to Daouda, undoubtedly, is both telling and speaking. It speaks to Daouda as it tells on its persona. Ramatoulaye in this instance wants Daouda's admiration (what woman would not?) without the commitment of marriage. Mariama Bâ is consistent in her skillful weaving of intricate human emotions into the narrative's texture. He does not want to pursue friendship with Ramatoulaye after he has been rejected in marriage. Consequently, Daouda writes back: 'All or nothing. Adieu.'

Despite their emotional impasse, Daouda Dieng supports Ramatoulaye in affirming her position in the progressive generation of Senegalese women – pathfinders who acknowledge the past as they contend with the present and future. Ramatoulaye repeats what Daouda has said concerning these women and their relationship to the nation:

La femme est la racine première, fondamentale de la nation où se greffe tout apport, d'où part aussi toute floraison. Il faut inciter la femme à s'intéresser d'avantage au sort de son pays. Même toi qui rouspètes, tu as préféré ton mari, ta classe, les enfants à la chose publique. Si des hommes seuls militent dans les partis, pourquoi songeraient-ils aux femmes? La réaction est humaine de se donner une grande portion quand on partage le gâteau.

(Women are the primary and fundamental root of the nation from which all else grows and blossoms. Women must be encouraged to take a keener interest in the destiny of the country. Even you who are protesting – you preferred your husband, your class, your children to public life. If men alone are active in the parties, why should they think of the women? It is only human

to give yourself the larger portion of the cake when you are giving it out.) *Lettre*, pp. 90–91.

Once more Mariama Bâ allows her central character to recast dialogue from memory as a way in which further to allow events to be interpreted. Daouda's intellectual and political integrity (he is even called a feminist among his political colleagues) along with his distinguished stature causes Ramatoulaye to realize how much of a 'rebel' she is in not accepting his marriage proposal.

Gossip as hearsay contextualizes Ramatoulaye's own situation, as it also confirms the daring enterprise of Aïssatou who, with her four sons, leaves Mawdo. Through gossip the entire community is caught up in Aïssatou's business about leaving. In the same instance that gossip becomes the ubiquitous 'they', it proves a challenge to Aïssatou and she becomes defiant regarding her decision to leave. '*On te conseillait des compromis: 'On ne brûle pas un arbre qui porte des fruits.' On te menaçait dans ta chair: 'Des garçons ne peuvent réussir sans leur père.' Tu passas outre.*' ('They advised you to compromise: 'One does not burn the tree which bears the fruit.' They threatened you through your flesh: 'Boys cannot succeed without their father.' You did not notice'; *Lettre*, p. 49.) Seen from the positive perspective of gossip, the collective 'they' acts as a vehicle for further understanding the significance of Aïssatou's decision because 'they' could not interfere with her departure. Ramatoulaye calls attention to what they said – the community's gossip – in order to illuminate her friend's emotional fortitude. Undoubtedly, from her perspective, recalling the gossip affirms Aïssatou's values and her own emotional perseverance. By citing gossip Ramatoulaye furthers her alliance with her friend and continues to affirm Aïssatou's own empowerment.

In containing its quality of social affirmation, gossip provides information about Aïssatou's character in its paradoxical voice of *spreading* information. It increases the bond between the two women at the time the events happened and at the time the past is recast through Ramatoulaye's letter.

In another instance Ramatoulaye reveals that the entire community knew about Tante Nabou (Aïssatou's mother-in-law) and her plot to ruin Aïssatou's marriage, while Aïssatou '*ne soupçonnais rein et rayonnais toujours*' ('suspected nothing and continued to be radiant'; *Lettre*, p. 48). Whereas Ramatoulaye may embody the substance of the mother-woman, Tante Nabou personifies the antagonistic mother-in-law (an archetype for the Terrible Mother) who causes havoc and disappointment among both men and women for her own material gain. Mbye C. Cham maintains that women such as Tante Nabou in *Lettre* and Yaye Khady in *Un chante écarlate* are prisoners of tradition and 'considered by Mariama Bâ to be anachronistic and inimical to socio-economic transformation'.[29] For mother-women like Tante Nabou, marriage is social mobility and material wealth, it is the exploitation of anyone for personal ascendency, and it is the attempt to enforce a rigid caste discrimination in order to ensure prestige and a false sense of self-

esteem. Tante Nabou upholds detrimental ways of an old system. Ramatoulaye brings Tante Nabou's actions into focus when she realizes that,

> [e]lle vivait dans le passé sans prendre conscience du monde qui muait. Elle s'obstinait dans les vérités anciennes. Fortement attachée à ses origines privilégiees, elle croyait ferme au sang porteur de vertus et répétait en hochant la tête, que le manque de noblesse à la naissance se retrouve dans le comportement.
> (She lived in the past unaware of the world that was changing. She clung to old beliefs. Strongly attached to her privileged origins, she firmly believed that blood carried its virtues and, nodding her head, she would repeat that the lack of noble birth would always show in a person's bearing.) *Lettre*, p. 42.

Again we learn about Aïssatou's story, that she is considered socially inferior by the mother-in-law because she is the daughter of a goldsmith, by way of reconstructed hearsay and allusions to hearsay; 'all talk assumes other talk.'[30] Opposed to Aïssatou's decision, the community needs to speculate and we are reminded of Spacks's assertion in another instance that gossip 'affirming communal continuity across time as well as space, insisting on the meaning a single family possesses for the society it inhabits, enriches our understanding of the community.'[31]

At 50, and after five years of living in an estranged marital situation, Ramatoulaye continues to view monogamous love as the ideal. Both Daouda and Ramatoulaye are strong-willed and, ironically, for both of them it is, indeed, 'all or nothing.' Moreover, she tells Aïssatou, '*tu m'a souvent prouvé la supériorité de l'amitié sur l'amour*' ('you have often proven to me the superiority of friendship over love'; *Lettre*, p. 105). Ultimately, their sisterhood, the spirituality of their womanhood together, enables her to understand how the depth and lasting quality of women's friendship transcends threatening and competitive love that, unfortunately, usually exists between men and women.

The bonding of an *earned* friendship between two women becomes another foundation (the other being the love between Ramatoulaye and Modou) on which love is based. The narrative moves beyond the emotional politics of male infidelity because it exorcizes the redemptive and spiritual make-up of self-expression among and between women.

The author's perspectives on women's bonding and sisterhood can be placed in the larger context of post-colonial writing by black women. For example, Toni Morrison's novel *Sula*[32] also illustrates an intimacy of and between women. To some critics this intimacy between Sula and Nel suggests that *Sula* is a lesbian novel. However, Morrison states that the term 'sister' has a deep old meaning – it was valid, never secondary:

> [t]here was a profound and real need there for physical as well as psychological survival. In *Sula*, I wanted to throw that relationship into relief. There is such a relationship as 'the other' ... the friend that is the other, and women must hang on to that. In the last half of the book, Sula is gone. When Nel

misses her, we miss her. What was valued was their friendship ... it was spiritual of first priority; the 'other I'.[33]

South African novelist Bessie Head similarly illustrates the bonding of two mother-women in her short story 'The Collector of Treasures.' Like Sula and Nel, Dikeledi and Kenalepe possess the 'deep and old meaning' of intimate sharing: 'It was not long before the two women had going one of those deep, affectionate, sharing-everything kinds of friendships that *only women know how to have*' (my emphasis).[34] These kinds of friendships are spiritual – they will survive even after the physical presence is gone. It is in the deep tradition of such woman-friendship, in the spiritual bonding between mother-women, that Ramatoulaye writes, conciliates, and reconciliates. She is able to navigate spiritually the circumstances of the past through the spirit of 'the other I.' Undoubtedly, the need to bond with other women increases in moments of crisis and emotional identification that extends through crisis. And talking through the crisis 'can also suggest the dimensions of a close relationship, particularly between or among women.'[35]

Ramatoulaye assumes communal gossip in a positive way as a means to an end. The end product is her mission as a mother-woman whose beliefs must sustain her own assessment of life choices. Hence, she internalizes the spiritual ascent and the refrain is read: '*Je survais ... je survais*' ('I survived ... I survived'). Despite Modou's absence and his lack of economic support, she survives emotionally, economically, and, above all, her spiritual vitality survives. The grief surrounding the passing of someone who was loved certainly is there: '*Modou est mort. Comment te raconter? On ne prend pas de rendez-vous avec le destin ... Modou Fall est bien mort, Aïssatou*' ('Modou is dead. How can I tell you? One does not make appointments with destiny ... Modou is indeed dead, Aissatou'; *Lettre*, pp. 8, 10). Modou's death enables Ramatoulaye to complete the introspective process of perseverance that began when she was forced to endure independently after his second marriage.

Traditional African art – functional art – is the framework upon which sacred and profane communitas is performed. The mask dances. The drum speaks. Woven fabric enacts the clan's history. Bâ's narrative creates the 'voice' – the written letter – and its transcendency to *la parole* is the framework through which the narrator speaks. Through the act of writing/speaking (an enactment of Nommo), Ramatoulaye communicates with Aïssatou and finds a space in which to search out social responses and economic pursuits for herself and her family (the profane empowerment). In this respect, Ramatoulaye is not only speaking/writing to Aïssatou, but she is empowering herself through the unsilencing of her own voice. The writing is both sacred and profane – it functions. Indeed, as Henderson points out in her paradigm of speaking: 'it is this subjective plurality (rather than the

notion of the cohesive or fractured subject) that, finally, allows the black woman to become an expressive site for a dialectics/dialogics of identity and difference.'[36]

The narrative letter reveals how, on a more profound level of commitment and personal testimony, Ramatoulaye is actually a reflection, a mirroring of Aïssatou in that both women realize the extent to which they can affirm their decisions. Katherine Frank maintains that 'Aïssatou embodies the self that Ramatoulaye is struggling to become. This is shown clearly in their very different reactions to their husbands taking second wives.'[38] Frank overlooks the fact that Ramatoulaye also has the choice to divorce her spouse. Divorcing the spouse who chooses to be polygamous does not set the criteria for arriving at the pinnacle of feminist liberation. With a western feminist approach to African women's writing, Frank claims that 'polygamy, of course, is the most glaringly inequitable and sexist feature of traditional African society.' Suffice it to say, this kind of cultural critique is similar to what nineteenth-century European missionaries assumed about polygamy in Africa.[38] It is debatable whether polygamy could be regarded as the most sexist feature that existed.

Polygamy has always been a central subject of concern for westerners regarding male/female relationships in Africa. In 1972, at a conference in Abidjan, Ivory Coast, entitled 'La civilisation de la femme dans la tradition Africaine,' the issue of polygamy in traditional and transitional societies was addressed. Fundamentally, polygamy had its place and purpose in traditional communities. Culture is a dynamic entity. Therefore, the African woman who finds herself caught within the transitional phase is faced with deciding which aspects of tradition she wants to retain and which to abandon.

Speaking about polygamy, Bâ maintains that men and women are complementary.

> Of course Ramatoulaye's husband was not just any man. He was enlightened and knew his duties. It was an ideal marriage. In the book we feel that it was very good before there was a second wife ... They had worked together and had complemented each other.[39]

As a mother very concerned about the welfare of her children and her spouse, Ramatoulaye understands how her life must be a blend of tradition and newly acquired values. This continuity of the mother-woman does not romanticize the archetypal figure of the Mother. Bâ writes: 'what women are searching for is not so much to destroy everything from the past. But the man must abandon a part of his power, his privileges from the past.'[40] In this framework of working in a complementary relationship that allows the woman her dignity and development in a new era, Ramatoulaye saw herself in a new kind of marriage. The ideal was that they not only have a family to rear together, and a nation to help develop, but each other to nurture.

Mariama Bâ's account of how Ramatoulaye finds out about her husband's second marriage to a younger and 'faster' woman does not appear to be unusual in neo-African women's writing. Ramatoulaye learns about her spouse's second marriage from her male in-laws who inform her after the ceremony has taken place. Modou's plan to marry the much younger Binetou is not only contrived by the girl's mother, Dame Belle-Mère, but sanctioned by their family. The extent to which Modou is bothered by the deceptive manner in which he marries Binetou betrays his guilt about the initial marriage vows to Ramatoulaye.

In the novel *The Joys of Motherhood*,[41] Buchi Emecheta's female protagonist learns of her new co-wife when the spouse brings her home. The Antillian wife in *Juletane* marries her student-husband in Paris. It is not until they are en route to his home in an unnamed francophone African country that she learns he has another wife and family: '*La gorge serrée, je me sentais paralysée par ce que je venais d'apprendre Une fois de plus je retrouvais mon angoisse d'orpheline. Perdue, seule au monde.*' ('My throat tightened; I felt paralysed by what I had come to know ... Once more I felt my anger about being orphaned. Lost, alone in the world.') In Aminata Sow Fall's *La grève des bàttus*,[42] the husband surprises his wife by simply telling her (without any ceremony) that he has made plans to marry, '*on me "donne" une femme demain.*' ('I'm taking another wife tomorrow.') All these examples depict husbands with promiscuous egos that insist on an economic practice that no longer works in contemporary and especially urban communities. These male spouses not only blatantly disregard the rituals and duties of respect connected with acquiring a second wife, but they cannot afford the economic upkeep of additional households as traditional tribal and Koranic laws require.

Staying or not staying in a polygamous marriage is not what Ramatoulaye calls into question nor is the narrative lamenting the failure of the pursuit of happiness as it relates to marriage.[43] The decision to not divorce her spouse is not indicative of weakness. However, Ramatoulaye's daughter, Daba, believes that her mother should divorce. More than Ramatoulaye or Aïssatou, Daba represents the caliber of yet another generation – for her it is all or nothing.

We may further understand Daba as being like the university-educated daughter in Fall's *La grève des bàttus*. As I have mentioned above, the husband in this novel also decides to marry again. Moor sheepishly makes his decision without informing Lolli, the first spouse and mother of his children, as at least traditional obligation requires. Despite the fact that it may have been suitable in the past, and despite the fact that her extended families support Moor because '*ton mari est libre,*' Lolli feels and is abandoned. She is not university-educated; she is a village woman. However:

Elle avait vu que les femmes n'acceptent plus d'être considérées comme de simples objets et engageaient une lutte énergique pour leur émancipation; partout, a la radio, dans les meetings, dans les cérémonies familiales, elles clamaient qu'au point de vue juridique, elles avaient les mêmes droits que les hommes; que bien sûr elles ne disputaient pas à

l'homme sa situation de chef de famille, mais qu'il était nécessaire que l'homme fût conscient que la femme est un être à part entière, ayant des droits et des devoirs.

(She had seen that women no longer accepted being considered as simple objects and were involved in an active struggle for their emancipation; especially on the radio, in meetings, and in family life, women were claiming that from the point of justice they had the same rights as men. Although they did not dispute the man's place as head of the family, it was necessary that the man accept the woman as a separate entity having rights and responsibilities.)44

Lolli does not divorce although their university-educated daughter wants her officially to end the marriage. This daughter has no sympathy for her father and:

Rabbi a essayé de convaincre sa mère qu'elle doit se battre, qu'elle ne doit pas accepter une situation ambiguë, qu'elle a le devoir de ne pas laisser une intruse lui disputer sa place, et pour cela 'il faut prendre tes responsabilités et demander à papa de choisir.'
(Rabbi tried to convince her mother that she should fight, that she should not accept an ambiguous situation, that she has the right to not let an intruder contest her place. And for that reason 'you must accept your responsibilities and demand that papa makes a choice.')[45]

The decision that Lolli and Ramatoulaye make may seem passive to some readers. Western perspectives that are less conscious of complex non-western sensibilities situate Aïssatou's action as heroic and, ultimately, the appropriate choice. Compared to Aïssatou's decision to divorce, to remain married to a polygamous partner may appear as an acceptance of the practice. It is more her refusal to deny the love that she continues to have for Modou than the principle of monogamy that underscores Ramatoulaye's decision. The decision to remain underscores the woman's sensibility in an ambiguous situation. Neither choice, to divorce or to remain in a polygamous union, represents a universal solution. Choices need to *work* for the women involved. Lolli's spouse returns to her after he discovers that he does not appreciate the younger woman's mannerisms and after he has been defeated in a political campaign. Ramatoulaye eventually triumphs (at Modou's funeral closing, it is she who is recognized as the first wife and mother) and is reconciled with her emotions. Because of her diplomatic position, Aïssatou is not only able to provide for her children, but also to purchase a car for Ramatoulaye when it is most needed. To be able to speak the choice that works and act upon it is what is necessary.

Discussing the nature of contemporary marriage in Senegal, Mariama Bâ asserts that:

[f]or today's woman marriage is a mixture of yesterday and the present … What women are searching for is not so much to destroy everything from the past. But the man must abandon a part of his power, his privileges from the past.[46]

Polygamy is one concern along with a woman's concern for family, the seeking of personal resolutions, and the foundations of love (for men and women). Bâ also depicts how class discrimination – the inferiority and superiority of caste based on local ethnic prejudices – can be emotionally damaging. Ramatoulaye writes that at one time she believed in the pursuit of happiness through marriage. Happiness is naively constructed as a perpetual state of being: *'Je n'ai jamais conçu le bonheur hors du couple ...'* ('I never conceived of happiness outside of marriage ...'; *Lettre*, p. 82). As part of a new generation of educated Senegalese, Ramatoulaye wants to marry from her own choice of love and not through an arrangement based on traditional class obligations or parental decision. She marries Modou for love and for an ideal of love. She recalls for Aïssatou her mother's paradoxical advice and wisdom: *'une femme doit épouser l'homme qui l'aime mais point celui qu'elle aime; c'est le secret d'une bonheur durable'* ('a woman must marry the man who loves her but not the one she loves: that is the secret of lasting happiness'; *Lettre*, p. 87). Yet Ramatoulaye does not adhere to her mother's advice even years later when Daouda Dieng, the man who loves her and whom she does not love, again asks her to marry him. What some critics may refer to as conservatism may also be viewed as Ramatoulaye's stubbornness in refusing to give up an ideal. Yet she somehow understands at the close of the letter that 'happiness' is, after all, a relative state of being and that her rebirth is not from the failed monogamous marriage, but from the affirmation of the redemptive qualities of her own decisions. Mbye C. Cham aptly refers to this kind of feminist spiritual redemption as 'the dialectic of oppression and struggle/regeneration ... one of the distinguishing features of the work of Mariama Bâ.'[47] In this respect, the letter again reflects Ramatoulaye's collective psyche – that of her foremothers (of which Aïssatou is a part) and the Spirit of the personal oracle within.

Calling into question the subjectivity of the writer's feminist discourse, criticism of *Lettre* in particular and recent writing by African women novelists in general focuses on seemingly contradictive ideas and ambiguous characterizations. For example, in discussing the novels of the Nigerian writer Buchi Emecheta, Katherine Frank maintains how an inherent problem exists in that 'the very notion of a liberated African woman is a contradiction in terms. There is an irremediable antagonism between the African woman's identity as an African and as a woman.'[48] This type of critical analysis subjects western feminist perspectives to women's communities and cultures that, although influenced by western ideologies, are essentially non-western in their world-view and feminist appropriations.

In her excellent essay 'The Concept of Choice in Mariama Bâ's Fiction,' Irene Assiba d'Almeida explores the interrelational dynamics of the protagonist's choices. Referring to what appears as negative ambiguity in writing by an African female novelist, d'Almeida states that:

[i]f Ramatoulaye is the persona that represents the writer's point of view, then Mariama Bâ belongs to a generation of African female novelists whose writing is characterized by a certain malaise. This malaise emerges from the dilemma women face in wanting to keep traditions while, at the same time, wanting to reject what, in society, ties women down.[49]

There is the 'dilemma,' but must one identity – to be or not to be feminist – be totally eclipsed by another in order to appropriate objective absolutes? While ambivalence exists, it emerges out of both indecision and the will to act. Ambivalence therefore becomes a strengthening modality rather than a weakening one. Bâ depicts ambivalence as part of the pathway to understanding the self, not as the end product of issues that cannot be resolved.

In assessing the critical reception to the Nigerian novelist Buchi Emecheta, Cynthia Ward suggests that if critics see Emecheta's writing as being pulled apart by an internal ambivalence caused by 'Africanity' and feminism then, certainly, 'Emecheta's works are pulled apart – not by the tensions inherent in her works but by the opposing forces that try to make her "speak" clearly and unambiguously for them.'[50] Similarly, critical readings that textualize Bâ's discourse as one of 'ambiguity,' 'contradictions,' and 'failed radicalism' seek a text that speaks in terms of absolutes and clearly defined feminist responses to traditional values. Discussing models of an 'African' or 'feminist' paradigm, Cynthia Ward contends that:

> the practitioners of such criticism, much like their colonial predecessors, demand an unproblematic self-representation of the authentic African woman that will erase deviation and contradiction ... Failure to delineate the essential features of what such critics feel an African woman is – or should be – leads to an accusation that she is unable to represent herself adequately.[51]

Feminism – conventionally labelled by many Euro-American feminist critics in the context of patriarchal oppression – has different meanings for women whose societies have been influenced by colonialism, nineteenth-century missionary Christianity, Islam, and indigenous beliefs. In the pathfinding process, if mistakes are made and dilemmas unresolved, are these modalities examples of diluted feminism or ambivalent African womanhood? Boyce Davies writes that:

> the very fact that it is necessary to qualify feminism or limit it with the word 'African' indicates implicitly the relationship between the two ... therefore, African feminism is a hybrid of sorts, which seeks to combine African concerns with feminist concerns. This is the nature of the 'balancing' which has to take place.[52]

Indeed, how does Bâ voice both an African and feminist consciousness while not subverting the indigenous values of collective womanhood? Not enough critical energy has explored the ways in which African women writers formulate

indigenous paradigms of 'women's emancipation' which serve their interests, those of the family, and those of their immediate societies. The concepts of feminism and women's emancipation are fraught with definitional problems even within western feminist discourse, but feminist critics and theorists, if they are willing, can work with new ideas and circumstances that have to be reconceptualized.

Defining an indigenous African feminist position, Boyce Davies further maintains that essentially African feminism

> is not antagonistic to African men but it challenges them to be aware of certain salient aspects of women's subjugation which differ from the generalized oppression of all African peoples ... examines African societies for institutions which are of value to women and rejects those which work to their detriment and does not simply import Western women's agendas ... looks at traditional and contemporary avenues of choice for women.[53]

In *The Black Woman CrossCulturally,* Filomina Chioma Steady also discusses the nature of feminism in the context of continuity and change. Indigenous feminism reclaims women's significance in the society as it simultaneously acknowledges the need for change. For African women, the feminist consciousness is linked to those traditional forces that include the family's importance and the woman's sustaining relationship to her children. The meaning of family continues to hold intrinsic values that can insure survival and self-reliance: 'the isolation of the nuclear family is not the typical pattern among Blacks in Africa nor in the diaspora.'[54] Steady continues to discuss that, '[n]o doubt the most important factor with regard to the woman in traditional society is her role as mother and the centrality of this role for society as a whole ... it is because of women that men can have a patrilineage at all.'

The importance of motherhood and the value placed on the childbearing capacity by African women is probably the most fundamental difference between the African woman and her western counterpart in their common struggle to end discrimination against women. Chinua Achebe's classic novel *Things Fall Apart* contains one of the most memorable passages in African literature. The narrator explains how the concept of mother is supreme:

> It's true that a child belongs to its father. But when a father beats his child, it seeks sympathy in its mother's hut. A man belongs to his fatherland when things are good and life is sweet. But when there is sorrow and bitterness he finds refuge in his motherland. Your mother is there to protect you. She is buried there. And that is why we say that mother is supreme.[55]

The belief is a metaphoric refrain throughout the novel. Okonkwo's defiance of the female Earth Spirit in different circumstances leads to his eventual downfall and to suicide – the final abomination against the female spirit, Ani.

The African mother-woman may still be supreme in the Achebean sense but now the key factor in that position is not being the so-called maternal, exploited 'vessel.' Being 'supreme' from an ontological perspective is one thing. Having/attaining social and economic equality in practice and acceptance is another.

Mariama Bâ aptly demonstrates how tradition is, because of its immediate presence and because of its own vitality, a source of spiritual strength as well as a source of social ambivalence. From a pragmatic perspective, reality is often contradictory if not ambivalent. Ramatoulaye meticulously determines her role as a mother-woman and as a Senegalese woman when she begins to formulate her significance in the family and larger community. Bâ does not offer Ramatoulaye a choice between being African or being feminist. Rather, she underscores that neither role is mutually exclusive of the other. Bâ asserts that:

> this book ... has so often been described as a 'cry from the heart', this cry is coming from the heart of *all women everywhere*. It is first a cry from the heart of the Senegalese woman, because it talks about the problems of Senegalese women, of Muslim women, of the woman with the constraints of religion which weigh on her as well as other social constraints. But it is also a cry which can symbolize the cry of the woman everywhere ... The cry might be different, but there is still a certain unity ... their cry will not be exactly the same as ours – we have not all got the same problems – but there is a fundamental unity in all of our sufferings and in our desire for liberation and in our desire to cut off the chains which date from antiquity.[56]

Ramatoulaye clearly places importance on being the spiritual mother-woman and moves beyond God the father (Islam) in order to empower herself. The 'tearing apart' of sensibilities or what may appear as the unresolved conflict between tradition and change, can better be regarded as a coming together of the collective and personal consciousness – change is inevitable and proves the dynamism of culture. In drawing on the inner strength that emanates from the connective consciousness of her mother-ancestors, Ramatoulaye is guided by her grandmother's vision of reality: '*A génération nouvelle, nouvelle methode*' ('A new generation, a new method'; *Lettre*, p. 113). Advocating the need for women to determine choices as they formulate change, Bâ's central characters do not indiscriminately abandon their 'ancient properties' nor do they indiscriminately move beyond the boundaries of their own social landscape in appropriating the spirit of the 'liberated' African woman.

Ramatoulaye wisely acknowledges the extent to which she cannot accept any new custom just because it is supposedly progressive and 'liberating.' For example, when her daughters begin to smoke, she refuses to permit the habit: '*La nocivité du tabac m'était connue et je ne pouvais souscrire à sa consommation. Ma conscience la rejetait, comme elle rejetait l'alcool*' ('I knew the harmful effects of tobacco and I

could not agree to its use. My conscience rejected it, as it rejected alcohol'; *Lettre*, p. 113). Ramatoulaye's responsibility toward her daughters regarding 'liberated' practices seems to be another major indication of ambivalence on which critics focus. Her refusal to acquiesce to smoking and alcohol (both are detrimental to one's health) yet accept the importance of their having a formal education is not out of vacillation between western and traditional values. Some critics maintain that allowing the daughters to wear pants yet not allowing them to smoke is another instance of Ramatoulaye's vacillation.

Is wearing pants a significant sign of women's emancipation? There are far more important issues and indicators at stake. Bâ may well understand that smoking is not a sign of 'liberation,' but rather a very real health issue.[57] *Lettre* again calls into question the static and dynamic qualities of culture. Within the realm of traditional values juxtaposed with contemporary and western practices, the novel explores the conditions of Senegalese women as mothers, mothers-in-law, wives, friends, and daughters in relation to men and in relation to other women. It focuses on the spiritual being of mother-women who, despite having undergone emotional crisis and humiliation, are able to reaffirm faith in themselves and in their families. Women such as Ramatoulaye and Aïssatou are like the Phoenix that can heal and take flight because it is reborn from its own ashes of grief and conflict.

Indigenous feminist perspectives lead to a development of greater resourcefulness for survival and self-reliance. Ramatoulaye's motivation lies in her search for the balance between maintaining traditional values that affirm and feminism that confirms – the acceptance of those beliefs and practices which will enable women to cease being victims of fear, oppression, and exploitation. Her family circumstances, her spouse's failure in the marriage and her attitudes toward traditional practices certainly touch sensitive areas. *Lettre* may be a 'cry from the heart,' but it is not a militant agenda for women's liberation. Nor is it a didactic appeal for change in face of the global currents of people demanding equality with dignity. Rather the narrative is one that testifies to the redemptive quality of emotional upheaval and loss arising from distilled values – those values of spouses, in-laws, and self-centered youth. Ramatoulaye decidedly grows spiritually and emotionally and is able to ascend through the reassuring habits (women-friendships) that affirm her being. By recasting the events that effected her in the past, Ramatoulaye measures her own stability and personal achievements as a wife, mother, and feminist.

The narrative voice of *Lettre* moves from an introspection of what went wrong with a marriage to '*si malheureuse que fût l'issue de nos union, nos maris avaient de la grandeur. Ils avaient mené le combat de leur vie, même si la réussite leur echappait; on ne vient pas facilement à bout des pesanteurs millénaires*' ('no matter how unhappy the outcome of our union, our husbands were great men. They led the struggle of their lives, even if success eluded their grasp; one does not easily overcome the

burdens of a thousand years'; *Lettre*, p. 106). Ramatoulaye places herself not only in the historical framework of African reality, but in the global context of women faced with the currents of change. Yet she does not come into this revelation until she confronts her suffering and then buries it in order to move on.

Amy Denver, the poor, uneducated girl in Toni Morrison's novel *Beloved*, speaks profoundly when she says to Sethe: 'Can't nothing heal without pain, you know.'[58] Such women unabashedly realize how there is no spiritual or emotional growth without conflict and pain. Ramatoulaye has to come to terms with her suffering before she can heal. Like Walker's *The Color Purple*, *Lettre* is not exclusively about men and women's conflicting social and emotional politics. It is more about women's spiritual qualities that are recoverable and reclaimable.

If *Lettre* is autobiographical, then it is an autobiography of many women. Bâ writes that men and women are complementary. And so, Mariama Bâ has written a love letter for a new coming together of men and women everywhere.

Notes

1. 'May my story be beautiful and unwind like a long thread.' This Kabyle (Algerian) recitation is taken from Charlotte Bruner's anthology of writing by women in Africa, *Unwinding Threads* (London: Heinemann, 1983).

2. Mariama Bâ, *Une si longue lettre* (Dakar: Les Nouvelles Editions Africaines, 1980). Subsequent references are to *Lettre* and are cited in text. Translations are mine.

3. Eldred Durosimi Jones, Eustace Palmer, et al. (eds), *Women in African Literature Today* (Trenton, NJ: Africa World Press, 1987), p.10.

4. I have used the term 'mother-woman' to refer to the woman who is an indigenous feminist in Angelita Reyes, 'Politics and Metaphors of Materialism in Paule Marshall's *Praisesong for the Widow* and Toni Morrison's *Tar Baby*,' in *Politics and the Muse: Studies in the Politics of Recent American Literature* (Bowling Green, OH: Bowling Green State University Press, 1989), pp. 179–201. That is to say, indigenous feminism implies the social context of men and women working for equality. The 'woman' component of the term here invokes but is not limited to Alice Walker's definition of womanism and mothering (Anzaldua). Kate Chopin uses the term mother-woman in *The Awakening* to mean 'women who idolized their children, worshipped their husbands, and esteemed it a holy privilege to efface themselves as individuals and grow wings as ministering angels' (p. 19). That is not the meaning intended in this essay.

5. Mae Henderson, 'Speaking in Tongues: Dialogics, Dialectics, and the Black Woman Writer's Literary Tradition,' in *Changing Our Own Words* ed. Cheryl A. Wall (New Brunswick: Rutgers University Press, 1989), 16–37.

6. M.M. Bakhtin, *The Dialogic Imagination*, trans. Caryl Emerson and Michael Holquist (Austin: University of Texas Press, 1981).
7. Henderson, 'Speaking in Tongues,' p. 22.
8. Ibid., pp. 17–18.
9. Ibid., p. 22.
10. Patricia Meyer Spacks, *Gossip* (New York: Knopf, 1985).
11. Miriam Wainer-Vieyra, *Juletane* (Paris: Presence Africaine, 1984; London: Heinemann, 1987).
12. Ama Ata Aidoo, *Our Sister Killjoy* (New York: Nok Publishers International, 1979).
13. Alice Walker, *The Color Purple* (New York: HBJ, 1982).
14. Ruth Perry, *Women, Letters and the Novel* (New York: AMS Press, 1980).
15. Mireille Bossis, 'Methodological Journeys Through Correspondences,' *Yale French Studies* 71 (1986), pp. 63–75; p. 66.
16. Mireille Bossis, 'Foreword: Men/Women of Letters,' *Yale French Studies* 71 (1986), pp. 1–14; p. 4.
17. Ramatoulaye's letter is a reply intended to be longer than the one she has received from Aïssatou ('*J'ai recu ton mot. En guise de reponse, j'ouvre ce cahier...*'), and therefore is not an exclusive and independent dialogue with herself that would constitute the function of diary writing. The structure is distinctly epistolary while the exploratory tone may indicate the writing of a personal journal.
18. Béatrice Didier, 'Auto portrit et journal intimé,' *Corps écrit*, 5 (1983), p. 173.
19. Bossis, 'Methodological Journeys,' p. 68.
20. The female voice is only 'silent' in that women like Ramatoulaye and Aïssatou are the generation of Senegalese women who have been influenced by global currents of the changing status of women. I take the liberty of making the generalization that in traditional African societies women were significant and 'supreme' in limited areas. More often than not, women had empowerment and not power. Lloyd Brown rejects the image of the free-spirited and independent African women whose problems, as women, 'have flowed from colonialism rather than indigenous mores.' When Chinua Achebe writes about the paradox of the mother's supremacy, he brings into focus the ontological belief that is unbalanced with the social reality.
21. Henderson, 'Speaking in Tongues,' p. 36.
22. Lemuel Johnson suggests that this utterance can also be viewed as a trope for the traditional Islamic way of speaking divorce that must be said three times: '*talek, talek, talek.*' In other words, by calling on her friend three times, Ramatoulaye foreshadows the recasting of their own estrangement (discussion held in 1986).

23. Roger Duchêne, *Madame de Sevigne ou la chance d'etre femme* (Paris: Fayard, 1982), p. 264.
24. Bakhtin, *The Dialogic Imagination*, pp. 280, 282, 284.
25. Carole Boyce Davies and A. Adams Graves, *Ngambika: Studies of Women in African Literature* (Trenton, NJ: Africa World Press, 1986) p. 16.
26. According to Ivan Illich, *Gender* (New York: Pantheon, 1982), gossip was once linked to the meaning of anthropology; 'when Aristotle uses it [anthropology] ... it means gossip' (p. 132).
27. Spacks, *Gossip*, pp. 5, 22, 37.
28. Ibid., p. 238.
29. Mbye C. Cham, 'Contemporary Society and the Female Imagination: A Study of the Novels of Mariama Ba,' in Jones et al., *Women*, pp. 89–101; p. 94.
30. Spacks, *Gossip*, p. 239.
31. Ibid., p. 240.
32. Toni Morrison, *Sula* (New York: Knopf, 1974).
33. Russell Sandi, ed. *Render Me My Song: African-American Women Writers from Slavery to the Present* (New York: St Martin's Press, 1990).
34. Bessie Head, *The Collector of Treasures* (London: Heinemann, 1977), p. 13.
35. Spacks, *Gossip*, p. 10.
36. Henderson, 'Speaking in Tongues,' p. 37.
37. Katherine Frank, 'Women With Men: The Feminist Novel in Africa,' in Jones et al., *Women*, pp. 14–34; p. 18.
38. See Maimouna Kane, 'The Status of Married Women Under Customary Law in Senegal,' *American Journal of Comparative Law* 20 (1972), pp. 716–23. Kane discusses how polygamy, on the contrary, was an asset in traditional African societies.
39. Barbara Harrell-Bond, 'Interview: Mariama Bâ,' *The African Book Publishing Record* 6 (1980), p. 28.
40. Ibid.
41. Buchi Emecheta, *The Joys of Motherhood* (New York: George Braziller, 1979).
42. Aminata Sow Fall, *La grève des bàttus* (Dakar: Les Nouvelles Editions Africaines, 1979).
43. Edris Makward, 'Marriage, Tradition and Woman's Pursuit of Happiness in the Novels of Mariama Bâ,' in Davies and Graves, *Ngambika*, pp. 271–81.
44. Fall, *La grève*, p. 42.
45. Ibid., p. 46.
46. Harrell-Bond, 'Interview: Mariama Bâ,' p. 210.
47. Cham, 'Contemporary Society,' p. 93.
48. Katherine Frank, 'The Death of a Slave Girl: African Womanhood in the Novels of Buchi Emecheta,' *World Literature Written in English*, 21 (1982), pp. 476–97; p. 492.

49. Irene Assiba d'Almeida, 'The Concept of Choice in Mariama Bâ's Fiction,' in Davies and Graves, *Ngambika*, pp. 161–71; p. 167.
50. Cynthia Ward, 'What They Told Buchi Emecheta: Oral Subjectivity and the Joys of "Otherhood",' *PMLA* 105 (1990), pp. 83–97; p. 85.
51. Ibid., pp. 85–6.
52. Boyce Davies, *Ngambika*, p. 12.
53. Ibid., pp. 9, 10.
54. Filomina Chioma Steady, *The Black Woman CrossCulturally* (Cambridge: Schenkman, 1983), pp. 1–41; p. 29.
55. Chinua Achebe, *Things Fall Apart* (London: Heinemann, 1958), p. 122.
56. Harrell-Bond, 'Interview,' p. 213.
57. In the American media, a prominent cigarette commercial supposedly aimed at savvy American women boasts that 'you've come a long way, baby.' Compared to attitudes before and during the early part of the century it is now acceptable and sometimes desirable for women to smoke. This is one of the deceptive indicators of progress in women's emancipation especially considering how detrimental smoking is to one's health. Regardless of the choices available, women must not indiscriminately accept practices that were previously denied by patriarchal boundaries in the pursuit of liberation.
58. Toni Morrison, *Beloved* (New York: Knopf, 1987), p. 78.

Women, Literature, and Politics: Haitian Popular Migration as Viewed by Marie-Therese Colimon and the Haitian Female Writer

Marie-Jose N'zengou-Tayo

In the Haitian literary tradition, migration is usually evoked through the themes of exile and/or the journey. According to the Haitian critic Yanick Lahens: 'exile is certainly one of the dimensions which along with resistance and syncretism, give Haitian culture its coherence. Just after Independence, while some were looking towards France, the place of commercial exchange and studies, others remained nostalgic for Africa.'[1]

A thematic inventory of Haitian fiction identifies departure/return as a recurrent theme. In addition, these images can be interpreted in terms of flight (departure) and of redemption (return).[2] From Fernand Hibbert's Sena (*Sena,*

1894) to Jacques Roumain's Manuel (*Gouverneurs de la Rosée/ Masters of the Dew*, 1945), '... heroes leave their native land in order to improve themselves and return to improve those they have left behind in their birthplace, although it may mean becoming martyrs because they are misunderstood.'[3]

In addittion, we have to remember that most Haitian writers have personally experienced exile and migration. This could explain the importance of these themes in their writings. The seductive power of 'Elsewhere,' common in many works by Caribbean writers, is mirrored in their fiction as an attempt at exorcism. This type of text, poetically named '*le dit de désertion*' (tale of desertion) by the Haitian novelist and essayist Jean-Claude Fignole,[4] is a way of expressing both the Haitian writer's inability to root him/herself in a society in which he/she feels marginalized (in Haiti, the intellectual/artist/writer has no established social status) and at the same time his/her rejection of this marginalization. By the 1960s, at a time when Haitian writers were starting to question their role in the society (the 'Haiti Litteraire' movement) and were preparing to assume what they identified as the necessary marginalization of intellectuals and artists, they began to be persecuted by the Duvalier dictatorship. Many of them were forced into exile.[5] These political circumstances were to give a new impulse to the themes of exile and migration in Haitian literature. The migratory process took on dramatic proportions with the arrival of the first 'boat people' on the sandy beaches of Florida in 1972. In recent years (1991–92) drama has turned to tragedy with the massive number of Haitian migrants trying to reach the USA by boat; 30,000 according to June 1992 figures, an estimated 5 per cent of whom may have perished on the high seas.

It is generally not long before reality is put into fiction as the writer cannot remain indifferent for long to what is happening in his/her society. Curiously, one has to wait until 1979 and Marie-Thérèse Colimon's *Le Chant de Sirenes* (*The Sirens' Song*)[6] in order to read about contemporary Haitian popular migration in fiction. In addition, this collection of short stories is the first to give the female viewpoint on that social and political subject. This fact invites us to assess the situation in Haitian female writing as far as migration is concerned since this has for a long time been the domain of male writers.

Historically, exile and emigration were the concern of men,[7] while women limited themselves to urban migration.[8] This could explain why the women's voice took so long to make itself heard. Though the theme of travel is mentioned in some of their writings, Marie-Thérèse Colimon is the real pathbreaker on that topic in women's writing. Fourteen years later, in the light of the Haitian migratory crisis, this essay aims at reassessing the author's viewpoint concerning Haitian migration in comparison with some other female writing (Marie Vieux Chauvet's *Amour, Colère et Folie/ Love, Anger and Madness*,[9] and Jan J. Dominique's *Mémoire d'une amnésique/Memories of an Amnesiac*).[10]

With regard to female migration, the political background of the period (the Duvalier repression of the 1960s and 30-year dictatorship) is never presented as the women's reason for leaving the country as it is for the men; women merely accompany the one traveling. For instance, in Chauvet's *Amour* it is left to Jean Luze, Felicia's French husband, to suggest migration as a mean of escaping political persecution. He is also the one who decides to take along with him a young man whose parents have been arrested and killed by the military. The female narrator of the story, Claire, is rather reluctant and hesitates at this idea:

J'arrive mal à imaginer ma vie ailleurs que dans cette maison ... La fuite me guérirait peut-être de ma passion. Je n'ai qu'à envisager un départ pour me sentir malade ... Pourrai-je à mon âge rompre avec mes habitudes si Jean Luze m'emmène avec lui? (148)
(I can scarcely imagine my life anywhere but in this house ... Perhaps running away would cure me of my passion. I only have to think of leaving and I feel ill ... At my age, would I be able to break with my old habits if Jean Luze were to take me away with him?)[11]

In the second novella, 'Colère,' we are presented with a young bourgeois girl, who prostitutes herself with a militia chief in order to obtain authorization for her brother to leave the country:

Tu sais ce que tu risques sans le jeu de mes fesses? Pourrir ici en ignorant comment sont faits les bancs des universités d'outre-mer. (*Amour*, p. 203)
(You know what you are risking if I don't give him a piece? You will rot here without even knowing what universities look like overseas.)

In the situation above, leaving the country appears to be the only way to avoid not only intellectual stagnation but also to escape forced enlistment in the militia and thus, according to the author, moral corruption:

Elle [Rose] s'avança vers son frère et le fixant dans les yeux: Tu n'as donc pas envie de partir toi? Et tes études d'architecture, ça ne te fait rien de les enterrer? As-tu envie de gaspiller ton temps, ta jeunesse, en attendant d'endosser leur uniforme? (*Amour*, p. 207)
(Rose came closer and looked her brother straight in the eyes: So you don't want to leave? What about your dreams of studying architecture? Does it mean nothing to you, to give them up? Do you want to waste your time, your youth, waiting to put on their uniform?)

In *Le Chant des Sirènes*, migration for political reasons is evoked in only one short story, 'La Solution,' in relation to a bourgeois youth who has been turned into a 'revolutionary' during his European university studies. The narrator insidiously expresses doubts about the sincerity of the character's political convictions by the use of derogatory expressions, referring to him as 'delinquant' and 'recal-

citrant'. In addition, there is a reference to the fact that he agrees to migrate only when his family pays him a substantial sum of money:

> *Ses activités revolutionnaires menacantes, ses gestes d'exaltés pouvaient compromettre tous les siens ... Après maintes démarches on arriva à convaincre le* délinquant *qu'il lui fallait quitter le pays. Pour ce départ, le père qu'il honnissait mit le prix qu'il fallait. ... Les horizons lointains reçurent dans leur sein le jeune récalcitrant qui par ses agissements ètait devenu le désespoir de sa famille.* ('Patrick,' *Le Chant,* p. 125)

(His dangerous revolutionary activities, his high and mighty airs could compromise his whole family ... After several attempts they managed to convince the *delinquent* son that he had to leave the country. For his departure, the father he cursed paid the price exacted ... Far off horizons received the *recalcitrant* young man, who had become the despair of his family because of this behavior.)[12]

Five years after Colimon, J.J. Dominique's *Mémoire d'une amnésique* is concerned with the migration of several women: Jocelyne, Lili's best friend, and Julia, Lili's mother. They migrate because of the depressing political climate, not because of any political activism. Jocelyn leaves in order to escape the sexual advances of a powerful Duvalier henchman (a *'croquemitaine'*). We have to note here the recurrence of a motif treated in more detail by Marie Vieux Chauvet in her 1968 *Amour:* the fact that political repression is suffered by (mulatto) women through sexual violence (rape, sadistic practices). Specifically in Marie Chauvet, gender relationships and politics are articulated according to the pattern of Beauty (the bourgeois mulatto woman) and the Beast (the black, ugly, military or militia man, of lowly social origins and recently promoted by the regime).

In Dominique's book, Julia's departure is presented as a failure: Julia migrates because she and her husband could no longer endure the situation (*'n'en pouvaient plus,'* *Mémoire,* p. 88). This exile is not the result of dangerous political activities but rather an individual reaction of escape in the face of a social situation that they can no longer accept. This explains why the narrator interprets these departures as 'defeats' (*Mémoire,* p. 88), though she is conscious that they prefigure her own departure as well as her future psychological transformation:

> *Pour elle, le temps devait battre au rythme des lettres mexicaines. En transparence une fille nouvelle ouvrait les yeux ... Ce départ, elle le souhaitait; ce départ qui l'arrachait à un pays qu'elle aimait et qu'au loin elle apprendrait a connaitre.* (*Mémoire,* p. 90)

(For her, time was to be measured by the regular rhythm of letters from Mexico. Underneath a new person was opening her eyes ... This departure, she longed for it, this departure which would tear her away from a country she loved, a country which she would learn to know from a distance.[13]

Surprisingly, whereas media reports and sociological surveys insist on the political nature of contemporary Haitian popular migration (for men as well as women),[14]

our women writers underestimate this aspect of female migration and stress economic and personal reasons. This is especially true of Marie-Thérèse Colimon. Although the short-story technique allows her to examine a large range of situations among various social classes, she constantly presents economic constraints (unemployment, failure in professional ventures, economic consequences of natural disasters) as the primary reason for migration, except in the bourgeois class. The author emphasizes a sharp feeling of failure among characters who have tried every single possibility for changing their situation but who have failed because of lack of opportunities due to the general economic bankruptcy of the country. Lack of opportunity is the leit-motif, explaining from one story to the next these departures presented novelist as a 'panic exodus'[15] toward 'elsewhere' and which affects all social classes indiscriminately.[16]

Among the various aspects of migration, Marie-Thérèse Colimon and J.J. Dominique present male/female relationships as one area which is seriously affected by the migratory process. Traditional patterns of gender relationships (sexual behavior as well) are questioned at various levels through migration. For instance, in terms of gender, there is a hierarchical order in migrating: men are the first in the family to leave. This pattern is breached in 'Le plat de lentilles' where a daughter is the first to migrate, hoping to bring her family (her brothers and sisters to join her. This exceptional change of pattern is justified by the father's failure as a provider for his family. As he remains unemployed, his role is supplemented with great hardship by his daughters. Therefore, it is left to the boldest one to seize the opportunity of migrating in order to help her family. And where male pre-eminence is respected, the tale indicates the potentially deceptive behavior of the man toward his wife. In 'Actuellement à New York ...' ('Right Now in New York ...'), Colimon tells the story of a devoted spouse who endures economic and moral hardship, depriving herself and getting into debt, in order to allow the illegal migration of her husband to the USA. Once this first step is taken, she starts waiting: waiting for news, for the tickets, and money which will allow the family to travel and join the migrant husband.

'Actuellement à New York ...' is an excellent example of the preparatory steps in Haitian popular migration. It also indicates the key role of women in financing male migration. In fact, if the husband is able to travel it is thanks to the tremendous efforts and faithfulness of his wife: she is the one to borrow money from her employer which she will pay back by monthly deductions from her meager salary as a primary school teacher while supporting herself and her two children. She also mortgages a plot of land (her mother's) to find the sum necessary for the payment of her husband's passage. In this first-person narrative, allusion and the unspoken play a significant role. The story uses the form of a diary written by the young wife, living and teaching in rural Haiti (l'Ile a Vaches/Cow Island, in the extreme south of Haitian waters) while she waits for her husband to send for her and her children. Very soon the reader is aware of

inconsistencies in her account of events. We are brought to question the husband's sincerity: unemployed and having failed at several professional ventures, he seems to have married the young teacher in order to facilitate her future migration when the time comes. Between the lines, the reader gathers that the marriage was a means to obtain financial support for his own departure. The narration exposes the blindness of the loving heroine who disregards her friends' and family's warnings of possible abandonment by her husband. On the other hand, the diary reveals the character's moral strength, since she succeeds in hiding her doubts and suffering from others. A new Penelope,[17] she waits resisting, not impatient suitors but boredom and depressing doubt instilled in her by those around her.

The diary covers a two-year period and the changes in the diarist's state of mind can be measured through the contrast between the lengthy detail of the entries at the beginning of the story and their reduction to laconic notations ('*Rien!*' 'Nothing!') at the end. The rhythm of the text follows the rise of silent despair accompanied by increasing self-absorption, shown in the shortening of the sentences.

More lengthy, almost a novella within the collection, 'La Solution' consists of five narratives and examines migration within the Haitian 'bourgeois' upper class. Through the mind of one character, Mrs Amelie Damien-Deltour, the author presents various aspects of bourgeois migration. This migration appears to be naturally linked with the Haitian bourgeois tradition of travel in the nineteenth century: that of the annual trip to Paris. However, over time, a change occurred in the destination: following the US Occupation, Paris has been replaced by New York. Another change relates to the duration of these trips; temporary in previous years and taken for culture and leisure, they became permanent for the younger generation, as was the case with popular migration. For instance, as a 'green card' holder, Mrs Deltour lives in Haiti and travels once a year to the USA in order to maintain the validity of her card. At the opposite extreme, all her children have migrated to the USA, seemingly with no intention of coming back.

Through this novella, Colimon ascribes a social function to migration for the Haitian upper class: one of regulation. Migration is used by this class both as a means of avoiding scandal and of freeing itself from its own narrow social constraints. The mentally handicapped child, the unruly and sexually free young woman, the too dangerously politically committed son: all are sent abroad by families who cannot cope with the social prejudices of their own class, in order to benefit from the anonymity of the large continental megalopolis of the USA. Even an ageing Mrs Deltour contemplates migration as a 'solution' in order to escape the social constraints imposed on bourgeois Haitian widows. In the case of the Damien-Deltours, migration raises the alarm because it is not imposed by economic necessity. Ironically enough, Colimon places the ultra-nationalis-

tic and anti-migration discourse in the mouth of a bourgeois professional, Alexandre Deltour:

> *Alors depuis le temps que nous chantons: 'Pour le pays … formons des fils, formons des fils,' nous nous fourrons le doigt dans l'oeil; nos fils, c'est pour d'autres pays que nous les formons, … J'admets encore que les jeunes gens, à qui la patrie refuse leur pain, aillent le chercher sous d'autres cieux mais une fille nantie comme la mienne!* ('Michèle,' *le Chant*, p. 103).

(So, all the time we have been singing 'Let we raise up sons for our country,' we have been fooling ourselves. Our sons, we've been nurturing them for other countries … I accept the fact that young people who cannot earn a living in their own country may have to go to seek their livelihood elsewhere, but a girl who is as privileged as my daughter!)

Middle-class migration is justified to some extent with arguments similar to those of the Trinidadian writer V.S. Naipaul (that is, the narrowness of the island which does not allow expression to intellectual gifts). It is also presented as unavoidable and accepted with some fatalism.

Marie-Thérèse Colimon insists on the consequences of migration for family links in the home country. She examines the loneliness of the aged devoted mother, too old to live in a cold foreign country with her family, and her slow solitary death in a hospital bed ('Le Rendez-vous'/'The Last Date'). She exposes the bitterness and anger of the adolescent girl growing up in Port-au-Prince in a boarding-house, waiting for the ticket which will take her to her family in New York ('Bonjour, Maman, Bonne Fête, Maman'/'Happy Mother's Day, Mom'). She denounces the loss of moral values among people who decide to leave the country by whatever means and at whatever cost. The only positive aspect of migration shown in these short stories has to do with the young Haitian female personality. Thanks to migration, these young women are able to assert themselves, to reject their mothers' submissiveness and bourgeois social prejudices as regards marriage ('Le plat de lentilles,' 'La Solution') or having a professional career ('La Solution').

Colimon's short stories appear to be a warning, and from this perspective the introductory quotation from *The Odyssey* seems very significant. If, following Maurice Blanchot,[18] we identify the writer with Ulysses tied to the mast of his ship, we have to read this collection as the result of a similar experience: the writer is the one who, like Ulysses, listens to the Sirens' song but victoriously resists their seductive power (the deceptive attractiveness of 'elsewhere'). From that ordeal, he brings forth the Book, a transcription of that song. From that point of view, the title of Colimon's collection is meaningful as a warning against the deceptive nature of migration to the USA. However, the lack of political vision and the nationalistic, conservative view of the author can be felt and constitute the major weaknesses of the book. Although she examines various

aspects of Haitian migration and at different levels of the society, never at any time does she discuss the political and structural causes of that migration, pointing only to economic reasons. This narrow point of view could be excused by the argument of 'self-censorship,' since the book was written and published in Haiti during the Duvalier dictatorship. However, this is not very convincing because the date of publication (1979) corresponds with a period of pseudo-liberalism (at least for intellectuals)[19] and because she has also made open political comments in a previous novel (*Fils de Misere/ Son of Poverty*). Therefore, it seems that nationalist preoccupations explain why the author chose to ignore the political dimension in Haitian popular migration.

As mentioned above, until 1982 Colimon was the only Haitian writer to devote an entire book of fiction to the theme of migration[20] but in another novel, *Mémoire d'une amnésique*, written by a younger female writer, J.J. Dominique, we find an account of the life of a young Haitian woman in her host country. The case of the heroine, Lili, may not be representative of a large group of Haitian migrants, but in terms of female experience it is very significant since it is an experience of formation. In Lili's case, migration allows the emergence of political consciousness and political commitment (participation in demonstrations, attendance at political meetings) with Haitian activists. This experience is very similar to that of Manuel (*Gouverneurs de la Rosée*) or Hilarion (*Compère Général Soleil*) and for this reason can be attached to a tradition in the Haitian novel. However, Lili's experience abroad has a specific female and also feminist component. In her case, migration offers the opportunity for privileged encounters with women and allows her to initiate a female bonding which will help her to build her personality and to achieve a better knowledge of herself.

> *Je me réveillais à peine, sortant lentement de ma nuit, saccagée, zombifiée* ... (*Mémoire*, p. 114)
> (I was just beginning to wake up, to emerge slowly from my darkness, confused, zombified ...)

> *J'étais en train de mettre au monde une femme lucide quand Liza m'apparut, debout dans l'embrasure. Elle assistera, précieuse, à la délivrance et les yeux grands ouverts je regardais vivre ma soeur siamoise.* (*Mémoire*, p. 140)
> (I was about to give birth to a lucid woman when Liza appeared before me, standing in the doorway. She was there at the birth, precious, and with my eyes wide open, I watched my siamese twin sister come to life.)

Through the narration we follow the heroine's evolution from negation to acceptance of her female nature with all its contradictions and extremes, even through homosexuality as a stage in the process of reappropriating the self.

In Lili's case, the migrant experience appears occasionally to be one of culture shock: the discovery of human indifference in large western cities, the experience

of racism. The heroine rejects these behaviors and dismisses the arrogance of those who pretend to be 'civilized' while they are excluding others.

... je n'arrive pas à rester impassible devant cette indifférence, cette peur, car il n'y a pas d'autres mots. Ils ont peur et ils ont oublié de voir ... Pourquoi cette indifférence criminelle? ... Je découvre l'angoisse dans la foule, dans la grande ville, dans cette société, je decouvre mon angoisse du dehors ... Rien n'est comparable à la cruauté de notre espèce, et les humanoïdes se classant dans la catégorie dite civilisée le sont encore plus. Seule assise sur ce trottoir glace, j'ai eu peur. (Mémoire, pp. 104–5).

(I cannot remain aloof in the face of this indifference, this fear, for there is no other word for it. They are afraid and they have forgotten how to see ... Why this criminal indifference? ... I am discovering anguish in the midst of the crowd, of the big city, of this society, and I realize I am afraid of open spaces. Nothing is more cruel than our species, and those humans who consider themselves 'civilized' are specially cruel. Alone, sitting on that frozen sidewalk, I was afraid.)

For Dominique's heroine, the migratory experience is in the final analysis a positive one, since it helps to rebuild a personality whose psyche has been divided and alienated by education in a repressive society where individuals are forced into silence by the dictatorship as well as by self-censorship The adaptation process in a different society helps the Haitian female migrant to put together the pieces of her fragmented psyche at the personal level (how to be a balanced woman in a macho society) as well as the collective one (how to be a committed Haitian within the silence of Haitian contemporary history). Once this is successfully achieved, the character can assume herself and contemplate the project of returning to her home country. There is at this point a deliberate political choice made by someone strong enough to resist the seductive and deceptive power of the 'Sirens' song.'

Notes

1. Y. Lahens, *L'Exil: Entre l'ancrage et la fuite, l'écrivain haitien (Between Writing and Place: The Haitian Writer)* (Port-au-Prince: H. Deschamps, 1990), p. 15. English translation from *Callaloo,* 15, 3 (1992), p. 736.
2. Ibid., pp. 25–30.
3. Ibid., p. 29. English translation adapted from *Callaloo* 15, 3, (1992), pp. 739–40.
4. J.C. Fignole, *Voeux de Voyage et intention Romanesque* (Port-au-Prince: Fardin, 1978). Cited in Lahens, *L'Exil.*
5. Lahens, *L'Exil.*
6. Marie-Thérèse Colimon, *Le Chant des Sirènes (The Sirens' Song)* (Port-au-Prince: Le Natal, 1973). Referred to here as *Le Chant.*

7. See Suzy Castor, *L'Occupation américaine d'Haiti (The American Occupation of Haiti)* (Port-au-Prince: H. Deschamps, 1986), pp. 98–100.

8. Uli Locher, 'Migration in Haiti,' in *Haiti: Today and Tomorrow*, ed. Foster and Valdman (Lanham/New York/London: University Press of America, 1984), p. 330.

9. Marie Vieux Chauvet, *Amour, Colere et Folie* (Paris: Gallimard, 1968). Referred to here as *Amour*.

10. Jan. J. Dominique, *Mémoire d'une amnesique* (Port-au-Prince: H. Deschamps, 1984). Referred to here as *Memoire*.

11. Translation of quotations from Marie Chauvet by Elizabeth (Betty) Wilson, University of the West Indies, Mona, Jamaica.

12. Quotations from Colimon's short stories translated by Elizabeth (Betty) Wilson. Emphases added.

13. Quotations from Dominique's *Memoire* translated by Elizabeth (Betty) Wilson.

14. See Jean-Claude Charles, *De si jolies petites plages (Such So Nice Little Beaches)* (Paris: Stock, 1982); and Josh DeWind and David H. Kinley, *Aiding Migration. The Impact of International Development Assistance on Haiti.* (Boulder/London: Westview Press, 1988).

15. 'Panic' should be read here with its strongest etymological meaning. One has to think of the Haitian painter and novelist Frank Etienne's paintings which were exhibited in Boston in June 1990. In many of them, the island is represented as a narrow enclosed space from which skeletal silhouettes try to escape.

16. See the description of the airport departure hall at the beginning of Colimon's 'Le plat de lentilles' ('A Plate of Lentils'); *Le Chant*, p. 29. English translation from *Callaloo* 15, 3 (1992).

17. We feel that the title of the collection and its epigraph from *The Odyssey* justify this comparison.

18. In *Le livre à venir (The Forthcoming Book)* in which Blanchot analyses *The Odyssey* episode of the Sirens as meaningful for the function of the writer.

19. Including Publication of Pierre Clitandre's political novel, *Cathedrale de Notre-Dame d'Aout*, in 1980; and the large readership of the independent magazine *Le Petit Samedi Soir*, from 1971 to 1982.

20. Emile Ollivier's novel, *Passages*, was published in 1992. Jean-Claude Charles's *De si jolies petites plages* (1982) is an account of his coverage of Haitian illegal migrants for the French television station, Antenne 2.

Aída Cartagena Portalatín: A Literary Life.
Moca, Dominican Republic, 1918–94

Daisy Cocco de Filippis

> *Hombres no han llorado*
> *porque caen los hombres.*
> *Cómo llorar la muerte de una rosa?*
> (Aída Cartagena Portalatín)
> (Man has not mourned
> because men have fallen.
> How can one mourn the death of a rose?)[1]

The most important woman writer in twentieth-century Dominican Republic, Aída Cartagena Portalatín was born and raised in the small coffee-plantation town of Moca. A folder of her early poems and an iron determination accompanied her to the capital city of Santo Domingo in the early 1940s. There she became part of a group of Dominican poets who were collaborating on *La Poesía Sorprendida*, the literary journal which was closed down in 1947 by Trujillo regime. Her first collections of poems were published during this period: *Del sueño al mundo*[2] in 1944 and *Víspera del Sueño*[3] and *Llámale verde*[4] in 1945. In his essay on Portalatín, Baeza Flores, the Chilean poet who was co-founder and collaborator of the journal, points out:

> *Desde este primer poema, que aparece en la revista, podemos sentirlo que será el aporte de Aída Cartagena a la poesía dominicana en el siglo XX: Es un enjambre de imágenes, metáforas, símbolos. Hasta entonces ninguna mujer, en la lírica dominicana, se había atrevido a una escritura poética tan rica en tropos, en contenidos metafóricos y significaciones.*[5]

(From this her first poem, which appears in the journal, we can sense what will be Aída Cartagena's contribution to Dominican literature in the twentieth century: It is an amalgam of images, metaphors, symbols. Until then no other woman, in Dominican lyric, had dared to write a poetry so rich in tropes, metaphorical content and significance.) (de Filippis, p. 1)

Her early poems, however, also present a poet who is lost in a world she cannot control, and desolation permeates her work, as seen in the poem 'Asolados' ('Sunburnt'):

Luna ceniza de mañana clara.
Parecerá que cubrirá la tierra
toda una nube blanca.
¿Quién tendrá un solo rayo?
Ha caído el cielo en una sombra.
Sol sin brazos, desdibujado
por un bregar de nubes.
(Moon of ashes in the morning light.
An immense white cloud seems
to cover the earth.
Who has even one ray of sunlight?
The sky has fallen into shadow.
Armless sun, obscured
by struggling clouds.)
(de Filippis, pp. 51–2)

'Sunburnt' is an example of the poetry written at a time when Portalatín had to find a way to fit into a society in which she had no accepted function. Having refused to marry or to emulate Dominican role models of the time, she faced a period of great uncertainty in her life which manifested itself in her use of language. A careful reading of 'Sunburnt' leads to the conclusion that although the poem is syntactically correct, it is semantically hollow. The development of the poem is precisely a denial of its title. Since it denies all possibility of a mimetic representation, the poem can be perceived as the manifestation of another landscape: the inner world of the poet.

Emma Jane Robinett, one of her translators, commenting on Portalatín's early poetry, has pointed out that:

> There is also a kind of energy and restlessness in these early poems that will not be satisfied to remain forever confined within those outmoded male definitions of what language and forms and subjects are proper for a woman who is also a poet. We can sometimes feel the poet's impatience with indirection and a great desire to confront herself and her world openly. (de Filippis, p. 19)

The closing down of *La Poesía Sorprendida* forced Portalatín into a decision: she had to travel in order to break down the barriers limiting her life. To a younger generation of Dominican woman writers, Portalatín's travels have come to symbolize Dominican woman's flight from her imposed surroundings, her home, and her taking on a world until then closed off from women's experience. In fact, Portalatín's poems of this period indicate that they were written in such diverse places as Athens, New Delhi, London, Paris, New York, and Santo Domingo. In a recent interview with the writer of this article, Portalatín confirmed this interpretation of her work and explained how much her travels

and associations with such influential writers as André Breton and Pablo Neruda had changed her poetry, giving it strength and audacity. This newly found energy and self-assurance spilt over into every aspect of her life. On her return to Santo Domingo in the 1950s, Portalatín undertook the rigorous task of being co-founder and co-editor of a series of publications which appeared under the name of 'La Isla Necesaria'. This collection published the works of young as well as older poets who were writing without the benefit of *apoyo oficial*. This was Portalatín's way of taking a stand against a system she did not approve of but could not openly confront. In 'La Isla Necesaria' she also published her own books of poetry under the titles of *Una mujer está sola*[6] and *Mi mundo el mar*,[7] and her monograph on the works of the painter Vela Zanetti.

José Alcántara Almánzar, the Dominican sociologist and critic, explains this new stage in Portalatín's craft:

> *Con* Mi mundo el mar, *la poetisa [sic] abrió una nueva etapa de su produción. Dejó el verso plurimétrico por una prosa poética de gran densidad, puso énfasis en el entorno antillano y asumió el papel de protagonista en las seis estancias que forman el libro. La poetisa [sic] devino, a un tiempo, sujeto y objeto de su poesia. Sujeto porque es ella quien vertebra cada una de las partes que componen la obra; objeto porque se visualiza a sí misma como una unidad integrada al habitat marino que aborda.*[8]

> (With *Mi mundo el mar*, the poetess [sic] opened a new cycle in her production. She left behind a plurimetric verse for a poetic prose of great density, she placed emphasis on the Antillean context and took on the role of protagonist of the six sections which make up the book. The poetess [sic] became at the same time subject and object of her poetry. Subject because it is she who vertebrates each one of the parts which make up the work; object because she visualizes herself as a unit integrated to the marine habitat she delineates.)

Almánzar's comments serve to underline to what extent Portalatín's poetry had changed. Thus, on her return to the island, the poet was ready to make another journey: a literary one. Woman's journey in the literary is discussed in Elaine Showalter's article 'Walking in the Wilderness' where Showalter points out that:

> Women writing are not then inside and outside of male tradition: they are inside two traditions simultaneously ... Indeed, the female territory might well be envisioned as one long border, and independence for women, not as a separate country, but as open access to the sea.[9]

In a poem written during this period, Aída Cartagena Portalatín finds herself in that territory which is no territory, the border, the fringes, or at the door of a new beginning which follows the rejections of a woman's assigned place, and its consequent isolation:

UNA MUJER ESTÁ SOLA

Una mujer está sola. Sola con su estatura.
Con los ojos abiertos. Con los brazos abiertos.
Con el corazón abierto como un silencio ancho.
Espera en la desesperada y desesperante noche sin perder
la esperanza.
Piensa que está en el bajel almirante
con la luz más triste de la creación.

(A WOMAN IS ALONE

A woman is alone. Alone with herself.
With open eyes and open arms.
With a heart opened by a wide silence.
She awaits in the desperate and despairing night without losing hope.
She believes herself to be in the leading vessel
lit by creation's saddest light.)
(de Filippis, p. 71–2)

Sherezada (Chiqui) Vicioso, a Dominican sociologist and one of the most outspoken Dominican poets of our day, calls *A Woman is Alone* the 'First Feminist Manifesto' written in the Dominican Republic. Vicioso points out that this is the first time that there is '*una voz que admite por primera vez las limitaciones de su condición de mujer y sus limitaciones políticas* ... ' ('a voice that acknowledges for the first time the biological and political limitations imposed on women'). Furthermore, Vicioso affirms that:

> *Este período en la creación poética de Aída, en el cual está más cerca que nunca de crear su propia literatura verdaderamente femenina en la República Dominicana, cambia con la muerte de Trujillo en 1961 cuando Aída publica* La voz desatada *y* La tierra escrita.[10]
> (This period when she [Portalatín] comes closer to creating her own literature and establishing the basis for a truly feminist literature in the Dominican Republic, changes with Trujillo's death in 1961 when Portalatín publishes *La voz desatada* and *La tierra escrita*.)

Dominican literary criticism of Portalatín's work is controversial. To date, an in-depth study of her work, life, and times has not been written. There are many issues that need to be addressed; in particular, how Portalatín's development as a writer has been influenced by the historical and economic situation of the Dominican Republic and her own class, gender, and race. Unfortunately, the limited scope of this study, the introduction of the writer to English-speaking readers, precludes such an incursion. It is hoped, however, that these considerations will weigh heavily on future, more extensive studies of her work. In the existing criticism in the Dominican Republic, however, there is much difference of opinion. For critics such as José Alcántara Almánzar[11] or Ramón Francisco,[12] it is not until the poetry of the 1960s that Portalatín gains a true poet's voice.

For others, like Vicioso, *A Woman is Alone* is Portalatín's finest hour. What a reading of her work makes clear, however, is that her poetry of the period, stripped of vague adjectives and yielding a strong language, sets the tone that will prevail in her later works. In *A Woman is Alone*, Portalatín shows her determination to strike down the lofty pedestals to which women seemed to have been so comfortably relegated by men in the past. With Cartagena Portalatín's works of this period begins the demythification of the role of women in the literature of the Dominican Republic. Significantly, it was in the 1950s that Portalatín discarded from Dominican poetic language such favored terms as *sumisa*, *virginal*, and *blanca*, as she began to redefine the boundaries of female experience.

In the 1960s Portalatín took on a more active role in educational, cultural, and literary institutions, an involvement which was to last the better part of three decades. She worked and taught at the Universidad Autónoma de Santo Domingo in various capacities, including Adjunct Professor of Art History, Colonial Art, and the History of Civilization. She also served as co-ordinator of programs in history and anthropology and as editor of the university's Annals and the journal of the humanities division. At that time she also edited a series of 'Cuadernos de las Brigadas Dominicanas' which gave a voice to a generation of writers who protested the Trujillo regime and its legacy: a North American invasion and a civil war. Her commitment to these activities, however, did not keep her from a continued dedication to her craft. During this decade Portalatín also wrote two collections of poems, *La voz desatada*[13] and *La tierra escrita*,[14] and she edited an anthology of Dominican short stories,[15] published by in 1978 in Venezuela.

In the 1960s, having come to terms with her independence and her right to her own voice, Portalatín's concerns became those of humanity as a whole and, in particular, those of the people's victimized by bigotry and racism:

Memorias negras
tono 1
vertical camino derribado
reducido a esencia original
fatalidad: el hombre
su problema inherente
simplemente la raza.
(Black Memories
tone 1
Vertical road trampled
reduced to its original being
misfortune: said simply
race is the problem
man inherits.)
(de Filippis, pp. 111,116)

In a courageous blow for Dominican racial identity, until recently linked to the European not to the African ancestor, Portalatín speaks of her own racially mixed background, and for the first time in Dominican poetry a poet faces her own racial identity without having to resort to euphemisms or justifications:[16]

Elegía Segunda
MI MADRE FUE UNA DE LAS GRANDES MAMA del mundo.
De su vientre nacieron siete hijos que serían en Dallas,
Memphis o Birmingham un problema racial
(ni blancos ni negros)
(Second Elegy
MY MOTHER WAS ONE OF THE GREAT MOTHERS of the world.
From her womb were born seven children who would be in
Dallas, Memphis or Birmingham a racial question.
[Neither black nor white])
(Translated by Emma Jane Robinett; de Filippis, pp. 93–4)

The poems of *La voz desatada* and *La tierra escrita* present a poet who has come to terms with her independence and right to her own voice. Since then Portalatín's poetry reflects her concern for humanity as a whole and her compassion for the victims of racial and social injustice. One of her finest and most poignant poems of this period is 'Otoño negro' where she repudiates the particularly brutal murder of four innocent victims of racial bigotry:

> *Sé que era otoño sin alondras ni hojas.*
> *Yo que lloro al árbol, al pez y a la paloma*
> *me resisto a los blancos del Sur*
> *a esos blancos con su odio apuntando a los negros.*
> *No les pregunto nunca, porque responderían*
> *que en Alabama pueden florecer las dos razas.*
> *Mas, después del Verano de Medgar W. Evers*
> *hicieron un Otoño de cuatro niñas negras.*
>
> (I know it was already autumn,
> Without leaves and a lark's song.
> I, who cry for the trees, for fish and doves,
> reject the white men of the South,
> those whites with their hatred aimed at black men.
> I'd never question their motives
> because they would answer
> that in Alabama both races can blossom.
> After the summer of Medgar W. Evers,
> Came the Fall of four black girls ...)
> (de Filippis, pp. 95–6)

In this poem, the trees, fish, and doves, symbols of a graceful, innocent, and generous nature, are the counterpoint to an act of gratuitous violence. As can be seen in the fragment above, Portalatín has stripped her verse of adjectives and has given it emotions as its only ornament. Yet her poetic line, sustained by a strong and unyielding anger, maintains a lyricism and a beauty which poignantly underscore the loss of possibilities: what might be when both nature and men are in harmony.

Portalatín's inclusion of social concerns in her writings and her commitment to political causes, however, have met with criticism among some Dominican critics. Unlike Almánzar and Francisco, who pointed out the literary beauty and value of the works of this period, Manuel and Lupo Hernández Rueda, editors of *Antología panorámica de la poesía dominicana contemporánea 1912–1962*, characterize *La tierra escrita* as one of Portalatín's less fortunate publications:

> *En su último libro de versos 'La Tierra Escrita' recurre a grafismos, diálogos, técnicas periodísticas e imágenes cinematográficas, usando como centro aglutinante una preocupación por el hombre y por sus libertades inculcadas. A pesar de la actualización que ella ha dado al mundo circundante, lo mejor de su poesía se nos ofrece en sus primeras publicaciones y en 'Una mujer está sola', sobre todo en esta última donde expresa con valentía su drama interior.*[17]

(Portalatín resorts to graphics, dialogues, the techniques of journalism, and the imagery of the cinema, using as a binding center her concern for mankind and his usurped freedoms. In spite of the sense of urgency she gives to the world, the best of her poetry is given to us in her earlier works and in a *Woman is Alone*, especially the latter where she valiantly portrays her inner drama.)

Manuel and Lupo Rueda, of course, betray their own allegiance to the *Poesía sorprendida*, a literary movement which advocated a poetry concerned mainly with form and style, a poetry written for its own sake and not at the service of a social cause. Critics outside the Dominican Republic, however, have praised Portalatín's experiments with form and her concern for social justice which are also at the core of her novel *Escalera para Electra*,[18] one of the finalists of the prestigious Seix-Barral award in 1969 where it was praised as

> *... especie de Electra tropical o, mejor aún, nudo vital en que se desarrollan los mitos de la Hélade y se aboceta la problemática de un mundo rural conmocionado por pasiones ... Numerosas reflexiones sobre el oficio de novelar coexisten con los acontecimientos que se narran e imbrican en ellos, determinan el relato y aclaran sus perfiles.*[19]

(... a sort of Electra of the Tropics, or better yet, the vital knot where the myths of Hellas and the complexity of a rural world shaken by emotion are developed ... There are numerous reflections about the craft of the novel which are narrated and intertwined to determine the narration and to sharpen profiles.)

Experiments with form and political and social engagement define her later works. *Tablero*,[20] a collection of short stories that portray the lives of women, is born out of these concerns. In 'They Called her Aurora. A Passion for Donna Summer,' the story that opens the book, Colita, the protagonist, is a symbol of a social group that has been denied a voice, name, and identity:

> *Mami me decía Colita. Colita García. Pero la señora Sarah me inscribió en la escuela pública con el nombre de Aurora. ¡Nada de Colita! gritó. Seguí sintiéndome interiormente Colita y oyéndome Aurora en la voz de los otros.*
> (Mami used to called me Colita. Colita García. But Mistress Sarah registered me in public school by the name of Aurora. Forget about Colita! She screamed. But I felt like a Colita that they all called Aurora.)

In *Tablero Checkerboard*, Portalatín created the space in which the lives of women, of the Colitas of Dominican culture, are played out by others with the same precision, deliberation, and cold-heartedness that it takes to win at this seemingly innocent game.

In *En la casa del tiempo* (1984),[21] her last work of fiction to be published to date, Portalatín's experimentation with form and content culminate in an angry verse characterized by the reduction of the poetic line which has gained strength and has become the visceral shriek of an anguished poet who needs to shake down the foundations of injustice:

Memorias negras
tono 5
ay, ay, ay, ay
asesinaron otra vez a África
otra vez en Sharpeville
ooooooh ooooooh
OooooooooooooooH
nadie grita: castigo

(ah, ah, ah, ah
they've murdered Africa again
once again in Sharpeville
ooooooh ooooooh
OooooooooooooooH
no one shouts: curses)
(de Filippis, p. 115)

Thus for Cartagena Portalatín, as she confirmed in a recent conversation, in her writings there is no return to a concern for the rose. A poet, short-story writer, novelist, essayist, editor, and college professor, Portalatín still has a very active role in Dominican literary circles. The author of 14 books, her last four, published in the 1980s – *Yania tierra* (poetry),[22] *La tarde en que murió Estefanía*

(novel),[23] *En la casa del tiempo* (poetry) and *Las culturas africanas: rebeldes con causa* (essays)[24] – bear witness to her continued support of the struggle against racism and social injustices and her experimentation with literary form.

Several tributes to her work include: 'De poetas a poetas, recital de poesia, tributo a Aída Cartagena Portalatín del Círculo de Mujeres Poetas' (in 1984, the newly-formed Circle of Dominican Women Poets dedicated a recital of their poetry to Portalatín, in acknowledgement of the role she played in paving the way for women's issues in Dominican literature); Sosa's anthology *La mujer en la literatura* (a 1966 collection of essays about women writers, including many studies of Portalatín's work); Daisy Cocco de Filippis's *Bilingual Anthology of the Poetry of Aída Cartagena Potalatín* (1988, the first ever bilingual edition devoted to the poetry of a single Dominican writer). These activities serve to underscore the fact that she is an author who must be considered, studied, and understood, if one is to write about Dominican literature in the twentieth century. Although in her seventies and retired from her university duties, Portalatín continued to write (she had a novel in progress) and remained involved in her craft and in her country. Until her passing in June, 1994, Portalatín remained clear-headed and committed to the cause of justice, still searching for new means of creative expression and determined to influence the course of Dominican letters in years to come.

Notes

This essay was first published in York College, CUNY, Proceedings of Women of Hispaniola Conference, Executive Report, Vol. 1, no. 2, 1993.

1. Daisy Cocco de Filippis (ed.), *Sin otro profeta que su canto, antología de poesía escrita por dominicanas/From Desolation to Compromise: A Bilingual Anthology of the Poetry of Aída Cartagena Portalatín* (Santo Domingo: Taller, Colección Montesinos 10, 1988), pp. 47–8. Subsequent references to this volume are cited in the text as de Filippis.
2. Aída Cartagena Portalatín, *Del sueño al mundo*, Ciudad Trujillo: La Poesía Sorprendida, Colección 'El Desvelado Solitario,' 1944.
3. Aída Cartagena Portalatín, *Víspera del Sueño*, Ciudad Trujillo: La Poesía Sorprendida, Coleccion 'El Desvelado Solitario,' 1945.
4. Aída Cartagena Portalatín, *Llámale verde*, Ciudad Trujillo: La Poesia Sorprendida, Coleccion 'El Desvelado Solitario,' 1945.
5. Alberto Baeza Flores, *La Poesía dominicana en el siglo xx, generaciones y tendencias, poetas independientes. La poesía sorprendida, suprarealismo, dominicinidad y universalidad (1943–1947) II* (Santiago: Universidad Católica Madre y Maestra, Colección Estudios 22, 1977), p. 621.
6. Aída Cartagena Portalatín, *Una mujer está sola*, Ciudad Trujillo: Colección 'La Isla Necesaria,' 1955.

7. Aída Cartagena Portalatín, *Mi mundo el mar*, Ciudad Trujillo: Colección 'La Isla Necesaria,' 1953.

8. José Alcántara Almánzar, *Estudios de poesía dominicana* (Santo Domingo: Alfay Omega, 1979), p. 274.

9. Elaine Showalter, 'Walking in the Wilderness,' *New Feminist Criticism* (New York: Pantheon, 1985), p. 264.

10. Sherezada (Chiqui) Vicioso, in *La mujer en la literatura, Homenaje a Aída Cartagena Portalatín*, ed. José Rafael Sosa. (Santo Domingo: Editora Universitaria, 1986), p. 82.

11. Almánzar, *Estudios de poesía dominicana*.

12. Ramón Francisco, *Literatura Dominicana 60* (Santiago: Universidad Católica Madre y Maestra, Colección Contemporáneos 7, 1969).

13. Aída Cartagena Portalatín, *La voz desatada*, (Santo Domingo: Brigadas Dominicanas, 1962).

14. Aída Cartagena Portalatín, *la tierra escrita*, (Santo Domingo, Brigidas Dominicanas, 1967).

15. Aída Cartagena Portalatín (ed.), *Narradores dominicanos* (Caracas: Monte Avila, 1978).

16. For a study of women and racial identity in Dominican poetry, see the introduction to de Filippis.

17. Manuel and Lupo Hernández Rueda (eds.), *Antología panorámica de la poesía dominicana contemporánea 1912–1962* (Santiago: Universidad Católica Madre y Maestra, Colección Contemporáneos 12, 1972).

18. Aída Cartagena Portalatín, *Escalera para Electra*, 2nd edn (Santo Domingo: Colección Montesinos, 1980).

19. Quoted in Sosa (ed.), *La mujer en la literatura*, p. 9

20. Aída Cartagena Portalatín, *Tablero*, (Santo Domingo: Taller, 1978).

21. Aída Cartagena Portalatín, *En la casa del tiempo* (Santo Domingo: Colección Montesinos, 1984).

22. Aída Cartagena Portalatín, *Yania tierra* (Santo Domingo: Colección Montesinos 5, 1984).

23. Aída Cartagena Portalatín, *La tarde en que murió Estefanía* (Santo Domingo: Colección Montesinos, 1984).

24. Aída Cartagena Portalatín, *Las culturas africanas: rebeldes con causa* (Santo Domingo: Colección Montesinos 5, 1986).

About the Power of Literature

Astrid Roemer

In the beginning was the word and after that the analphabets.

If I, as a so-called Third World Woman in an extremely western world, interpret literature, then I am trying to do that with a consciousness that is first cleansed more or less of traditional western literary concepts.

For instance: comparing the Surinamese literature with the Dutch makes no sense for the following reasons. The Netherlands has a long literary tradition which, in addition, is inspired by the 'Classics' which in turn also collected their wisdom from the Africans, the Asiatics, and the Indians. The Netherlands has a class society which makes it impossible for some people to practice literature as a profession and/or as a leisure occupation. The Netherlands has an official reading-culture which is supported by a population of millions. The Netherlands, in addition, is a highly developed and rich country.

What applies to the Netherlands is typical of industrialized countries which look upon the mineral- and agrarian-producing countries as belonging to the Third World. No wonder that the Surinamese author is associated with thin, badly-produced books, edited under his own supervision, with mimeographs, pamphlets, and such products, dripping frustration because of colonialism. And nobody looks at the human being behind the author, only with deprecation.

These are the facts which incite me, at least, to look for my own paradigm for the literature of non-western countries in general, and as an author according to that.

Historical Context

Literature, in general, runs more or less along with history, in general. But besides the historical tradition of a country, a nation, and its people, literature also delivers us documents of smaller collectives – as for instance classes, families, small family units, even of individuals. As a 'Nation,' Suriname is young and still free of tradition. But in its authentic diversity, the Surinamese people have a burdened past, a vibrating present, and a future full of surprises.

So, to look at the existing literature of my home country, it seems to be most important to ask myself which points of recognition do I find in the literature – as an individual, both as personality, and as a member of a more general and historical burdened collective (woman, Afro-Surinamese, and so on). Historical facts which are specific and peculiar to that country – the heterogeneity of the

238 *Moving Beyond Boundaries*

population, the multiculture and the multilingual idiom usage, as well as in a certain sense the diffuse colonial and post-colonial history of each nation individually and collectively – form the base that one must search by means of points of recognition for affinity with the (Surinamese) literature.

1950–80 Alienation and Recognition

Alienation, 1950–1980. Although I discovered Surinamese literature by my own initiative and not because of education and training, my feeling toward it was, in the first place, one of disappointment. Mulisch, Claus, Wolkers, Vestdijk, Multatuli – especially the '80s generation – were my reference authors and, in comparison with them, many 'homeland authors' like Robin Ravales, Ruud Mungroo, Thea Doelwijt, and many poets shrank into nothingness, so I judged, although I was charmed by the fact that I was a Surinamese human being who had a lot more in common with them than with my Dutch idols.

In the works of white male authors who were suggested to me by similar specialists of Dutch literature, I was attracted generally by the techniques applied to the words so that the reader experiences them as 'naked.' And besides that, the profiles of being Jewish by Mulisch, the breaking-down of borders between the genres by Claus, the eroticism of Wolkers dazed me; Multatuli and Vestdijk: the first had my interest because of his political commitment and his description of the tropics (-people), and the second had an oeuvre that struck me to my knees. The '80s generation moved me with their passionate writing. This recognition was virile but produced only pseudo-fruits: insight into white lifestyle and admiration for highly developed authorship.

In the same period, I also read Lou Lichtveld (pseud. Albert Helman), especially his great Surinamese novels like *The Silent Plantation, My Monkey is Laughing,* and *My Monkey is Crying,* but the intellectual children of this man, born and raised in Suriname, left me with an alienated feeling: I did not exist, my family did not exist, the Surinamese society as a recognizable organism did not exist either. Helman talked in his Surinamese novels about things which for me, as a Surinamese woman, did not in any way reflect my experience and affection. (Later, as I grew a bit older and used his essays to interpret his fiction, I went on to accept this author as a writer of the 'Surinamese house.')

Whereas Helman as an author of Surinamese origin did not speak about me at all, the 'Moetete-group' (1962) had been founded especially for Surinamese literature. What was intended as a literary revolution, turned out to be caught up with its own words: a magazine (*Moetete* which flourished for a very short time) flanked by additional publications. The group whirled up enough dust, was clearly engaged, and was not absorbed by form-dispute. *Moetete* (Indian name: basket) did not start to move the literature, because it was only a noise. Rich in sound and rhythmical and actual in content was the prose and the poetry that

found its way as offset-prints in piles to the public which breathlessly listened to its authors.

But *Moetete* stayed a noise and did not become a school or current within the home-literature. Polemics about structure and form-questions were background music, an accompaniment to café conversation. The people were allowed to listen and buy, were allowed to be consumers and did not get secondary literature to keep them occupied with the authors. Besides that, here too occurred the same old evil: in its contents, this literature did not deliver any substantial points of recognition for individual Surinamese. Of course, the topics were generally human and referred to the idiomatic use of something recognizable, but the gap which separates fiction from reality and the ideal from the action yawned as a sterile void.

Was it true that this alienating feeling which my own literature and my own authors raised in me had something to do with my own individuality? Was my perception of being Surinamese so extremely different from that of the authors?

I informed myself about the Surinamese libraries of friends, acquaintances, and others, and discovered to my astonishment that the works of our authors, self-edited with so many difficulties, suffered a virgin existence as nostalgic decorations. It was then that I consoled myself with the idea, precisely like so many literate people, of being too much influenced by colonial values, because of which 'identification with one's own' had turned out to be impossible.

Although I did not know anybody who distinguished himself in writing in a way which touched me, I remained a believer in the art of the word and in the power of the imagination. Still more direct, I sought and even found in old bookshops chronicle writers, but they seemed to be only acute observers. Nothing in me and nothing outside of me brought me the idea of plunging into the literature of the so-called 'own-region' or of searching for the literature of blacks and/or women. In the first place, because of my totally one-sided education, I was adjusted to Dutch-speaking literature; in the second place, even in a political sense, the Caribbean area and the hinterland of Suriname or of the whole of Latin America, did not exist at all! And, what contributed, too, to my selective interest, was my nearly neurotic desire to find inescapable points of recognition transported in imaginative literature.

Recognition, 1960–80. My technical ability is not developed to give words to what happened to me reading *Soul on Ice* by Eldridge Cleaver. Everything that simmered in me was brought to a boil by this black American, and I was sure about what I wanted to publish and why I was writing: to create a counter-image in the literary reality in which the most specific aspect of myself was lacking.

Of course, every Surinamese poet had sung of the woman as lover and as mother, described lyrically as a biological phenomenon. But always-always again she was made subservient to the perception of the man. Of course, all these authors used

my language but they did not beautify it. Of course, I saw their commitment, but it was much too conceptual and generally applicable. Cleaver derailed me and, step by step, I approached a world of experiences which are rooted in the base of my Surinamese consciousness. I revived. I had found the way and the reason to communicate directly. Personal experiences, I realized, could be the most effective source of inspiration.

Where for heaven's sake did I find, in the Surinamese literature, examples like that? That I had to read Koenders, said a friend, and I read all those yellow *Foetoeboi's* That Eddy Bruma had it, thought somebody else, and I worked myself also through *sranan-tongo*. In fact, in these two Surinamese men, completely devoted to their home-country and authors time to time, I had heard more or less a sound that harmonized a bit, that is to say, did not disharmonize, with my feelings of self-worth. That was what I had never found in the Surinamese literature. I was not foolish, touched, or deprived. On the contrary: it is legitimate to make one's own value manifest.

In 1968 I read *Atman*, the intriguing novel of Leo Ferrier. I was in the Netherlands for the first time and had been there nearly a year, and while I read a greedy feeling of nostalgia stirred in me: I knew, that is, I recognized the consciousness of the characters, of my people, of my country, and of the author. The mother-figure whom Ferrier had designed, frightened me of something that was developing itself within me: being a woman – as a mother of independent children, as a wife of an intangible man, but above all as a sexual partner of a totally unknown person whom I loved painfully. In my deepest essence, as a person and as a woman, I was touched. For me, the Surinamese literature is re-created in *Atman* by Ferrier as the archetypical face of the Surinamese woman: deeply experienced and disgustingly absorbing.

A few years after *Atman*, I read Bea Vianen (*Sarnami Hai*, *Penal Cage*, *I eat, I eat*, and so on), whose fascinating books incited a high volume of nostalgia because they seemed to sprout from an experienced Surinamese consciousness. Her characters, particularly the men, are recognizable and reproduced in a surprisingly realistic way. Her women outraged me because of their acts of emancipatory courage in their relations to their men – so more Surinamese are they, indeed.

In her debut-novel, *Sarnami Hai* (*Surinam, I am*) this writer-woman unveils on a Hindustan-Surinamese background the daily life of a young woman. And to the archetype of Leo Ferrier another is added. The anguishing face of a girl who is to become a woman in a society where men dictate form and content. Also, the characters of Vianen are wounded in life and since she does not elaborate alternatives in her oeuvre, her anti-heroes remain as stereotypes in my imagination.

As afraid as I was of Leo Ferrier because of the dazzling depths in *Atman*, and as proud as I was because of Bea Viannen, our first female novelist, so more reading hunger touches me with any title by Edgar Cairo.

I thought: Ferrier and Vianen are finally of a different origin from Cairo and I, so his characters will call up more in me; and Cairo is a scientific literary critic and will, beyond his fictional eruptions, also publish enough theoretical reflections, for I was searching in the mean time for more inspiring examples. Also, Cairo laid things bare, literally and figuratively. He provided, *nota bene*, the Surinamese literature with a historical political truth: the poorest of our country, the paupered so-called town negroes. This author has an inimitable way of describing 'poorness' as culture. Men, women, and their children, descendants of those who 'fled' to the capital, Africans abused as slaves, crowd his fiction. I know, recognize, and see this reality as an integral part of our colonial past, but my feeling of self-value reflects his characters.

The Scope of the Literature

The publications of the last 20 years particularly are the ones which profile the Surinamese literature in a clear way. Especially the last-mentioned authors have contributed a lot to that. What should not be forgotten, however, is that these authors, too, precisely like the many 'nameless' writers, began by publishing their own works until some western publisher found them interesting enough and saleable. So, although there are few exceptions on our literature market, there exists a fruitful symbiosis between the so-called official and the self-published literature. So much has been written and published. There hardly exists a topic that is not included in our literature either as a fiction and/or non-fiction.

But does literature only concern registration of processes and documentation of reality, or will it produce truth as existential? Searching for a new paradigm these questions pose themselves, although they remain without answer. There are many studies about 'the language' as appearance, and the researchers agree unconditionally about this one question: language is thinking. And even there, where words fail (e.g. in exact sciences) it is the language which gives the 'signs.'

Literature has to do with words, words personify and abstract a culture, a culture is given form and content by human beings. This implies that lingual usage is never free of values; that languages' contents influence the thought; in short, that language is a power medium. The largest part of what I think I know is stored in language and has come to me via language usage. Especially through the language, for instance literature, total strangers communicate with each other worldwide. Ideas, thoughts, feelings, even dreams are made recognizable by language. But also so-called fact-material information is transmitted in this way.

Language, as also literature, is definitely a medium through which persons can be manipulated, (can) obtain power and/or exercise influence on their own lives and/or those of others. How is Surinamese literature related to this factor?

Within the context of the literature, I indicated that the structure of the Surinamese consciousness is formed by historical facts which are specific to and

belong to that land. If literature can at least be a medium to exercise influence on consciousness, then our literature will be a powerful medium only if it shows an extremely recognizable affinity with what is specific and particular in the Surinamese consciousness. This affinity can be a question of form and/or content. Any model that can serve as a projection-screen for the Surinamese author displays from the first gaps which deform the imagination. It is precisely that deformation that demands a literature which supplies new insights into recognizable situations. Parting with the idea that language is a power medium, the new paradigm modifies itself as our literature that as a model is inspired in the emotional and intellectual consciousness of Surinamese (persons who feel themselves more or less involved with Suriname and feel themselves to be a part of that people).

Is there any piece of prose or poetry that imagines the above-mentioned model of literature?

Just as each drop of rain is water, but not yet a river and certainly not a sea current, you could answer that question affirmatively. But where do I stay with my point, that language is a power medium and that artificial language-usage, for instance, can get individuals out of their isolation, can move social forces, can help whole peoples to regain their self-respect and dignity? It seems easy to formulate goals; to imagine a paradigm also. But it will be the skills, especially the capacity of identification of the author himself, which will elevate language-usage to literature.

Locating Myself in Language

As for me: my invariable marks are my violent pigmentation and my absolute sex. In addition, I am a product of a so-called primary product-producing 'poor' country. Women, blacks, and so-called Third World citizens do not have power media such as capital and production resources. Besides that, we have to be conscious of the fact that we will not get them for the time being, because 'nobody' is willing to part with them and 'everybody' tends to give just as much as serves his 'own interest,' and then only the personal interest. Since the international communication between human beings is intensified and mass-communication media (radio, television, cassettes, video, computers) have come within the scope of consciousness of nearly everybody, the time has come for us to orient ourselves on the idea of language-usage as an emancipatory power medium.

The *form* in the concept of literature as power medium for blacks, women, and citizens of so-called Third World countries is not primarily the printed word. The book, for instance, as phenomenon is for us an almost obsolete thing: books are always produced in/through so-called manufacturing or highly developed countries. Suriname does not have publishers; paper is extremely expensive; printing houses offer their services to commerce and government; and the bookshops

support the imports. If we want to build up an oeuvre that is our own, then we will have to thank the 'book-printing art'. No emergency: our past hands us over the form, because as Black, as Women, and as a so-called Third World citizens, we possess a rich tradition of listening and speaking, of experiencing and narrating, of complaining and celebrating. Why should we silence our imagination which lightens our spirit in language-sounds? I mean: why not opt for literature with a voice-listen-literature.

The analphebetism with which the so-called lettered people reproach us again and again no longer exists the moment that language-usage is seen to be an oral fact – a problem less! We are still struck speechless by their modern communication apparatus. It is high time to use these indoctrinating media to tell our own story. I challenge especially myself to fabricate listen-literature which is by no means inferior to the silence of the printed word. What black author has extended himself to such proportions worldwide to the consciousness of people, as for instance Michael Jackson or Bob Marley (as black singers). From that we have to learn; so do not copy careless western forms, but search for what our literature is dictating to us.

The *content*, consequently, must do justice to what the paradigm presupposes and so has to be rooted in the consciousness of the Surinamese man. But precisely because that collective consciousness is humanly spoken, a conglomeration of the possible and the impossible, it will be a function of the personal history of the author and of the consumer to determine how 'liberating' the literature is. Also, the Zeitgeist plays in this context an obtrusive role, as does the national political situation.

Referring to the last factor, there seems to be little difference between the characters in the novels of, for instance, Dutch and Surinamese authors. In the end, they are all victims, sometimes of their own emotions, sometimes of others and often of a system. Humanly spoken, any literature has the function of a bridge: a certain measure of recognition for everybody.

It is the language-usage that can build up walls, sometimes too abstract, other times too flowery and too metaphorical, sometimes too flat and too ordinary; mostly it is simply inaccessible for other languages. For Suriname is a multilingual country with more than 14 mother-languages, one oral lingua franca and one official language, and the various groups of the population have not developed equally or equivalently.

Referring to the existing literature, we can say that its language-usage is not representative of the Surinamese population. But the new paradigm also takes into account the multilingual situation of the country: language-usage is not the exclusive treasure of one competitive, self-confirming elite; language-usage is the right of every individual to express himself in the most personal and most human way. Let us, especially as authors, use the language which we command best in a way which fits us best.

Finally: literature can be a power medium if we reject the models which western literary history dictates and are conscious of a specific paradigm that the historicity of our country and our people impose on us. Only if we are rescued from the mirror image of the material rulers of this world and search for what are our essential values, for what is inherent in our essential values, as individuals and as a collective, as lettered and as unlettered persons, will literature speak for us because only then will the language find its originality. In the beginning was the word ...

<div style="text-align:right">Netherlands, Summer 1986
Translation: Rita Gircour</div>

Zora Neale Hurston: A Subversive Reading

bell hooks

Although much is written about Zora Neale Hurston's life, her flamboyant personality, there is little information about her engagement with books. What writers did she read and the like? Whose work influenced her writing? Robert Hemenway's[1] biography mentions only that:

> Zora learned to read before school age, and her quickness set her apart. Of all the school's students it was the fifth grader Zora Hurston who so impressed two visiting Yankee ladies that they were moved to send her a box of books. Suddenly her single-volume library, the family's Bible, was augmented by Grimm's fairy tales, Greek and Roman myths, Norse legends, Kipling, and Robert Louis Stevenson.

Like Hurston, diverse books I could call my own first came into my childhood as gifts – a retired black schoolteacher was cleaning out her house and throwing away shoe boxes filled with tiny books in leather. They were the 'classics' of white western literature. From among these writers I chose one whose work influenced me, Emily Dickinson.

At 13, I knew I wanted to write. Confident that this was my destiny, at 16 I read Virginia Woolf's *A Room of One's Own* and chose another guide. She was the sister-informant, sharing the secrets of what it would mean to be a woman and a writer, telling me what I would need. I never thought of Dickinson or Woolf as 'white women.' They entered the segregated world of my growing up as writers, and most importantly as women writers. Later I would learn the distance separating their experience from my own, the politics of race, sex, and class – still their work spoke to me. However, it was the discovery of black writers in general, and black women writers in particular, which fully affirmed that I

could indeed become a writer, that it was vital and necessary to draw upon the experience of black culture and black life for inspiration and imaginative direction. Zora Neale Hurston became the representative mentor for me. Her background was similar to my own (rural, Southern, religious, lacking in material privilege) and I was profoundly impressed by her commitment to writing, to breaking through silences, and her willingness to experiment with form and content.

Like many readers I have often thought *Their Eyes Were Watching God*[2] most fascinating because of the way it challenges conventional sexist notions of woman's role in marriage and romantic love, insisting on the importance of female self-actualization. I, too, have celebrated Hurston's fictional portrait of love between a black woman and man. Critical attention has necessarily focused on these aspects of the novel, so intensely, however, that readers are inclined to overlook Hurston's concern with the construction of 'female imagination' and the formation of a critical space where woman's creativity can be nurtured and sustained. These concerns radically inform the structure of *Their Eyes Were Watching God* and its narrative direction. They can be fully addressed only if readers no longer centralize Janie's relationships with men. Strategically, the focus on romance is a device Hurston uses to engage readers while subtly interjecting a subversive narrative.

Hurston's passion for the folktale which captivates audiences by sharing a story cast in terms which appear familiar, coupled with her sense that stories were most interesting when lies masked truth, greatly influenced her writing style. Barbara Johnson comments on this strategy:

> If, as Hurston often implies, the essence of telling 'lies' is the art of conforming a narrative to existing structures of address while gaining the upper hand, then Hurston's very ability to fool us into thinking we have been fooled – is itself the only effective way of conveying the rhetoric of the 'lie.'[3]

Much of Hurston's magic and power as a writer centers on her incredible ability to manipulate multiple plots in a single narrative. Her insistence on playful subterfuge is often missed by readers of *Their Eyes Were Watching God* who see the novel as conventional linear narrative weakened by textual gaps.

Discussing the work of nineteenth-century white women writers, Eva Figes reminds readers in her chapter on 'The Suppressed Self' that it was 'not remotely possible for women to express themselves through fiction in terms of full indi-viduation, because they were not free.'[4] She emphasizes that internal and external constraints ensured that woman's subjective voice would be 'expressed with a certain degree of disguise and subterfuge.' These comments hold true for black women's writing in the early twentieth century. Structural ambiguity is not a failing in Hurston's work, it is a tactic, leading the unsuspecting reader astray. Within traditional African-American folk culture, telling a story to a listener who perpetually misses the point was seen as an indication that they were not meant

to 'hear' the message. They could enjoy the story without understanding it. One constructs a tale so that it appears to address everyone even though it speaks in its deepest structure to a select few. Without a doubt, Hurston intended *Their Eyes Were Watching God* to be an appealing story, one that would sell to a wide audience. To enhance the likelihood of such appeal she exploits many conventional aspects of romantic fiction. Yet she was not writing a romance. There are many plots and much social commentary in *Their Eyes Were Watching God*. One very moving story is the romance of Janie and Tea Cake. Just as everyone comes to the courtroom to hear Janie tell her story (the narrator comments 'who was it didn't know about the love between Tea Cake and Janie'), it is this story more so than any other told in the novel that continues to have appeal – it speaks to everyone.

Critics talk about the love between Janie and Tea Cake as the catalyst for her self-actualization, using the metaphor of her 'coming to voice,' becoming a story-teller as sign of female empowerment. Consistently read as a novel that celebrates Janie's finding a voice, readers are nevertheless disturbed by the concrete fictive circumstance which frames Janie's autonomous identity as the novel closes. Hortense Spillers's critique implies that Hurston's ending betrays the character-ization of Janie as self-actualized.[5] Reading the ending as a 'eulogy for the living,' she suggests that 'Janie has been "buried" along with Tea Cake.' In an even more suspicious reading, one which goes against the grain, Mary Helen Washington asserts that the novel 'represents women's exclusion from power, particularly from the power of oral speech.'[6] Approaching the novel primarily through a com-parative lens where Janie's status is viewed in contrast to that of men or contemporary feminist standards, these readings simplify Hurston's vision.

Spillers focuses on the persistence of Tea Cake's presence, even after his death, and Washington calls attention to the few times Janie actually 'speaks.' They read gaps in the novel as lacks, representing Hurston's failed or distorted insight. These gaps can be viewed as narrative clues underscoring the extent to which Hurston's critical project was not simply to create a female hero who resists sexist oppression, asserting autonomy and selfhood. When she stops speaking through the text to a mass audience engaged in emphatic identification with Janie's effort to resolve her quest for love and selfhood, Hurston speaks to her select few. Then the novel is more a fictive manifesto on the subject of gender roles as they influence and effect the construction of the female imagination. It echoes and extends the commentary Woolf begins in *A Room of One's Own*, centralizing the plight of underclass black women who might wish to develop their creative talent.

Janie's quest for selfhood ends in her return to a space where she can be solitary, critically reflective, where she can 'tell her story.'

Significantly, she returns economically self-sufficient – the material conditions which Woolf insisted were necessary for any woman desiring to write. Just as Woolf delivers her important comments on female creativity to an audience of

women, Janie tells her story to a black woman, Phoeby, inviting her to share the tale with others. Expressing confidence in Phoeby's ability to convey the truth of her experience, Janie offers a provocative metaphor for sisterhood, declaring 'mah tongue is in mah friend's mouf.' Much of the language describing their friendship is romantic – intimate and familiar. As story-teller and listener they complement one another. A similar complementarity exists between Janie and the third-person narrator who intervenes and shares the telling of Janie's story.

Unlike the conventional third-person narrator who assumes a privileged distance from the story, Hurston's narrator is engaged, familiar, and intimate. The tone the narrator uses is akin to Janie's even though it is a more sophisticated voice. Some critics see Hurston's use of third-person narration as a gesture which undermines the development of Janie's voice. Mary Helen Washington assumes that 'Hurston was indeed ambivalent about giving a powerful voice to a woman like Janie who is already in rebellion against male authority and against the role prescribed for women in a male-dominated setting.' Had the story been told in Janie's fictive patois there would have been little or no space for the inclusion of a wide range of folklore and folk wisdom (much of which surfaces in dialogues between characters Janie would not have been in a position to hear). Hurston's skillful repression of Janie's voice never jeopardizes its significance. Even though readers do not hear her voice in the courtroom scene, we learn that she moved her audience, that she achieved the desired effect. Third-person narration does not deflect attention away from that achievement, or Hurston's didactic insistence that women must come to voice to be fully self-empowered. If Hurston was ambivalent, her concern may have been that the novel not be viewed as a fictive sociology of black folk life. Though she wanted to celebrate folk experience in her writing, she wanted readers to recognize that her novel was a carefully constructed imaginative work. Third-person narration calls attention to Hurston's authorial voice, highlighting the importance of writing.

Zora Neale Hurston could easily have become a renowned oral story-teller; she chose writing. *Their Eyes Were Watching God* celebrates story-telling as imaginative work that can serve as the foundation for the development of a written story. It is this fictive art form (oral story-telling in the African-American folk tradition) that most influenced Hurston's work. Hence the importance of her fictive opposition to black male domination which precludes female participation in oral story-telling. This critique implies that denying black women access to a mode of artistic expression so fundamental as a ritual of daily life, is an exclusionary practice that eliminates any possibility that females can develop their imaginative skills.

Suppression of female imagination does not begin in *Their Eyes Were Watching God* with male domination. Hurston links the realm of fantasy and imagination to the experience of eros (desire) and sexual awakening. At 16 Janie's ecological communion with a pollinating pear tree stirs her senses, simultaneously stimu-

lating a desire for knowledge. Intuitively experiencing an erotic metaphysic wherein she witnesses the unity of all life, Janie confronts her ignorance, the absence of an ontological framework that could serve as a basis for the construction of autonomous self and identity. Acknowledging her longing to 'struggle with life' she is eager to follow intuition, to become a seeker on the path of self-realization. These longings and her unrepressed imagination are stifled by her grandmother, whose vision of life has been overtly determined by racist and sexist politics of domination. Using a popular folktale (one Hurston did not create), Janie's grandmother explains the way the convergence of race, class, and gender domination shapes the social circumstance of black women. A political commentary which concludes with the statement 'de nigger woman is de mule uh de world.' Materialist to her core, Janie's grandmother confronts the harsh reality of white supremacist capitalist patriarchy and strategically defines the terms of her survival, working within the existing structure. It is this non-oppositional legacy she shares with Janie, forcing her to adopt a similar survival to self-knowledge, her imaginative exploration of the meaning of existence, and her sexuality are all suppressed in the interest of material survival.

Unable to envision new paradigms for black womanhood, Janie conforms. Her marriage to a 'good provider' ensures material survival even as it requires sexual and emotional repression. Yet Janie's erotic imagination is never completely submerged. Throughout the novel Hurston toys with the idea that eros can be a catalyst for self-discovery and transformation, that repression of this inner power leads to acquiescence, submission, domination. It is the convergence of power and desire that informs Janie's relationships to men. Given her race, class, and gender, it is only through an involvement with a male that she can hope to change her circumstances. Hurston assumes that it is a natural outcome of patriarchal socialization that female imagination is most expressed initially with the realm of romantic fantasy. She evokes the 'feminine ideal' only to show how it leads to the subjugation and subordination of the 'desired' female. Janie is never completely taken in or corrupted by idealized notions of femininity. Though she outwardly conforms, inwardly she resists. Hurston portrays this contradiction sympathetically though she is more scathing in her fictive social commentary on masculinity.

Men, Hurston suggests, are psychologically unable to be existentially self-reflective about masculinity. In *Their Eyes Were Watching God*, masculinity is seldom celebrated and often mocked. Hurston's focus on Janie's men is not male-identified, for she exposes and unmasks. Again, there are correlations between her strategy and the literary tactics Woolf employs in *A Room of One's Own*. In both works the characterization of men is double-edged and ironic. Hurston's portrait of Joe Starks is initially flattering, becoming progressively negative as his character unfolds. Despite social superiority, men in *Their Eyes Were Watching God* look good from afar; close-up their flaws and failings surface. They are pre-

occupied with representation, obsessed with appearances. Janie hardly notices her long hair and never focuses on physical beauty. She is attracted to men who behave in a manner that appeals. Ultimately, Hurston's fictional portrayals suggest that men lack substance.

All of Janie's loves, Logan Killicks, Joe Starks, and Tea Cake, are insanely egotistical. Each man suffers because he is unable to make full empathic connection with the world and people around him. On his deathbed, Joe is confronted with Janie's critical assessment of this failing. She tells him 'you was so busy worshippin' de works of yo' own hands, and cuffin' folks around in their minds till you didn't see uh whole heap up things yuh could have.' Tea Cake's egotism leads him to ignore the signs and warnings which indicate a hurricane is coming. Risking his life and Janie's, he places himself above God and nature. A similar concern with image and masculine ego is evoked in the scene where Tea Cake hits Janie to prove to other men that she is 'his' woman.

Feminist readers are usually disturbed by what appears to be Hurston's uncritical acceptance of male physical violence against women, overlooking the way in which the novel portrays violence as an integral part of black folk life. The first person who slaps Janie is her grandmother. Tea Cake and Janie first struggle physically when she attacks him. Significantly, in the passage describing this conflict initial emphasis is placed on Tea Cake's efforts to talk with Janie. Her response is to 'cut him short with a blow.' Although their fighting ends in lovemaking, this is not a scenario advocating physical abuse of women – Janie is not represented as a victim of domination. Tea Cake restrains her to 'keep her from going too far,' suggesting she has the power to hurt him. Hurston was quite familiar with 'shoot and cut' relationships where black women physically attacked and killed black men. She did not see black women within the communities of her growing up as passive victims of male abuse. Her uncritical acceptance of violence as a 'natural' outcome of conflict should form the basis of feminist critique. There is a distinctly different tone in the novel when Hurston portrays Joe Starks's slapping Janie to maintain coercive male domination and Tea Cake's slaps. Starks's brutality is underscored. Tea Cake appears vulnerable, pathetic, and ridiculous. Hurston is critical of the circumstances and reasons why men are violent toward women. She calls attention to the way in which male notions of female inferiority must be continually reaffirmed by active aggression, thereby challenging notions of innate difference which would support the claim of male superiority.

Indeed, Hurston's characterizations of males and females often suggest that women are possibly the superior gender. Janie intervenes in male conversation to challenge the notion of male superiority. Claiming to be on intimate terms with God (who is constantly evoked as a power stronger than men), she asserts, 'He tole me how surprised He was 'bout y'all turning out so smart after Him makin' yuh different.' Divine presence magnified in nature is evoked by Hurston

as part of her questioning of sexist defined roles. Using her fiction to denounce expressions of masculinity associated with coercive domination, she challenges the accepted belief that the male who is best able to provide material possessions is the most desirable companion. New paradigms for heterosexual bonding are suggested via the characterization of Tea Cake, in many ways an anti-masculinist man with no desire to dominate others. Even though he has sexist attitudes, they are not the basis of his relationship with Janie. From the onset of their romantic bonding, Tea Cake introduces a model of heterosexual bonding based on reciprocity and mutuality. Susan Willis identifies the subversive nature of their relationship:

> Since possession and objectification do not define the dynamic of their union, Tea Cake and Janie are free to devote their energy and attention to maintaining reciprocity. When, at their first meeting, Tea Cake teaches Janie to play checkers, he sets the terms of their relationship in which all endeavor will be defined as sport and shared equality. Heterosexuality is neither a basis for power nor a reason for submission, but a mode in which a man and a woman might equally participate.[7]

Tea Cake's alternative masculinity is linked to a repudiation of materialist values. Sustaining a non-exploitative relationship to nature, radical disengagement from a market economy, he is not alienated from a realm of expressive feelings and emotions usually associated with children and women. Tea Cake values 'play.' He is able to express a wide range of emotions, to be empathic. Sharing his intuitive trust in the power of feelings and his belief that the desire to experience pleasure can be the organizing principle of daily life, he is able to help Janie recover the 'feeling' self she has long repressed.

Through a shared eros, Janie reconnects with the passionate part of her being experienced in her adolescence. Through this reconnection she is able to heal her wounded psyche – to be born again. Recognizing the gift Tea Cake has given her, she affirms their bonding as they face the possibility of death: 'If you kin see de light at daybreak, you don't keer if you die at dusk. It's so many people never see de light at all. Ah uz fumblin' round and God opened de door.' More than an affirmation of her love for Tea Cake, this statement reveals Janie's belief in a divine force made manifest in human relations. The 'light' here is not romantic love, it is spiritual awareness – vision, insight. Experiencing mutual romantic love has been a means for Janie to know divine love, to return to that erotic metaphysic expressed in her girlhood. Connecting with Tea Cake, she experiences anew the unity of all life. Returning to an uncorrupted natural environment, 'the muck,' she learns to live in harmony with nature, with a multiethnic diverse community of people. In this world of unrepressed emotions she learns to sing and dance, to tell stories. Tea Cake nurtures Janie's growth, assuming a maternal role, yet another aspect of his alternative masculinity.

Hurston does not sustain the portrait of Tea Cake as symbol of oppositional, reconstructed, potentially feminist, masculinity. His radical transgression of gender norms are undermined by sexist attitudes and behavior surfacing whenever he feels jealousy. During these times Tea Cake is obsessed by the desire to show others that he 'possesses' Janie. Just as jealousy prompts his slapping her, it leads him to attack her when he is sick. After Tea Cake battles the mad dog, he completely reverts to a sexist masculine posture. Confiding in Janie the belief that his rescue of her affirms his masculinity, asserting: 'Ah want yuh tuh know it's uh man heah.' Just as Janie has been a divided soul, passively submitting to sexist defined female roles while alternately rebelling against those roles, Tea Cake both embraces and rejects aspects of traditional masculinity. His ability to disengage fully from sexist norms undermines the transformative power of feminist aspects of their heterosexual bonding. Attacking Janie, Tea Cake employs violent rhetoric similar to the verbal assaults of Janie's previous husbands, Logan Killicks and Joe Starks. Commanding her to 'answer me when Ah speak,' Tea Cake assumes a dominating threatening stance.

Ironically, Janie can effectively oppose the reinscription of a life-threatening male domination by using skills Tea Cake helped her to acquire. Their life and death confrontation is the ultimate test of her newly found self-regard. If she had become a whole person through loving and sharing life with Tea Cake, a person capable of autonomous individuation, she must shatter the illusion that 'Tea Cake wouldn't hurt her' – facing reality. Acknowledging conflicting identities, the courageous self within 'fighting for its life' and the 'sacrificing self,' Janie confidently chooses. No longer victimized by passivity and a fearful inability to exercise autonomous resistance in the face of male domination, she reveals a decisive mindset. It is this climactic moment in the novel which indicates that Janie has constructed an autonomous self more so than any act of story-telling.

Janie's killing of Tea Cake subverts traditional notions of romantic love which encourage female masochism; she is not willing to die for love. Earlier in the novel Janie has called attention to distortions and perversions in relationships enacted in the name of love, sharing her insight that 'most humans didn't love one another.' Hurston offers a different version of romantic love, one that repudiates female masochism. Though the two lovers initially experience a temporary loss of ego boundaries – Janie describes her feelings as 'a self crushing love' and Tea Cake expresses the depth of his surrender by declaring that she has 'got do keys tuh de kingdom' – mutual growth and sharing leads to enhanced individuation. Despite Tea Cake's jealous fear that he will lose Janie, he encourages her to be self-sufficient. Though longing to assume the role of protector, he understands that she must learn to protect herself. At times both lovers don the mantle of androgyny, displaying characteristics commonly associated with the opposite sex. In an uncorrupted world of gender relations, Tea Cake can be a nurturer, can express vulnerability and fear; Janie can work

and shoot like a man, she can even dress like a man. Through most of the novel, Janie's long hair is her distinguishing feature, the mark of her idealized femininity, on the muck it is no longer an important signifier. There androgyny is represented as an utopian ideal.

A central idea in Woolf's *A Room of One's Own* is the assertion that great writing is created by an androgynous mind, that women and men must be able to transcend limited sex roles if the imagination, the source of a writer's power, is to have full expressive range. Woolf emphasizes that writers must be able to travel, to explore and experience life fully, stressing the way the female imagination suffers because women lack complete freedom of movement. In *Their Eyes Were Watching God* Janie longs to travel, to move freely. Her passionate desire to 'journey to the horizon,' to transcend boundaries, to be an adventurer, is a repudiation of the traditional female role. Hurston's fictive characterization of the ease with which Janie flaunts convention, leaving marriage and comfortable material circumstances, having a love affair with a younger man, were daring authorial gestures for her time. Sensibly, Hurston does not suggest that Janie can wander alone, that would have given the novel less credibility. Witnessing Janie's various attempts to conform to societal norms, the containment and repression of her passionate adventurous nature, readers in the 1930s could sympathize with her plight and applaud her rebellion.

Hurston seizes every opportunity to reiterate the conviction that transgressive behavior, which promotes and encourages self-exploration, is essential for the development of an artistic sensibility. Critically reflecting about her past when Joe Starks dies, Janie laments the loss of intense creative impulses. Recalling her intuitive awareness of the importance of creativity in girlhood, she remembers thinking 'she had found a jewel down inside herself.' Then Janie saw herself as gifted. Falling in love with another gifted person, Tea Cake, she regains the power to imagine, to dream, to create. Bohemian in style, Tea Cake is both musician and composer. Art is an integral part of daily life, never separate or fetishized. Burying him with a new guitar, Janie imagines he resides in a realm beyond death 'thinking of new songs to play to her.' Writing *Their Eyes Were Watching God* at a time in life when she was struggling with the issue of commitment to art and fidelity to romantic relationships, Hurston could not have made Janie a writer, for the novel would have seemed too much like autobiography. Even so, Janie is not an artist without an art form. She consciously approaches life as though it were a creative project, making no separation between life and art. In her life with Tea Cake, story-telling becomes the medium for the expression of her creativity. Like Tea Cake's music it is represented as a part of the dailiness of life.

Significantly, when Janie tells her story to Phoeby, it is as though she is painting a portrait. This story begins with uncertainty about representation. Janie cannot recognize her own image. Defined and named by others in childhood, Alphabet (as Janie is called then) cannot know or name herself. Ultimately her

triumph in womanhood is that she acquires the ability to name and define her reality. Choosing to return to the house she owns, and the community she knows after Tea Cake's death, Janie acknowledges that the muck was really his place. Bringing with her seeds to plant, a memento of her life with Tea Cake, a symbol of her love, she plants to nurture new life. Janie returns to her old community with new vision and insight. She is able to see the folks around her through the eyes of awareness. Self-realized, she need not experience interiority as confinement nor the outside world as threatening.

The courtroom scene is a crucial rite of passage for Janie. Just as she must privately prove that she has claimed her life by killing Tea Cake, she must be able discursively to defend her actions in public space. Publicly naming the radical subversive nature of her life and love with Tea Cake, Janie again risks her life. In the courtroom she is the ultimate outsider. Cut off by a blaming, unsupportive black community, she must confront a jury of 'strange' white men. Janie stands alone. At the end of the trial Hurston incorporates a popular folk expression which claims that 'uh white man and uh nigger woman is de freest thing on earth' as an ironic gesture, highlighting all that Janie endures and suffers to be free. Of course the black men sharing this sentiment fail to understand her experience. Janie can survive the courtroom scene and Tea Cake's death because she has acquired an ontological framework on which to base the construction of self and identity. She can both speak the truth and live the truth of her experience. Sharing with Phoeby the importance of experience she bears witness:

'Course talkin' dont amount tuh uh hill uh beans when yuh can't do nothing else. And listenin' tuh dat kind uh talk is jus' lak openin' yo' mouth and lettin' de moon shine down yo' throat. It's uh known fact, Phoeby, yo got tuh go there. Yo' papa and yo' mama and nobody else can't tell yuh and show yuh. Two things everybody's tuh do fuh theyselves. They got tuh go tuh God, and they got tuh find out about livin' fuh theyselves.'

Heterosexual bonding with Tea Cake enables Janie to fulfill her longing for romantic love and her quest for self-realization. Without embarrassment, Hurston suggests that poor black women victimized by gender discrimination must learn from men. She then suggests that having acquired necessary knowledge and skill, women can not only survive without men; we can flourish. The ending of *Their Eyes Were Watching God* would be problematic if Janie had returned home depressed and isolated. Though weary from her journey, she returns and reunites with her friend Phoeby. Mutually nourishing one another, Phoeby gives Janie food for the body and she gives her sustenance for the soul. When Phoeby tells Janie, 'Ah done growed ten feet higher jus listenin' tuh you,' the primacy of female bonding based on sharing knowledge is affirmed. Janie's quest for experience and knowledge does not lead her to abandon Phoeby. Hence, just as Hurston rewrites the script of heterosexual romantic love, she insists that women

need not be rivals as sexist norms suggest, instead they can share power, reinforcing one another's autonomy. Janie shares her new found 'ideology of liberation' so that it can also have a transformative impact on Phoeby's life. Offered a new paradigm for heterosexual bonding, Phoeby can evaluate her life with Sam and suggest a new direction. Janie's power lies both in the ability to tell her story and the didactic impact of that telling.

Woolf ends *A Room of One's Own* by calling attention to the untapped creativity in all women and our capacity to nurture one another. Recognizing this to be an important stage in the process of self-development, but only a stage, she concludes by urging women to escape from isolation, from sex-segregated space. Her final charge is that women face 'that there is no arm to cling to, but that we go alone and that our relation is the world of reality, and not only to the world of men and women.' Hurston ends the novel with a fictive mirroring of this prophetic declaration. It is an ending which celebrates woman's capacity to face life alone. Janie is not cut off from life. Possessing a keen memory and a powerful liberated imagination, she can create and be a world for herself. Last described in the act of reflection, Janie is thinking, remembering, imagining. Still rebellious, she challenges accepted perceptions of reality by positing a radically different way to view dying. Janie sees death not as an end to life but simply another stage of growth. Viewed from this perspective, death can be approached without fear, and the death of a loved one, though grievous, can become another ecstatic occasion where one bears witness to the unity of all life. It is this revelation that she witnesses at the end of the novel, that she calls 'her soul to come and see.'

As the novel ends, interiority is not depicted as a space of enclosure. It is not restrictive or confining. Janie opens windows, letting in air and light. Transformed interior space is expansive; it mirrors Janie's psyche. Importantly, the last paragraph reaffirms this transformation of inner domestic space. Janie has more than a room of her own, she has the capacity to live fully in that room – to resurrect, to reconcile, to renew. Janette Turner Hospital reminds us that Virginia Woolf's room of her own did not keep her alive.[8] Hurston not only saves Janie's life, she gives her space to rest and renew her spirit, a space of infinite possibility, a space where she can create. Such a space, Hospital claims, is absolutely essential for the growth and development of the 'female imagination': 'The quest for women writers then, and of their protagonists, is a search not just for a room of their own, but for safe private space, for non-toxic air, for a place where the self can really breathe.'

Hurston spent most of her life trying to find such a place. It was an unfulfilled quest. Without stones in her pocket, she, like Woolf, sank into the abyss, one the abyss of poverty and misfortune, the other madness and the suffocation of privilege that does not ensure freedom from pain. In *Their Eyes Were Watching God* Hurston creates this safe place – a wide transformative space Janie calls 'home.'

Notes

1. Robert Hemenway, *Zora Neale Hurston: A Literary Biography* (Urbana: University of Illinois Press, 1977).
2. Zoral Neale Hurston, *Their Eyes Were Watching God* (1937) (Urbana: University of Illinois Press, 1978).
3. Barbara Johnson 'Thresholds of Difference: Structures of Address in Zora Neale Hurston,' in *'Race,' Writing and Difference*, ed. Henry Louis Gates, Jr, (Chicago: University of Chicago Press, 1986), pp. 317–28.
4. Eva Figes, *Sex and Subterfuge: Women Novelists to 1850* (London: Macmillan, 1982).
5. Hortense Spillers, 'A Hateful Passion, A Lost Love,' in *Feminist Issues in Literary Scholarship*, ed. Shari Benstock (Bloomington: University of Indiana Press, 1987), pp. 181–207.
6. Mary Helen Washington, "I Love the Way Janie Crawford Left Her Husbands': Zora Neale Hurston Emergent Female Hero,' *Invented Lives: Narratives of Black Women 1860–1960* (New York: Anchor/Doubleday, 1987), pp. 237–54.
7. Susan Willis, *Specifying. Black Women Writing the American Experience* (Madison: University of Wisconsin Press, 1987).
8. Janette Turner Hospital, 'Space Invaders,' *Women's Review of Books* 5 (1988), pp. 10–11.

'Who can take the multitude and lock it in a cage?'[1]
Noemia De Sousa, Micere Mugo, Ellen Kuzwayo: Three African Women's Voices of Resistance

Arlene A. Elder

Micere Mugo's *The Trial of Dedan Kimathi*, co-authored with Ngugi wa Thiong'o, Noemia De Sousa's poems, 'black blood,' 'if you want to know me,' 'Appeal,' and 'the poem of joao,' and Ellen Kuzwayo's memoir, *Call Me Woman*, despite their different genres, are works united in their complex understanding of modes of imperialism and their call for resistance through political and social co-

operation.[2] As Margaret Dickinson observes, in a colonial situation, 'a poet's vision is likely to make [her] first and foremost a revolutionary; [her] poetry, when [she] can steal time to write it, will be the expression of this revolution in which [her] life is spent.'[3] The revolutionary works of each of these writers raise issues of both feminist and aesthetic import, integral questions, that is, of genre, language, and the social function of the artist. Their writing, in other words, reflects not only the turbulent political arena of its subject and composition, but also contemporary critical attitudes toward the form and function of literature itself, issues largely deriving from considerations intrinsic to Third World writing.

Activists all, Mugo of Kenya, De Sousa of Mozambique, and Kuzwayo of South Africa, have suffered exile and displacement in their own lives. Mugo lived in Zimbabwe and now in New York State, De Sousa in Paris, and Kuzwayo, while able to leave and return to South Africa, has observed of the country that imprisoned her for her political activities, 'You don't have to go out of the boundaries of South Africa to be in exile.'[4] These three artists are united, as well, by their understanding of community as the source of political and psychological strength and by their emphasis upon women as doubly oppressed by both traditional and colonial patriarchy. Of the three, De Sousa is the most conventionally 'literary,' with her lyrical paeans to Africa. Yet her desire to awaken the revolutionary spirit and unity of her people allows her works transcendence over static, satisfied contemplations of Négritude, intruding them, instead, into the dangerous world of action. Art as action is a mode De Sousa participates in with Micere Mugo; speech as expressive of a womanist concern with community, an ideal she shares, as well, with Ellen Kuzwayo.

One branch of current feminist research posits a distinct feminine imagination and, consequently, an art form that is 'fluid, nonlinear, decentralized, nonhierarchic, and many-voiced.'[5] *The Trial of Dedan Kimathi*, both in its structure and in the actual facts of its composition, reflects this approach. In their joint Preface, Micere and Ngugi explain the political motivation behind their co-authoring this play, that is, to celebrate the 'peasant armed struggle against the British Forces of occupation,' thus depicting 'the people, the masses, as capable of making and changing history' (TDK, p. v). They also formally acknowledge the work as 'a result of a collective effort with many concerned people freely giving us their comments and suggestions most of which we did incorporate into the play' (TDK, p. iv). Further demonstrating Elaine Showalter's observations of some contemporary feminist strategies as 'fluid,' 'nonlinear,' and 'many-voiced' is their explanation of the play's form in their 'Preliminary Notes':

The play is in three movements which should be viewed as a single movement. The action should on the whole be seen as breaking the barrier between formal and infinite time, so that past and future and present flow into one another. The scenes (street, cell, courtroom) should also flow into one another. There

is impersonation, merging of character and reflection of history emphasizing the complexity, duality and interrelationships of people and events. (TDK, p. 2)

Obviously, one is not asserting that Micere and Ngugi were deliberately following feminist techniques or that these dramatic devices are now, or have been used, exclusively by feminist writers; Bertold Brecht's dramatic experiments served, no doubt, as an important influence. It is clear, however, that the canonically-sanctioned, 'rational,' well-made play and the chronological narrative found insufficient by contemporary women writers intent on expressing nontraditional experiences also were rejected by these African playwrights, influenced further by Gikuyu orature.

Dedan Kimathi, one of Micere's Gikuyu ancestors, no doubt heard his exploits celebrated in numbers of songs composed by the common people he led and inspired during the 1950s resistance of the Land and Freedom Fighters. Maina wa Kinyatti, whose collection of patriotic songs of that period contains several featuring Kimathi by name, reports that 'Even to this day, Kimathi ... remains one of the most popular leaders and patriots in Kenya's history.'[6] The progressive political function of some types of orature directs these songs, for Ngugi notes that besides 'demanding back the land and power,' the Freedom Fighters 'rejected the culture of the oppressor and created a popular oral literature embodying anti-exploitation values.'[7] *The Trial of Dedan Kimathi*, with its engaging and enspiriting re-creation of Kenyan song and dance, very properly can be seen as a contemporary example of such traditional orature.

During the play's premier at the National Theatre in Nairobi, at times the stage and even the aisles of the theater were filled with singers and dancers, reproducing traditional dance steps and the call and response of freedom songs. The play ends with the thunderous 'People's Song and Dance,' and, while it is true that the singing represents, in a socialist sense, the unified determination of the workers and peasants, such an analysis is bloodless and uninspired when considered alongside the actual enthusiasm and involvement of the participating audience during the play's performance. African music, song, and dance invigorated the communities from which they sprang long before audience and art were defined by either Marxist or mainstream critics. It is clear, then, that much of the power of this play emerges from the authors' reflecting the artistry of the indigenous Kenyan society that it celebrates, a culture acutely aware of the artist's political role and the participatory involvement of the community.

When one turns, however, to the explicit portrayal of women and their historical function, a judgment about the revolutionary contribution of *The Trial of Dedan Kimathi*, as well as about Gikuyu society, becomes more complicated, especially when one examines the gender implications of the play's language, rather than focusing solely upon the heroic portrayal of its main characters. What is at issue, of course, is the gender politics of language, especially the hegemonic implica-

tions of what Adrienne Rich calls 'the oppressor's language, a language sometimes criticized as sexist, sometimes as abstract.'[8]

Micere and Ngugi were inspired by a woman they met when they visited Karumaini, Kimathi's birthplace. The defiant pride of the woman, who had been Kimathi's pupil at Karumaini Independent School, her continuing love of her former teacher and leader, and her insistence to the visitors that 'Kimathi will never die' (TDK, p. vii), challenged Mugo to create the Woman of the play, a multifaceted individual presented as of almost equal importance to Kimathi himself. Micere, an actress, as well as a writer, educator, administrator, and political activist, played this central Woman's role during the play's premier run.

We know from history that many Kenyan women supported, even fought alongside, the men during their struggle for national liberation. As Maina wa Kinyatti tells us:

> In most cases it was the women who bravely rescued the Mau Mau forces from encirclement and annihilation; ... Thousands of them trudged day and night on hazardous routes and braved the enemy's wrath in order to supply the Mau Mau forces with food, medicine, ammunition and information. Others, with arms in their hands joined the guerilla army in the forest.[9]

So, in one sense, Micere's emphasis on the Woman can be seen as evidence of her commitment to socialist realism, an implicit assertion that classes and their historical conflicts, not gender, is the authors' main concern. The Woman functions historically in the play, as Kimathi does, carrying out acts of subversion; she operates politically by analysing the exploitive colonial economic situation and eloquently announcing the Freedom Fighters' plans for recovery from imperialism (TDK, p. 18). Linked to Wanjiru, a guerrilla, 'who fought like a tiger ... ' (TDK, p. 10), she is a 'mother, a fighter all in one' (TDK, p. 8). She becomes symbolic, moreover, of all the women of her class, not only those who actually helped the guerrillas; the authors state explicitly, 'the woman now represents all the working mothers' (TDK, p. 59).

Many of her characteristics, while essential for a socialist-realist heroine, are also traditional for an ordinary African woman. She works within the community for its welfare, providing both physical and intellectual nourishment for the young; she instructs the Boy and Girl in proper social and political behavior; finally, exploiting a very conventional concept of the source of women's power, she uses sexual wiles and a mask of helplessness to fool a white soldier and prevent his finding the gun she is carrying to Kimathi.

In non-traditional times, however, every member of society plays non-traditional roles. Besides feeding the young Boy, she, rather than the father-figure, Kimathi, is his initiator into manhood by charging him with the ideological task of discovering his true enemies as a first step toward maturation, and the political job of supplying a gun to Kimathi as evidence of his understanding of his proper

role as a revolutionary. Under the grisly circumstances of oppression, the conventional female role of protector of the young no longer allows for keeping children out of danger; on the contrary, it requires showing them how to attack militantly the destructive forces around them, despite the danger.

A significant aspect of this break with tradition is what appears to be Micere's characterization of the Woman as, actually, an androgynous figure, representative of class struggle and de-emphasizing gender. This interpretation is reinforced by the image of the Woman, in the 'Second Movement,' disguised as a man (TDK, p. 22). It is true, as Ogundipe-Leslie observes, that European notions of femininity do not always apply to the reality of women's lives in Africa.[10] Ogundipe-Leslie cites such examples as eighteenth- and nineteenth-century women in the armies of Dahomey, women who marry wives in Igboland, and women who are called 'men when they attain certain levels of economic and social independence.'[11] There appear to be no such traditions among the Gikuyu, however, where gender roles in ordinary times are clearly defined; therefore Micere's portrayal of the Woman in this instance can be interpreted as a deliberate attempt to emphasize her revolutionary spirit while, at the same time, employing her to remind contemporary Kenyans of the historical bravery of women during the Emergency.

The political importance of androgyny in the play is reinforced by the Woman's relationship with Kimathi. In Kenneth Watene's play on the same biographical subject,[12] there appears a traditional love interest and sexual rivalry among the female characters for Kimathi's attentions. Since Ngugi and Micere explicitly reject earlier depictions of their hero, it is not surprising that, in their play, no such romance exists. Their Kimathi depends on the Woman for military help and tactical advice. In a key scene, the beleaguered leader is faced with the decision whether or not to execute some formerly trusted colleagues, including his own younger brother, who have gone behind his back to negotiate with the British. His male colleagues offer contradictory advice, one warning him against killing a kinsman: 'The blood might turn against us/And cry for vengeance from the earth' (TDK, p. 72). He turns then to the Woman, first praising her, as if to establish her equality with the men, hence her authority to speak. When she does speak, her advice, ironically, is but an extension of that offered earlier as a directive to the Boy, the young initiate; she instructs Kimathi to discover his enemies and be perceptive and courageous enough to eliminate them. Indecisive, however, he turns to the prisoners and asks each of them to defend his actions. When his brother's turn comes, he cleverly reminds Kimathi of the desperate plight of their mother, driven mad by her personal losses and desperate at the thought of losing her youngest son, too.

The Woman's verbal response to Kimathi at this point is crucial in understanding how gender-specific language functions in this play. With carefully chosen words, she admits that thinking of personal loss 'pains the *woman* in me too!'

(TDK, p. 77, my emphasis) but warns Kimathi that such tender-heartedness 'Can weaken our resolve' (TDK, p. 77). She reminds him of his position as leader of the revolution and of the fact that others, too, have loved-ones like his mother whom they have left at home. Despite the Woman's advice, Kimathi decides to punish, not execute, the traitors and admits, 'Something strange rubs me/Under the skin ... My mother ... ' (TDK, p. 78). While the Woman has suppressed the 'woman' in her, Kimathi succumbs to the 'woman' in him, a weakness leading to personal danger and to the endangering of the entire struggle. The prisoners escape while he is vacillating about their punishment; finally, too late, he declares that they should be shot on sight. The point here is that Kimathi's admittedly short-sighted allegiance to clan, even his understandable but risky bond to family, dangerous in desperate circumstances, are labeled not just as strategic mistakes or character flaws developing from his personal weakness but, specifically, as 'woman'-ish. If such errors are part and parcel of the make-up of the female gender, to avoid them, one must leave the realm of simple 'femaleness'; hence, to be heroic, the Woman is androgynous, the mother but the fighter, who performs the masculine function of initiating the young Boy into danger, disguises herself as a man, and turns a cold eye on the claims of kinship. Kimathi's own androgyny, his acceptance of the 'woman' in him, is perceived as personally and politically destructive.

Moreover, the next generation is pictured as playing out a similar struggle grounded in traditional concepts of gender qualities and expressed in stereotypic language. The Girl, who like the Boy has been instructed by the Woman, is the far more acute and militant of the two; yet she defines courage and commitment as male characteristics. Carrying the gun to Kimathi in her dress, she continually must urge on her reluctant male companion. When they encounter a guard at the jail, however, the Boy's resolution fails. 'I'm tired of it,' he complains; 'I'm tired. We should throw it into a latrine or into the bush and forget the whole thing.' 'Is that how to become a *man?*' (TDK, p. 52, my emphasis) the girl challenges. Later, the Boy admits that he was afraid, 'but the Girl here ... She was all strength and daring and no fear' (TDK, p. 60). In other words, in the gender-specific terms of the play, the Girl is the one who has 'become a man.'

In an interview, Micere links much exploitation of African women to capitalism, their most obvious disadvantage being that they are even more poorly educated than their oppressed male counterparts.[13] She acknowledges that sexual abuse occurs in socialist countries as well, but does not comment upon gender discrimination in traditional societies like the Gikuyu. One's language, even under the pressure of artistic transformation, frequently reveals the assumptions of one's culture. *The Trial of Dedan Kimathi*, like other examples of East African literature, suggests that British colonialism may have imported into Kenya a European sexism that exacerbated previously existing, denigrating concepts about women, but it did not create them. It is clear, too, that the Woman is

created as a heroic model of correct attitudes and behavior; there is no ironic distance between her ideas and language and the authors'. Now, it is neither to deny the positive political images of the Woman and the Girl, nor to reject the humanizing, liberating function of androgyny to point out the, no doubt unconscious, acceptance of sexist male/female terms and concepts in *The Trial of Dedan Kimathi*. It is instructive to note that even in the face of such historically accurate and transcendent female portraits, conventional, subordinating concepts of gender, paradoxically, rear their ugly heads.

Additionally, the reader, sensitive to the absence of female depiction in literature, would like to see represented more of the acknowledged female presence in the Kenyan liberation struggle than the Woman, the Girl, and the absent mother, driven mad by the horror of the situation, can suggest. Despite Micere and Ngugi's express desire to make the Woman and the Girl representative of all Kenyan women exploited by colonialism, their solitary roles actually make them seem exceptional. As if to counter this focus on a few individuals, the Woman is further abstracted, of course, in a way that Kimathi is not, by never even being accorded a name of her own. Possibly the same cultural traditions that were revealed by Micere's gender-specific language account for this discrepancy in characterization. Dedan Kimathi can exist in the dual realm of historical reality and future projection and empowers the play as both an individual and a symbol, but Kongania, Me Kitilili, Mary Nyanjiru, and Wanjiru are dramatically functional only as a single androgynous symbol that is, actually, more gender-reductive than their synthetic embodiment at first suggests, since the Woman has killed off the 'woman' in herself.

Although this discussion, so far, has credited Micere with the creation and development of the Woman, it is, of course, impossible to know which writer was responsible for which parts of *The Trial of Dedan Kimathi*. One can reasonably assume, however, that the female collaborator would try her hand at the female portraiture. In any case, both authors agreed upon the final version of the play. Certainly, the image of Kimathi is a result of their joint desire to portray not only the man, judged 'a genius in this struggle,' but, as importantly, 'to recapture the heroism and the determination of the people in [a] glorious moment of Kenya's history.'[14] Kimathi, then, much more surely than the Woman, is to be taken both as a real figure with an historical individuation and, also, as a mythic configuration, that is, as an embodiment of the qualities – courage, intelligence, dedication – traditionally valued by his society. These qualities are transformed in the crucible of colonial oppression into the revolutionary spirit judged by the authors responsible for independence and, as importantly, for future triumph over neo-colonial imperialism.

This complex of meanings is obvious in the comments of the Karunaini village woman Micere and Ngugi met, who 'talked of [Kimathi's] warm personality and his love of people. He was clearly their beloved son, their respected

leader and they talked of him as still being alive' (TDK, p. vii). Her fond wistfulness for a real former acquaintance changes suddenly to a bold assertion of Kimathi's mythic reality, typically defiant and ahistorical, when one of the visitors raises a question about his death:

> 'Kimathi will never die,' the woman said. 'But of course if you people have killed him go and show us his grave.' She said this in a strange tone of voice, between defiance and bitterness, and for a minute we all kept quiet. (TDK, p. vii)

The actual Dedan Kimathi was born on 31 October 1920. The details of his life before he became a leader of the Land and Freedom Fighters are not unusual. While he was educated above the general level and, for a while, was a school teacher, he also worked in circumstances common to many other Kenyans, including jobs as a clerk to a dairy co-operative, as a trader in hides, and as a laborer on a pig farm.[15] Moreover, his involvement in the Kenya Africa Union, before going into the forest, was certainly not unusual for politically-aware young Gikuyu of his time. Historically, then, Kimathi's background and activities are representative of those of many during the first half of the twentieth century.

In the play, his major function is also representative. Kimathi's speeches serve a number of expected political intentions: he protests the injustice of imperialism; he educates the audience to the historical situation of the Kenyans during the fight for independence; he also informs the audience of the Freedom Fighters' activities and plans and praises the heroism of the workers and peasants. Even when distinguishing himself by name, he simultaneously links himself to the cause for which he is fighting: 'Kimathi wa Wachiuri will never betray the people's liberation struggle … !' (TDK, p. 35). While Kimathi is being tortured by his captors, Micere and Ngugi deflect our attention from his solitary suffering by shrouding him in semi-darkness and miming, in a lighted area of the stage, scenes representative of the history of general black oppression and exploitation (TDK, p. 56). Although many of his utterances are poetic and presented in a typography on the page and a cadence in performance that mark them as poetry, even this artistic ability is not intended to single out Kimathi as special. As is evident in Maina's collection, many people at the time, inspired by their struggle, composed revolutionary verse; *Thunder from the Mountains* contains 102 examples, almost all of them anonymous.

One passage of dialogue, in particular, establishes Kimathi's symbolic function in the play. 'Who really is Dedan Kimathi?' asks the Girl. What follows is a litany combining aspects of his political role – 'Leader of the landless. Leader of them that toil' (TDK, p. 61) – and mythic deification: 'I have … heard it said that he could turn himself into an aeroplane … '; 'That he could walk for 100 miles on his belly …' (TDK, p. 61). If Kimathi, the man, 'Great commander that he was, Great organizer that he was, Great fearless fighter that he was,' was also, according to the Woman, 'human! … Too human at times!' (TDK, p. 62), clearly, his role

in this play is not personal. '[t]hey only captured his shadow, his outer form ... and let his spirit abroad, in arms,' the Boy says; 'No bullet can kill him for as long as women continue to bear children' (TDK, p. 21).

The source for this mode of characterization, moreover, is significant for the play's socialist purposes. As noted earlier, when Micere and Ngugi visited Kimathi's birthplace, the people there 'talked of him as still being alive' (TDK, p. vii). As their incorporation of the villagers' suggestions in the writing of the play indicates, it is these people's vision, not only their own limited perspective, that the playwrights wish to communicate. The challenge in writing *The Trial of Dedan Kimathi*, they say, 'was to truly depict the masses (symbolized by Kimathi) in the only historically correct perspective: positively, heroically and as the true makers of history' (TDK, p. ix). Their symbolic characterization and collective composition posits 'the masses' as the 'true makers' of art and its true subjects as well.

Attempting to determine the role of women writers in Africa, Ogundipe-Leslie notes that western feminists posit two major responsibilities for the woman writer: 'first to tell about being a woman; secondly to describe reality from a woman's view, a woman's perspective.'[16] She goes on to define this requirement in view of historical/social reality and concludes that '[B]eing aware of oneself as a Third World person implies being politically conscious, offering readers perspectives on and perceptions of colonialism, imperialism, and neo-colonialism as they affect and shape our lives and historical destinies.'[17] She credits Ama Ata Aidoo and Micere Mugo with this awareness and practice in their work, but another writer who merits equal praise is the Mozambican Noemia De Sousa, whose major work, produced before the independence of her country from Portuguese rule, combines a Negritudinist lament for a 'lost' Africa and sharp protest against colonial atrocities.

A pessimistic image of the situation of African women appears in De Sousa's 'Appeal,' whose empathetic narrator asks, 'Who has strangled the tired voice/of my forest sister?' The narrator sustains only a vague hope for the woman's mystical continuance 'in the proud memorial of [mother Africa's] arms.'[18] The fate of this woman and its cause are left ambiguous. There is a strong suggestion of her being oppressed by her traditional role; she is remembered as 'leashed with children and submission .../One child on her back, another in her womb/ – always, always, always!' But, there is also an allusion to the brutality of colonialism as the possible reason for her disappearance:

> Io mamane,
> who can have shot the noble voice
> of my forest sister?
> What mean and brutal rhino-whip
> has lashed until it killed her?

There is even a suggestion that the woman, a charcoal-vendor, representative of the poor, was destroyed by her unavoidable intrusion every morning into nature itself, that she is 'the victim of the forest's vaporous dawns'; possibly, she died in childbirth.

The very ambiguity of 'Appeal' powerfully underscores the precariousness of the life of the 'forest sister,' at the mercy of so many forces beyond her hard-working control. This indeterminacy accounts, as well, for the frustration and mourning of the narrator who can receive no satisfactory explanation of her sister's disappearance. In modern Africa, dangers abound, De Sousa suggests, especially for women, and clarification, much less accountability, is difficult, if not impossible, to achieve. Neither nature nor the gods any longer provide answers and retribution.

The last stanza apostrophizes 'Africa, my motherland,' asking, first, for an explanation, but settling for the vague notion that the 'heroic sister' will be eternally remembered 'in the proud memorial of [Africa's] arms!' It is in this expression that De Sousa's Negritudinist impulse is revealed, for the ending strikes this reader as an unsuccessful attempt to 'tidy up' the unruly possibilities raised by the rest of the poem and achieve easy closure with a conventional personification of Africa as the great, suffering Mother. The portrayal of the actual woman in the poem, on the other hand, sets her within a historically real, traditional, and colonial situation of female hardship and never stereotypes her as either an exotic primitive or a representative of the deeper mysteries of African culture.

De Sousa applies both these typical characterizations, however, as well as the familiar image of victimization, to Africa in 'black blood.'[19] Africa is 'strange and wild/my virgin raped,' redolent with 'the warm caresses of … moonlight,' and 'dew-drenched forests,' a 'Great pagan, sensual slave/mystic, charmed …' The primary conflict in the work is between the narrator, who has opted for 'city streets, pregnant with a foreign race,' 'cinemas and cafes,' and Africa's 'sons,' 'tall and bronze,' 'incorruptible and suffering/struggling/bound to the land/in work, in love, in song,/as slaves.' On a more revealing psycho/political level, a resolution is being sought between the narrator's guilt at having 'exiled' herself from her Mother Africa, becoming 'alienated, distant, self-absorbed,' and her present realization that her homeland, her 'beginning and end,' provides both the freedom she sought elsewhere and her sense of identity. Significantly, Africa, the 'ancient source,' is credited with 'the black, the savage blood' that allows the narrator to 'live,' 'laugh,' 'endure,' and, presumably, speak poetically.

Africa as the source of the narrator's identity is made explicit in 'if you want to know me.' If, once again, the reader encounters a stereotyped designation of the continent as 'Tortured and magnificent/proud and mysterious,'[20] nevertheless, De Sousa's sensory evocation of the historical oppression of Africa as a shaper of her narrator's own being saves this poem from mere platitudes. In addition to references to the 'soul' of Africa, and 'the strange sadness which flows/from

an African song, through the night,' the narrator reports on 'the black dockworker's groans/the Chope's frenzied dances/the Changanas' rebellion.'

'[I]f you want to know me' ends with implicit hope in revolutionary action that is made explicit in De Sousa's lengthier 'the poem of joao.'[21] 'Joao,' who 'was young like us,' like Dedan Kimathi, exists dually, both as an individual, who 'enjoyed literature/enjoyed poetry and Jorge Amado,' and as an emblem of the masses: 'Joao was the blood and the sweat of multitudes.' This symbolic relationship convinces, because it is most often expressed in vivid specifics:

> He smiled that same tired smile of shop girls leaving work
> he suffered with the passivity
> of the peasant women
> he felt the sun piercing
> like a thorn in the Arabs' midday
> he bargained on bazaar benches
> with the Chinese
> he sold tired green
> vegetables
> with the Asian traders

Moreover, Joao symbolizes Mozambique itself and is destroyed because of his freedom-loving nature and hatred of 'prisons and the men who make them.' Despite the narrator's lament for Joao, she asserts the continuation of his revolutionary spirit in others:

> and Joao, in being Joao,
> is also Joaquim, Jose Abdullah,
> Fang, Mussumbuluco, is Masarenhas
> Omar, Yutang, Fabiao
> Joao is the multitude,
> the blood and sweat of multitudes.
> For 'Joao is us all,' and 'who can take the multitude and lock it in a cage?'

Much of the power of this poem lies in its lyrical, repetitious sound structure. 'Joao was young like us' serves as a refrain linking its stanzas together and conjuring up the various peoples and natural features of Mozambique. Many of the other phrases are repeated as well, reinforcing the progressive ideas of the poem and creating a rhythm that involves the reader in a way similar to the emotionally compelling songs and dances of *The Trial of Dedan Kimathi*.

The type of poetry now being produced in post-Independence Mozambique has changed from the protest mode of De Sousa's most prolific period of the 1950s: 'The function of poetry [in this new period] is one of affirmation, often a celebration, of the Revolution. This means that often its previous *critical* function during the colonial time remains suspended.'[22] Chris Searle quotes

Mozambican poet Rui Nogar, imprisoned during the final years of Portuguese rule, who considers poetry, despite the liberation from colonialism, a weapon still, particularly in the battle against cultural imperialism. Nogar notes that by poetry's very essence, especially its orality, 'it has the advantage of at any time or any place being read or recited, taking on a mobilizing role of great importance.' Moreover, he cautions contemporary poets to educate 'themselves aesthetically. This is so as not to make verses which are only transcriptions of our party's slogans. There are means which already exist for this. We should say that our poets must strive to reach an artistic form suitable for revolutionary content which they want to transmit poetically.'[23]

Contemporary Mozambican poetry has inherited a model of such commitment, intelligence, and artistry in the work of Noemia De Sousa. It seems impossible from the perspective of neo-colonialism to disagree with South African poet Kgositsile, that 'in a situation of oppression, there are no choices beyond didactic writing; either you are a tool of oppression or an instrument of liberation.'[24] Yet, as Nogar implies, not all didactic writing is effective, frequently because it becomes only rather flat-footed sloganeering.[25] De Sousa's greatest strength is her ability to convey vividly the reality of oppression while emotionally involving her reader or listener through carefully-wrought rhythmical effects. Moreover, despite her poetry being commonly assigned to the protest category, her audience is, more appropriately, the colonized rather than the colonizers or their sympathizers, another source of her work's power. Speaking of the role of art in South Africa, Jacques Alvarez-Pereyre asks,

> What can poetry do against apartheid? ... Poetry cannot, it is quite true, have any direct influence on events. But it can do a great deal to help a people to discover its own spirit ... So, if the white will not share power, the black will have to wrench it from him. This is the significance of the failure of committed poetry (white or black) aimed at the whites, it perhaps explains the success of black committed poetry aimed at the blacks. The day will come when the people will be ready for action, stirred by what has been the collective consciousness of their time.[26]

As has been suggested earlier in this essay, De Sousa's ease within the mode of orature accounts to a large extent for her ability to make the real audience of her protest poetry the oppressed themselves, whose conditions she shares. *Critical* or *protest* writing usually addresses the group the writer is indicting, hence its general failure in political effectiveness, but De Sousa escapes this content/audience dilemma, because she employs the techniques of African orature:

> No oral poet has problems in relating the language and the forms of his poetry to the society he lives in or the landscape he inhabits. The assumptions embodied in his poetry are those of his culture and are shared by his audience

– which is there on the spot before him while he performs, not living six thousand miles away or constituting a possible 'virtual public' in the future.[27]

In pre-colonial times, as studies have shown, a dual audience existed for orature, with the poet frequently praising the people for their heroism, as De Sousa does, but also acting as

'the conscience of the nation,' addressing the ruler on the people's behalf. Meanwhile, the role of the traditional storyteller, as he provided variations on known motifs, was to 'articulate the people's problems and their complaints and to project their collective aspiration.'[28]

Moreover, this question of form becomes almost as significant as the one that has raged for the past decade in African literary studies about language. As even a cursory glance at contemporary African literature will reveal, autobiography is a dominant genre and not, as White and Couzens note, merely because of egotism or defective imaginations. It is a reflection, forced on writers by the special circumstances in which they have become writers, of a quality of self-consciousness, a nagging awareness that, as V.S. Naipaul has put it, 'there's something absurd about the fictional form: it's an artificial activity, made-up people taking part in invented actions.'

Ellen Kuzwayo's *Call Me Woman*, a memoir, shares the historical grounding of *The Trial of Dedan Kimathi* as well as the complex audience of 'the poem of joao.' Like a monologue insistently begun in the middle of a conversation, this form can convey a rich politico/historical context, while simultaneously reinforcing the personal bond between speaker and listener. Although captured on the printed page, the memoir evokes an immediacy and intimacy less intense than, but comparable to, the performance of a play or the chanting of a poem. *Call Me Woman*, true to its form, transcends the one life it recounts to reflect the similar situation of all South African women, burdened not only by traditional sexism but apartheid as well.

The work is anchored, of course, in the eventful life of its author. Ellen Kuzwayo was born in 1914 in a rural area of South Africa but has lived most of her life in the city, in Johannesburg. She trained as a social worker; one of her fellow students was Winnie Mandela. In 1937, the year of fellow South African artist Bessie Head's birth, Kuzwayo suffered a nervous breakdown; her memoir, like Head's novels, is filled with instances of her continuing sense of exile. Because of personal dislocations – her parents' divorce when she was only two; when she was six, the death of the grandparents who raised her; her mother's death, when Ellen was 16; being forced to leave home by her Aunt Blanche, who had married her stepfather; serious illness following a miscarriage; the break-up of her own marriage; her fleeing to Johannesburg to live with her real father, leaving behind her two young sons; the death of her second husband; the persecution of her second son for political activity; the government's confiscation of her family's

farm under the Group Areas legislation; and her own detention, without charge, for five months for political activity – she is understandably sensitive to the identity crisis caused by such uprooting. At one point in the work, she starkly asserts, 'I felt pushed out like pus from inflamed tissues. I felt naked, helpless and forlorn' (CMW, p. 111).

Nevertheless, her book insists upon setting her own life within the, ironically, 'normalizing' context of the dislocation of all black and colored South Africans, especially women. Again, like Bessie Head and her character Elizabeth in *A Question of Power*, Kuzwayo's growth toward a positive self-image largely results from her taking control of her own life through communal organization. Most of her adult experience has been that of political involvement, a commitment which resulted in her aforementioned detention for five months in 1977–78. In the face both of family members' attempts to subordinate her and the South African government's intention to demoralize the entire black and colored population, Kuzwayo insists on asserting her sense of self: in her abusive marriage, before the dismissive white magistrate, in prison, and in the streets of Soweto.

One extremely important source of her strength is her early family ties, especially her grandmother; another is the many female role models she cites in the memoir: neighbors in Soweto and educated and successful black professionals. She includes at the end of her work two long lists of black South African female medical doctors and lawyers. Moreover, the memoir is dedicated to, among many others, 'All my sisters in exile. I am so aware of their painful separation from their families and country' (CMW, p. x). *Call Me Woman*, then, is bracketed by references to those whose lives have been fragmented by apartheid and those who have been able to develop and hold themselves together in the midst of it.

This social, rather than individual, concern is evident from the book's beginning; as early as page 4, Kuzwayo asks, 'Where is home for a black person in South Africa?' Although men, particularly nationalist leaders like the murdered Steve Biko, a companion of one of her own sons, figure prominently in these pages, the writer's first concern is with women and children. She is especially effective in demonstrating how the South African economic situation has affected women and their traditional desire to provide nurturing and stability for their families. She describes, in very human terms, the consequences of such events as the Native Land Act of 1913, which designated 87 per cent of the land for whites and 13 per cent for the black majority; that is, the resulting mass movement of men from the rural areas to work in the mines and other industries in cities like Johannesburg. After the male migration to the cities, there were very serious questions and problems for the womenfolk in the rural areas. The responses came in an endless flow of black women to the cities in search of their husbands, and fathers of their children, even, at times, in search of their missing sons (CMW, p. 14).

Soon, huge slums like Soweto developed, where 'it is not easy to live and to bring up children in a community robbed of its traditional moral code and values:

a community lost between its old heritage and culture and that of its colonists' (CMW, p. 21). Kuzwayo threw herself wholeheartedly into working with social organizations within Soweto, particularly women's self-help groups.

A work eschewing abstraction and symbolism, poetic or otherwise, Kuzwayo's memoir ends, nevertheless, with a moving testament to present-day black unity and historical continuity, particularly among the 'black women in South Africa' who 'have shown outstanding tenacity against great odds' and who 'remain determined like the women of our community of previous generations, who have left us a living example of strength and integrity' (CMW, p. 262). *Call Me Woman* convincingly juxtaposes a sense of black people's powerlessness in legal and economic realms in South Africa and Kuzwayo and others' strong awareness of a traditional resource for combating social evil in one's community, specifically, in this instance, other women. Like Micere and Ngugi's Gikuyu Woman, Kuzwayo's self-portrait highlights not an individual alone, but mirrors the suffering and strength of all oppressed South African women.

It is of some symbolic significance that, in 1949, Ellen Kuzwayo appeared in a small role in the film version of Alan Paton's *Cry the Beloved Country*, for the thrust of her own book represents a black self-confidence that signals a break with the liberal tradition of which Paton was the best-known literary example. Commenting upon new directions in South African literature, Michael Vaughn remarks on the populism, rather than elitism, of both the concerns and audience of current black writing:

> The category of the generic, the mass, the people is implicitly evoked by reference to blackness. This indicates that a wide disparity exists between the orientation of the new black literature, and the orientation of an earlier, liberal tradition in South African literature, where the category of 'the individual' was central, and literary themes were mediated by a concern with sensitively individualised experiences and interactions.[29]

Vaughn's subsequent discussion of the paradoxical meaning of a dramatic photograph in the progressive black journal *Staffrider*, a picture of a silhouetted figure of a youth jumping over a barbed-wire barricade in front of a massed group of other figures, sheds light on the similar political significance of details of Kuzwayo's life in her memoir:

> [T]he positive meaning in such a figure derives from his close identification with the conditions of township life: in this sense, he is a 'popular' figure ... an initiate in the circumstances of township life: he uses his knowledge, with skill and daring, not so much to transcend these circumstances (that would be too ambitious an idea) as to establish a greater ease and space within them. He remains, therefore, popular rather than becoming exceptional, romantic.[30]

As 'exceptional' as Kuzwayo's life strikes the reader, her memoir insists upon its representativeness of both political and gender subordination and strength. As all three authors demonstrate, the relationship between African women's writing and 'committed' literature is intrinsic. Christiane Rochefort has remarked, 'I consider women's literature as a specific category, not because of biology, but because it is, in a sense, the literature of the colonized.'[31] This sense of unity with others in the struggle, whether the declared war of the Kenyan Emergency, the overthrow of the Portuguese in Mozambique, or the continued resistance in the streets of Soweto, is expressed in these women's writing with artistry redolent of Black Aesthetic and socialist values of the communality of African culture and the significant political/spiritual role of the artist. Moreover, their focus on the experience of African women, even when traditionally stereotypic, provides an essential, added dimension to other, more general, contemporary accounts of the struggle against colonial and neo-colonial oppression.

Notes

1. Noemia De Sousa, 'the poem of joao,' in *When Bullets Begin to Flower*, ed. M. Dickinson (Nairobi: East African Publishing House, 1972), p. 74.
2. Micere Githae Mugo and Ngugi wa Thiong'o, *The Trial of Dedan Kimathi* (Nairobi: Heinemann, 1976) (referred to here as TDK); Ellen Kuzwayo, *Call Me Woman* (San Francisco: Spinsters Ink, 1985) (referred to here as CMW).
3. Margaret Dickinson, *When Bullets Begin to Flower*, pp. 9–10.
4. Ellen Kuzwayo, speech at the Conference on Black Women Writers of the Diaspora, Michigan State University, October 1985.
5. Elaine Showalter, 'Feminist Criticism in the Wilderness,' in *The New Feminist Criticism*, ed. E. Showalter (New York: Pantheon, 1985), p. 15.
6. Maina wa Kinyatti, *Thunder from the Mountains* (London: Zed Press, 1980), p. 6.
7. Ngugi wa Thiong'o, *Writers in Politics* (London: Heinemann, 1981), p. 27.
8. Adrienne Rich in Showalter, *New Feminist Criticism*, p. 253.
9. Kinyatti, *Thunder*, pp. 6–7.
10. 'Molara Ogundipe-Leslie, 'The Female Writer and Her Commitment,' in *Women in African Literature Today*, ed. E.D. Jones, E. Palmer, et al.(Trenton, NJ: Africa World Press, 1987), p. 10.
11. Ibid., p. 8.
12. Kenneth Watene, *Dedan Kimathi* (Nairobi: Transafrica, 1974).
13. Quoted in Carole Boyce Davies, 'Introduction: Feminist Consciousness and African Literary Criticism,' in *Ngambika. Studies of Women in African Literature*, ed. C. Boyce Davies and A. Adams Graves (Trenton, NJ: Africa World Press, 1986), p. 11.

14. Ngugi, *Writers in Politics*, p. 51.
15. Watene, 'Preparatory Information,' in *Dedan Kimathi*.
16. Ogundipẹ-Leslie, 'The Female Writer,' p. 5.
17. Ibid., p. 11.
18. G. Moore and U. Beier (eds), *Modern Poetry from Africa* (Harmondsworth: Penguin, 1963), pp. 239–40.
19. De Sousa, 'black blood,' pp. 56–8.
20. De Sousa, 'if you want to know me,' *Bullets*, pp. 50–60.
21. De Sousa, 'the poem of joao,' *Bullets*, pp. 70–74.
22. Chris Searle, 'The Mobilization of Words: Poetry and Resistance in Mozambique,' in *Marxism and African Literature*, ed. G.M. Gugelberger (Trenton, NJ: Africa World Press, 1986), p. 163.
23. Ibid., p. 160.
24. Quoted in Jacques Alvarez-Pereyre, *The Poetry of Commitment in South Africa* (London: Heinemann, 1979), p. 2.
25. Ibid., pp. 264–7.
26. Ibid., pp. 164–7.
27. Landeg White and Tim Couzens (eds), *Literature and Society in South Africa*, (Harlow: Longmans, 1984), Introduction, p. 9.
28. Ibid., p. 17.
29. Michel Vaughn, '*Staffrider* and Directions within Contemporary South African Literature,' in Gugelberger, *Marxism*, p. 197.
30. Ibid., pp. 208–9.
31. C. Rochefort in Showalter, *New Feminist Criticism*, p. 259.

Selected Bibliography

Julie Gayle and Marisol Santiago

This bibliography is by no means exhaustive or conclusive. In fact, a variety of important bibliographic works have attempted to provide full coverage of these various bodies of black women's literature. All of them conclude, and I concur, that we are merely scratching the surface of what is clearly an enormous field of creative and critical activity. Therefore this bibliography is offered not in terms of definitiveness but in terms of representativeness, since we know, as we bring it to a close, that there are many other texts and authors who would have been included, had space allowed. *Carole Boyce Davies*

Accad, Evelyne. 'L'Écriture (comme) éclatement des frontières.' *L'Esprit Créateur* 33:2 (Summer, 1993), 119–28.

—— 'Mashreq and Maghreb Women Writers of Arabic Expression.' *Revue Celfan/Celfan Review* 7:1–2(1987–8), 43–6.

Acholonou, Catherine Obianuju. *Into the Heart of Biafra* (Play). Owerri, Nigeria: Totan Publishers, 1985.

—— *Nigeria in the Year 1999* (Poetry). Owerri, Nigeria: Totan Publishers, 1985.

—— *The Spring's Last Drop* (Poetry). Owerri, Nigeria: Totan Publishers, 1985.

—— *Trial of the Beautiful Ones* (Play). Owerri, Nigeria: Totan Publishers, 1985.

—— *The Deal and Who is the Head of State*. Owerri, Nigeria: Totan Publishers, 1986.

Acosta-Belén, Edna, ed. 'Ideology and Images of Women in Contemporary Puerto Rican Literature.' *The Puerto Rican Woman*. New York: Praeger, 1979, 85–109.

—— 'Ideología e imagenes de la mujer en la literatura Puertorriqueña contemporánea.' In *La mujer en la sociedad puertoriqueña*. Río Piedras, Puerto Rico: Ediciones Huracán, c. 1980, 125–56.

Adebayo, Aduke Grace. 'Tearing the Veil of Invisibility: The Roles of West African Female Writers in Contemporary Times.' María Elena de Valdes and Margaret R. Higonnet, eds. *New Visions of Creation: Feminist Innovations in Literary Theory*. Tokyo: University of Tokyo Press, 1993, 64–75.

Adisa, Opal Palmer, with Devorah Major. *Pina, the Many-Eyed Fruit*. San Francisco, CA.: Julian Richardson Associates, 1985.

—— *Bake-Face and Other Guava Stories*. Berkeley, CA: Kelsey Street Press, 1986.

—— *Traveling Women*. Oakland, CA: Jukebox Press, 1989.

—— 'She Scrape She Knee: The Theme of My Work.' In Selwyn R. Cudjoe, ed. *Caribbean Women Writers*. Wellesley: Callaloux, 1990, 145–50.

—— *Tamarind and Mango Women.* Toronto, Canada: Sister Vision Press, 1992.

Aidoo, Ama Ata. *The Dilemma of a Ghost and Anowa.* London: Longman, 1965, 1985; New York: Collier-Macmillan, 1971.

—— *No Sweetness Here.* London: Longman, 1970; Garden City, New York: Doubleday, 1971.

—— *Our Sister Killjoy or Reflections from a Black-Eyed Squint.* New York: Nok Publishers International, 1979; London: Longman, 1977, 1981.

—— *Someone Talking To Sometime.* Zimbabwe: College Press, 1985.

—— *Changes.* London: Women's Press, 1991; New York: Feminist Press, 1991.

—— *An Angry Letter in January.* Coventry: Dangaroo Press, 1992.

Alarcón, Norma and Sylvia Kossnar. *Bibliography of Hispanic Women Writers.* Chicano-Riqueño Studies bibliography series, no. 1. Bloomington, IN. Chicano-Riqueño Studies, c. 1980.

Albert-Robatto, Matilde, 'Reflexiones en torno a la actual poesía femenina puertorriqueña'. *Revista/Review Interamericana* 12, no. 3 (Fall 1982), 462–73.

Alcántara Almánzar, José. 'Aída Cartagena Portalatín.' *Estudios de Poesía Dominicana.* Santo Domingo, República Dominicana: Alfa y Omega, 1979, 269–85.

Alkali, Zaynab. *The Stillborn.* Harlow: Longman, 1984.

—— *The Virtuous Woman.* Harlow: Longman, 1987.

Allen, Paula Gunn, ed. *Studies in American Indian Literature: Critical Essays and Course Designs.* New York: Modern Language Association of America, 1983.

Allen, Zita. 'Close but No Cigar.' Review of *Annie John* by Jamaica Kincaid. *Freedomways* 25 (1985), 116–19.

Allfrey, Phyllis Shand. In David E. Herdeck, ed. *Caribbean Writers: a Bio-bibliographical-critical Encyclopedia.* Washington, DC: Three Continents Press, 1979, 18–20.

Alves, Miriam. *Momentos de Busca. Poemas.* São Paulo, 1983.

—— *Estrelas no Dedo.* São Paulo, 1985.

—— 'O Discuro Temerario.' *Criacao Crioula, Nu Elefante Branco.* São Paulo, 1987.

—— ed. *Emfin Nos. Todas Negras Escritoras Brasileras.* Trans. Carolyn Richardson. Washington, DC: Three Continents Press, forthcoming.

Amadiume, Ifi. *Passion Waves* (Poetry) London: Karnak House, 1985.

—— *Afrikan Matriarchal Foundations. The Igbo Case.* London: Karnak House, 1987.

—— *Male Daughters, Female Husbands. Gender and Sex in an African Society.* London and New Jersey: Zed Books, 1987.

Amrouche, Fadhma. *My Life Story. The Autobiography of a Berber Woman.* Trans. Dorothy Blair. New Brunswick: Rutgers University Press, 1989; London: Women's Press, 1988; Paris: Maspero, 1968.

Anderlini, Serena. 'Self-representation in Performance Art. The City/Text of the Female/Black Subject.' *Rivista di Studi Anglo–Americani* 6:8 (1990), 201–11.

Anderson, Marian. *My Lord, What a Morning!* New York: Viking, 1956.

Anderson, Margaret. 'Women's Studies/Black Studies: Learning from Our Common Pasts, Forging a Common Future.' *Women's Place in the Academy: Transforming the Liberal Arts Curriculum*. Totowa, New Jersey: Rowman and Allanheld, 1985, 62–72.

Andrews, William L., Catherine L. Albanese, Stephen J. Stein and Marilyn Richardson. *Sisters of the Spirit: Three Black Women's Autobiographies of the Nineteenth Century*. Bloomington: Illinois University Press, 1986.

Angelou, Maya. *I Know Why the Caged Bird Sings*. New York: Bantam, 1971.

—— *Just Give Me a Cool Drink of Water 'fore I Diiie*. New York: Random House, 1971.

—— *Gather Together In My Name*. New York: Random House, 1974.

—— *And Still I Rise*. New York: Random House, 1978.

—— *The Heart of a Woman*. New York: Random House, 1981.

—— *All God's Children Need Traveling Shoes*. New York: Random House, 1986.

—— *I Shall Not Be Moved*. New York: Random House, 1990.

Ansano, Richenel, Joceline Clemencia, Jeanette Cook and Eithel Marits, eds. *Mundu Yama Sinta Mira. Womanhood in Curacao*. Scharlooweg 29, Fundashon Publikashon, Curaçao, 1992.

Apandaye, Eintou. 'The Caribbean Woman as Writer.' In Roseann P. Bell, Bettye J. Parker and Beverly Guy-Sheftall, eds. *Sturdy Black Bridges: Visions of Black Women in Literature*. Garden City, New York: Anchor/Doubleday, 1979, 62–8.

Araújo, Helena. '"Mujer Negra." La poesía de Nancy Morejón.' *Khipu* 3 (1983), 53–4.

Arrillaga, María. 'La narrativa de la mujer puertorriquena en la decada del setenta.' *Homines* 8, no. 1 (1984), 327–34.

Atiya, Nayra. *Khul Khaal. Five Egyptian Women Tell Their Stories*. London: Virago, 1988; Syracuse, New York: Syracuse University Press, 1982.

Austin, Doris Jean. *After the Garden*. New York: New American Library, 1987.

Bâ, Mariama. *Une si longue lettre*. Dakar: Les Nouvelles éditions Africaines, 1980. *So Long A Letter*. Trans. Modupe Bode-Thomas. London: Heinemann, 1981.

—— *La chante écarlate*. Dakar: Les Nouvelles éditions Africaines, 1981. *The Scarlet Song*. Trans. Dorothy Blair. Harlow, Essex: Longman, 1986.

Badran, Margot and Miriam Cooke. *Opening the Gates. A Century of Arab Feminist Writing*. Bloomington and Indianapolis: Indiana University Press, 1990.

Baeza Flores, Alberto. *La Poesía Dominicana en el Siglo xx generaciones y tendencias, poetas independientes. La poesia sorprendida, suprarrealismo, dominicanidad y universalidad (1943–1947) 11*. Santiago: Universidad Católica Madre y Maestra, Colección Estudios 22, 1977.

Baker, Houston A., Jr., Elizabeth Alexander and Patricia Redmond. *The Workings of the Spirit: The Poetics of Afro-American Women's Writing*. Chicago: University of Chicago Press, 1991.

Balutansky, Kathleen M. 'Naming Caribbean Women Writers.' *Callaloo: An Afro-American and African Journal of Arts and Letters* 13:3 (Summer 1990), 539–50.

Bambara, Toni Cade, ed. *The Black Woman: An Anthology*. New York: New American Library, 1970.

—— *The Salt Eaters*. New York: Random House, 1980.

—— *Gorilla, My Love*. New York: Random House, 1981.

—— *The Sea Birds Are Still Alive*. New York; Random House, 1981.

Baraka, Amiri (LeRoi Jones) and Amina Baraka, eds. *Confirmation: An Anthology of African American Women*. New York: Quill, 1983.

Barradas, Efraín. 'La negritud hoy: Nota sobre la poesía de Nancy Morejón.' *Areito* 6:24 (1980), 33–9.

—— Review of *Vírgenes y mártires*, by Ana Lydia Vega and Carmen Lugo Filippi. *Revista/Review Interamericana* 11, no. 3 (1981), 465–6.

Barratt, Harold. 'A Shuttered Cleavage: Marion Jones' Tormented People.' *World Literature Written in English* 19, no. 1 (Spring 1980), 57–62.

Barry, Kesso. *Kesso, Princesse peuhle*. Paris: Seghers, 1988.

Barthold, Bonnie J. 'Women: Chaos and Redemption.' In *Black Time: Fiction of Africa, the Caribbean, and the United States*. New Haven: Yale University Press, 1981, 99–136.

Bataille, Gretchen M. and Kathleen Mullen Sands. *American Indian Women: Telling Their Lives*. Lincoln: University of Nebraska Press, 1984.

Bates, Daisy. *The Long Shadow of Little Rock: A Memoir*. New York: McKay, 1962.

Baugh, Edward. 'Goodison on the Road to Heartease.' *Journal of West Indian Literature* (Barbados) 1, no. 1 (October 1986), 13–22.

Beal, Frances M. 'Black Women and the Science Fiction Genre: Interview with Octavia Butler.' *Black Scholar* (March–April 1986), 14–18.

Bejel, Emilio. 'Nancy Morejón.' *Escribir en Cuba. Entrevistas con escritores cubanos: 1979–1989*. Río Piedras, PR: Editorial de la Universidad de Puerto Rico, 1991, 227–42.

Belgrave, Valerie. *Ti Marie*. London: Heinemann International, 1988.

Bell, Roseann P., Betty J. Parker, and Beverly Guy-Sheftall, eds. *Sturdy Black Bridges: Visions of Black Women in Literature*. Garden City, NY: Anchor/Doubleday, 1979.

—— 'A Selected Bibliography of Caribbean Women Writers And General Caribbean Literature including Criticism, Fiction, Drama, and Poetry.' In *Sturdy Black Bridges*. Garden City, New York: Anchor/Doubleday, 1979, 410–17.

Bell-Scott, Patricia et al. *Double Stitch. Black Women Write About Mothers and Daughters*. Boston: Beacon Press, 1991.

Belles Lettres 2, no. 3 (January/February 1987): special sections: 'Hispanic Women's Prose' and 'Re-Visions of Black Writers.'

—— no. 5 (May/June 1987): special sections: 'Asian Women Writers' and 'Native American Writers.'

Bennett, Louise. 'Bennett on Bennett.' *Caribbean Quarterly* 14, nos. 1 and 2 (1968), 98.

—— *Jamaican Dialect Poems.* Kingston, Jamaica: Herald, 1942.

—— *Jamaican Humor in Dialect.* Kingston, Jamaica: Jamaica Press, 1943.

—— *Laugh with Louise.* Kingston, Jamaica: City Printery, 1961.

—— *Jamaica Labrish.* Kingston, Jamaica: Sangsters, 1966.

—— *Anancy and Miss Lou.* Kingston, Jamaica: Sangsters, 1979.

Bernabe, Jean. 'Lé travail de l'ecriture chez Simone Schwarz-Bart.' *Présence Africaine* nos. 121–2 (1982), 166–79.

Berrian, Brenda F. *Bibliography of African Women Writers and Journalists.* Washington, DC: Three Continents Press, 1985.

—— *Bibliography of Women Writers from the Caribbean. (1831–1986).* Washington, DC: Three Continents Press, 1989.

Bethel, Marion. 'In a Shallow Sea.' *Bahamian Anthology.* Habana, Cuba: Casas de las Americas, 1993.

Bilingual Review 11, no. 2 (1984): special issue: 'Nosotras: Latina Literature Today.' Mari del Carmen Boza, Beverly Silva and Carmen Valle, eds.

Binder, Wolfgang. '"O, Ye Daughters of Africa, Awake! Awake! Arise ..."': The Functions of Work and Leisure in Female Slave Narratives.' *Actes du colloque des 3,* Serge Ricard, (introd.) *Les Etats–Unis: Images du travail et des loisirs.* Aix-en-Provence: University de Provence, 1989, 127–44.

Black, Ayanna. *No Contingencies.* Toronto: Williams and Wallace, 1986.

Bloom, Valerie. *Teach Mi, Tell Mi.* London: Bogle L'Ouverture, 1983.

Blount, Marcellus. 'The Past Is Prologue: Black Women Seize Their Day.' *Village Voice Literary Supplement.* (November 1988), 18–19.

Borza, Maria del Carmen, Beverly Silva, Carmen Valle, eds. *Nosotras. Latina Literature Today.* Binghamton, NY: Bilingual Press, 1986.

Bowles, Juliette. *In the Memory and Spirit of Frances, Zora and Lorraine: Essays and Interviews on Black Women and Writing.* Washington, DC: Institute for the Arts and the Humanities, Howard University Press, 1979.

Braendlin, Bonnie Hoover. 'Building In Ethnic Women Writers.' *Denver Quarterly* 17 (Winter 1983), 75–87.

Brand, Dionne. *'Fore Day Morning.* Toronto: Khosian Artists, 1978.

—— *Earth Magic, Winter Epigrams and Epigrams to Erneste Cardenal in Defense of Claudia.* Toronto: Williams and Wallace, 1983.

—— *Chronicles of the Hostile Sun.* Toronto: Williams and Wallace, 1984.

—— *Sans Souci and Other Stories.* Toronto: Williams and Wallace, 1988.

—— and Krisantha Sri Bhaggiyadatta. *Rivers Have Sources, Trees Have Roots.* Toronto: Cross-Cultural Communication Center, 1986.

Brant, Beth, ed. *A Gathering of Spirit: Writing and Art by North American Indian Women.* Rockland, ME: Sinister Wisdom Books, 1984, 2nd edn.

Brathwaite, Edward and Lucille Mair. *The Caribbean Woman*. Special issue of *Savacou* 13 (1977).

Braxton, Joanne M. *Black Women Writing Autobiography: A Tradition Within a Tradition*. Philadelphia: Temple University Press, 1989.

Braxton, Joanne M. and Andrée Nicola McLauglin, eds. *Wild Women in the Whirlwind: Afro-American Culture and the Contemporary Literary Renaissance*. New Brunswick, NJ: Rutgers University Press, 1989.

Breeze, Jean 'Binta'. *Spring Cleaning*. London: Virago, 1992.

Brock, Sabine. '"Talk as a Form of Action": An Interview with Paule Marshall, September 1982'. Gunter H. Lenz, ed. *History and Tradition in Afro–American Culture*. Frankfurt: Campus, 1984, 194–206.

Brodber, Erna. *Jane and Louisa Will Soon Come Home*. London and Port-of-Spain: New Beacon Books, 1980.

—— ed. *Perceptions of Caribbean Women: Towards a Documentation of Stereotypes*. Institute of Social and Economic Research (Eastern Caribbean). Women in the Caribbean Project, no. 5. Cave Hill, Barbados: ISER(EC), University of the West Indies, 1982.

—— *Myal*. London and Port-of-Spain; New Beacon Books, 1988.

Bromley, Roger. 'Reaching a Clearing: Gender and Politics in *Beka Lamb*.' *Wasafiri* 1, no. 2 (Spring 1985), 10–14.

Brooks, Gwendolyn. *Maude Martha*. New York: Harper, 1945.

—— *A Street in Bronzeville*. New York: Harper, 1953.

—— *In the Mecca*. New York: Harper and Row, 1968.

—— *The World of Gwendolyn Brooks*. New York: Harper and Row, 1971.

—— *Annie Allen*. (1949) New York: Greenwood, 1972.

Brown, Beverly. *Dream Diary*. Kingston, Jamaica: Savacou Co-operative, 1982.

Brown, Bev. E.L. 'Mansong and Matrix: a Radical Experiment.' *Kunapipi* 7, nos. 2 & 3 (1985), 68–79. (Discusses the work of Zee Edgell and Jean Rhys.)

Brown, Lloyd. *Women Writers in Black Africa*. Westport, Connecticut: Greenwood Press, 1981.

Bruner, Charlotte H., ed. *Unwinding Threads*. London: Heinemann, 1983.

—— *African Women's Writing*. London: Heinemann, 1993.

Bruner, Charlotte H. 'A Decade for Women Writers.' Stephen H. Arnold, ed. *African Literature Studies: The Present State/L'Etat présent*. Washington, DC: Three Continents, 1985, 217–27.

Bruner, Charlotte and David Bruner. 'Buchi Emecheta and Maryse Condé: Contemporary Writing from Africa and the Caribbean.' *World Literature Today* 59: 1(1985), 9–13.

Bryan, Beverly, Stella Dadzie and Suzanne Scafe. *The Heart of the Race*. London: Virago, 1985.

Bueno, Salvador. 'El negro en la poesía cubana.' *Revista de la Biblioteca Nacional José Martí* 23 (1981), 71–105.

Buffong, Jean. *Under the Silk Cotton Tree*. London: Women's Press, 1992.

Buffong, Jean and Nellie Payne. *Jump-up-and-Kiss-Me*. London: Women's Press, 1990.

Bugul, Ken. *The Abandoned Baobab. The Autobiography of a Senegalese Woman*. New York: Lawrence Hill, 1991. (*Le Baobab Fou*. Dakar: Les Nouvelles éditions Africaines, 1984.)

Bulletin of Eastern Caribbean Affairs (Barbados) 11, no. 1 (March–April 1985). Special issue 'The Female Presence in Caribbean Literature.'

Burford, Barbara, Gabriela Pearse, Grace Nichols and Jackie Kay. *A Dangerous Knowing. Four Black Women Poets*. London: Sheba, 1985.

—— *The Threshing Floor*. London: Sheba, 1986; Ithaca, NY: Firebrand Books, 1987.

Busby, Margaret, ed. *Daughters of Africa. An International Anthology of Words and Writings by Women of African Descent from the Ancient Egyptian to the Present*. London: Jonathan Cape Ltd and New York: Pantheon Books, 1992.

Bush, Barbara. *Slave Women in Caribbean Society, 1650–1838*. Kingston, Jamaica: Heinemann Caribbean; Bloomington: Indiana University Press; London: James Currey, 1990.

Busia, Abena. *Testimonies of Exile*. Trenton, NJ: Africa World Press, 1990.

Butler, Johnella E. 'Minority Studies and Women's Studies: Do We Want to Kill a Dream?' *Women's Studies International Forum* 7, no. 3 (1984), 135–8.

—— 'Toward a Pedagogy of Everywoman's Studies.' In Margo Culley and Catherine Portuges, eds. *Gendered Subjects: The Dynamics of Feminist Teaching*, Boston: Routledge and Kegan Paul, 1985, 230–9.

—— 'Transforming the Curriculum: Teaching About Women of Color.' In James A. Banks and Cherry A. McGee Banks, eds. *Multicultural Education: Issues and Perspectives*. Boston: Allyn and Bacon, 1989, 145–63.

Butler, Octavia E. *Mind of My Mind*. New York: Avon, 1980.

—— *Dawn. Xenogenesis I*. New York: Warner, 1987.

—— *Kindred*. Boston: Beacon Press, 1988.

—— *Wild Seed*. New York: Warner, 1988; London: Gollancz, 1990.

—— *Imago. Xenogenesis III*. New York: Warner, 1990.

—— *Adulthood Rites. Xenogenesis II*. New York: Warner, 1993.

Bryne, Mary Ellen. 'Welty's "A Worn Path" and Walker's "Everyday Use": Companion Pieces.' *Teaching English in the Two–Year College* 16 (May 1989), 129–33.

Byrne, Pamela R. and Suzanne R. Ontiveros, eds. *Women in the Third World: a Historical Bibliography*. Santa Barbara, CA: ABC-Clio, 1986 (Chapter 6, 'Women in Latin America and the West Indies').

Cabakulu, Mwamba. 'Femmes africaines écrivaines: Une Certitude de revanche?' *Cahiers de l'Institut Panafricain de Geo–Politique* 7 (1989), 98–110.

Cabello-Argandona, Robert et al. *The Chicana: A Comprehensive Bibliographic Study.* Los Angeles: UCLA Chicana Studies Center, 1975.

Calio, Louise. 'A Rebirth of the Goddess in Contemporary Women Poets of the Spirit.' *The New Voices* (Trinidad & Tobago) 12, no. 23 (1984), 41–51.

Calyx: A Journal of Art and Literature by Women 8, no. 2 (Spring 1984): special issue: 'Bearing Witness/Sobreviviendo: an Anthology of Native American/Latina Art and Literature.' Jo Cochran et al., eds.

Campbell, Elaine. 'Oroonoko's Heir: the West Indies in the Late Eighteenth-Century Novels by Woman.' *Caribbean Quarterly* 25, nos. 1–2 (March–June 1979), 80–4.

—— 'An Expatriate at Home: Dominica's Elma Napier.' *Kunapipi* 4, no. 1 (1982), 81–93.

—— 'Two West Indian Heroines: Bita Plant and Fola Piggot.' *Caribbean Quarterly* 29, no. 2 (June 1983), 22–9.

—— '*In the Cabinet:* a Novelistic Rendition of Federation Politics.' *Ariel* 17, no. 4 (October 1986), 117–25.

Captain-Hidalgo, Yvonne. 'The Poetics of the Quotidian in the Works of Nancy Morejón.' *Callaloo* 10:4 (1987), 596–604.

Carby, Hazel V. 'White Woman Listen! Black Feminism and the Boundaries of Sisterhood.' *The Empire Strikes Back. Race and Racism in '70s Britain.* London: Hutchinson/Birmingham, England: Centre for Contemporary Cultural Studies, 1982.

—— 'On The Threshold of Woman's Era: Lynching, Empire, and Sexuality in Black Feminist Theory.' *Critical Inquiry* 12:1 (Autumn 1985), 262–77.

—— 'Introduction.' In Frances E. Harper. *Iola Leroy, or Shadows Uplifted.* Boston: Beacon Press, Black Women Writers Series, 1987, ix–xxx.

—— *Reconstructing Womanhood: The Emergence of the Afro-American Woman Novelist.* New York: Oxford University Press, 1987.

—— 'It Jus Be's That Way Sometimes. The Sexual Politics of Women's Blues.' Robyn R. Warhol and Diane Price Herndl, eds. *Feminisms. An Anthology of Literary Theory and Criticism.* New Brunswick, NJ: Rutgers University Press, 1991, 746–58.

Caribbean Documentation Centre. *A Selected Bibliography*, Part Two. Leiden, The Netherlands: Dept of Caribbean Studies, Royal Institute of Linguistics and Anthropology, 1985.

Carter, Sheila. 'Women in Carlos Guillermo Wilson's *Chombo.*' In Lloyd King, ed. *La Mujer en la Literatura Caribena.* St Augustine, Trinidad: Dept of French and Spanish Literature, University of the West Indies [1984?], 69–93.

Castro-Klaren, Sare. ' La crítica literaria feminista y la escritoria en America latina.' In Patricia Elena González and Eliana Ortega, eds. *La Sartèn por el Mango: Encuentro de Escritoras Latinoamericanas.* Rìo Piedras, Puerto Rico: Ediciones Huracán, 1984, 27–46.

Césaire, Ina. 'La triade humaine dans le conte antillais.' *Présence Africaine* nos. 121–2 (1982), 142–53.

Cham, Mbye C. 'Contemporary Society and the Female Imagination: A Study of the Novels of Mariama Bâ.' Eldred Durosimi Jones, ed. *Women in African Literature Today*. London: James Currey; Trenton, New Jersey: Africa World Press, 1987.

Chamberlain, Mary. *Growing up in Lambeth*. London: Virago, 1989, ix, 182.

Chapman, Dorothy Hilton. *Index to Poetry by Black American Women*. New York: Greenwood Press, 1986.

Charles, Christopher. 'L'oiseuse feminine de la Guadeloupe: recherché d'identité.' *Présence Africaine* no. 99/100 (1976), 155–6.

—— 'Évolution de la poésie féminine haitienne, 1876–1976.' *Le Nouveau Monde,* supplement, 22 and 29 October, 5, 12, 29 November and 10 December 1978.

—— 'Man, Woman and Love in French Caribbean Writing.' *Caribbean Quarterly* 27, no. 4 (December 1981), 31–6.

—— 'La femme antillaise et l'avenir des Antilles françaises.' *Croissance des jeunes nations* 24 (juillet–aôut 1982), 33–5.

Chee, Valerie Lee. 'Birds of a Feather.' *Corlit* 3, (July 1974), 11–13.

Chemain-Degrange, Arlette. *Émancipation féminine et roman africain*. Dakar: Nouvelles éditions Africaines, 1980.

Cherry, Gwendolyn et al. *Portraits in Color: The Lives of Colorful Negro Women*. Paterson, NJ: Pageant Books, 1962.

Cheung, King-kok. 'Reflections on Teaching Literature by American Women of Color.' *Pacific Coast Philology* 25:1–2 (November 1990), 19–23.

Childress, Alice. *Like One of the Family*. Brooklyn, NY: Independence, 1956.

Chiriboga, Luz Argentina. *Bajo la piel de los tambores: novela*. Quito, Ecuador: Editorial Casa de la Cultura Ecuatoriana, 1991.

—— *La contraportada del deseo*. Quito, Ecuador: Editorial Casa de la Cultura Ecuatoriana (ABYA-YALA), 1992.

—— *Manual de Ecología*. Quito, Ecuador: Editorial Abrapalabra, 1993.

—— *Jonatas y Manuela*. Quito, Ecuador: Editorial Abrapalabra, 1994.

Choong, Da, Olivette Cole Wilson, Sylvia Parker and Gabriela Pearse. *Don't Ask Me Why. An Anthology of Short Stories by Black Women*. London: Black Womantalk, 1991.

Choong, Da, Olivette Cole Wilson, Bernardine Evaristo and Gabriela Pearse. *Black Woman Talk Poetry*. London: Black Womantalk, 1987.

Chowdhry, Maya, Seni Seneviratne and Shahidah Janjua. *Putting the Pickle Where the Jam Should Be*. Sheffield, 1989.

—— and Seni Seneviratne. *Climbing Mountains. A Collection of Poetry and Song*. Sheffield, 1991. Cassette tape.

Christian, Barbara. *Black Women Novelists: The Development of a Tradition, 1892–1976.* Westport, CT: Greenwood, 1980.

—— 'Alice Walker: The Black Woman Artist as Wayward.' In Mari Evans, ed. *Black Women Writers (1950–1980): A Critical Evaluation.* Garden City, NY: Anchor/Doubleday, 1984, 457–77.

—— 'Paule Marshall (9 April 1929).' In Thadious M. Davis and Trudier Harris, eds. *Dictionary of Literary Biography.* Detroit: Gale Research, c. 1984, 161–70.

—— *Black Feminist Criticism: Perspectives on Black Women Writers.* New York: Pergamon, 1985.

—— 'Trajectories of Self-Definition: Placing Contemporary Afro-American Women's Fiction.' In Marjorie Pryse and Hortense J. Spillers, eds. *Conjuring: Black Women, Fiction, and Literary Tradition.* Bloomington: Indiana University Press, 1985, 233–48.

—— 'The Race for Theory.' *Feminist Studies* 14, no. 1 (Spring 1988), 67–79.

—— 'But What Do We Think We're Doing Anyway: The State of Black Feminist Criticism(s) or My Version of a Little Bit of History.' Cheryl A. Wall, ed. *Changing Our Own Words: Essays on Criticism, Theory, and Writing by Black Women.* New Brunswick: Rutgers University Press, 1989.

Clarke, Cheryl. *Narratives. Poems in the Tradition of Black Women.* New York: Kitchen Table/Women of Color Press, 1983.

—— *Living as a Lesbian.* Ithaca, NY: Firebrand, 1986.

Cleage, Pearl. *Mad At Miles. A Blackwoman's Guide to Truth.* Southfield, Michigan: Cleage Group, 1990.

—— *Deals With the Devil And Other Reasons to Riot.* New York: Ballantine, 1993.

Clayton, Cherry. *Women and Writing in South Africa: A Critical Anthology.* Marshalltown: Heinemann Southern Africa, 1989.

Cliff, Michelle. *Claiming an Identity They Taught Me to Despise.* Watertown, MA: Persephone, 1980.

—— 'Objects into Subjects: Some Thoughts on the Work of Black Women Artists.' *Heresies* 15 (1982), 35–40.

—— *Abeng.* Trumansburg, NY: Crossing Press, 1984.

—— *The Land of Look Behind.* Ithaca, NY: Firebrand, 1985.

—— *No Telephone to Heaven.* New York: Dutton, 1987.

—— *Bodies of Water.* New York: Dutton and Pantheon, 1990.

—— 'Women Warriors: Black Writers Load the Canon.' *Village Voice Literary Supplement* (May 1990), 20–2.

Clifton, Lucille. *Good Times.* New York: Random House, 1969.

—— *Two-Headed Woman.* Amherst, MA: University of Massachusetts Press, 1980.

Cobham, Rhonda and Merle Collins, eds. *Watchers and Seekers: Creative Writing by Black Women in Britain.* London: Women's Press, 1987.

Cobham-Sander, C. Rhonda. 'The Creative Writer and West Indian Society: Jamaica 1900–1950.' University of St Andrews, 1981, Chapter 4: 'Women in Jamaican Literature 1900–1950', 175–252.

—— 'Getting Out of the Kumbla: Review of *Jane And Louisa Will Soon Come Home.*' *Race Today* 14 (December 1981–January 1982), 33–4.

—— 'Making it Through the Night.' Review essay of *Because the Dawn Breaks*, by Merle Collins. *New Beacon Reviews* nos. 2/3 (November 1986), 72–7.

Cohen-Stuart, Bertie A. *Women in the Caribbean: a Bibliography, Part Two.* Leiden, The Netherlands: Dept of Caribbean Studies, Royal Institute of Linguistics and Anthropology, 1985.

Cole, Johnetta B., ed. *All American Women: Lines That Divide, Ties That Bind.* New York: Free Press, 1986.

Collier, Eugenia. 'The Closing of the Circle. Movement from Division to Wholeness in Paule Marshall's Fiction.' In Mari Evans, ed. *Black Women Writers. (1950–1980): A Critical Evaluation.* Garden City, NY: Anchor/Doubleday, 1984, 295–315.

—— 'Fields Watered with Blood: Myth and Ritual in the Poetry of Margaret Walker'. Mari Evans, ed. *Black Women Writers (1950–1980): A Critical Evaluation.* Garden City, NY: Anchor/Doubleday, 1984, 499–510.

Collins, Merle. *Because the Dawn Breaks.* London: Karia Press, 1985.

—— *Angel.* London: Women's Press, 1987.

—— 'Themes and Trends in Caribbean Writing Today.' In Helen Carr, ed. *From My Guy to Sci–Fi: Genre and Women's Writing in the Postmodern World.* London: Pandora, 1989, 179–90.

—— *Rain Darling and Other Stories.* London: Women's Press, 1990.

—— *Rotten Pomerack.* London: Virago, 1992.

—— ed. *Inside Ant's Belly.* London: National Council of Teachers of English, 1994.

Collins, Patricia Hill. 'The Emerging Theory and Pedagogy of Black Women's Studies.' *Feminist Issues* 6, no.1 (Spring 1986), 3–18.

—— *Black Feminist Thought.* London: Routledge, 1990.

Comma-Maynard, Olga. *Carib Echoes: A Collection of Short Stories and Poems.* Port-of-Spain, Trinidad: Uyille's Printerie, 1944.

Commissiong, Barbara and Marjorie Thorpe. 'A Selected Bibliography of Women Writers in the Eastern Caribbean.' *WLWE* 17, no. 1 (1978), 279–304.

Condé, Maryse. *La Parole des femmes. Essai sur les romancières des Antilles de langue française.* Paris: L'Harmattan, 1979.

—— *Moi, Tituba sorcière…. Noire de Salem,* Paris: Mercure de France, 1986

—— *A Season in Rihata.* London and New Hampshire: Heinemann, 1988.

—— *Segou.* New York: Ballantine, 1988.

—— *The Tree of Life.* New York: Ballantine, 1992.

—— *The Children of Nya.* New York: Viking/Penguin, 1989.

Bibliography 283

—— *The Children of Segou*. New York: Ballantine, 1990.

—— *Hérémakhonon*. Paris: Union Générale des Éditions, 1976; Washington, DC: Three Continents Press, 1992.

—— *I Tituba, Black Witch of Salem*. Charlottesville: University Press of Virginia, 1992.

Conditions: Five: *The Black Women's Issue*. Edited by Lorraine Bethel and Barbara Smith. Brooklyn, NY: Conditions, 1979.

Conlon, Faith, Rachel Da Silva and Barbara Wilson, eds. *The Things That Divide Us*. Seattle: Seal Press, 1985.

Cooper, Afua. *Breaking Chains*. Toronto: Sister Vision Press, 1984.

—— 'Finding My Voice.' In Selwyn R. Cudjoe, ed. *Caribbean Women Writers*. Wellesley: Callaloux, 1990, 301–5.

—— *Memories Have Tongue*. Toronto: Sister Vision Press, 1992

Cooper, Anna Julia. *A Voice From the South by a Black Woman of the South*. Xenia, OH: Adline Printing House, 1982.

Cooper, Carolyn. 'Noh Lickle Twang: An Introduction to the Poetry of Louise Bennett.' *World Literature Written in English* 17 (April 1978), 317–27.

—— 'That Cunny Jamma Oman: the Female Sensibility in the Poetry of Louise Bennett.' *Bulletin of Eastern Caribbean Affairs* (Barbados) 11, no. 1 (March–April 1985), 13–27.

—— 'The Oral Witness and the Scribal Document: Divergent Accounts of Slavery in Two Novels of Barbados.' In Mark McWatt, ed. *West Indian Literature and its Social Context*, St Michael, Barbados: English Department of University of the West Indies, 1985, 3–11.

—— 'The Fertility of the Gardens of Women.' Review essay of *Jane and Louisa Will Soon Come Home*, by Erna Brodber. *New Beacon Reviews* nos. 2–3 (November 1986), 139–47.

—— 'Disarming Women.' *Journal of West Indian Literature* 2 (January 1987), 55–66.

—— *Noises in the Blood*. London: Macmillan, 1993

Cooper, J. California. *A Piece of Mine*. Navarro, CA: Wild Trees Press, 1984.

—— *Homemade Love*. New York: St Martin's Press, 1986.

—— *Some Soul to Keep*. New York: St Martins Press, 1988.

—— *Family*. New York: Doubleday, 1992.

Cortera, Martha. *Latina Sourcebook*. Austin, TX: Information System Development, 1982.

Cortez, Jayne. *Festivals and Funerals*. New York: Phrase Text, 1971.

—— *Scarifications*. New York: Bola Press, 1973.

—— *Firespitter*. New York: Bola Press, 1982.

—— *Coagulations. New and Selected Poems*. New York: Thunders Mouth, 1984.

—— *Mouth on Paper*. New York: Bola Press, 1991.

—— *Poetic Magnet*. New York: Bola Press, 1991.

Cortina, Lyn Ellen Rice. *Spanish-American Women Writers: a Bibliographical Research Checklist*. New York: Garland Publishing, c. 1983.

Creque-Harris, Leah. 'Literature of the Diaspora by Women of Color.' *SAGE: A Scholarly Journal on Black Women* 3 (Fall 1986), 61–4.

Cudjoe, Selwyn R., ed. *Caribbean Women Writers: Essays from the First International Conference*. Wellesley: Callaloux, 1990.

Cypess, Sandra Messinger. 'Women Dramatists of Puerto Rico.' *Revista/Review Inter-americana* 9:1 (1979), 24–41.

―――― 'La dramaturgia femenina y su contexto sociocultural'. *Latin American Theatre Review* 13, no. 2 Supplement (Summer 1980), 63–8.

―――― 'Tradition and Innovation in the Writings of Puerto Rican Women.' Carole Boyce Davies and Elaine Savory Fido, eds. *Out of the Kumbla. Caribbean Women and Literature*. Trenton, NJ: Africa World Press, 1990, 75–88.

da Conceiçao, Sonia Fatima. *Marcas, Sonhos e Raizes. Novela*. Sao Paulo: Quilhomboje Literatura, 1991.

d'Almeida, Irene Assiba. 'The Concept of Choice of Mariama Bâ's Fiction.' In Carole Boyce Davies and Anne Adams Graves, eds. *Ngambika*. Trenton, NJ: Africa World Press, 1985, 161–71.

―――― and Hamou, Sion. 'L'Écriture féminine en Afrique noire francophone: Le Temps du miroir.' *Études Littéraires* 24:2 (Fall 1991), 41–50.

―――― *Destroying the Emptiness of Silence. Francophone African Women Writers*. Miami: University of Miami Press, 1994.

Dance, Daryl Cumber, ed. *Fifty Caribbean Writers: A Bio-Bibliographical and Critical Sourcebook*. Westport, Conn: Greenwood Press, 1986. Includes bibliographies and articles on the works of Phyllis Shand Allfrey, Louise Bennett, Dionne Brand, Erna Brodber, Jean D'Costa, Merle Hodge, Marion Patrick Jones, Jamaica Kincaid, Jean Rhys and Sylvia Wynter.

Dandridge, Rita B. 'From Economic Insecurity to Disintegration: A Study of Characters in Louise Merriwether's *Daddy Was a Number Runner*.' *Negro American Literature Forum* 9 (1975), 82–5.

Dangarembga, Tsitsi. *Nervous Conditions*. Seattle: Seal Press, 1989.

Dash, Julie. *Daughters of the Dust: The Making of an African American Woman's Film*. New York: New Press, 1992.

Davies, Barrie. 'Neglected West Indian Writers.' Review of *The Orchid House*, by Phyllis Allfrey. WLWE 11, no. 2 (November 1972), 81–3.

Davies, Carole Boyce. 'Black Woman's Journey into Self: a Womanist Reading of Paule Marshall's *Praisesong for the Widow*.' *Matatu* (West Germany) 1:1 (1987).

―――― 'Finding Some Space: Black South African Women Writers.' *Current Bibliography on African Affairs 1986–1987* 19, 1 (1987), 31–45.

―――― 'Wrapping One's Self in Mother's Akatado-Cloths: Mother–Daughter Relationships in the Works of African Women Writers.' *SAGE: A Scholarly Journal on Black Women* 4:2 (Fall 1987), 11–19.

—— 'Private Selves and Public Spaces: Autobiography and the African Woman Writer.' *Neohelicon: Acta Comparationis Litterarum Universarum* 17:2 (1990), 183–210.

—— *Black Women, Writing, Identity. Migrations of the Subject.* London: Routledge, 1994.

—— and Elaine Savory Fido, eds. *Out of the Kumbla. Caribbean Women and Literature,* Trenton, NJ: Africa World Press, 1990.

—— and Elaine Savory Fido. 'Towards a Literary History of African Women Writers.' Oyekan Owomoyela, ed. *A History of Twentieth Century African Literature.* Lincoln and London: University of Nebraska Press, 1993, 311–46.

—— and Anne Adams Graves, eds. *Ngambika: Studies of Women in African Literature.* Trenton, NJ: Africa World Press, 1986.

Davis, Angela. *If They Come In the Morning.* New York: Okpaku, 1971.

—— *Women, Race and Class.* New York: Random House, 1982.

—— *Angela Davis – An Autobiography.* London: Women's Press, 1990.

Davis, Elizabeth. *Lifting As They Climb: The National Association of Colored Women.* Washington, DC: National Association of Colored Women, 1933.

Davis-Lett, Stephanie. 'The Image of the Black Woman as a Revolutionary Figure: Three Views.' *Studies in Afro-Hispanic Literature* 2–3 (1978–9), 118–33.

Davis, Thadious. 'Nella Larsen.' In Trudier Harris and Thadious M. Davis, eds. *Afro-American Writers from Harlem Renaissance to 1940.* Vol. 51 of the *Dictionary of Literary Biography.* Detroit: Gale Research,1987, 182–92.

—— 'Alice Walker's Celebration of Southern Generation.' In Peggy Prenshaw, ed. *Women Writers of the Contemporary South.* Jackson: University Press of Mississippi, 1984, 39–53.

Davison, Jean. *Voices from Mutiso. Lives of Rural Gikuyu Women.* Boulder and London: Lynne Rienner Publishers, 1989.

'Death of a Native Daughter.' Editorial. *The Nation* (Barbados), Weekend edn, 14 February 1986. (Tribute to Phyllis Shand Allfrey.)

De Beer, Gabriella. 'Femenismo en la obra poética de Rosario Castellanos.' *Revista de Crítica Literatura Latinoamericana* 7, no. 3 (1981), 105–12.

DeCosta Willis, Miriam, ed. *Blacks in Hispanic Literature. Critical Essays.* Port Washington, NY: Kennikat Press, 1977.

—— Reginald Martin, and Roseann P. Bell, eds. *Érotique Noir/Black Erotica.* New York: Anchor/Doubleday, 1992.

de Filippis, Daisy Cocco, ed. *From Desolation to Compromise. A Bilingual Anthology of the Poetry of Aída Cartagena Portalatín.* Santo Domingo: Taller, Coleccion Montesions no. 10, 1988.

—— 'Indias y Trigueñas No Longer: Contemporary Dominican Women Poets Speak.' *Cimarrón* 1:3 (1988), 132–50.

de Jesus, Carolina Maria. *Child of the Dark. The Diary of Carolina Maria de Jesus.* New York: New American Library, 1962.

Dearborn, Mary V. *Pocahonta's Daughters: Gender and Ethnicity in American Culture.* New York: Oxford University Press, 1986.

Delaney, Sarah and Elizabeth with Amy Hill Hearth. *Having Our Say. The Delaney Sisters' First 100 Years.* New York: Tokyo, London: Kodansha International, 1993.

De Weever, Jacqueline. *Mythmaking and Metaphor in Black Women's Fiction.* New York: St Martin's Press, 1991.

Diallo, Nafissatou N. *De Dakar au Plateau, une enfance dakaroise,* Dakar: NEA, 1977.

—— *Fary, Princess of Tiali.* Trans. Ann Woollcombe. Washington, DC: Three Continents Press, 1987.

Dickens, Dorothy Lee. *Black on the Rainbow.* New York: Pageant Press, 1952.

Didier, Beatrice. 'Autoportrait et journal intimé.' *Corps écrit* 5 (1983).

Dike, Fatima. *The First South African.* Johannesburg: Ravan Press, 1979.

Down, Lorna. 'Singing One's Own Song: Woman and Selfhood in Recent West Indian Fiction'. Thesis (MA) University of the West Indies, 1985. (Discusses *Beka Lamb,* by Zee Edgell, *Crick Crack Monkey,* by Merle Hodge, and *Jane and Louisa Will Soon Come Home,* by Erna Brodber.)

Driver, Dorothy. 'M'a-Ngoana O Tsoare Thipa ka Bohaleng – The Child's Mother Grabs the Sharp End of the Knife: Women as Mothers, Women as Writers.' Martin Trump, ed. *Rendering Things Visible: Essays on South African Literary Culture.* Athens: Ohio University Press; Johannesburg, South Africa: Ravan Press, 1990, 225–55.

DuCille, Ann. *The Coupling Convention. Sex, Text, and Tradition in Black Women's Fiction.* New York and Oxford: Oxford University Press, 1993.

Dunham, Katherine. *A Touch of Innocence.* New York: Harcourt, Brace, 1959.

Durix, Jean Pierre. 'Review of *Jane and Louisa Will Soon Come Home.*' *Afram* 14 (1982).

Edgell, Zee. *Beka Lamb.* London: Heinemann, 1982.

—— *In Times Like These.* London: Heinemann, 1991.

Edmonds, Ursula. 'Toward Liberation: Black Women Writing.' *African Research & Documentation* v: 36 (1984), 18–24.

Eko, Ebele. 'Beyond the Myth of Confrontation: a Comparative Study of African and Africa-American Female Protagonists.' *Ariel* 17, no. 4 (October 1986), 139–52.

el Saadawi, Nawal. *Two Women In One.* London: Al Saqi Books, 1985 (1975).

—— *The Hidden Face of Eve.* Boston: Beacon Press, 1980.

—— *Woman at Point Zero.* London: Zed Books, 1983.

—— *Douze femmes dans Kanater.* Paris: des Femmes, 1984.

—— *The Circling Song.* London and Atlantic Highlands, NJ: Zed Books, 1986.

—— *Memoirs from the Women's Prison.* Trans. by Marilyn Booth. London: Women's Press, 1986.

—— *She Has No Place in Paradise*. Trans. Shirley Eber. London: Methuen, 1987.

—— *Memoirs of a Woman Doctor*. London: Al Saqi Books, 1988.

—— *Femmes Egyptiennes: tradition et modernite*. Paris: des femmes, 1991.

—— *Searching*. London: Zed Books, 1991.

—— *My Travels Around the World*. London: Methuen, 1991.

—— *Death of an Ex-Minister*. London: Minerva, 1992.

Ellis, Deborah. 'The Color Purple and the Patient Griselda'. *College English* 49 (1987), 188–201.

Emecheta, Buchi. *The Bride Price*. New York: George Braziller, 1976.

—— *The Slave Girl*. New York: George Braziller, 1977.

—— *The Joys of Motherhood*. New York: George Braziller, 1979.

—— *Double Yoke*. New York: George Braziller, 1983.

—— *Second Class Citizen*. New York: George Braziller 1983.

—— *The Rape of Shavi*. New York: George Braziller, 1985.

—— *In the Ditch*. New York: Schocken, 1987.

—— *Destination Biafra*. New York: Schocken, 1988.

—— *The Family*. New York: George Braziller, 1990.

—— *Head Above Water*. London: Kayode, 1991.

—— *Kehinde*. Oxford and Portsmouth, NH: Heinemann, 1994.

Engling, Ezra S. 'The "Compact" Woman in Ana Lydia Vega's *Pollito chicken*.' In Lloyd King. ed. *La Mujer en la literatura Caribeña*. St Augustine, Trinidad: Dept of French and Spanish Literature, University of the West Indies [1984?], 94–107.

Enssein, Klaus. 'Collective Experience and Individual Responsibility: Alice Walker's *The Third Grange Copeland*.' In Peter Bruck and Wolfgang Karrer, eds. *The Afro-American Novel Since 1960*. Amsterdam: Gruner, 1982, 189–218.

Erickson, Peter. '"Cast Out Alone/To Heal and Re-Create": Family-based Identity in the Work of Alice Walker.' *College Language Association Journal* 23 (1979), 71–94.

Espinet, Ramabai. 'A Short Account of the Life and Work of Phyllis Shand Allfrey.' *Bulletin of Eastern Caribbean Affairs* (Barbados) 12, no. 1 (March/April 1986), 33–5.

—— ed. *Creation Fire. A CAFRA Anthology of Caribbean Women's Poetry*. Toronto: Sister Vision Press, 1990.

Esteves, Sandra María. 'The Feminist Viewpoint in the Poetry of Puerto Rican Women in the United States.' In *Images and Identities: The Puerto Rican in Two World Contexts*. Asela Rodríguez de Lanuna, ed, New Brunswick, NJ: Transaction, 1987, 171–7.

Esteves, Carmen C. and Lizabeth Paravisini-Gebert, eds. *Green Cane and Juicy Flotsam*. New Brunswick, New Jersey: Rutgers University Press, 1991.

Evans, Mari. *Black Women Writers (1950–1980): A Critical Evaluation*. Garden City, NY: Anchor/Doubleday, 1984.

—— *I Am A Black Woman*. New York: Morrow, 1970.

Fabio, Sarah Webster. *A Mirror: A Soul*. San Francisco: Richardson, 1969.

Fabre, Genevieve. 'Selected Bibliography of Essays on Black Women and Black Feminist Criticism.' *Revue Francaise d'Études Américaines* 11:30 (November 1986), 501–2.

—— 'Genealogical Archeology: Black Women Writers in the 1980s and the Search for Legacy.' *Revue Francaise d'Études Américaines* 11:30 (November 1986), 461–7.

Fauset, Jessie R. *There is Confusion*. New York: Boni and Liveright, 1924.

—— *Plum Bum: A Novel Without a Moral*. New York: Frederick A. Stokes, 1929.

—— *Comedy, American Style*. New York: Frederick A. Stokes. 1933.

—— *The Chinaberry Tree: A Novel of American Life*. New York: Negro Universities Press, 1931, 1969.

—— 'Gift of Laughter.' In *Black Expressions*, ed. Addison Gayle. New York: Weybright & Tally, 1969.

Ferguson, Moira, ed. *Dreams of Alliouagana: An Anthology of Montserrat Prose and Poetry*. Montserrat: University Centre, 1974.

—— *Jamaica Kincaid: Where the Land Meets the Body*. Charlottesville and London: University Press of Virginia, 1994.

Fernandes Cintrón, Celia and Marcia Rivera Quintero. 'Bases de la sociedad sexista en Puerto Rico.' *Revista/Review Interamericana* 4, no. 2 (1974), 239–45.

Fernández Olmos, Margarite. 'El genero testimonial: aproximaciones feministas'. *Revista/ Review Interamericana* 11, no. 1 (1981), 69–75.

—— 'From the Metropolis: Puerto Rican Women Poets and the Immigration Experience.' *Third Woman* 1:2 (1982), 51.

—— ed. *Contemporary Women Authors of Latin America: Introductory Essays*. Brooklyn: Brooklyn College Press, 1983.

—— 'Desde una perspectiva femenina: la cuentistica de Rosario Ferre y de Ana Lydia Vega.' *Homines* 8, no. 2 (1984–85), 303–11.

—— 'Survival, Growth, and Change in the Prose Fiction of Contemporary Puerto Rican Women Writers.' Asela Rodríguez de Langua, ed. *Images and Identities: The Puerto Rican in Two World Contexts*. New Brunswick, NJ: Transaction, 1987, 76–88.

Ferré, Rosario. 'La cocina de la escritura.' In Patricia Elena González and Eliana Ortega, eds. *La Sartén por el Mango: Encuentro de Escritora Latinoamericanas*. Río Piedras, Puerto Rico: Ediciones Huracán, 1984, 137–62.

Fido, Elaine Savory. 'Christine Craig's Most Recent Poems: a Cause for Celebration.' Review of *Quadrille for Tigers*. *Caribbean Contact* (November 1984), 15.

—— 'Radical Woman: Woman and Theater in the Anglophone Caribbean.' In Erika Sollish Smilowitz and Roberta Quarles Knowles, eds. *Critical Issues in West Indian Literature*. Parkersburg, Iowa: Caribbean Books, 1984, 33–45.

—— 'Woman on Women: how Far to Disclose.' *Bulletin on Eastern Caribbean Affairs* 11 (March–April 1985), 35–44.

—— 'Crossroads: Third World Criticism and Commitment with Reference to African-Caribbean Women Poets.' *ACLALS Bulletin* 7th ser, 4 (1986), 10–25.

—— 'A Womanist Vision of the Caribbean.' In Carole Boyce Davies and Elaine Savory Fido, eds. *Out of the Kumbla. Caribbean Women and Literature.* Trenton, NJ: Africa World Press, 1990, 265–71.

Figüeroa, Ramón. 'Nacionalismo y universalismo en "Escalera para Electra".' *Areíto* 10:38 (1984), 41–3.

Finch, Jacqueline B. 'Merle Hodge's *Crick Crack Monkey:* Textual Adroitness.' St Croix, US Virgin Islands: College of the Virgin Islands, 1985. Unpublished paper.

Fisher, Dexter, ed. *The Third Woman: Minority Women Writers of the United States.* Boston: Houghton Mifflin, 1980.

Fleming, Robert E. 'The Influence of Main Street on Nella Larsen's *Quicksand.*' *Modern Fiction Studies* 31 (1985), 547–54.

Flewellen, Elinor C. 'Assertiveness vs. Submissiveness in Selected Works by African Women Writers.' *Ba Shiru: A Journal of African Languages and Literature* 12:2 (1985), 3–18.

Flynn, Joyce & Stricklin, Joyce Occomy. *Frye Street and Environs: The Collected Works of Marita Bonner.* Boston: Beacon, 1987.

Fonrose, Veronica. *The Evil Spirit.* Port-of-Spain, Trinidad: University of the West Indies, Extramural Department, 1966 (drama).

Ford-Smith, Honor. 'SISTREN – Woman's Theatre – a Model for Consciousness Raising.' In Margaret Hope, ed. *Journey in the Shaping. Report of the First Symposium on Women in Caribbean Culture – July 24, 1981.* St Michael, Barbados: Women and Development Unit (WAND), University of the West Indies, 1981, 52–8.

—— 'Women, the Arts and Jamaican Society: the Work of SISTREN Collective in Context.' Paper presented at the Fifth Annual Conference of the Society of Caribbean Studies, 26–28 May 1981, at High Leigh, Herts, England.

—— 'Sistren: Exploring Women's Problems Through Drama.' *Jamaica Journal* 19, no. 1 (February–April 1986), 2–12.

Foster, Frances Smith. 'Between the Sides: Afro–American Women Writers as Mediators.' *Nineteenth-Century Studies* 3 (1989), 53–64.

Foster, Frances Smith. *Written by Herself: Literary Production by African American Women, 1746–1892.* Bloomington: Indiana University Press, 1993.

Foster, Virginia Ramos. 'La critica literaria de las profesoras norteamericana ante las letras femininas hispanicas.' *Revista Interamericana de Bibliografía* 30, no. 4 (1980), 406–12 (Bibliographical survey).

290 *Moving Beyond Boundaries*

Fox-Genovese, Elizabeth. 'To Write My Self: The Autobiographies of Afro-American Women.' Shari Benstock and Catharine R. Stimpson, eds. *Feminist Issues in Literary Scholarship.* Bloomington: Indiana University Press, 1987.

—— 'My Statue, My Self: Autobiographical Writings of Afro-American Women.' Shari Benstock, ed. *The Private Self: Theory and Practice of Women's Autobiographical Writings.* Chapel Hill: University of North Carolina Press, 1988, 63–89.

Francisco, Ramón. *Literatura Dominicana 60.* Santiago: Universidad Católica Madre y Maestra, Colección Contemporáneos no. 12, 1972.

Franca, Aline. *A Mulher de Aleduma.* Salvador, Bahia, Brasil: Edicoes Ianama, 1985.

Fuller, Vernella. *Going Back Home.* London: Women's Press, 1992.

Fullerton, Janet. 'Women in Trinidadian Life and Literature.' *The New Voices* (Trinidad & Tobago) 5, no. 9 (March 1977), 9–31.

Gardiner, Madeleine. *Visages de femmes portraits d'ecrivains: etude.* Port-au-Prince, Haiti: Prix Litteraire H. Deschamps, 1981.

Gaston, Karen C. 'Women in the Lives of Grange Copeland.' *College Language Association Journal* 24 (1981), 276–86.

Gates, Henry Louis, Jr. 'Color Me Zora: Alice Walker's (Re)Writing of the Speakerly Text.' Patrick O'Donnell and Robert Con Davis, eds. *Intertextuality and Contemporary American Fiction.* Baltimore: Johns Hopkins University Press, 1989, 144–67.

Gautier, Arlette, ed. 'Antillaises = West Indian Women.' *Nouvelles Questions Feministes* (Paris. Special issue), no. 9/10 (Spring 1985).

Georgoudaki, Ekaterini. *Race, Gender, and Class Perspectives in the Works of Maya Angelou, Gwendolyn Brooks, Rita Dove, Nikki Giovanni, and Audre Lorde.* Thessaloniki: Aristotle University Press of Thessaloniki, 1991.

Gibson, Althea. *I Always Wanted to Be Somebody.* New York: Harper, 1958.

Giddings, Paula. *When and Where I Enter: The Impact of Black Women on Race and Sex in America.* New York: Morrow, 1984.

—— *In Search of Sisterhood: Delta Sigma Theta and the Challenge of the Black Sorority Movement.* New York: Morrow, 1988.

Gilard, Jacques. 'La obra poética de Nancy Morejón: un despertar de la negritud.' Robert Jammes, ed. *Cuba: Les étapes d'un liberation: Hommage a Juan Marinnello et Noël Salomon.* Toulouse, France: University de Toulouse-Le Mirail, 1979–80, 319–35.

Gilfillan, Lynda. 'Black Women Poets in Exile: The Weapon of Words'. *Tulsa Studies in Women's Literature* 11:1 (Spring, 1992), 79–93.

Gilroy, Beryl. *Black Teacher.* London: Cassell, 1976.

—— *In For a Penny.* London: Cassell, 1980; New York: Holt Saunders, 1982.

—— *Frangipani House.* London: Heinemann Educational, 1986.

—— *Boy-Sandwich.* London: Heinemann International, 1989.

—— 'The Woman Writer and Commitment: Links between Caribbean and African Literature.' *Wasafiri* no. 10 (Summer 1989), 15–16.

—— 'I Write Because ...' Selwyn R. Cudjoe, ed. *Caribbean Women Writers: Essays from the First International Conference.* Wellesley: Callaloux, 1990, 195–201.

—— *Echoes and Voices. (Open-Heart Poetry).* New York and Los Angeles: Vantage Press, 1991.

—— *Stedman and Joanna. A Love In Bondage.* New York: Vantage, 1991.

Giovani, Nikki. *Black Feeling, Black Talk/Black Judgement.* New York: Morrow, 1970.

—— ed. *Night Comes Softly: Anthology of Black Female Voices.* New York: Nik-Tom Publications, 1970.

—— *The Women and the Men.* New York: Morrow, 1975.

Glikin, Ronda. *Black American Women in Literature: A Bibliography, 1976 through 1987.* Jefferson, NC: Mcfarland, 1989.

Gloudon, Barbara. 'Fifty Years of Laughter. The Hon. Louise Bennett, O.J,' *Jamaica Journal* 19, no. 3 (1986), 2–10.

Gold, Janet. 'Feminine Space and the Discourse of Silence: Yolanda Oreamuno, Elena Poniatowska, and Luisa Valenzuela.' Noël Valis and Carol Maiser, eds. *In the Feminine Mode. Essays on Hispanic Women Writers.* Lewisburg, Pennsylvania: Bucknell University Press, 1990, 195–203.

Golden, Marita, ed. *Wild Women Don't Wear No Blues.* New York: London and Toronto: Doubleday, 1993.

—— *Long Distance Life. A Novel.* New York: Bantam, Doubleday, 1989.

—— *Migrations of the Heart.* Garden City, NY: Anchor/Doubleday, 1983.

Gomez, Alma, Cherríe Moraga and Mariana Romo-Carmona, eds. *Cuentos: Stories by Latinas.* New York: Kitchen Table/Women of Color Press, 1983.

Gomez, Jewelle L. *Flamingoes & Bears.* New Jersey: Grace Publications, 1986.

—— 'Black Women Heroes: Here's Reality, Where's the Fiction?' *Black Scholar* 17:2 (March–April 1986), 8–13.

—— *The Gilda Stories.* Trumansburg, NY: Firebrand, 1991.

—— *Forty-three Septembers.* Trumansburg, NY: Firebrand, 1993.

—— and Barbara Smith. 'Taking The Home Out of Homophobia: Black Lesbians Look in Their Own Backyard.' *Out/Look* no. 8 (Spring 1990), 32.

González, Iris G. 'Some Aspects of Linguistic Sexism in Spanish'. *Revista/Review Interamericana* 11, no. 2 (1981), 204–19.

González, Julio Ariza. 'Aproximaciones a la imagen trágica de dos personajes femeninos en *Cien años de soledad.*' In Lloyd King, ed. *La Mujer en la Literatura Caribeña.* St Augustine, Trinidad: Dept of French and Spanish Literature, University of the West Indies [1984?], 130–41.

González, Patricia Elena and Eliana Ortego, eds. *La Sartén por el Mango: Encuentro de Escritoras Latinoamericanas*. Río Piedras, Puerto Rico: Ediciones Huracán, 1984.

González, Sylvia. 'Cramped Creativity.' Guest editorial. *The New Voices* (Trinidad & Tobago) 3, no. 5 (1975), 3–6, 31.

Goodison, Lorna. *Heartease*. London: New Beacon, 1988.

—— *I Am Becoming My Mother*. London: New Beacon, 1986.

—— *Lorna Goodison*. New York: Research Institute for the Study of Man, 1989.

—— Interview. With Norval Nadi Edwards. *Pathways: a Journal of Creative Writing* (Jamaica) 2, no. 4 (December 1984), 8–12 (Part 1); 3, no. 5 (December 1985), 3–8 (Part 2).

—— *Tamarind Season*. Kingston: Hummingbird Publication, 1980.

Goodwin, Ruby Berkley. *It's Good to be Black*. Garden City, NY: Doubleday, 1953.

Gossett, Hattie. *Presenting Sister No Blues*. Ithaca, NY: Firebrand, 1988.

Graham, Maryemma. 'Frances Ellen Watkins Harper.' In *Afro-American Writers Before the Harlem Renaissance*. Vol. 50 of the *Dictionary of Literary Biography*, ed Trudier Harris and Thadious M. Davis. Detroit: Gale Research, 1986, 164–73.

Grantt, Barbara N. 'The Woman of Macondo: Feminine Archetypes in García Marquez *Cien años de soledad*.' In Lloyd King, ed. *La Mujer en la Literatura Caribeña*. St Augustine, Trinidad: Dept of French and Spanish Literature, University of the West Indies [1984?], 130–41.

Greene, Sue. 'Six Caribbean Novels by Women.' *New West Indian Guide* 58, nos. 1 & 2 (1984), 61–74.

Grewal, Shabnam, Jackie Kay, Liliane Landor, Gail Lewis and Pratibha Parmar. *Charting the Journey. Writings by Black and Third World Women*. London: Sheba Feminist Publishers, 1988.

Griffin, Farah Jasmine. '"Sister, Sister?": Recent Writings on Black and White Southern Women.' *NWSA Journal* 3:1 (Winter 1991) 98–109.

Gross, Theodore. 'Ann Petry: The Novelist as Social Critic.' In Robert Lee, ed. *Black Fiction: New Studies in the Afro-American Novel Since 1945*. London: Vision Press, 1980, 41–53.

Grötsh, Kurt. 'Sozialisticher Alltag und Soziale poesie bei Nancy Morejón.' Harold Wentzlaff-Eggebert, ed. *Die Legitimation der Allagssprache in der Modernen Lyrik: Antworten aus Europa und Lateinamerika*. Erlangen: Universitätsbund Erlangen-Nümberg, 1984, 113–34.

Guitart, Jorge and Kevin Power. 'Two Women Poets of Cuba: Belkis Cuza Malé and Nancy Morejón.' *Latin American Literary Review* 8: 125–6 (1979), 130–3.

Guy, Rosa. *Bird at My Window*. London: Souvenir Press, 1966; Philadelphia: Lippincott, 1970.

—— *The Friends*. London: Gollancz; New York: Holt, Rinehart and Winston, 1973.

—— *Edith Jackson*. New York: Viking, 1978.

—— *A Measure of Time*. New York: Holt, Rinehart and Winston, 1983.

—— *Ruby*. New York: Bantam, 1983.

—— *My Love, My Love or the Peasant Girl*. New York: Holt, Rinehart and Winston, 1985.

—— *The Music of Summer*. New York: Doubleday, 1992.

Guy-Sheftall, Beverly. *Daughters of Sorrow: Attitudes Toward Black Women, 1880–1920*. Brooklyn, New York: Carlson, 1990.

Guzmán, Catherine. 'Onomatology in Aída Cartegena Portalatín's Fiction.' *Literary Onomastics Studies* 10 (1983), 75–86.

Guzmán, Daisy Santos. Review of *Abeng*, Michelle Cliff. *Sargasso* (Puerto Rico) no. 2 (1984), 65–6.

Hammond, Jenny with Neil Druce. *Sweeter Than Honey. Ethiopian Women and Revolution: Testimonies of Tigrayan Women*. Trenton, NJ: The Red Sea Press, 1990.

Hancock, Joel. 'Elena Poniatowska's *Hasta no verte Jesús Mío*: the Remaking of the Image of Woman.' *Hispania* 66, no. 3 (September 1983), 353–9.

Harkness, Shirley and Cornelia B. Flora. 'Women in the News: an Analysis of Media Images in Colombia.' *Revista/Review Interamericana* 4, no. 2 (Summer 1974), 136–47.

Harley, Sharon and Terborg-Penn, Rosalyn, eds. *The Afro-American Woman, Struggles and Images*. Port Washington, NY: Kennikat Press, 1978.

Harper, Frances E. W., *Iola Leroy, Or Shadows Uplifted*. Philadelphia: Garrigues, 1892.

Harrell-Bond, Barbara. 'Interview: Mariama Bâ.' *The African Book Publishing Record* 6 (1980), 209–14.

Harris, Claire. *Traveling into Fiction*. New Brunswick, Canada: Gooselane Editions, 1984.

—— *Traveling to Find a Remedy*. New Brunswick, Canada: Gooselane Editions, 1986.

Harris, Marie, and Kathleen Aguero, eds. *A Gift of Tongues: Critical Challenges in Contemporary American Poetry*. Athens: University of Georgia Press, 1987.

—— *An Ear to the Ground: An Anthology of Contemporary American Poetry*. Athens: University of Georgia Press, 1989.

Harris, Trudier. 'From Exile to Asylum: Religion and Community in the Writings of Contemporary Black Women.' Mary Broe and Angela Ingram, eds. *Women's Writing in Exile*. Chapel Hill: University of North Carolina Press, 1989, 151–69.

—— 'Three Black Women Writers and Humanism: A Folk Perspective.' R. Baxter Miller, ed. *Black American Literature and Humanism*. Lexington: University Press of Kentucky, 1981, 50–74

Harris, Trudier, and Thadious Davis, eds. 'Violence in *The Third Life of Grange Copeland.*' *College Language Association Journal* 29 (1975), 238–47.

—— 'On *The Color Purple*, Stereotypes, and Silence.' *Black American Literature Forum* 18 (Winter 1984), 215–29.

Harrison, Polly F. 'Images and Exile: the Cuban Woman and her Poetry.' *Revista/Review Interamericana* 4, no. 2 (Summer 1974), 184–219.

Head, Bessie. *When Rainclouds Gather*. London: Gollancz, 1968.

—— *Maru*. London: Gollancz, 1971.

—— *A Question of Power*. London: Heinemann, 1974.

—— *The Collector of Treasures and Other Botswana Village Tales*. London: Heinemann, 1977.

—— *Serowe, Village of the Rainwind*. London: Heinemann, 1981.

—— *Bewitched Crossroads: An African Saga*. Johannesburg: Ad Donker, 1984.

—— *Tales of Tenderness and Power*. London: Heinemann, 1990.

—— *A Woman Alone: Autobiographical Writings*. London: Heinemann, 1990.

Hellenbrand, Harold. 'Speech, After Silence: Alice Walker's *The Third Life of Grange Copeland.*' *Black American Literature Forum* 20 (1986), 113–28.

Hemenway, Robert, ed. *Zora Neale Hurston: A Literary Biography*. Urbana: University of Illinois Press, 1978.

Henderson, Mae. 'Speaking in Tongues: Dialogics, Dialectics, and the Black Woman Writer's Literary Tradition.' Cheryl A. Wall, ed. *Changing Our Own Words*. New Brunswick: Rutgers University Press, 1989, 16–37.

Henry, F. and P. Wilson. 'The Status of Women in Caribbean Societies: an Overview of their Social, Economic and Sexual Roles.' *Social and Economic Studies* 24, no. 2 (1975), 165–98.

Hernton, Calvin C. *The Sexual Mountain and Black Women Writers: Adventures in Sex, Literature and Real Life*. New York: Doubleday, 1987.

Herrera-Sobek, María, and Helena María Viramontes, eds. *Chicana Creativity and Criticism: Charting New Frontiers in American Literature*. Houston: Arte Público Press, 1988.

Herzberger-Fofana, Pierrette. 'Les Influences religieuses dans la littérature féminine francophone d'Afrique noire.' *Nouvelles du Sud* 6 (1986–7), 191–202.

Hine, Darlene Clark. 'To Be Gifted, Female, and Black.' *Southwest Review* 67:4 (Autumn 1982), 357–69.

Hoberman, Louisa S. 'Hispanic American Women as Portrayed in the Historical Literature: Type or Archetypes?' *Revista/Review Interamericana* 4, no. 2 (Summer 1974), 136–47.

Hodge, Merle. *Crick Crack Monkey*. London: Deutsch, 1970; London: Heinemann, 1981.

—— 'The Shadow of the Whip'. In Orde Coombs, ed. *Is Massa Day Dead?: Black Moods in the Caribbean*. New York: Anchor/Doubleday, 1974, 111–19.

—— 'Novels on the French Caribbean Intellectuals in France.' *Revista/Review Interamericana* 4, no. 2 (Summer 1976), 211–31.

—— 'Young Women and the Development of Stable Family Life in the Caribbean.' *Savacou* 13 (1977), 39–44.

—— 'Introduction'. *Perceptions of Caribbean Women: towards a Documentation of Stereotypes.* Institute of Social and Economic Research (Eastern Caribbean). Women in the Caribbean Project, no. 5. Ed. Erna Brodber. Cave Hill, Barbados: ISER (EC), University of the West Indies, 1982, viii–xiii.

—— 'Caribbean Women face Conflicting Contradictory Codes'. *Caribbean Contact* (August 1985), 11, 13.

—— 'Whither the Young Caribbean Women.' *Women Speak* (Barbados), no. 17 (April 1985), 4–6.

—— Interview. *Women Speak* (Barbados), no. 18 (July/December 1985), 6–7 (discusses women in Trinidad).

Holiday, Billie with William Duffy. *Lady Sings the Blues.* Garden City, NY: Doubleday, 1956.

Holland, Sharon Patricia. '"Which Me Will Survive?": Audre Lorde and the Development of a Black Feminist Ideology.' *Critical Matrix: Princeton Working Papers in Women's Studies* 1 (Spring 1988), 1–30.

Holloway, Karla F. C. *Moorings & Metaphors: Figures of Culture and Gender in Black Women's Literature.* New Brunswick, NJ: Rutgers University Press, 1992.

Homar, Susana. 'Inferioridad y cambio: los personajes femeninos en la literature puertorriqueña.' *Revista de Ciencias Sociales* 20, nos. 3–4 (December 1978).

Honey, Maureen, ed. *Shadowed Dreams: Women's Poetry of the Harlem Renaissance.* New Brunswick, NJ: Rutgers University Press, 1989.

hooks, bell. *Ain't I a Woman: Black Women and Feminism.* Boston: South End Press, 1981.

—— *Yearning: Race, Gender, and Cultural Politics.* Boston: South End Press, 1990.

—— *Breaking Bread: Insurgent Black Intellectual Life.* Boston: South End Press, 1991.

—— *Black Looks: Race and Representation.* Boston: South End Press, 1992.

Hope, Margaret, ed. *Journey in the Shaping. Report of the First Symposium on Women in Caribbean Culture – July 24, 1981.* St Michael, Barbados: Women and Development Unit (WAND), University of the West Indies, 1981, 52–8.

Hope Scott, Joyce. 'Bodies of Texts and Texts of Bodies: (Re) Presentations of Slavery in African–American Women's Fiction.' *Bridges: A Senegalese Journal of English Studies/Revue Senegalaise d'Études Anglaises* 5(1993), 67–74.

Hopkins, Pauline. *Contending Forces.* Boston: Colored Cooperative Publishers, 1900.

Horne, Lena (as told to Helen Austein and Carlton Moss). *In Person: Lena Horne.* New York: Greenberg, 1951.

Horno-Delgado, Asunción, et al., eds. *Breaking Boundaries: Latina Writing and Critical Readings*. Amherst: University of Massachusetts Press, 1989.

House, Amelia. *Our Sun Will Rise: Poems from South Africa*. Washington, DC: Three Continents Press, 1989.

Howard, Lillie P. 'Marriage: Zora Neale Hurston's System of Values.' *College Language Association Journal* 21 (1977), 256–68.

Hull, Gloria, T. *Color, Sex, and Poetry: Three Women Writers of the Harlem Renaissance*. Bloomington: Indiana University Press, 1982.

—— 'The Black Woman Writer and the Diaspora.' *Black Scholar* 17:2 (March–April 1986), 2–4.

—— *Healing Heart: Poems, 1973–1988*. New York: Kitchen Table/Women of Color Press, 1989.

—— 'Rewriting Afro-American Literature: A Case for Black Women Writers.' In Robert C. Rosen and Leonard Vogt, eds. *Politics of Education: Essays from Radical Teacher*. Albany: State University of New York Press, 1990.

—— and Barbara Smith, and Patricia Bell Scott, eds. *All the Women Are White, All the Blacks Are Men, But Some of Us Are Brave: Black Women's Studies*. Old Westbury, NY: Feminist Press, 1982.

Hullebroeck, Joelle. 'La mujer en los cuento de Júan Bosch: sombra omnipresente.' In Lloyd King, ed. *La Mujer en la Literatura Caribeña*. St Augustine, Trinidad: Dept of French and Spanish Literature, University of the West Indies [1984?], 151–67.

Hunter, Charles. 'Belize's First Novel, *Beka Lamb*.' *Belizean Studies* 10, no. 6 (December 1982), 14–21.

Hunter, Kristen. *God Bless the Child*. New York: Scribner's, 1964.

—— *The Landlord*. New York: Scribner's, 1966.

Hurston, Zora Neale. *Mules and Men*. Philadelphia: Lippincott, 1937.

—— *Their Eyes Were Watching God*. Urbana: University of Illinois Press, [1937] 1978.

—— 'Women in the Caribbean.' In *Voodoo Gods: an Enquiry into Native Myths and Magic in Jamaica and Haiti*. London: Dent, 1939, 61–6.

—— *Dust Tracks on A Road*. Philadelphia: Lippincott, 1942.

—— *I Love Myself When I Am Laughing … And Then Again When I Am Looking Mean and Mysterious*. Alice Walker, ed. New York: The Feminist Press, 1979.

—— *Jonah's Gourd Vine*. New York: Harper & Row, 1990.

—— *Moses Man of the Mountain*. New York: Harper & Row, 1991.

—— *Seraph on the Sewanee*. New York: Harper and Row, 1991.

Ibrahim, Huma. 'The Autobiographical Content in the Works of South African Women Writers: The Personal and the Political.' In Carol Ramelb, ed. *Biography: East and West*. Honolulu: University of Hawaii Press, 1989, 122–6.

Ingram, Elwanda Deloris. 'Black Women: Literary Self-portraits.' Diss. University of Oregon, 1980.

Insanally, Annette. 'Eroticism as an Expression of the Consciousness of Self in Rosario Ferré's *Fabulas de la Garza Desangranda* and Lorna Goodison's *Tamarind Season*.' Paper presented at the Fifth Conference on West Indian Literature. St Thomas, Virgin Islands, 23–24 May 1985.

—— 'Contemporary Female Writing in the Caribbean.' *The Caribbean Novel in Comparison*. Proceedings of the Ninth Conference of Hispanists, 7–9 April 1986, University of the West Indies, St Augustine, Trinidad. Ed. Ena V. Thomas. St Augustine, Trinidad: Dept of French and Spanish Literature, University of the West Indies, 1986, 115–41.

—— 'Sexual Politics in Contemporary Female Writing in the Caribbean.' Paper presented at the Seventh Annual Conference on West Indian Literature at the University of Puerto Rico, 25–28 March 1987.

—— 'Sexual Politics in Contemporary Female Writing in the Caribbean.' Lowell Fiet, ed. *West Indian Literature and Its Political Context*. Rio Piedras, Puerto Rico: University of Puerto Rico, 1988 79–91.

Ivy, James W. 'Mrs Petry's Harlem.' *The Crisis* 53 (May 1946), 154–5.

Jabavu, Noni. *Drawn in Colour. African Contrasts*. New York: St Martin's Press, 1962.

—— *The Ochre People*. South Africa: Ravan Press, 1982.

Jackson, Shirley. 'The Special Gifts of Literature.' *Monographic Review/Revista monográfica* (1985), 83–9.

Jackson, Richard L. *The Black Image in Latin American Literature*. Albuquerque: University of New Mexico Press, 1976.

Jacobson, Angeline. *Contemporary Native American Literature: A Selected and Partially Annotated Bibliography*. Metuchen, NJ: Scarecrow, 1977.

Jaén, Didier. 'Tatia Hicotéa en los cuentos negros de Lydia Cabrera.' *Caribe* 1.1 (1976), 101–10.

James, Adeola. *In Their Own Voices: African Women Writers Talk*. London: James Currey, 1990.

Jenkins, Joyce Odessa. 'To Make a Black Woman Black: A Critical Analysis of the Women Characters in the Fiction and Folklore of Zora Neale Hurston.' Diss. Bowling Green State University, 1978.

Jiménez, Reynaldo L. 'Cuban Women Writers and the Revolution: Toward an Assessment of Their Literary Contribution.' *Twentieth Century Foreign Women Writers*. Folio no. 11 (1980), 75–95.

Jiménez Wagenheim, Olga. 'The Puerto Rican Woman in the Nineteenth Century: an Agenda for Research.' *Revista/Review Interamericana* 11, no. 2 (1981), 196–203.

Johnson, Amryl. *Long Road to Nowhere*. London: Virago, 1985.

—— *Sequins for a Ragged Hem*. London: Virago, 1988.

—— *Tread Carefully in Paradise*. London: Cofa Press, 1991.

Johnson, Georgia Douglas. *The Heart of A Woman and Other Poems*. Boston: Cornhill, 1918.

Johnson, Roberta. 'The Paradigmatic Story Mode of Carmen Naranjo, Eunice Odio, Yolanda Oreamuno, Victoria Urbano, and Rima Vallbona.' *Letras Femininas* 6.1 (1980), 14–24.

Jones, Eldred Durosimi, Eustace Palmer, et al. *Women in African Literature Today*. Trenton, New Jersey: Africa World Press, 1987.

Jones, Gayl. *Corregidora*. New York: Random House, 1975.

—— *Eva's Man*. New York: Random House, 1976.

Jones, Marion Patrick. *Pan Beat*. Port-of-Spain, Trinidad: Columbus Publishers, 1973.

—— *J'Ouvert Morning*. Port-of-Spain, Trinidad: Columbus Publishers, 1976.

Jordan, June. *Who Look at Me*. New York: Crowell, 1969.

—— *Civil Wars*. Boston: Beacon Press, 1981.

—— *Living Room*. New York: Thunder's Mouth, 1985.

—— *On Call. Political Essays*. Boston: South End Press, 1985.

—— *Technical Difficulties*. New York: Pantheon, 1992.

Joubert, Elsa, ed. *Poppie Nongena. One Woman's Struggle Against Apartheid*. New York: Henry Holt, 1980.

Joyce, Joyce Ann. 'Nella Larsen's *Passing*: A Reflection of the American Dream.' *The Western Journal of Black Studies* 7 (1983), 68–73.

Juménez-Muñoz, Gladys M. 'The Elusive Signs of African-Ness: Race and Representation Among Latinas in the United States.' *Border/Lines. Canada's Magazine of Cultural Studies* 29/30 (1993), 9–15.

Kalina de Piszk, Rosita. 'Escritoras costarricenses: María Fernández de Tinóco.' *Kanina* 5, no. 2 (July–December 1981), 28–36.

Karodia, Farida. *Daughters of the Twilight*. London: Women's Press, 1986.

—— *Coming Home and Other Stories*. London: Heinemann, 1988.

Katz, Janet, ed. *I Am the Fire of Time: Writings by Native American Women*. New York: Dutton, 1977.

Keita, Aoua. *Femme d'Afrique. La vie d'Aoua Keita racontée par elle-même*. Paris: Présence Africaine, 1975.

Kemp, Yakini. 'Woman and Woman Child: Bonding and Selfhood in Three West Indian Novels by Women.' *Sage* 2 (Spring 1985), 24–7. Discusses *Crick Crack Monkey, Beka Lamb*, and *Jane and Louisa Will Soon Come Home*.

Kennedy, James H. 'Recent Afro-Brazilian Literature: A Tentative Bibliography.' *Current Bibliography on African Affairs* 17 (1984–5), 328.

The Kenyon Review 'De Colores.' 13:4 (Fall 1991).

Kincaid, Jamaica. *At the Bottom of the River*. New York: Farrar, Straus, Giroux, 1984; New York: Aventura/Vintage Books, 1985.

—— *Annie John*. New York: Farrar, Straus, Giroux, 1985; New York: Plume Book/New American Library, 1986.

—— *A Small Place*. New York: Farrar, Straus, Giroux, 1988.

—— *Lucy*. New York: Farrar, Straus, Giroux, 1990.

King, Lloyd, ed. *La Mujer en la literatura Caribeña*. Sexta conferencia de Hispanistas, 6–8 Abril 1983. St Augustine, Trinidad: University of the West Indies, [1984?].

Kitt, Eartha. *Thursday's Child*. New York: Dell, 1956.

Kitson, Norma, ed. *Zimbabwe Women Writers*. Anthology no. 1. Harare: Zimbabwe Women Writers, 1994.

Knaster, Meri. *Women in Spanish America: an Annotated Bibliography from Pre-Conquest to Contemporary Times*. Boston: G.K. Hall, c. 1977.

Kouadio, Akissi. *Impossible amou: une ivoirienne raconte*. Abidjan: INADES-Edition, 1983.

Kuzwayo, Ellen. *Call Me Woman*. San Francisco: Spinsters Ink, 1985.

—— *Sit Down and Listen. Stories from South Africa*. London: Women's Press, 1990.

Ladner, Joyce. *Tomorrow's Tomorrow: The Black Woman*. New York: Doubleday, 1971.

Laplaine, Jean. 'Fantômes et fantasmagories de la nègrite.' Review of *Ti-Jean l'Horizon*, by Simone Schwarz-Bart. CARE (Guadeloupe) 5 (January 1980), 151–6.

Larrier, Rénée. 'Racism in the United States: An Issue in Caribbean Poetry.' *Journal of Caribbean Studies* 2:1 (1981), 51–71.

Larsen, Nella. *Quicksand*. New York: Alfred A. Knopf, 1928.

—— *Passing*. New York: Alfred A. Knopf, 1929.

'The Latin American Woman: Image and Reality.' *Revista/Review Interamericana* Special Edition, 4 no. 2 (Summer 1974).

Latortue, Regine. 'The Black Woman in Haitian Society and Literature.' In Filomena C. Steady, ed. *The Black Woman Cross-Culturally*. Cambridge, Mass: Schenkman Publishing, 1981, 535–60.

Lattin, Patricia H. and Vernon E. Lattin. 'Dual Vision in Gwendolyn Brooks's *Maud Martha*.' *Critique: Studies in Modern Fiction* 25 (1984), 180–9.

Lauter, Elaine H. 'Race and Gender in the Shaping of the American Literary Canon: A Case Study from the Twenties.' *Feminist Studies* 9, no. 3 (Fall 1983), 435–63.

Lawrence, Leota S. 'Three West Indian Heroines: an Analysis.' *CLA Journal* 21, no. 2 (December 1977), 238–50.

—— 'The Mother-child Relationship in Selected Works of British Caribbean Literature.' *Western Journal of Black Studies* 5, no. 1 (1981), 10–17.

—— 'Women in Caribbean Literature: the African Presence.' *Phylon* 44, no. 1 (Spring 1983), 1–11.

—— 'The Historical Perspective of the Caribbean Woman.' *Negro Historical Bulletin* 47, nos 1 and 2 (1984).

Lebarón Savinon, Mariano. 'Poesía femenina en la República Dominicana.' *Historia de la cultura Dominicana V.4*. Santo Domingo, República Dominicana: Universidad Nacional Pedro Henríquez Urena, 1982. 107–14.

LeClair, Thomas. 'A Conversation with Toni Morrison: The Language Must Not Sweat.' *New Republic* 21 March 1981, 26–9.

Lee, Sonia. 'L'image de la femme dans le roman francophone de l'Afrique occidentale,' Doctoral Thesis, University of Massachusetts, 1974.

—— 'Conversation with Miriam Tlali.' *African Literature Association Bulletin, Summer* 17:3 (1991), 40–2.

Leigh, Nancy J. 'Mirror, Mirror: the Development of Female Identity in Jean Rhys' Fiction.' *World Literature Written in English* 25, no. 2 (Fall 1985), 270–85.

Levine, Linda Gould and Gloria Feiman Waldman. 'No Más Máscaras: un Diálogo Entre Tres Esritos del Caribe.' Rose S. Minc, ed. *Literature in Transition: The Many Voices of the Caribbean*. Gaithersburg, Maryland: Hispamérica, 1982, 189–97.

Lewis, Vashti. 'The Near-White Female in Frances Ellen Harper's *Iola Leroy*.' *Phylon* 45 (1984), 314–22.

Liking, Werewere. *Orphée Dafric. Théâtre-rituel*. Paris: L'Harmattan, 1981.

—— *Elle sera de jaspe et de corail*. Paris: L'Harmattan, 1983.

Lindberg-Seyersted, Brita. 'The Color Black: Skin Color as Social, Ethical, and Esthetic Sign in Writings by Black American Women.' *English Studies: A Journal of English Language and Literature*, 73: 1 (February 1992), 51–67.

Lindstrom, Naomi. 'Feminist Criticism of Latin American Literature: Bibliographic Notes.' *Latin American Research Review* 15, 1 (1980), 151–9.

Linthwaite, Illona, ed. *Aint I a Woman. Poems by Black and White Women*. London: Virago, 1987.

Lobo-Cobb, Angela, ed. *Winter Nest: A Poetry Anthology of Midwestern Women Poets of Color*. Madison: Blue Reed Arts, 1987.

Lockett, Cecily. 'The Fabric of Experience: A Critical Perspective on the Writing of Miriam Tlali.' Cherry Clayton, ed. *Women and Writing in South Africa: A Critical Anthology*. Marshalltown: Heinemann Southern Africa, 1989, 275–85.

Loeb, Catherine. 'La Chicana: A Bibliographic Survey.' *Frontiers* 5, no. 2 (Summer 1980), 59–74.

Loncke, Joycelynne. 'The Image of the Woman in Caribbean Literature with Special Reference to *Pan Beat* and *Hérémakhonon*.' *Bim* 16, no. 64 (December 1978), 272–81.

Lopez, Ivette. 'Puerto Rico: las nuevas narradoras y la identidad cultural.' *Perspectives on Contemporary Literature* no. 8 (1982), 77–83.

Lorde, Audre. *The Black Unicorn*. New York: W. W. Norton, 1978.

—— *The Cancer Journals*. New York: Spinsters Ink, 1980.

—— *Chosen Poems. Old and New.* New York: W.W. Norton, 1982.

—— *Sister Outsider.* Freedom, California: The Crossing Press, 1984.

—— *Our Dead Behind Us.* New York: W.W. Norton, 1986.

—— 'Sisterhood and Survival.' *Black Scholar*, 17:2 (March–April 1986), 5–7

—— *A Burst of Light.* Ithaca, NY: Firebrand Books, 1988.

—— 'I am Your Sister: Black Women Organizing Across Sexualities,' in *A Burst of Light.* Ithaca, New York: Firebrand Books, 1988.

—— 'Age, Race, Class and Sex: Women Redefining Differences.' Christian McEwen & Sue O'Sullivan, eds. *Out the Other Side: Contemporary Lesbian Writing.* Freedom, California: The Crossing Press, 1989, 273–4.

—— *Need: A Chorale for Black Woman Voices.* New York: Kitchen Table/Women of Color Press, 1990.

—— 'Showing Our True Colors.' *Callaloo: A Journal of African–American and African Arts and Letters* 14:3 (Winter 1991), 67–71.

—— *Undersong: Chosen Poems, Old and New.* New York: W.W. Norton, 1992.

—— *Zami. A New Spelling of My Name.* Watertown, Mass.: Persephone Press, 1982; Freedom, CA: The Crossing Press, 1993.

Lupton, Mary Jane. 'Clothes and Closure in Three Novels by Black Women.' *Black American Literature Forum* 20 (1986), 409–21.

McKenzie Mavinga, Isha and Thelma Perkins. *In Search of Mr. McKenzie. Two Sisters Quest for an Unknown Father.* London: Women's Press, 1991.

Macht der Nacht. Eine Schwarze Deutsche Anthologie. Herausgeberin/Bezug, 1991/1992.

Madgett, Naomi Long. *Songs to a Phantom Nightingale.* New York: Fortuny's, 1941.

—— *Star by Star.* Detroit: Harlo, 1965.

Makeba, Miriam. *Makeba. My Story.* New York: New American Library, 1987.

Makward, Christiane & Cazenave, Odile. 'The Others' Others: Francophone Women and Writing.' *Yale French Studies* 75 (1988) 190–207.

Mandela, Winnie. *Part of My Soul Went With Him.* New York and London: W.W. Norton, 1984.

Mandiela, Ahdri Zhina. *Dark Diaspora in Dub.* Toronto: Sister Vision, 1991.

Marshall, Paule. *Brown Girl, Brown Stones.* New York: Random House, 1959.

—— *Soul Clap Hands and Sing.* New York: Atheneum, 1961.

—— 'To Da-duh in Memoriam.' *New World Quarterly* 3, nos. 1 and 2 (1966–67), 97–101.

—— 'Barbados.' Langston Hughes, ed. *The Best Short Stories by Negro Writers: An Anthology from 1899 to the Present.* Boston: Little, Brown, 1967.

—— *The Chosen Place, The Timeless People.* New York: Harcourt, Brace, 1969.

—— *Reena and Other Stories.* Old Westbury, NY: Feminist Press, 1981.

—— *Praisesong for the Widow.* New York: G.P. Putnam; London: Virago, 1983.

—— *Daughters.* New York: Atheneum; Toronto: Collier Macmillan Canada; New York: Maxwell Macmillan International, 1991.

Marson, Una. *Heights and Depths.* Kingston, Jamaica: Gleaner, 1931.

—— *The Moth and the Star.* Kingston, Jamaica: Gleaner, 1937.

Martínez Echazábal, Lourdes. 'Oposiciones Binaries en "Octubre imprescindible" y "Cuaderno de Granada" de Nancy Morejón.' *Crítica* 2:1 (1988), 79–87.

Marting, Diana E. 'The Representation of Female Sexuality in Nancy Morejón's "Amor, Cuidad Atribuida".' *Afro-Hispanic Review* 7:1–3 (1988), 36–8.

Mashinini, Emma. *Strikes Have Followed Me All My Life. A South African Autobiography.* New York: Routledge, 1991; London: Women's Press, 1989.

McCray, Carrie Allen. 'The Black Woman and Family Roles.' In La Frances Rodgers-Rose, ed. *The Black Woman.* Beverly Hills: Sage Publications, 1980, 67–78.

McCaffrey, Kathleen M. *Images of Women in the Literature of Selected Developing Countries.* Washington, DC: Office of Women in Development, Agency for International Development, 1979.

McCallister, Myrna J. Review of *Hérémakhonon*, by Maryse Condé. *Library Journal* 107, no.10 (15 May 1982), 1009.

McCredie, Wendy J. 'Authority and Authorization in *Their Eyes Were Watching God.*' *Black American Literature Forum* 16 (Spring 1982), 25–8.

McDowell, Deborah Edith. 'Women on Women: The Black Woman Writer of the Harlem Renaissance.' Dissertation, Purdue University, 1979.

—— 'New Directions for Black Feminist Criticism.' *Black American Literature Forum* 14 (1980), 153–9.

—— 'The Neglected Dimensions of Jessie Fauset.' *Afro-Americans in New York Life and History* 5 (July 1981), 33–49; rpt in *Conjuring: Black Women Fiction, and Literary Tradition*, eds. Majorie Pryse and Hortense J. Spillers. Bloomington: Indiana University Press, 1985, 86–104.

—— 'Reading Family Matters.' In Cheryl A. Wall, ed. *Changing Our Own Words: Essays on Criticism, Theory, and Writing by Black Women.* New Brunswick: Rutgers University Press, 1989, 75–97.

McDowell, Margaret B. 'The Black Woman as Artist and Critic: Four Versions.' *The Kentucky Review* 7:1 (Spring 1987), 19–41.

• McKay, Nellie. 'An Interview With Toni Morrison.' *Contemporary Literature* 24 (1983), 413–29.

—— 'Reflections on Black Women Writers: Revising the Literary Canon.' Christie Farnham, ed. *The Impact of Feminist Research in the Academy.* Bloomington: Indiana University Press, 1987, 174–89.

McKenzie, Hermione. 'Introduction, Caribbean Women: Yesterday, Today, Tomorrow.' *Savacou* 13 (Gemini 1977), vii–xiv.

Mc Millan, Terry. *Mama.* New York: Washington Square Press, 1987.

—— *Disappearing Acts.* New York: Viking, 1989.

—— *Waiting to Exhale*. New York: Viking, 1992.

Mealy, Rosemari. *Lift These Shadows from Our Eyes*. (Poetry). Cambridge, MA: West End Press, 1978.

Merriwether, Louise. *Daddy Was a Number Runner*. Englewood Cliffs, NJ: Prentice Hall, 1970.

Meyer, Doris and Margarita Fernández Olmos. *Contemporary Women Authors of Latin America*, vol. 1. New York: Brooklyn College Press, c. 1983.

Miller, Yvette E. and Charles M. Tatum. *Latin American Women Writers: Yesterday and Today*. Proceedings of the First Conference on Women Writers from Latin America, 1975. Pittsburgh: Latin American Literary Review, 1977.

Milton, Edith. Review of *At the Bottom of the River*, by Jamaica Kincaid. *New York Times Book Review* (15 June 1984), 22.

Mimiko, Ajoke. 'Neurose et psychose de devenir l'autre chez la femme antillaise a travers l'oeuvre de Michele Lacrosil.' *Peuples noirs, peuples africains* 32 (mars–avril 1983), 136–46.

Minh-ha, Trinh. *Woman Native Other*. Bloomington: Indiana University Press, 1989.

Mirza, Sarah and Margaret Stroebel, eds and trans. *Three Swahili Women. Life Histories from Mombasa, Kenya*. Bloomington and Indianapolis: Indiana University Press, 1989.

Mhlope, Gcina with Maralin Vanrenen and Thembi Mtshali. *Have You Seen Zandile?* London: Methuen; Portsmouth, New Hampshire: Heinemann, 1988.

Mlama, Penina Muhando. *Culture and Development: The Popular Theatre Approach in Africa*. Stockholm: Scandinavian Institute for African Studies, 1991.

Mohr, Eugene V. Review of *Beka Lamb*, by Zee Edgell. *Revista/Review Interamericana* 11, no. 4 (1981), 619–20.

Montero, Susana R. *La Narrativa Femenina Cubana, 1923–1958*. La Habana: Editorial Academia, 1989.

Montes Huidobro, Matías. 'Itinerario del Ebó.' *Studies in Afro-Hispanic Literature* 2–3 (1978–9), 1–13.

—— 'Itinerario del Ebó'. *Círculo* 8 (1979), 105–14.

Moody, Ann. *Coming of Age in Mississippi*. New York: Dial, 1968.

Mora, Gabríel. 'Narradoras hispanoamericanas: vieja y nueva problemática en renovadas elaboraciones.' In Gabríela Mora and Karen Van Hooft, eds. *Theory and Practice of Feminist Literary Criticism*. Ypsilanti, MI: Bilingual Press/Editorial Bilingual, 1982, 156–74.

Moraga, Cherríe and Gloria Anzaldúa, eds. *This Bridge Called My Back: Writings by Radical Women of Color*. Watertown, MA: Persephone Press, 1981.

—— *Loving in the War Years*. Boston: South End Press, 1983, 128.

Mordecai, Pamela. '"Into this beautiful garden" – Some Comments on Erna Brodber's *Jane and Louisa*.' *Caribbean Quarterly* 29, no. 2 (June 1983), 44–53.

——— 'Wooing with Words: Some Comments on the Poetry of Lorna Goodison.' *Jamaica Journal* 45 [1981?], 34–40.

Morejón, Nancy. *Richard trajo su flato y otros argumentos.* Havana: Instituto Cubano del Libro, 1967.

——— *Lengua de pajaro.* Havana: Instituto Cubano del Libro, 1971.

——— *Recopilación de textos sobre Nicolas Guillen.* Havana: Casa de las Americas, 1974.

——— *Parajes de una época.* Havana: Editorial Letras Cubanas, 1979.

——— 'Poesía del caribe'. *Revolución y cultura* 82 (1979), 56–7.

——— 'Mirta Aguirre y su Ayer de Hoy.' *Casa de las Américas* 21:122 (1980), 122–32.

——— *Nación y mestizaje en Nicolas Guillén.* Havana: Unión de Escritos y Artistas de Cuba, 1982.

——— *Grenada Notebook. (Cuaderno de Grenada).* Trans. Lisa Davis. New York: Circulo de Cultura Cubana, 1984.

——— *Where the Island Sleeps Like a Wing.* San Francisco, CA: Black Scholar Press, 1985.

——— *Piedra pulida.* Havana: Letras Cubanas, 1986.

——— *Fundacion de la imagen.* La Habana: Letras Cubanas, 1988.

——— *Balades para un Sueño.* La Habana: Union, 1989.

——— *Ours the Earth.* Selected and translated by J. R. Pereira. Mona: Institute of Caribbean Studies, 1990.

Morris, Mervyn. 'On Reading Louise Bennett Seriously.' *Jamaica Journal* no. 1 (December 1967), 69–74.

——— 'The Dialect Poetry of Louise Bennett.' In Edward Baugh, ed. *Critics on Caribbean Literature.* London: George Allen & Unwin, 1978, 137–48.

——— 'Louise Bennett in Print.' In Roberta Knowles and Erika Smilowitz, eds. *Conference on Critical Approaches to West Indian Literature: a Compilation of Position Papers.* St Thomas, US Virgin Islands: Humanities Division, College of the Virgin Islands, 1981, 136–59.

——— Review of *Quadrille for Tigers: Poems,* by Christine Craig. *Jamaica Journal* 18, no. 4 (November 1985–January 1986), 62.

Morrison, Toni. *The Bluest Eye.* New York: Holt, Rinehart and Winston, 1970.

——— *Sula.* [1973] New York: Bantam Books, 1980.

——— *Song of Solomon.* [1977] New York: New American Library, 1978.

——— *Tar Baby.* New York: Alfred A. Knopf, 1981.

——— 'Rootedness: The Ancestor as Foundation.' In Mari Evans, ed. *Black Women Writers (1950–1980): A Critical Evaluation.* Garden City, NY: Anchor/Doubleday, 1984, 339–45.

——— 'Memory, Creation, and Writing.' *Thought* 59 (1984), 385–90.

——— *Beloved.* New York: Alfred A. Knopf, 1987.

——— *Jazz.* New York: Knopf, distributed by Random House, 1992.

—— *Playing in the Dark: Whiteness and the Literary Imagination.* Cambridge, MA: Harvard University Press, 1992.

Mudimbe-Boyi, Elisabeth, ed. 'Francophone and Anglophone Literature: The Women Writers.' *Callaloo: A Journal of African–American and African Arts and Letters* 16:1 (Winter 1993), 73–242.

Murray, Pauli. *Proud Shoes.* New York: Harper, 1956.

—— *Dark Testament and Other Poems.* Norwalk, CT: Silvermine, 1970.

—— *Song in a Weary Throat: An American Pilgrimage.* New York: Harper & Row Publishers, 1987.

Musgrave, Marian. 'Triangles in Black and White: Interracial Sex and Hostility in Black Literature.' *College Language Association Journal* 14 (1971), 444–51.

Muthoni, Wanjira G. 'Women in Action: A Socioeconomic Survey of Women as Seen by Black Francophone Women Writers.' *Journal of Eastern African Research and Development* vol. 19 (1989), 172–86.

Nankoe, Lucia and Essa Reijmers. 'To Keep the Memory of the Past Alive: A Theoretical Approach to Novels of Black Women Writers.' Geoffrey V. Davis and Hena Maes–Jelinek, eds. *Crisis and Creativity in the New Literatures in English: Cross/Cultures.* Amsterdam: Rodopi, 1990, 481–97.

Naylor, Carolyn. 'Cross-Gender Significance of the Journey Motif in Selected Afro-American Fiction.' *Colby Library Quarterly* 18 (1982), 26–38.

Naylor, Gloria. *The Women of Brewster Place.* New York: Houghton-Mifflin, 1982.

—— *Linden Hills.* New York: Viking Penguin, Inc., 1985.

—— *Mama Day.* New York: Ticknor & Fields, 1988.

—— *Bailey's Cafe.* New York: Harcourt Brace Jovanovich, 1992, 229.

Naylor, Gloria and Toni Morrison. 'A Conversation.' *The Southern Review,* 21 (1985) 567–593.

Neggers, Gladys. 'Clara Lair y Julia de Burgos: reminiscencias de Evaristo Ribera Chevremont y Jorge Font Saldana.' *Revista/Review Interamericana,* Special Edition 4, no. 2 (Summer 1974), 258–63.

Netifa, Masimba. *A Woman Determined.* London: Research Associates School, Times Publications, 1987.

Ngcobo, Lauretta, ed. *Cross of Gold.* London: Longman Group, 1981.

—— 'The African Woman Writer'. *Kunapipi* 7:2–3 (1985), 81–2.

—— ed. *Let It Be Told: Black Women Writers in Britain.* London: Virago, 1987.

—— *And They Didn't Die.* London: Virago Press, 1990.

Nichols, Grace. *I Is a Long Memoried Woman.* London: Karnak House, 1983.

—— *The Fat Black Woman's Poems.* London: Virago, 1985.

—— *Lazy Thoughts of a Lazy Woman.* London: Virago, 1989.

—— *Poetry Jump Up.* Harmondsworth: Penguin, 1989.

Nielsen de Abruna, Laura. 'Twentieth Century Women Writers from the English Speaking Caribbean.' *Modern Fiction Studies* 34 (Spring 1988), 85–96.

Nigro, Kirsten F. 'Rosario Castellano's Debunking of the *Eternal Feminine*.' *Journal of Spanish Studies: Twentieth Century* 8, nos. 1 & 2 (Spring and Fall 1980), 89–102.

Njau, Rebeka. *Ripples in the Pool*. London: Heinemann, 1975.

Ntantala, Phyllis. *A Life's Mosaic*. Cape Town: David Philip, 1992.

Nowak, Hanna. 'Alice Walker: Poetry Celebrating Life.' Haslauer, Wilfried, intro. *A Salzburg Miscellany: English and American Studies 1964–1984*. Salzburg: Institut fur Anglistik and Amerikanistik, University of Salzburg, 1984, 111–25.

Nowakowska Stycos, Maria, ed. 'New Approaches to Twentieth-century Hispanic Women Poets.' *Revista/Review Interamericana* 12, no. 1 (1982).

Nuñez-Harrell, Elizabeth. 'Beauty from Decay.' Review of *The Orchid House*, by Phyllis Allfrey. *CRNLE Reviews Journal* no. 1 (July 1983) 97–9.

—— 'The Paradoxes of Belonging: the White West Indian Woman in Fiction.' *Modern Studies*, 13, no. 1 (Summer 1985), 281–93.

—— *When Rocks Dance*. New York: Putnam, 1986.

Nwankwo, Chimalum. 'The Progressive Vision of African Womanhood: Towards a Typology.' *Griot: Official Journal of the Southern Conference on Afro-American Studies, Inc.* 6:2 (Summer 1987), 46–55.

Nyabongo, Elizabeth. *Elizabeth of Toro. The Odyssey of an African Princess*. New York and London: Simon and Schuster, 1989.

Nzenza, Sekai. *Zimbabwean Woman. My Own Story*. London: Karia Press, 1988.

O'Callaghan, Evelyn. 'Driving Women Mad.' Review of *Beka Lamb*, by Zee Edgell. *Jamaica Journal* 16, no. 2 (May 1983), 71.

—— 'Rediscovering the Natives of my Person: a Review of Erna Brodber, *Jane and Louisa Will Soon Come Home*.' *Jamaica Journal* 16, no. 3 (August 1983), 61–4.

—— '"The Bottomless Abyss": "Mad" Women in Some Caribbean Novels.' *Bulletin of Eastern Caribbean Affairs*. (Barbados) 11, no. 1 (March–April 1985), 45–58.

—— Review of *Woman's Tongue*, by Hazel Campbell. *Jamaica Journal* 19, no. 2 (May–July 1986), 50–1.

—— Review of *Summer Lightning and Other Stories*, by Olive Senior, *Journal of West Indian Literature* (Barbados) 1, no. 1 (October 1986), 92–4.

—— 'Feminist Consciousness: European/American Theory, Jamaican Stories.' In Lowell Fiet, ed. *West Indian Literature and Its Political Context*. Río Piedras, Puerto Rico: University of Puerto Rico, 1988, 27–51.

—— 'Interior Schisms Dramatised: The Treatment of the 'Mad' Woman in the Work of Some Female Caribbean Novelists.' *Out of the Kumbla. Caribbean Women and Literature*, eds Carole Boyce Davies and Elaine Savory Fido. Trenton, New Jersey: Africa World Press, 1990, 89–109.

—— *Woman Version. Theoretical Approaches to West Indian Fiction by Women*. New York: St Martin's Press, 1993.

O'Connor, Mary. 'Subject, Voice, and Women in Some Contemporary Black American Women's Writing.' In Dale M. Bauer and Susan Jaret McKinstry, eds. *Feminism, Bakhtin, and the Dialogic.* Albany: State University of New York Press, 1991, vi, 199–217.

Odaga, Asenath Bole. *Riana.* Kisumu, Kenya: Lake Publishers and Enterprises Press, 1991.

Ogot, Grace. *The Graduate.* Nairobi, Kenya: Uzima Press, 1980.

—— *The Island of Tears.* Nairobi, Kenya: Uzima Press, 1980.

—— *The Strange Bride.* Nairobi, Kenya: East African Educational Publishers, 1989.

—— *The Other Woman.* Nairobi, Kenya: East African Educational Publishers, 1976/1992.

Ogundipẹ-Leslie, 'Mọlara. 'Not Spinning on the Axis of Maleness.' *Sisterhood is Global. The International Women's Movement Anthology.* Garden City, NY: Anchor/Doubleday, 1984, 494–504.

—— *Sew the Old Days and Other Poems.* Nigeria: Evans Brothers, 1985.

—— 'The Female Writer and Her Commitment.' *Women in African Literature Today* 15 (1987), 5–13.

—— 'African Women, Culture and Another Development.' *Theorizing Black Feminisms.* Ed. Stanlie James and Abena Busia. London and New York: Routledge, 1993.

—— 'Beyond Hearsay and Academic Journalism. The Black Woman and Ali Mazrui.' *Research in African Literatures* 24:1 (1993), 105–12.

—— *Re-creating Ourselves: African Women and Critical Transformations.* Trenton, NJ: Africa World Press, 1994.

Okoye, Ifeoma. *Men Without Ears.* London: Longman, 1984.

Onwueme, Tess Akaeke. *The Desert Encroaches.* Nigeria, Heinemann Educational Books, 1985.

—— *The Broken Calabash.* Nigeria: Heinemann Educational Books, 1988.

—— *The Reign of Wazobia.* Nigeria: Heinemann Educational Books, 1988.

—— *Legacies.* Nigeria: Heinemann, 1989.

—— *Go Tell It To Women. An Epic Drama for Women.* Newark, NJ: African Heritage Press, 1992.

Opitz, May, Katharina Oguntoye, Dagmar Schultz and Audre Lorde (trans by. Anne V. Adams). *Showing Our Colors: Afro-German Women Speak Out.* Amherst, MA: University of Massachusetts Press, 1992.

Ordoñez, Elizabeth J. 'Chicana Literature and Related Sources: A Selected and Annotated Bibliography.' *Bilingual Review* 7, no. 2 (1980), 143–64.

—— 'Narrative Texts by Ethnic Women: Rereading the Past, Reshaping the Future.' *MELUS* 9, no. 3 (Winter 1982), 19–28.

Ormerod, Beverley. *An Introduction to the French Caribbean Novel.* London: Heinemann, 1985.

—— and Jean-Marie Volet, 'Francophone Women Writers from Sub-Saharan Africa: An Annotated Bibliography.' *African Literature Association Bulletin* 18:4 (Fall 1992), 15–22.

Oshana, Maryann. *Women of Color: A Filmography of Minority and Third World Women*. New York: Garland, 1988.

Otukunefor, Henrietta and Obiagele Nwodo, eds. *Nigeria Female Writers. A Critical Perspective*. Lagos: Malthouse, 1989.

Paravisini-Gebert, 'Lizabeth. *Caribbean Women Novelists: An Annotated Bibliography*. Westport, Conn.: Greenwood Press, 1993.

Parker, Dorothy. 'Review of *Jane and Louisa Will Soon Come Home.*' *Black Books Bulletin* 7 (1981–2), 57–8.

Parker, Pat. *Movement in Black*. Ithaca, NY: Fireband Books, 1978.

Parr, Carmen Salazar, and Genevieve M. Ramirez. 'The Chicana in Chicago Literature.' In *Chicano Literature: A Reference Guide*. Ed. by Julio A.Martínez and Francisco A. Lomeli. Westport, CT: Greenwood, 1985, 97–107.

Pattulia, Polly. 'Caribbean Chronicle.' *Observer Magazine* 22 (July 1984), 22–5. (On Phyllis Shand Allfrey.)

Pereira, Joseph. 'Image and Self-Image of Women in Recent Cuban Poetry'. *La mujer en la literatura caribeña*. St Augustine, Trinidad: University of the West Indies, 1983, 51–68.

Perera, Hilda. *Idapo: El sincretismo en los cuentos negros de Lydia Cabrera*. Miami: Ediciones Universal, 1971.

Peréz, Arturo P. 'La mujer en dos novelas de Rosario Castellanos.' *Cuadernos Americanos* (Mexico) 10, no. 38 (May–July 1979), 221–6.

Perkins, Kathy A., ed. *Black Female Playwrights: An Anthology of Plays before 1950*. Bloomington: Indiana University Press, 1989.

Perry, Constance M. 'Preface. The Special Issue in Perspective: the Hispanic Caribbean Woman and the Literary Media.' *Revista/Review Interamericana* 4, no. 2 (1974), 131–5.

—— 'Teaching a Controversial Novel to a Conservative Classroom: *The Color Purple.*' *Feminist Teacher* 2, no. 3 (1987), 25–30.

Petry, Anne. *The Street*. Boston: Beacon Press, [1946] 1985.

Pettis, Joyce. 'Difficult Survival: Mothers and Daughters in *The Bluest Eye.*' *SAGE: A Scholarly Journal on Black Women* 4:2 (Fall 1987), 26–9.

Phillips, Jane. *Mojo Hand*. New York: Simon and Schuster, 1966.

Philip, Marlene Nourbese. *Thorns*. Toronto: Williams and Wallace, 1980.

—— *Salmon Courage*. Toronto: Williams and Wallace, 1983.

—— *Harriet's Daughter*. London: Heinemann Education, 1988.

—— *She Tries Her Tongue. Her Silence Softly Breaks*. Prince Edward Island, Charlottetown, Canada: Ragweed Press, 1989.

—— 'Managing the Unmanageable.' In Selwyn Cudjoe, ed. *Caribbean Women Writers*. Wellesley: Callaloux, 1990.

—— *Looking for Livingstone. An Odyssey of Silence.* Stratford, Ontario: Mercury Press, 1991.

—— *Frontiers. Essays and Writings in Racism and Culture.* Stratford, Ontario: Mercury Press, 1992.

—— *Showing Grit. Showboating North of the 44th Parallel.* Toronto: Publications, 1993.

Pollard, Velma. (ed.) *Anansesem.* Kingston: Longman Jamaica, 1985.

—— 'Cultural Connections in Paule Marshall's *Praise Song for the Widow.*' *World Literature Written in English* 25, no. 2 (Fall 1985), 285–98.

—— *Considering Woman.* London: Women's Press, 1989.

—— *Shame Trees Don't Grow Here ... But Poincianas Bloom.* Leeds: Peepal Tree Books, 1992.

—— *Homestretch.* London. Longman, 1994.

—— *Karl and Other Stories.* London: Longman, 1994.

Poynting, Jeremy. 'East Indian Women in the Caribbean: Experience and Voice.' In *India in the Caribbean.* London: Hansib Publications, 1987.

Prescod, Marsha. *The Land of Rope and Tory.* London: Akira Press, 1985.

Prince, Mary. *A Black Woman's Odyssey Through Russia and Jamaica. The Narrative Of Mary Prince.* New York: Marcus Wiener Publishing, 1990 (first pub. 1850).

Pryse, Marjorie and Hortense Spillers, eds. *Conjuring: Black Women, Fiction, and Literary Tradition.* Bloomington: Indiana University Press, 1985.

Pyne-Timothy, Helen. 'Perceptions of the Black Woman in the Work of Claude McKay.' *CLA Journal* 19, no. 2 (December 1975), 152–64.

—— 'Women and Sexuality in the Later Novels of V.S. Naipaul.' *WLWE* 25, no. 2 (Autumn 1985), 298–306.

—— ed. *The Woman, The Writer, The Caribbean.* Proceedings of the 2nd International Conference of Caribbean Women Writers. Los Angeles, CA: CAAS, forthcoming.

Rahim, Jennifer. *Mothers Are Not the Only Linguists and Other Poems.* Diego Martin, Trinidad and Tobago: New Voices, 1992.

Rámos, Emelda and Elías Miguel Muñoz, eds. 'Hacia una Narrativa Femenina en la Literatura Dominicana.' In Eunice Myers and Ginette Adamson, eds. *Continental, Latin-American and Francophone Women Writers.* Lanham, Maryland: University Presses of America, 1987, 167–75.

Rebolledo, Tey Diana. 'The Maturing of Chicana Poetry: The Quiet Revolution of the 1980s.' In Paula Treicher, Cheris Kramarae and Beth Stafford, eds. *For Alma Mater: Theory and Practice of Feminist Scholarship.* Urbana: University of Illinois Press, 1985,143–158.

Reddock, Rhoda E. 'Women and Slavery in the Caribbean: a Feminist Perspective.' *Latin American Perspectives* (Winter 1985).

310 *Moving Beyond Boundaries*

Redfern, Bernice. *Women of Color in the United States: A Guide to the Literature.* New York: Garland, 1989.

Research Institute for the Study of Man. Library for Caribbean Research. *Women in the non-Hispanic Caribbean: a Selective Bibliography.* New York: Research Institute for the Study of Man, 1982.

Resha, Maggie. *Mangoana Tsoara Thipa Ka Bohaleng. My Life in the Struggle.* London and Johannesburg: Congress of South African Writers, 1991.

Reyes, Elma. 'Women in Calypso.' *Woman Speak* (Barbados) no. 12 (1983), 12–13, 20.

Rheddock, Rhoda. *Elma Francois.* London: New Beacon Books, 1988.

Ribeiro, Esmeralda. *Malungos & Milongas. Conto.* Sao Paulo: Quilhomboje Literatura, 1988.

Riley, Joan. *The Unbelonging.* London: Women's Press, 1985.

—— *Waiting in the Twilight.* London: Women's Press, 1987.

—— *Romance.* London: Women's Press, 1988.

—— *A Kindness to the Children.* London: Women's Press, 1992

Rivera, Eliana S. 'Las Nuevas Poetas Cubanas'. *Areíto* 5,17 (1978), 31–7.

Revista Chicano-Riqueña 11, no. 3/4 (Fall/Winter 1983): special issue: 'Woman of Her Word: Hispanic Women Write.' Ed. by Evangelica Vigil.

Politics and the Muse: Studies in the Politics of Recent American Literature. Bowling Green, OH: Bowling Green State University Press, 1989, 179–201.

Roberson, Sadie. *Killer of the Dream.* New York: Carlton, 1963.

Roberts, J.R. *Black Lesbians: An Annotated Bibliography.* Tallahasse, FL: Naiad Press, 1981.

Rodgers, Carolyn. *Songs of a Black Bird.* Chicago: Third World Press, 1967.

—— *How I Got Ovah.* Garden City, NY: Anchor/Doubleday, 1975.

Rodgers-Rose, La Frances, ed. *The Black Woman.* Beverly Hills: Sage Publications, 1980.

Rodríguez, María Cristina. 'The Role of Women in Caribbean Prose Fiction.' Dissertation, New York: City University of New York: 1979.

—— 'Tema y estilo en la poesía escrita por mujeres Puertorriqueñas en la decada de setenta.' In *Poetry of the Spanish-speaking Caribbean. Conference Papers.* 2nd edn. Third conference of Latin Americanists, University of the West Indies, Mona Campus, Jamaica, 10–12 July 1980. Mona, Jamaica: Dept of Spanish, University of the West Indies, 1984, 1–18.

Rodríguez-Peralta, Phyllis. 'Images of Women in Rosario Castellano's Prose.' *Latin American Literary Review* 6, no. 11 (1977), 68–80.

Rodríguez Tomeu, Julia. 'Cuentos Negros de Cuba.' *Cuadernos Americanos* 7:2 (1949), 279–81.

Roemer, Astrid. *The Order of the Day. A Novella.* Trans. Rita Gircour, 1991. De Orde van de Dag Conserve, Schoorl, The Netherlands, 1988.

—— *A Name for Love. A Novel.* Trans. Rita Gircour, 1991. Levenslang Gedicht In de Knipscheer, Amsterdam, 1987.

—— *Een Naam Voor de Liefde.* Amsterdam: Rainbow Pocketboeken, 1987.

—— *Over de Gekte van een Vrouw.* Amsterdam: Rainbow Pocketboeken, 1982.

Rogríguez, Rafael. 'Nancy Morejón en su Habana.' *Areíto* 8:32 (1983), 23–5.

Romero, Patricia, ed. *Life Histories of African Women.* London & Atlantic Highlands, NJ: Ashfield Press, 1988.

Rosario Candelier, Bruno. *Tendencias de la Novela Dominicana.* Santiago, República Dominicana: Pontificia Universidad Católica Madre y Maestra, 1988.

RoseGreen-Williams, Claudette. 'Rewriting the History of the Afro-Cuban Women: Nancy Morejón's "Mujer negra".' *Afro-Hispanic Review* 8:3 (1989), 7–13.

—— 'Feminist Perspectives in Rosario Ferré's *Papeles de Pandora.*' In *La Mujer en la Literatura Caribeña.* Ed. Lloyd King. St Augustine, Trinidad: Dept of French and Spanish Literature, University of the West Indies, [1984?], 108–29.

Roses, Lorraine Elena and Ruth Elizabeth Randolph. *The Harlem Renaissance and Beyond: Literary Biographies of 100 Black Women Writers, 1900–1945.* Boston: G.K. Hall, 1989.

Rowe, Maureen. 'The Woman in Rastafari.' *Caribbean Quarterly* 26, no. 4 (December 1980), 13–21.

Royster, Beatrice Horn. 'The Ironic Vision Of Four Black Women Novelists: A Study of the Novels of Jessie Fauset, Nella Larsen, Zora Neale Hurston and Ann Petry.' Dissertation, Emory University, Atlanta, 1975.

Royster, Phillip M. 'In Search of our Fathers' Arms: Alice Walker's Persona of the Alienated Darling.' *Black American Literature Forum* 20 (Winter 1986), 347–70.

Rueda, Manuel and Lupo Hernández Rueda. *Antología panoramica de la poesía Dominicana 1912–1962.* Santiago: Universidad Católica Madre y Maestra, Colección contemporáneos no. 12, 1972.

Rufino, Alzira. *Eu, Mulher Negra, Resisto.* Santos, SP., Brasil, 1988.

Rushing, Andrea Benton. 'An Annotated Bibliography of Images of Black Women in Black Literature.' *CLA Journal* 21 (March 1978), 435–42.

—— 'An Annotated Bibliography of Images of Black Women in Literature.' *CLA Journal* 25, no. 2 (December 1981), 234–62.

Russell, Sandi, ed. *Render Me My Song. African–American Women Writers from Slavery to the Present.* New York: St Martin's Press, 1990.

Rutherford, Anna. Review of *Summer Lightning and Other Stories,* by Olive Senior, *Kunapipi* 8, no. 2 (1986), 114–15.

Ryan, Pamela. 'Black Women Do Not Have Time to Dream: The Politics of Time and Space.' *Tulsa Studies in Women's Literature* 11:1, (Spring, 1992), 95–102.

Sadoff, Dianne F. 'Black Matrilineage: A Case of Alice Walker and Zora Neale Hurston.' *Signs: Journal of Women in Culture and Society* 11 (1985), 4–26.

Salgado, María A. 'Women Poets of the Cuban Diaspora: Exile and the Self.' *The Americas* 18, 3–4 (1990), 113–21.

Salvaggio, Ruth. 'Octavia Butler and the Black Science-Fiction Heroine.' *Black American Literature Forum*. 18:2 (Summer 1984), 78–81.

Sánchez, Marta Ester. *Contemporary Chicana Poetry: A Critical Approach to an Emerging Literature.* Berkeley, CA: University of California Press, 1985.

Sánchez, Sonia. *Homecoming.* Chicago, Ill.: Broadside Press, 1969.

—— ed. *Three Hundred and Sixty Degrees of Blackness Comin' at You.* New York: 5x Publishing Co., 1971; New York: Bantam, 1971.

—— ed., *We Be Word Sorcerers: 25 Stories by Black Americans,* New York: Bantam, 1973.

—— *I've Been a Woman: New and Selected Poems.* Chicago: Third World Press, 1981.

—— *Homegirls and Handgrenades.* New York: Thunder's Mouth, 1984.

—— *Under a Soprano Sky.* Trenton, NJ: Africa World Press, 1987.

Sanders, Dori. *Clover.* Chapel Hill: Algonquin Books, 1990.

—— *Her Own Place.* Chapel Hill: Algonquin Books, 1993.

Santos Febres, Mayra. *Anamo y Manigua.* Río Piedras, Puerto Rico: La iguana dorada, 1991.

Santos Silva, Loreina. *'La pasión segun Antigona Peréz:* la mujer como reafirmadora de la dignidad política.' *Revista/Review Interamericana* 11, no. 3 (1981), 438–43.

Sariol, Jose Prats. 'Poemas de Nancy Morejón en Mexico.' *Por La Poesía Cubana.* La Habana: Ediciones Union, 1988, 207–9.

Sato, Hiroko. 'Under the Harlem Shadow: A Study of Jessie Fauset and Nella Larsen.' In Arna Bontemps, ed. *The Harlem Rennaissance Remembered: Essays Edited with a Memoir.* New York: Dodd, Mead and Company, 1972, 63–89.

Savacou. A Journal of the Caribbean Artists Movement (Mona, Jamaica, West Indies) no. 13 (1977). ('Caribbean woman.' Special issue, ed. Lucille Mathurin Mair.)

Scafe, Suzanne. *Teaching Black Literature.* London: Virago, 1989.

Scarborough, Dorothy. *From a Southern Porch.* New York: Putnam, 1919.

Schipper, Mineke, ed. *Unheard Words: Women and Literature in Africa, the Arab World, Asia, the Caribbean and Latin America.* London: Allison & Busby, 1985.

Schreiber, Sheila. 'Art and Life: The Novels of Black Women.' Dissertation, University of New Mexico, 1981.

Schroeder, Aribert. 'An Afro–American Woman Writer and Her Reviewers/Critics: Some Ideological Aspects in Current Criticism of Toni Morrison's Fiction.' *Arbeiten aus Anglistik und Amerikanistik* 15:2 (1990), 109–25.

Schultz, Elizabeth. '"Free in Fact at Last": The Image of the Black Woman in Black American Fiction.' In Marlene Spinger, ed. *What Manner of Woman: Essays on English and American Life and Literature.* New York: New York University Press, 1977.

—— 'The Novels of Toni Morrison: Studies of the Individual and the Neighborhood.' In Hedwig Bock and Albert Wertheim, eds. *Essays on the Contemporary American Novel.* München: Hueber, 1986, 281–304.

Schwarz-Bart, Simone. *Un plat de porc aux bananes vert* (with Andre Schwarz-Bart). Paris: Editions du Seuil, 1967.

—— *Pluie et vent sur Telumee Miracle.* Paris: Editions du Seuil, 1972.

—— *Ti Jean l'horizon.* Paris: Editions du Seuil, 1979.

Seaforth, Sybil. *Growing Up with Miss Milly.* Ithaca, NY: Callaloux, 1988.

Senior, Olive. *Talking of Trees.* Kingston, Jamaica: Calabash, 1985.

—— *Summer Lightning.* London: Longman, 1986.

—— 'Interview.' With Anna Rutherford. *Kunapipi* 8, no. 2 (1986), 11–20.

—— *The Arrival of the Snake Woman and Other Stories.* London: Longman Caribbean, 1989.

—— *Working Miracles.* Bloomington: Indiana University Press, 1991.

Shakur, Assata. *Assata! An Autobiography.* Westport, Conn.: Lawrence Hill, 1987.

Shange, Ntozake. *For Colored Girls Who have Considered Suicide When the Rainbow is Enuf.* New York: Bantam, 1977.

—— *Sassafrass, Cypress & Indigo.* New York: St Martin's Press, 1982.

—— *A Daughter's Geography.* New York: St Martin's Press, 1983.

Shea, Maureen Elizabeth. 'A Growing Awareness of Sexual Oppression in the Novels of Contemporary Latin American Women Writers.' *Confluencia* 4:1 (1988), 53–9.

Shinebourne, Janice. *Timepiece.* Leeds, Yorkshire: Peepal Tree Press, 1986.

—— *The Last English Plantation.* Leeds, Yorkshire: Peepal Tree Press, 1988.

Shipley, William M. 'History's Phoenix: Black Woman in Literature.' In O.R. Dathorne, Ed. *Afro-World: Adventures in Ideas.* Coral Gables, Florida: Association of Caribbean Studies and the University of Wisconsin, Wisconsin System, 1984, 15–23.

Shockley, Ann Allen. *Afro-American Women Writers, 1746–1933: An Anthology and Critical Guide.* Boston: G.K. Hall, 1988

Shostak, Marjorie, ed. *Nisa. The Life and Words of a Kung Woman.* New York: Vintage Books, 1981.

Silvera, Makeda. *Silenced.* Toronto: Williams and Wallace Publishers, 1983.

—— *Remembering G and Other Stories.* Toronto: Sister Vision Press, 1991.

—— *Piece of My Heart. A Lesbian of Color Anthology.* Toronto: Sister Vision Press, 1992.

Simon, Lilian. *Inyanga. Sara Mashele's Story.* Johannesburg: Justified Press, 1993.

Sims, Janet L. *The Progress of Afro-American Women: A Selected Bibliography and Research Guide.* Westport, CT: Greenwood Press, 1980.

SISTREN, Lionheart Gal. *Life Stories of Jamaican Women.* London: Woman's Press, 1986.

Skerret, Joseph, Jr. 'Recitation to the Griot: Storytelling and Learning in Toni Morrison's *Song of Solomon*.' In Majorie Pryse and Hortense J. Spillers, eds. *Conjuring: Black Women, Fiction and Literary Tradition*. Bloomington: Indiana University Press, 1985, 192–201.

Smart, Ian I. 'La mulatez y la imagen de la nueva mujer negra en la poesía de Nicolás Guillén.' *Union, Revista de la Union de Escritores y Artistas de Cuba*, no. 4, (1983).

—— 'The New Poet: Its West Indian Themes.' *Central American Writers of West Indian Origin. A New Hispanic Literature*. Washington, DC: Three Continents Press, 1984, 87–108.

—— 'Eulalia Bernard: A Caribbean Woman Writer and the Dynamics of Liberation.' *Letras Femininas* 13:1–2 (1987), 79–85.

Smilowitz, Erika S. 'Una Marson: Woman before her Time.' *Jamaica Journal* 16, no. 2 (1983), 62–8.

—— '"Weary of life and all my heart's dull pain": the Poetry of Una Marson.' In Erika S. Smilowitz and Roberta Q. Knowles, eds. *Critical Issues in West Indian Literature ...*' Parkersburg, Iowa: Caribbean Books, 1984, 19–32.

Smith, Barbara. 'Towards a Black Feminist Criticism'. In by Gloria T. Hull, Patricia Bell Scott and Barbara Smith, eds. *All The Women Are White, All the Blacks Are Men, But Some of Us Are Brave: Black Women's Studies*. Old Westbury, NY: Feminist Press, 1982, 157–175.

—— ed. *Home Girls*. New York: Kitchen Table/Women of Color Press, 1983.

Smith-Wright, Geraldine. 'In Spite of the Klan: Ghosts in the Fiction of Black Women Writers.' Lynette Carpenter and Wendy Kolmar, eds. *Haunting the House of Fiction: Feminist Perspectives on Ghost Stories by American Women*. Knoxville: University of Tennessee Press, 1991, 142–65.

Solera, Rodrigo. 'Tres Escritoras de Costa Rica y su Aporte a las Letras Nacionales.' In Eunice Myers and Ginette Adamson, eds. *Continental, Latin American and Francophone Women Writers*. Lanham, Maryland: University Presses of America, 1987, 161–5.

Solomon, Frances Anne. 'I Is A Long Memoried Woman.' Film. London: Leda Serene/YOD Video, 1990.

Sosa, José Rafael, ed. *Mujer y Literatura. Homenje a Aída Cartegena Portalatín*. Santo Domingo, República Dominicana: Editora Universitaria, 1986.

Soto, Sara. *Mágia y Historia en los 'Cuentos negros,' 'Por que' y 'Ayapa' de Lydia Cabrera*. Miami: Ediciones Universal, 1988.

Southerland, Ellease. 'Zora Neale Hurston: The Novelist–Anthropologist's Life/Works.' *Black World* 23 (August 1974), 20–30.

Spencer, Mary Etta. *The Resentment*. Philadelphia: A.M.E. Book Concern, 1921.

Spillers, Hortense J. '*Chosen Place, Timeless People*: Some figurations on the New World.' In Marjorie Pryse and Hortense J. Spillers, eds. *Conjuring: Black*

Women Fiction and Literary Tradition. Bloomington: Indiana University Press, 1985, 151–75.

—— 'Crosscurrents, Discontinuities: Black Women's Fiction.' In Marjorie Pryse and Hortense J. Spillers, eds. *Conjuring: Black Women, Fiction and Literary Tradition*. Bloomington: Indiana University Press, 1985, 249–61.

—— 'Mama's Baby, Papa's Maybe. An American Grammar Book.' *Diacritics* 17 (Summer 1987), 65–81.

—— ed. *Comparative American Identities. Race, Sex and Nationality in the Modern Text*. New York: Routledge, 1991.

Spivak, Gayatri Chakravorty. 'Three Women's Texts and a Critique of Imperialism.' *Critical Inquiry* 12:1 (Autumn, 1985).

—— *In Other Worlds: Essays in Cultural Politics*. New York and London: Routledge, 1988, 207.

—— 'Can the Subaltern Speak?' In Cary Nelson and Lawrence Grossberg, eds. *Marxism and the Interpretation of Cultures*. Urbana: University of Illinois Press, 1988, 271–313.

Springer, Eintou Pearl. *Out of the Shadows*. London: Karia Press, 1988.

—— *Godchild. Stories and Poems for Children*. London: Karia Press, 1988.

—— 'Anansi, nansi, Anansi: Full Length Musical in Three Acts.' Unpublished manuscript, 1989.

—— *Focussed*. London: Karia Press, 1991.

Steady, Filomena C., ed. *The Black Woman Cross-Culturally*. Cambridge, MA: Schenkman, 1981.

Sterling, Dorothy. *Ahead of her Time: Abby Kelley and the Politics of Anti-Slavery*. New York: W.W. Norton, 1991.

Stetson, Erlene, ed. *Black Sister: Poetry of Black Women, 1749–1980*. Bloomington, IN: Indiana University Press, 1981.

—— 'Silence: Access and Aspiration.' In Carol Ascher, Louise DeSalvo and Sara Ruddick, eds. *Between Women: Biographers, Novelists, Critics, Teachers, and Artists Write about Their Work on Women*. Boston: Beacon, 1984.

Stevenson, Rosemary. 'Black Women in the United States: A Bibliography of Recent Works.' *The Black Scholar* 16, no.2 (March/April 1985), 45–9.

Stoner, K. Lynn. *Latinas of the Americas: A Source Book*. New York: Garland, 1988.

Stringer, Susan, 'Nafissatou Diallo – A Pioneer in Black African Writing.' Selected Papers from the Wichita State University Conference on Foreign Literature, 1986–7. In Ginette Adamson and Eunice Myers, eds. *Continental, Latin-American and Francophone Women Writers*, vol. II. Lanham, Maryland: University Press of America, 1987.

—— 'Cultural Conflict in the Novels of Two African Writers, Mariama Bâ and Aminata Sow Fall.' *SAGE: A Scholarly Journal on Black Women* (1988), 36–41.

Sulter, Maud. *As a Black Woman. Poems 1982–1985*. London: Akira Press, 1985.

316 *Moving Beyond Boundaries*

—— 'Everywoman's Right, Nobody's Victory.' In Pearlie McNeill et al., eds *Through the Break*. London: Sheba Feminist Publishers, 1987.

—— ed. *Passion. Discourses on Black Women's Creativity*. London: Urban Fox Press, 1990.

Sutherland, Efua. *Foriwa*. Accra: Ghana Publishing Corp, 1967.

—— *Edufa*. London: Longman, 1967.

—— *The Marriage of Anansewa. A Storytelling Drama*. London: Longman, 1975.

Sylvander, Carolyn Wedin. *Jessie Redmon Fauset, Black American Writer*. Troy, NY: The Whitston Publishing Co., 1981.

Tadjo, Veronique. *Le royaume aveugle*. Paris: Editions L'Harmattan, 1990.

Talkers Through Dream Doors. Poetry and Short Stories by Black Women. Manchester: Crocus, 1989.

Tally, Justine. 'Black Women's Studies in the 1980s: An Interview with Beverly Guy-Sheftall.' *Revista Canaria de Estudios Ingleses*. v. 10 (April, 1985) 195–204.

Tate, Claudia, ed. 'Nella Larsen's *Passing*: A Problem of Interpretation'. *Black American Literature Forum* 14 (1980), 142–6.

—— *Black Women Writers at Work*. New York: Continuum, 1983.

—— 'On Black Literary Women and the Evolution of Critical Discourse.' *Tulsa Studies in Women's Literature* Spring, 5:1 (1986), 111–23.

—— 'Reshuffling the Deck; Or, (Re)Reading Race and Gender in Black Women's Writing.' *Tulsa Studies in Women's Literature* 7:1 (Spring 1988), 119–32.

—— *Domestical Allegories of Political Desire: The Black Heroine's Text at the Turn of the Century*. Oxford: Oxford University Press, 1992.

Taylor, Elizabeth. 'Tradition and the Woman Writer in Southern Africa, or How to Enjoy the River without Carrying the Water Drums.' *Bucknell Review: A Scholarly Journal of Letters, Arts and Sciences* 37:1 (1993), 99–110.

Taylor, Mildred D. *Let the Circle Be Unbroken*. New York: Dial Press, 1981.

Terrell, Mary Church. *A Colored Woman in a White World*. Washington, DC: Ransdell, 1940.

Thiam, Awa. *Black Sisters, Speak Out. Feminism and Oppression in Black Africa*. London: Pluto Press, 1978.

Thomas, Elean. *Word Rhythms From the Life of a Woman*. London: Karia Press, 1986.

Thomas, Ena, V. 'Women and the national ethos in the drama of Francisco Arrivi.' In Lloyd King, ed. *La Mujer en la Literatura Caribeña*. St Augustine, Trinidad: Dept of French and Spanish Literature, University of the West Indies, [1984?], 142–50.

Thompson, Mildred. *Ida Wells-Barnett: An Exploratory Study of an American Black Women, 1893–1930*. Brooklyn, NY: Carlson, 1990.

Thornton, Hortese E. 'Sexism as Quagmire: Nella Larsen's *Quicksand*.' *College Language Association Journal* 16 (1973), 285–301.

Thorpe, Majorie. 'Beyond the Sargasso: the Significance of the Presentation of the Woman in the West Indian Novel.' Dissertation, Queens University, Kingston, Ontario, 1975.

—— 'The Problem of Cultural Identification in *Crick Crack Monkey*.' *Savacou* no.13 (1977), 31–8.

—— 'Women in Culture – a Literary Review.' In Margaret Hope, ed. *Journey in the Shaping. Report of the First Symposium on Women in Caribbean Culture – July 24, 1981*. St Michael, Barbados: Women and Development Unit (WAND), University of the West Indies, 1981, 47–51.

Tlali, Miriam. *Muriel at Metropolitan*. Johannesburg: Ravan Press, 1975.

—— *Amandla*. Johannesburg: Ravan Press, 1980.

—— *Mihloti*. Johannesburg: Skotaville Publishers, 1984.

—— *Soweto Stories*. London: Pandora Press, 1989.

Trescott, Jacqueline. 'Jamaica Kincaid: Words and Silences.' *International Herald Tribune* (29 April 1984), 8.

Troester, Rosalie Riegle. 'Turbulence and Tenderness: Mothers, Daughters and "Othermothers" in Paule Marshall's *Brown Girl, Brownstones*.' *Sage* 1 (Fall 1984), 13–16.

Turnbull, Patricia. *Rugged Vessels*. Tortola, British Virgin Islands: Archipelago Press, 1992.

Turner, Darwin T. 'Theme, Characterization, and Style in Works of Toni Morrison.' In Mari Evans, ed. *Black Women Writers (1950–1980)*. Garden City, NY: Anchor/Doubleday, 1984, 361–9.

Turner, Tina (with Kurt Loder) *I Tina, My Life Story*. New York: William Morrow, 1986.

Umeh, Marie. 'Poetics of Thwarted Sensitivity.' In Ernest N. Emenyonu, ed. *Critical Theory and African Literature*. Ibadan: Heinemann Educational, 1987.

Umpierre-Herrera, Luz María. *The Margarita Poems*. Bloomington, Indiana: Third Woman Press, 1987.

—— 'Transcendence.' In Norma Alarcón, Ana Castillo and Cherríe Moraga, eds. *Third Woman: The Sexuality of Latinas*. Berkeley, CA: Third Woman Press, 1993, 39.

Underwood, Edna W. 'Some Women Poets of Cuba.' *The West Indian Review* 3:1 (1936), 36–9.

Urbano, Victoria, ed. *Five Women Writers of Costa Rica*. Beaumont, Texas: Asociación de Literatura Femenina Hispánica, 1978.

Vallbona, Rima de. 'Trayectoria actual de la poesía femenina en Costa Rica.' *Kanina* 5, no. 2 (July–December 1981), 18–27.

Vega, Ana Lydia. 'El no de las niñas: trangresion y subversion en los cuentos de tres narradoras Puertorriqueñas.' In Lloyd King, ed. *La Mujer en la Literatura Caribeña*. St Augustine, Trinidad: Dept of French and Spanish Literature, University of the West Indies, [1984?], 40–50.

Vicioso, Sherezada. 'El éxito Según San ... Hacia una Reinvindicción de la Poesía Feminina en la República Dominicana.' *Algo que Decir, Ensayos Sobre Literatura Femenina (1981–1991).* Santo Domingo, República Dominicana: Editora Búho, 1991, 23–40.

—— 'Los Caminos de la Solidaridad Entre las Mujeres Escritoras.' *Algo que Decir, Ensayos Sobre Literatura Femenina (1981–1991).* Santo Domingo, República Dominica: Editora Búho, 1991, 127–38.

—— 'La Mujer en la Literatura Dominicana. A Cuarenta y Siete Años de Camila Henríquez.' *Algo que Decir. Ensoyas Sobre Literatura Femenina* (1981–1991). Santo Domingo, República Dominica: Editora Búho, 1991, 117–26.

Valasco, María Mercedes de. 'El Marianismo y el Machismo en "Eterno Femenino" de Rosario Castellanos.' Nora-Orthmann and Júan Cruz Mendezabel, eds. *La Escritura Hispanica.* Miami: Ediciones Universal, 1990, 189–98.

Valdés-Cruz, Rosa. 'El Realismo Mágico en "Los Cuentos Negros" de Lydia Cabrera.' Donald A. Yates, ed. *Otros Mundos, Otros Fuegos: Fantasía y Realismo Mágico en Iberoamérica. Memoria del XVI Congreso International Literatura Iberoamerica.* East Lansing, Michigan: Michigan State University, Latin American Studies Center, 1975, 206–9.

—— 'The Short Stories of Lydia Cabrera: Transpositions or Creations.' Yvette E. Miller and Charles M. Tatum, eds. *Latin American Women Writers: Yesterday and Today.* Pittsburgh, Pennsylvania: Latin American Literary Review, 1977, 148–54.

Vroman, Mary E. *Esther.* New York: Bantam Books, 1963.

—— *Harlem Summer.* New York: Berkley Publishing Corporation, 1968.

Wade-Gayles, Gloria. 'She Who is Black and Mother: In Sociology and Fiction, 1940–1970.' In La Frances Rodgers-Rose, ed. *The Black Woman.* Beverly Hills: Sage Publications, 1980, 89–106.

—— *No Crystal Stair: Visions of Race and Sex in Black Women's Fiction.* New York: Pilgrim Press, 1984.

—— 'Black, Southern, Womanist: The Genius of Alice Walker.' Inge Tonette Bond, ed. *Southern Women Writers: The New Generation.* Tuscaloosa: University of Alabama Press, 1990, 301–23.

—— *Pushed Back to Strength. A Black Woman's Journey Home.* Boston: Beacon Press, 1993.

Waldman, Gloria Feiman. 'Affirmation and Resistance: Women Poets from the Caribbean.' Doris Meyer and Margarite Fernández Olmos, eds. *Contemporary Women Authors of Latin America: Introductory Essays.* Brooklyn: Brooklyn College Press, 1983, 33–57.

Walker, Abena. *Word Magic. Praise Songs and Other Poems.* Washington, DC, 1981.

Walker, Alice. *The Third Life of Grange Copeland.* New York: Harcourt Brace Jovanovich, 1970.

—— *Meridian.* New York: Washington Square Press, 1977.

—— ed. *I Love Myself When I Am Laughing ... And Then Again When I Am Looking Mean and Impressive: A Zora Neale Hurston Reader.* Old Westbury, New York: Feminist Press, 1979.

—— 'Saving the Life That is Your Own: The Importance of Models in the Artist's Life.' In Dexter Fisher, ed. *The Third Woman: Minority Women Writers of the United States.* Boston: Houghton Mifflin, 1980, 151–8.

—— *You Can't Keep a Good Woman Down.* New York: Harcourt, Brace Jovanovich, 1981.

—— *The Color Purple.* (1982) New York: Harvest/HBJ and London: Women's Press, 1983.

—— *In Search of Our Mothers' Gardens.* New York: Harvest/HBJ, 1983.

—— *The Temple of My Familiar.* New York: Harvest/HBJ, 1989.

—— *Possessing the Secret of Joy.* New York: Harvest/HBJ, 1992.

Walker, Magaret. *For My People.* New Haven: Yale University Press, 1942.

—— *Jubilee.* (1966) New York: Bantam Books, 1972.

—— *How I Wrote Jubilee and Other Essays on Life and Literature.* New York: Feminist Press, 1990.

Walker, Melissa. 'The Verbal Arsenal of Black Women Writers in America.' Proceedings of the Essex Sociology of Literature Conference, July 1983. Francis Barker, Peter Hulme, Margaret Iverson and Diana Loxley, eds. *Confronting the Crisis: War, Politics, and Culture in the Eighties.* Colchester: University of Essex, 1984, 118–30.

Walker, Robbie J. 'Coping Strategies of the Women in Alice Walker's Novels: Implications for Survival.' *College Language Association Journal* 30 (1987), 401–18.

Walker, S. Jay. 'Zora Neale Hurston's *Their Eyes Were Watching God*: Black Novel of Sexism.' *Modern Fiction Studies* 20 (1974–5), 519–25.

Walker-Johnson, Joyce. 'Autobiography, History and the Novel: Erna Brodber's *Jane and Louisa Will Soon Come Home.*' *Journal of West Indian Literature* 3 (January 1989), 47–59.

Wall, Cheryl A. 'Zora Neale Hurston: Changing Her Own Words.' In Fritz Fleischmann, ed. *American Novelists Revisited: Essays in Feminist Criticism.* Boston: G.K. Hall, 1982, 371–93.

—— 'Passing for What? Aspects of Identity in Nella Larsen's Novels.' *Black American Literature Forum* 20 (Spring/Summer 1986), 97–111.

—— ed. *Changing Our Own Words: Essays on Criticism, Theory, and Writing by Black Women.* New Brunswick, NJ: Rutgers University Press, 1989.

Wallace, Karen Smyley. 'Black Women in Black Francophone Literature: Comparisons of Male and Female Writers.' *International Fiction Review* (Summer 1984) 112–14.

Wallace, Michelle. *Invisibility Blues. From Pop to Theory. Towards a Black Feminist Cultural Criticism.* New York and London: Verso, 1990.

—— *Black Macho and the Myth of the Superwoman.* New York and London: Verso, 1990.

Walther, W. 'Aspects of Female Emancipation as Reflected in the Works of Some Arab Women Writers.' M. Galik, ed. Proceedings of the Fourth International Conference on the Theoretical Problems of Asian and African Literatures. Bratislava: Literary Institute of the Slovak Academy of Sciences, 1983, 390–97.

Ward, Cynthia. 'What They Told Buchi Emecheta: Oral Subjectivity and the Joys of "Otherhood".' *PMLA* 105 (1990), 83–97.

Warner-Vieyra, Myriam. *Juletane.* Trans. Betty Wilson. London: Heinemann, 1987.

Washington, Mary Helen, ed. *Black-Eyed Susans: Classic Stories By and About Black Women.* Garden City, New York: Anchor/Doubleday, 1975.

—— 'Teaching *Black-Eyed Susans*: An Approach to the Study of Black Women Writers.' *Black American Literature Forum* 11 (Fall 1977), 20–4.

—— 'Zora Neale Hurston: A Woman Half in Shadow.' In Alice Walker, ed. *I Love Myself When I Am Laughing ... And Then Again When I Am Looking Mean and Impressive: A Zora Neale Hurston Reader.* Old Westbury, NY: The Feminist Press, 1979, 7–25.

—— ed. *Midnight Birds: Contemporary Black Women Writers.* New York: Doubleday, 1980.

—— 'Lost Women: Nella Larsen: Mystery Woman of the Harlem Renaissance.' *Ms.* 9 (December 1980), 44, 47, 48, 50.

—— 'How Racial Differences Helped Us Discover Our Sameness.' *Ms.* 10, no. 3 (September 1981), 60–2, 76.

—— 'Taming All that Anger Down: Rage and Silence in Gwendolyn Brooks' *Maud Martha.' Massachusetts Review,* 24 (1983), 453–66.

—— ed. *Invented Lives. Narratives of Black Women 1860–1960.* New York: Anchor/Doubleday, 1987.

—— 'These Self–Invented Women: A Theoretical Framework for a Literary History of Black Women.' In Robert C. Rosen and Leonard Vogt, eds. *Politics of Education: Essays from Radical Teacher.* Albany: State University of New York Press, 1990, 89–98.

Watson, Carole McAlpine. *The Novels Of Black American Women, 1891–1965.* Westport, Conn.: Greenwood Press, 1985.

Watts, Marguerite, ed. *Washer Woman Hangs Her Poems In the Sun. Poems by Women of Trinidad and Tobago.* Tunapuna, Trinidad and Tobago: Gloria V. Ferguson Ltd, 1990.

Webber, Storme. *Diaspora.* New York: NY: Saalfield, 1985.

Weixlmann, Joe and Houston A. Baker, eds. *Black Feminist Criticism and Critical Theory.* Greenwood, FL: Penkevill, 1988.

Welles, Marcia L. 'The Changing Face of Woman in Latin American Fiction.' In Beth Miller, ed. *Women in Hispanic Literature: Icons and Fallen Idols.* Berkeley: University of California Press, 1983, 208–88.

Wells, Rosalind. *Entwined Destinies.* New York: Dell, 1981.

Werner, Craig Hansen. *Black American Women Novelists: An Annotated Bibliography.* Pasadena, CA: Salem Press, 1989.

West, Dorothy. *The Living Is Easy.* (1948) New York: Arno Press, 1969.

Wickham, John. 'On Going through the Red: a Comment on *Lights.*' *Bulletin of Eastern Caribbean Affairs* (Barbados) 11, no. 1 (March–April 1985), 80–1. (Reviews the performance of a dramatic presentation about the lives of women, given in Barbados by the Stage One Players.)

Wicomb, Zoe. *You Can't Get Lost in Cape Town.* New York: Pantheon Books, 1987.

Wilentz, Gay. *Binding Cultures: Black Women Writers in Africa and the Diaspora.* Bloomington: Indiana University Press, 1992.

Wilentz, Gay. 'Affirming Critical Difference: Reading Black Women's Texts.' *The Kenyon Review,* 13:3 (Summer 1991), 146–51.

Williams, Cheryl. 'The Role of Women in Caribbean Culture.' *Bulletin of Eastern Caribbean Affairs* (Barbados) 11, no. 2 (May/June 1985), 46–50.

Williams, Claudette May. 'Images of the Black and Mulatto Woman in Spanish Caribbean Poetry: Discourse and Ideology.' Dissertation, Palo Alto, California: Stanford University, 1986.

Williams, John, trans. 'Return of a Native Daughter: An Interview with Paule Marshall and Maryse Condé.' *Sage* 3 (Fall 1986), 52–3.

Williams, Ora. *American Black Women in the Arts and Social Sciences: A Bibliographic Survey.* Metuchen, NJ: Scarecrow Press, 1978.

Williams, Sherley Anne. *Give Birth to Brightness: A Thematic Study in Neo-Black Literature.* New York: Dial Press, 1972.

—— *Dessa Rose.* New York: William Morrow, 1986.

—— 'Some Implications of Womanist Theory.' *Callaloo* 9:2 (Spring 1986), 303–8.

Willis, Susan. 'Eruptions of Funk: Historicizing Toni Morrison.' *Black American Literature Forum* 16 (1982), 34–42.

—— 'Black Women Writers: Taking a Critical Perspective.' Gayle Greene and Coppelia Kahn, eds. *Making a Difference: Feminist Literary Criticism.* London: Methuen, 1985, 211–37.

—— 'Nancy Morejón: Wrestling History from Myth.' *Literature and Contemporary Revolutionary Culture: Journal of the Society for the Study of Contemporary Hispanic and Lusophone Revolutionary Literature* 1 (1984–5), 247–56.

—— *Specifying: Black Women Writing the American Experience.* Madison: University of Wisconsin Press, 1987.

Wilson, Betty. 'Sexual, Racial and National Politics: Jacqueline Manicom's *Mon examen de blanc.*' *Journal of West Indian Literature* 1, no.2 (1987), 50–7.

Wilson, Judith. 'A Conversation with Toni Morrison.' *Essence* (July 1981), 84, 86, 128, 130, 133, 134.

Winchell, Donna Haisty. 'Tracing the Motherlines.' *Mississippi Quarterly: The Journal of Southern Culture* 46:4 (Fall 1993), 625–37.

Wisker, Gina, ed. *Black Women's Writing*. New York: St Martin's Press, 1993.

Woman Speak! A quarterly newsletter about Caribbean women. St Michael, Barbados: Women and Development Unit (WAND), University of the West Indies.

Wright, Sarah. *This Child's Gonna Live*. New York: Dell, 1969.

Wynter, Sylvia. *The Hills of Hebron*. New York: Simon & Schuster, 1962; London: Longman, 1984.

——*Jamaica is the High Bolivia*. New York: Vantage Press, 1979.

—— 'Beyond Miranda's Meanings. Un/Silencing the Demonic Ground of Caliban's Woman.' Carole Boyce Davies and Elaine Savory Fido, eds. *Out of the Kumbla. Caribbean Women and Literature*. Trenton, New Jersey: Africa World Press, 1990, 355–72.

Youman, Mary Mabel. 'Nella Larsen's Passing: A Study in Irony.' *College Language Association Journal* 17 (1974), 235–41.

Young, Ann Venture. 'The Black Woman in Afro-Caribbean Poetry.' In Miriam DeCosta Willis, ed. *Blacks in Hispanic Literature: Critical Essays*. Port Washington, NY: Kennikat Press, 1977, 137–42.

—— 'Black Women in Hispanic American Poetry: Glorification, Deification and Humanization.' *Afro-Hispanic Review* 1, no. 1 (January 1982), 23–8.

Zimra, Clarisse, 'Patterns of Liberation in Contemporary Women Writers.' *L'Esprit Créateur* 27:2 (1972), 103.

—— 'W/Righting His/tory: Versions of Things Past in Contemporary Caribbean Women Writers.' Matoto Ueda, ed. *Explorations: Essays in Comparative Literature*. Lanham, MD: University Presses of America, 1986, 227–52.

—— 'Righting the Calabash: writing History in the Female Francophone Narrative.' In Carole Boyce Davies and Elaine Savory Fido, eds. *Out of the Kumbla. Caribbean Women and Literature*. Trenton, New Jersey: Africa World Press, 1990, 143–59.

Zubena, Sister. *Calling All Sisters*. Chicago: Free Black Press, 1970.

Notes on Contributors

Ifi Amadiume is a Professor in the Departments of Religion and Black Studies at Dartmouth College. She is the author of *Male Daughters, Female Husbands. Gender and Sex in an African Society* (1987) and *Afrikan Matriarchal Foundations* (1987). She has produced two volumes of poetry, *Passion Waves* (1985) and *Ecstasy* which won the ANA-Cadbury award in 1992.

Carol Beane is an Assistant Professor of Spanish in the Department of Modern Foreign Languages at Howard University. She has published articles on Afro-Hispanic authors and subjects, translated poetry from the Spanish, and is writing a book on the representation of slavery and freedom in Latin American literature.

Brenda Berrian is an Associate Professor of Africana Studies and English. She also chairs the Department of Africana Studies at the University of Pittsburgh and is the editor of *Bibliography of African Women Writers and Journalists* (1985) and *Bibliography of Women Writers from the Caribbean* (1989). Her current research interest centers upon black British women writers.

Luz Argentina Chiriboga of Esmeraldas and Quito, Ecuador, participant in many conferences on black culture and black women held in Latin America, has authored two novels, *Bajo la piel de los tambores/ Under the Drum Skins* (1992), and *Aguas turbulentas* (1994). Selections from the former work appear in the anthology, *Erotique Noire* (1992); her own collection of erotic poetry, *La contraportada del deseo! The Backpage of Desire*, was published in 1992. Her prize-winning short stories and articles have appeared in numerous journals and magazines in Latin America. She is presently at work on another novel.

From Grenada, **Merle Collins** is a poet, writer and teacher who received her undergraduate training in English and Spanish at the University of the West Indies in Mona, Jamaica. She completed her Masters in Latin American Studies at Georgetown University in Washington, DC and her doctorate in Government at the University of London's School of Economics and Political Science. At the beginning of her literary career Collins used to perform her poems for political rallies in Grenada. Her work has appeared in a number of anthologies, and she has co-edited *Watchers and Seekers: Creative Writing by Black Women in Britain* (1987) and is the author of two poetry collections *Because the Dawn Breaks* (1985) and *Rotten Pomerack* (1992), the novel *Angel* (1987), and a short story

collection *Rain Darling* (1990). Currently, Collins resides in London where she teaches at the University of North London.

Irène Assiba d'Almeida comes from the Republic of Benin in West Africa. She spent most of her childhood in Dakar, Senegal, where she was born. She studied in France where she obtained a Licence d'Anglais from the University of Amiens, in Nigeria where she received a Master of Philosophy degree from the University of Ibadan, and in the USA where she received a PhD from Emory University. An Associate Professor of French and Francophone African Literature at the University of Arizona, Tuscon, her book *Francophone African Women Writers: Destroying the Emptiness of Silence* was published in 1994. She is also involved in creative writing, particularly poetry. She has written a few poems in English but writes primarily in French. At present she is working on a 'lighthearted' auto-biography.

Tsitsi Dangarembga is the author of *Nervous Conditions* (1989), which won the Commonwealth Prize for Fiction for 1988. After abandoning medical studies at Cambridge, she studied psychology at the University of Zimbabwe. She is completing a degree in film in Germany. She has written a play *She No Longer Weeps* and is working on several film scripts.

Carole Boyce Davies has research, and writing interests in African, Caribbean and African-American women's writing and black feminisms. She is Professor of English, Africana Studies and Comparative Literature with appointment in Women's Studies at State University of New York, Binghamton. Besides numerous articles, chapters and essays on black women's writing, she has edited two collections, *Ngambika. Studies of Women in African Literature* (1986) and *Out of the Kumbla. Caribbean Women and Literature* (1990). Her most recent book is *Migrations of the Subject. Black Women, Writing, and Identity* (1994).

Miriam DeCosta Willis is a Professor of Spanish and Afro-American Studies and University of Maryland, Baltimore County where she teaches courses in Caribbean, Latin American and black literatures in general. She has edited *Blacks in Hispanic Literature* and co-edited *Homespun Images: An Anthology of Black Memphis Writers and Artists* and *Erotique Noire/Black Erotica* and *Double Stitch: Black Women Write About Mothers and Daughters*. She is editing the forthcoming *Nancy Morejón: Critical Essays* and has edited *The Memphis Diary of Ida B. Wells*. She is an associate editor of the *Afro-Hispanic Review*, and *Sage: A Scholarly Journal of Black Women*. Her articles have appeared in *Callaloo*, *The Journal of Caribbean Studies*, *Latin American Literary Review* and *Libido: The Journal of Sex and Sensuality*.

Daisy Cocco de Filippis is Professor of Spanish in the Foreign Languages department at York College, City University of New York. She has published many articles and translated the works of Dominican women writers. Her most recent publications include *Sin otro profeta que su canto: antologia de poesia escrita por dominicans* (1988) *Combatidas, combaticas y combatientes: Narradoras dominicanas* (1992) and *Stories from Washington Heights* (1994).

Arlene Elder is Professor of English and Comparative Literature at the University of Cincinnati, teaching and writing on African, Australian Aboriginal and Ethnic American literatures and oratures with an emphasis on women's writing. She was a Senior Fulbright Lecturer at the University of Nairobi, 1976–77, and has published *The Hindered Hand, Cultural Implications of Early African American Fiction* and articles, chapters, and encyclopedia entries on African, African American and Aboriginal writers and oratures.

Jeanne Garane (formerly published as Jeanne Snitgen) received her PhD from the University of Michigan and is completing work on her first book, *Subjective Cartographies, Imagined Geographies: Marguerite Duras, Jeanne Hyvrard, Simone Schwarz-Bart.* She recently joined the faculty of the University of Evansville, Indiana as Assistant Professor of French.

Julie Gayle is a graduate student at Binghamton University who is doing her Masters in Business Administration and maintains an interest in black women's writing. Her future goals include building a successful career in marketing and finishing her first novella.

bell hooks (Gloria Watkins) is distinguished professor of English at City College, New York. She is a leading feminist theorist who has authored several works including *Ain't I A Woman: Black Women and Feminism* (1981), *Feminist Theory: From Margin to Center* (1984), *Talking Back. Thinking Feminist, Thinking Black* (1989), *Yearning: Race, Gender and Cultural Politics* (1991), *Black Looks. Race and Representation* (1992), and most recently *Outlaw Cultures. Resisting Representations* and *Teaching to Transgress* (1994).

Joyce Hope Scott is Associate Professor of English at Massachusetts Maritime College. She has been Fulbright Professor of American literature at the Université de Ouagadougou, Burkina Faso, West Africa (1991–3). She is the author of articles on African-American literature, in particular African American women's novels and folklore in African-American literature. Her works in progress are critical texts on African-American women writers and the feminine voice in West African/Sahelian literature.

Gladys M. Juménez-Muñoz is Assistant Professor in the Women's Studies Department, State University College at Oneonta, Oneonta, New York. She has published a number of articles on history, social criticism, and feminist theory. She recently received her PhD in Women's History at Binghamton University-State University of New York, with a dissertation on the textual practices of the women's suffrage movement in Puerto Rico during the late 1920s.

Celeste Dolores Mann is a doctoral candidate in Spanish at the University of Iowa. She received her BA in 1987 from Yale University in Spanish with distinctions. In 1989, she received her MA from the University of Iowa, also in Spanish. She studied at the Catholic Universities in both Rio de Janeiro and the Dominican Republic. Currently she is writing her dissertation on the Cuban poet, Nancy Morejón, and is Minority Scholar in Residence and Visiting Lecturer at Bowdoin College in Maine.

Rosemari Mealy is a freelance writer and radio host over WBAI Pacifica Network in New York, and the author of *Lift These Shadows* (1976) and *Fidel and Malcolm – Memories of A Meeting* (1993). A Labor historian, Rosemari also teaches black literature and writing at SUNY-Empire State Corporate College Program and is completing a degree in Law.

Marie Jose N'Zengou-Tayo is a lecturer in the Department of French, University of the West Indies, Mona, Jamaica, whose work is mainly on comparative literature of the French-speaking Caribbean. She is currently working on Italian popular migration and its literary representation.

M. Nourbese Philip is a poet and writer who lives in Toronto. She has published four books of poetry, *Thorns, Salmon Courage, She Tries Her Tongue: Her Silence Softly Breaks,* and her most recent, *Looking for Livingstone: An Odyssey of Silence,* a poem in prose and poetry. Her first novel, *Harriet's Daughter* (1988) was a finalist in the 1989 Canadian Library Association Prize for Children's Literature; the Max and Greta Abel Award for Multicultural Literature, 1990 and the Toronto Book Awards, 1990. Her manuscript *She Tries Her Tongue...* was awarded the 1988 Casa de las Americas prize for poetry. In 1990 M. Nourbese Philip was made a Guggenheim Fellow in poetry and in 1991 became a MacDowell Fellow. Her short stories, essays, reviews, and articles have appeared in magazine and journals in Canada, the UK and the USA and her poetry and prose have been extensively anthologized. Her most recent work, *Frontiers. Essays and Writings in Racism and Culture,* was published in 1992.

'Molara Ogundipe-Leslie was a Professor and poet on the faculty of the University of Ibadan, Nigeria for over a decade and later head of the Department

of English at Ogun State. She has lectured at major universities in the United States, Europe and Africa. A leading scholar in women's studies, African studies, and critical theory, her work as a poet has appeared in authoritative anthologies such as *The Penguin Book of Modern Poetry* (1985), *Voices from Twentieth Century Africa* (1988), *New African Writing* (1981), *Voices* (1992) and *Daughters of Africa* (1992). Her books are *Sew the Old Days and Other Poems* (1985) and *Re-Creating Ourselves. African Women and Critical Transformations* (1994), a selection of her writing over the years. She has done a great deal of work in women's organizing in Africa, in the founding body of AAWORD (Association of African Women in Research and Development) and WIN (Women in Nigeria.)

Juanita Ramos is a black, Puerto Rican, lesbian, feminist, socialist. Editor of *Companeras: Latina Lesbians* (1987), she is an Assistant Professor of Sociology, Women's Studies and Latin American Studies. Her work has appeared in *Third World Women and the Politics of Feminism* (1991). Her forthcoming work under the name Juanita Diaz-Cotto is *Gender, Ethnicity and the State. Latina and Latino Prison Politics.*

Thelma M. Ravell-Pinto currently teaches English at Olympus College in Rotterdam, The Netherlands. From 1986–91 she was Assistant Professor in the African-American Studies Department at Temple University, Philadelphia. She has taught at the University of Delaware, Newark and at Spelman College, Atlanta. In 1980, she went to Zimbabwe as an external consultant for a Dutch Development Aid organization. From 1981–2, she was the first Director of the Melfort Women's Educational Centre in Zimbabwe, which served as a training center for female ex-combatants. She has worked as a consultant for foreign women in the Netherlands, as a foreign correspondent for Dutch radio, the VARA and as an external examiner for the International Baccalaureate. Ravell-Pinto's research interests center on gender and South African literature. She has several publications on South African and literature in English and Dutch and has co-authored *Kan namens Mij een Blanke Spraken?* (Can the White Man Speak for me?) (1982), an overview of black South African literature and *Verbreek Kulturele Kontakten met Zuid-Afrika* (Break the Cultural Links with South Africa) (1982).

Angelita Reyes is Associate Professor in Women's Studies at the University of Minnesota, Minneapolis. Her research and writing focus on African, Caribbean and African American literary studies in the context of indigenous feminisms. Her research has appeared in numerous international and national publications. Her book *Crossing More Bridges: Representations of the Mother-Woman in Post-Colonial Women's Writing* (1995) is an exploration of mothering and motherhood from neo-African perspectives. She is co-editor of a collection of contemporary non-Western writing, *Global Voices* (1994) and is a special-issue editor of *SIGNS: A*

Journal of Women in Culture and Society for the issue on 'Postcolonial, Indigenous, and Emergent Feminisms.'

Astrid H. Roemer was born in Paramaribo, Suriname in 1947. She moved to the Netherlands as a young person and now lives in Den Haag (The Hague) where she makes a living from her writing and as a family-therapist. She has written numerous plays and has been active in creating musical and television programmes that deal with multiracialism in the Netherlands and with the Surinam community in general. Astrid H. Roemer writes essays, columns, and gives lectures on writing-courses. Her books include *Sasa* (1970) a volume of poetry and several novels including *Nergens ergens* (Nowhere, Somewhere) (1983), *Neem mijn terug, Suriname* (Surinam, Take Me Back), *Levenslang gedicht* (1985), *Een naam voor de liefde* (A Name for Love) (1987) and *Over de gekte van een vrouw* (About a Woman's Madness) (1979).

Marisol Santiago is a graduate student in Comparative Literature at Binghamton University. She is pursuing her research in black women's writing from Latin America.

Assata Shakur, author of *Assata: An Autobiography*, published in 1987, was a committed participant in the 1970s Black Liberation Movement. Under J. Edgar Hoover's Counter Intelligence Program (COINTELPRO), whose aim was to destroy the movement by criminalizing activist-organizers, Shakur was charged with crimes she did not commit and hunted. Still revolutionary, she has lived for thirteen years in Havana, Cuba where she writes, lectures and is an active member of her community.

Flora Veit-Wild, born in Germany in 1947, lived in Zimbabwe from 1983 to 1993. Her PhD was on the social history of Zimbabwean literature, and she is a founder member of Zimbabwean Women Writers and the Dambudzo Marechera Trust. She is also Marechera's biographer and the editor of his posthumous work, and now lives in Germany.

Index